All art is at once surface and symbol

Oscar Wilde: *The Picture of Dorian Gray*

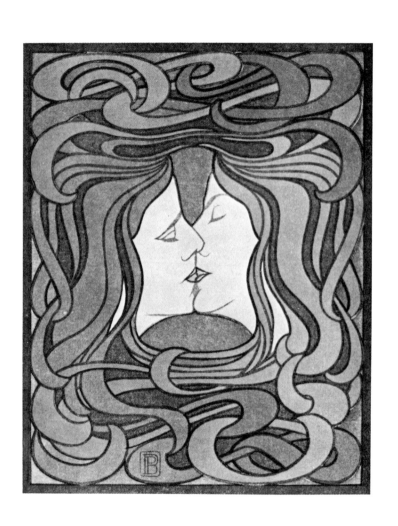

ART NOUVEAU

Art and Design at the Turn of the Century

Edited by Peter Selz *and* Mildred Constantine
with articles by Greta Daniel, Alan M. Fern, Henry-
Russell Hitchcock *and* Peter Selz.

New, Revised Edition

The Museum of Modern Art, New York

Distributed by New York Graphic Society, Boston

This revised edition is dedicated to the memory of Greta Daniel.

Copyright © 1959, 1975, by The Museum of Modern Art
All rights reserved
New, revised, first paperbound edition, 1975
Library of Congress Catalog Card Number 75-15064
ISBN 0-87070-222-X
The Museum of Modern Art
11 West 53 Street
New York, N.Y. 10019
Book design by Charles Oscar; cover design by Frederick Myers
Printed by The Murray Printing Company, Forge Village, Mass.

Frontispiece: Behrens: *The Kiss*. 1896-97. Color woodcut. 10⅝ x 8½". Private collection, New York

Editor's note: For this revised edition of Art Nouveau *the authors have provided corrections and revisions that bring the text up to date. In addition, a section of eight color plates is included for the first time.*

CONTENTS

Acknowledgments 6

Introduction *by Peter Selz* 7

Graphic Design *by Alan M. Fern* 18

Painting and Sculpture, Prints and Drawings
 by Peter Selz 46

Decorative Arts *by Greta Daniel* 86

Architecture *by Henry-Russell Hitchcock* 122

Notes to the Text 148

Bibliography *by James Grady* 152

Biographies and Catalogue of the Exhibition 162

Index 186

ACKNOWLEDGMENTS

It is important to note that as early as 1933, at a time when Art Nouveau was still considered little but the extravagant conclusion of a tasteless era, Philip Johnson directed a small exhibition at the Museum of Modern Art, which, under the title *Objects 1900 and Today* suggested an early re-evaluation of the style.

During the same spring a comprehensive Art Nouveau exhibition was proposed by Alfred Barr but aroused little response. Shortly after the War the Museum collection of Art Nouveau objects began to grow with the encouragement of Edgar Kaufmann, and in 1949 the Museum exhibited a special gallery of Art Nouveau accessions, including work by Guimard, Tiffany, Munch, Lautrec and others. Today the collection has increased to such an extent that it has provided over forty loans for the present exhibition.

Scholarly investigations on Art Nouveau began to be published in the 1930s but it was not until 1952 that the first all-inclusive exhibition of the movement was organized by the Kunstgewerbemuseum in Zurich. The recent turnabout in the evaluation of Art Nouveau calls for renewed interpretation and, above all, a definition of this elusive style. It is hoped that this collection of essays will stimulate further investigation and discussion toward defining this style in which a specific creative force broke with the historicism of the past to prepare the ground for the art of this century.

This book, issued in conjunction with the Art Nouveau exhibition at The Museum of Modern Art, The Carnegie Institute, Pittsburgh, the Los Angeles County Museum, and the Baltimore Museum of Art, is largely a result of the collaboration between the Department of Architecture and Design and the Department of Painting and Sculpture Exhibitions at the Museum of Modern Art. Special acknowledgments are due to Arthur Drexler for his valuable suggestions and his brilliant installation of the exhibition in New York, and to Alicia Legg and Ilse Falk for their editorial assistance, and the preparation of the catalogue, biographies, and index.

The editors and authors of this book have benefited greatly from the advice and courtesy of European museums whose staffs worked tirelessly assisting us in our preliminary research and making their collections and documents available to us. We have, in addition, received the most generous help from a great many individuals in Europe and the United States, among whom the following deserve special mention: Charles Alexander, Alfred H. Barr, Jr., Leonard Baskin, Edgar Breitenbach, Bernard Dorival, Hans A. Halbey, Thomas Howarth, Agnes Humbert, Harold Joachim, Robert Koch, John Jacobus, William S. Lieberman, Maurice Malingue, A. Hyatt Mayor, Carroll L. V. Meeks, G. W. Ovink, Nikolaus Pevsner, John Rewald, Willy Rotzler, Herwin Schaefer, Darthea Speyer, Gordon Washburn, James M. Wells, and Siegfried Wichmann.

For special assistance we owe thanks to Jacques Stoclet and L. Wittamer deCamps of Brussels, to J. Hembus O. H. B. of Frankfurt and to Liberty & Co., of London.

On behalf of the Trustees of the Museum of Modern Art and of the collaborating museums, I wish to express my sincere appreciation to the museums, libraries, collectors, and dealers who graciously lent to the exhibition.

PETER SELZ
Director of the Exhibition

INTRODUCTION

In February 1894 Claude Debussy's "Quartet in G Minor" and "La Damoiselle Elue" (after the poem "The Blessed Damozel" by Dante Gabriel Rossetti) was played at the opening of the first exhibition of *La Libre Esthétique* in Brussels. In the exhibition were paintings by Puvis de Chavannes as well as Camille Pissarro, Renoir, Gauguin, and Signac, and also Redon, Toorop, and Ensor. In addition to the paintings, selected with remarkable catholicity, there were shown—on the same level with "fine arts"—William Morris' illuminated books of the Kelmscott Press, Aubrey Beardsley's illustrations for Oscar Wilde's *Salome,* posters by Toulouse-Lautrec, Chéret, and Eugène Grasset, tapestries by Maillol, woodcuts by Vallotton, an interior designed by Gustave Serrurier-Bovy, spoons, cups, buckles, and bracelets which Charles Ashbee had designed for the Guild and School of Handicraft in London. The guests at this opening must have been struck by the diversity of the objects. Yet, listening to Debussy's music, gazing at Gauguin's paintings, and examining Ashbee's metal craft, they may also have perceived a purposeful attempt on the part of the exhibitors to manifest a relationship between all the arts, an effort which was soon to be spelled out in Henry van de Velde's lecture "L'art futur" scheduled during the exhibition.

Three years later, in May 1897, the German architect Alexander Koch called for "the need of a complete integration of all artists, architects, sculptors, painters, and technical artists. They all belong intimately together in the same place, each thinking individually, yet working hand in hand for a larger whole."[1] This appeal was published in the first issue of the journal *Deutsche Kunst und Dekoration,* which almost immediately became the voice of a new movement in the visual arts. The statement, using approximately the same wording as the First Proclamation of the Bauhaus,[2] which it preceded, however, by twenty-two years, was largely the outgrowth of Morris' Arts and Crafts movement, whose aim Walter Crane defined as "turning our artists into craftsmen and our craftsmen into artists."[3] Indeed during the late eighties and the nineties, a good many painters such as Henry van de Velde and Peter Behrens, turned from painting to architecture and design.

THE ARTS AND CRAFTS MOVEMENT William Morris, painter, poet, craftsman, lecturer, and militant pamphleteer, had been clamorous enough in his demand for a unification of all the arts and crafts to bring about important reforms in architecture, interior design, furniture, chintzes, carpets, wallpapers, and typography, to accomplish indeed such a unification in his workshop. Similarly, Arthur Mackmurdo, who founded the Century Guild in 1880-81, emphasized the indivisible unity of the arts and crafts, as did the Art Workers' Guild, established by Walter Crane and Lewis Day two years later. The Arts and Crafts Exhibition Society, founded in 1888 with Crane as president, brought a comprehensive program to the attention of a wide public by means of its exhibitions, lectures and demonstrations. An integral concept of the unity of art and life was the belief, first expressed by John Ruskin and constantly reiterated by Morris, that true art was the expression of man's pleasure in his work and that therefore the arts, when honest, were simultaneously beautiful and useful. So they seemed to have been in the Middle Ages, and from the medieval period the men of the nineteenth century learned that high artistic achievement might best be accomplished by communal effort. The men of the Arts and Crafts movement would have fully agreed with Tolstoy, who postulated in *What Is Art?* (translated in 1899) that it is "a means of union among men, joining them together in the same feelings, and indispensable for the life and progress towards well-being of individuals and of humanity."[4]

THE "DECADENCE" No greater contrast could be imagined than that between the old Tolstoy and the young Oscar Wilde. The latter had as little use for social reform as he had for utility. Artifice and affectation, perversity and egoism were the very essence of Wilde's world and of the whole movement known as The Decadence. To Wilde, brilliant conversationalist and cultivated dandy, the artful attitude was more desirable than the work of art itself. He had early announced the intention of living up to his blue-and-white china, and to him and his circle a doorknob could be as admirable as a painting; the necktie, the boutonniere, the chair, were of essential importance to the cult of living.

We find then a strange encounter in the 1890s: the socialists and moralists of the Arts and Crafts movement felt an ethical obligation to reconcile art and society and to create a better environment for themselves and for the working classes with objects of more honest design and production. The Decadents of the Aesthetic Movement of the *fin de siècle,* on the other hand, were eager to keep their sophistication far removed from popular culture by withdrawing into an esoteric world in which art was to become *the* way of life. *The Yellow Book,* that great journal of the Decadence with Aubrey Beardsley as its art editor, seems, however, related to Mackmurdo's Arts and Crafts publication, *The Hobby Horse,* in its freshness of approach to typography (page 26), its use of original illustrative material, and in the combination of stories, drawings by new artists, advanced poetry, and essays on music and other cultural aspects catching the fancy of the editors. The two journals were strikingly different in purpose and appearance, but even so the Decadents seemed to agree with the moralists that a synthesis of the arts was utterly desirable.

SYNTHESIS OF THE ARTS Motivated by this desire, both groups shared an admiration for Richard Wagner,[5] who combined a rather synthetic but nevertheless clearly pronounced belief in folk art with the actual creation of the *Gesamtkunstwerk.* Indeed the German composer's attempt at synesthesia of music and drama for the "total theatre"

encouraged architects, painters, designers, and craftsmen to make similar efforts toward unifying all the arts of living. This unity of the arts was most evident in the comprehensive design of the house. There the wallpaper design is related to the light fixtures and the cutlery; and the design of the book carefully echoes that of the cabinet. For their predominantly decorative qualities murals, tapestries, and stained glass are preferred to paintings and sculpture which, when introduced, are intended to be seen as part of a larger whole. The jewelry corresponds to the furniture. Henry van de Velde and Hector Guimard followed William Morris by actually designing their wives' costumes so that the very gesture would become an integral part of the environment (right). It even went so far that when Toulouse-Lautrec was invited to a luncheon at van de Velde's house in Uccle, the choice of food, its color and consistency was harmonized with table-setting, curtains, and the whole interior.[6] Horta abolished any clear distinctions among floor, wall, and ceiling by creating a fluid baroque space based on plant ornament. The similarity between the composition of a printed page and the façade of a building is remarkable, and the title page of a book may easily be transposed into a portal[7] (see page 44).

THE SEARCH FOR THE NEW The 1890s was a period of boldness in experimentation, a time which not only tolerated new ideas but was eager for novelty, if not the sensational. Disgusted with the old naturalistic formulas—whether in the imitation of nature on canvas, or the imitation of craftsmanship in cheap, machine-produced furnishings—people seemed to have had their fill of the philistinism which characterized so much of life and taste of the nineteenth century. The flagrantly inequitable social conditions made a great many artists and intellectuals turn toward socialism and anarchism. The success of technology as the great benefactor of the masses was questioned, and faith in materialism grew shaky.

There was also a move toward religion and mysticism. Both Beardsley and Wilde were penitent converts to the

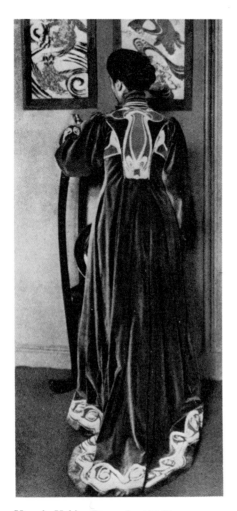

Van de Velde: Dress (c. 1896)

Roman Catholic Church before their deaths. Some of the *Nabis* became ardent Catholics, Jan Verkade even joined a monastery. Others turned toward Buddhism; the Rosicrucians and Theosophists had many followers among the artists and writers.

SYMBOLISM Shunning narrative and disinterested in quotidian affairs, writers and soon other artists became more concerned with the veiled essence of reality, with the IDEA behind the shape. In 1886 Jean Moréas had published the Symbolist Manifesto,[8] summarizing concepts which permeated the poetry of Verlaine and Mallarmé and the prose of Huysmans. Realism in art and naturalism in poetry were rejected in innumerable "little reviews" of the avant garde. The aim of art was not to describe observed reality, but rather to suggest felt reality. "To name an object," said Mallarmé, "that is to suppress three-quarters of the enjoyment of the poem which comes from the delight of divining little by little: *to suggest it,* that's the dream."[9]

Verse dissociated itself from established patterns, and instead of describing nature it attempted to externalize ideas and sensations, to reveal the true meaning of life and nature by evoking a direct response through the use of sounds, rhythms and associations. The SYMBOL gives concrete form to the ideas—it is not didactic like the allegory; it addresses itself to the emotion, not the intellect; it does not stand for something else, it is close to myth; it is both the key to the meaning and the meaning itself.[10]

In France, Odilon Redon developed his personal dream world in close association with the Symbolist poets. Their program of expressing subjectively an idea by means of evocative and decorative form was adopted by a group of painters at Pont-Aven dominated by Paul Gauguin.[11] Soon this attitude found its expression in the painting of the *Nabis* in France, Ferdinand Hodler in Switzerland, Edvard Munch in Norway, Gustav Klimt in Austria, and in the drawings of Aubrey Beardsley in England and Jan Toorop in Holland. Almost at once it appeared in the applied arts: in the vases of Emile Gallé—significantly called *études*—

9

in which shape, color and texture created a symbolist decor, underlined further by aphoristic phrases from Baudelaire, Verlaine, or Maeterlinck that were fired into the glaze. We see it in the whole poster movement of France, and it is noteworthy that the Symbolist periodical *La Plume* after devoting special issues to the work of Verlaine, Mallarmé, Huysmans, and Baudelaire, in 1894 inaugurated poster exhibitions sponsored by the *Salon des Cent,* and devoted a special issue to the work of Eugène Grasset (page 39), one of the chief exponents of the new poster movement.[12]

The personal relationship between Symbolist writers and artists was intimate. They published in the same journals in France, Belgium, Holland, England, and Germany. Frequently the artists illustrated the poetry and prose of their avant-garde companions.[13]

SYMBOLISM OF LINE The place occupied by sound in Symbolist poetry was now held by line in the new art (frontispiece). Line became melodious, agitated, undulating, flowing, flaming. The symbolic quality of line as an evocative force was expressed as early as 1889 by Walter Crane, whose work, although in the William Morris tradition, anticipated many of the characteristics of the new movement: "Line is all-important. Let the designer, therefore, in the adaptation of his art, lean upon the staff of line —line determinative, line emphatic, line delicate, line expressive, line controlling and uniting."[14] At the same time Seurat and Signac, following the researches of Charles Henry, spoke of complementary line as well as complementary color and then van de Velde, himself originally a Neo-impressionist painter, wrote of the line as "a force which is active like all elemental forces."[15]

This is the esthetic basis of Horta's abstractions of intricate linear loops in the Tassel House; it is the essential quality of the fantastic vegetative ornaments of Guimard's Métro stations, or of Endell's façade of the Atelier Elvira in Munich. Endell saw the ultimate meaning of the new Symbolism of form when he wrote in 1898: "We stand at the threshold of an altogether new art, an art with forms which mean or represent nothing, recall nothing, yet which can stimulate our souls as deeply as the tones of music have been able to do."[16]

TERMINOLOGY This was the ultimate formulation of the chief esthetic characteristic of a movement which developed simultaneously all over Europe. By the late nineties "Art Nouveau" had achieved a remarkable international success as *the* style of fashion and the avant garde. In the various countries it went by different names and was, in fact, ambivalently considered a national style or else an import from a foreign country, depending on a positive or negative attitude toward the mode. Only fairly recently has it been generally recognized as an international movement.

At first, nobody seemed to know where it originated. The English, not realizing the major contributions they themselves had made—especially in graphic design—and never really participating in the full-blown movement, called it Art Nouveau. In France, the country of the Symbolist movement, it was referred to occasionally as "Modern Style," and went under a great many names at first, such as the graphic "Style nouille," or, even more literally, "Style de bouche de Métro." Hector Guimard, the man responsible for these subway entrances—this odd-looking street furniture of Paris—preferred his own "Style Guimard." Edmond de Goncourt, aware of the streamlined elements, pejoratively called it "Yachting Style." Eventually the name Art Nouveau was adopted. In Germany it was at first variously called "Belgische" and "Veldesche" after the Belgian Henry van de Velde, who, upon coming to Germany in 1897, had assumed leadership of the movement there. Or it was referred to as "Studio-Stil" after the English publication which reflected the work of the Arts and Crafts Exhibition Society. Other more whimsical names were "Schnörkelstil" (flourish-style) and "Bandwurmstil" (tapeworm style). It was, however, the term "Jugendstil," from the highly popular Munich magazine *Jugend,* which entered the vocabulary. The Austrians referred to it as "Secessionsstil" because of the Vienna Secession which, under the

leadership of Klimt, Hoffmann, and Olbrich, was holding highly cosmopolitan exhibitions in Vienna. The Scots, who undoubtedly had a considerable influence on the Viennese, named their corollary "The Glasgow School." In Spain it was called "Modernismo," in Italy it went by the title of "Stile floreale" but, generally, as "Stile Liberty" after Liberty's London store and the printed, often Oriental, textiles it offered for sale. The Italians, no doubt, were fully aware of the double meaning in this name. In Belgium it was called "Paling stijl" (*Paling:* Flemish for "eel") or "Le Style des Vingt" or "La Libre Esthétique" to identify it with the names of these exhibition groups which, under the brilliant guidance of Octave Maus, were the most advanced anywhere in Europe and were largely responsible for the leadership Brussels assumed in the new movement.

MAISON DE L'ART NOUVEAU The term Art Nouveau, which was finally accepted in most countries, derives from S. Bing's shop Maison de l'Art Nouveau, at 22, rue de Provence in Paris. Bing, a native of Hamburg, had previously been primarily concerned with Japanese art as connoisseur, publisher, and dealer. Vincent van Gogh was one of his customers[17] and Louis C. Tiffany patronized the New York branch of his establishment.[18]

For his first *Salon de l'Art Nouveau,* which opened in December 1895, Bing commissioned Bonnard, Grasset, Ibels, Roussel, Sérusier, Toulouse-Lautrec, Ranson, Vallotton, and Vuillard to make designs for stained glass executed by Louis C. Tiffany in the United States. The Salon itself included paintings by most of these artists as well as Carrière, Denis, and Khnopff, sculpture by Rodin, and— placing the applied arts on an equal basis—glass by Gallé and Tiffany, jewelry by Lalique, posters by Beardsley, Bradley, and Mackintosh. In 1896 Bing presented the first Paris exhibition of paintings by Edvard Munch. He also introduced van de Velde to Paris by inviting him to send four completely designed rooms to the establishment. Less than two years later Bing had van de Velde invited to Germany to participate in the large international art exhibition of

1897 in Dresden, which was acclaimed as "The trumpet call inaugurating a new time."[19] The special pavilion, "Art Nouveau Bing" at the Paris *Exposition Universelle* of 1900, stressed the work of Colonna, de Feure, and Gaillard, and though less epoch-making, showed a refined taste which seemed lacking in most of the exhibits.

ANTI-HISTORICISM In an article which Bing wrote about the term Art Nouveau, he says that it was "simply the name of an establishment opened as a meeting ground for all ardent young artists anxious to manifest the modernness of their tendencies,"[20] and, taking issue with the historicism still so prevalent at the time, he continued: "Amidst this universal upheaval of scientific discoveries the decoration of the day continued to be copied from what was in vogue in previous centuries, when different habits and different masters were current. What an astonishing anachronism!"[21]

The anti-historical attitude was as much an earmark of Art Nouveau as was its striving toward the synthesis of the arts. As early as 1885 Louis Sullivan, whose work predicted so many characteristics of Art Nouveau, proclaimed: "Our art if for the day, is suited to the day, and will also change as the day changes."[22] And Otto Wagner wrote ten years later in Vienna that the new style was not a renaissance, but a naissance, that modern life alone must be the sole starting point of our artistic creation, and that all else is archaeology.[23] Wagner's student, Joseph Maria Olbrich, inscribed in large letters on the building he designed for the Vienna Secession in 1898: *Der Zeit ihre Kunst,*[24] and the preface to the Munich periodical *Jugend,* which indeed gave the name to the style in Germany, reads in part: "We want to call the new weekly *Youth.* This really says all we have to say."[25] When in 1902 A.D.F. Hamlin published an article on Art Nouveau in the first critical series on the movement in the United States, he pointed out that there was little agreement among its adherents and that all they had in common was "an underlying character of protest against the traditional and the commonplace."[26]

ACCEPTANCE OF MODERN TECHNOLOGY As part of this break with historicism and in contrast to the attitude of the Arts and Crafts movement, van de Velde defended the machine as an acceptable tool for the designer. He considered the engineer "the creator of the new architecture,"[27] whose boldness has surpassed even the daring of the builders of cathedrals, and who now works in metal and glass instead of stone and wood. His Belgian contemporaries, Hankar and Horta, made wide use of iron in their buildings, and Horta displayed the structural qualities of iron in his Tassel House with ornamental emphasis. This is not to stay that iron construction was actually one of the sources of Art Nouveau.[28] It would seem more likely that Horta's sense of design and esthetic feeling—and possibly his familiarity with drawings and designs by Mackmurdo, Khnopff, Toorop, and Beardsley—determined his use of iron. But although the metal did not dictate his fluid, organic forms, iron was a fitting material for the architect's purpose. One of the essential aspects of Art Nouveau was the acceptance of technology and the machine as a means toward creating a new style, without, however, elevating functionalism to an esthetic principle.

In general, the Art Nouveau artists were convinced that they were evolving a new and contemporary style in which the flouting of convention—the attitude of *épater le bourgeois*—was "advanced" and desirable. The scathing social accusations of Ibsen's plays found, in a certain sense, a parallel in the impudence of the unconventional Art Nouveau whiplash ornament that appeared in the theatre programs.

HISTORICISM Art Nouveau claimed to be the new art of the new time. Yet its avowed break with tradition was never complete. In certain ways Art Nouveau actually belongs with the nineteenth-century historical styles. The century had earlier run the gamut from the Egyptian revival of the first Empire to the baroque revival of the second. Now at the end followed Art Nouveau which, in France at least, often merged with a rococo revival. As Bing himself said: ". . . try to pick up the thread of . . . grace, elegance, sound logic, and purity, and give it new developments, just as if the thread [of the French tradition] had not been broken. . . ."[29]

ROCOCO Art Nouveau shared with the rococo a desire to make painting part of the general decor. Painters and decorators showed a preference for a light, high-keyed color scheme. Rococo characteristics can be observed in Horta's flowing space, in his asymmetrical ornamentation, his vigorous curves which, however, have substituted a more abrupt termination for the easy, elegant flow of the eighteenth century. Aubrey Beardsley in his last drawings culled quite consciously from eighteenth-century draftsmen like Saint-Aubin and Debucourt. Gallé, Majorelle, and Vallin, however, probably came closest to the gracefulness of rococo design, working in Nancy with its magnificent eighteenth-century Place Stanislas.

CELTIC ART The marked individuality of Art Nouveau in different countries is partly due to revivals of specific traditions. If the Nancy School seemed inspired by the rococo, the cult of the Celt attracted the Glasgow designers of the nineties in their search for an independent national culture. The flat patterns of Celtic manuscripts (page 13), brooches and chalices in which intricate linear design of tangled interlace and coiled spirals is rigidly controlled by geometry is echoed in the early drawings and repoussé designs by Mackintosh (page 19) and the Macdonald sisters (page 18) and appears again in the murals of the Buchanan Street Tearooms of 1897 (page 69) and in the wrought-iron ornament of the Glasgow School of Art (page 145).

GOTHIC The fascination with the Celtic is part of the more comprehensive interest in the Middle Ages which spanned the nineteenth century. The Gothic Revival had begun in the 1750s with Horace Walpole's Strawberry Hill, and continued to flourish under the aegis of A.W.N. Pugin, Ruskin, Morris, and Viollet-le-Duc. The latter, in-

deed, advocated the use of iron as a new building material, and the unconcealed display of structural members in the Gothic may well have inspired Horta's daring use of iron, while van de Velde was proud to admit his conscious use of Gothic space concepts.[30] But in addition to their admiration for the rational nature of Gothic architecture, Art Nouveau artists were also intrigued by the ornament, especially in the late manifestations of the Gothic. These late buildings with their observations of natural growth, their flamelike and leaflike tracery, double curved ogee arches and flowing shapes, are called Curvilinear in England and Flamboyant in France, and even their names are descriptive of the very elements which appealed to the Art Nouveau. Guimard's Castel Béranger and Horta's Hotel Solvay, for instance, exemplify the relationship of Art Nouveau to the Flamboyant Gothic.

BLAKE A similar flowing, undulating Gothic linearity appears in the book illuminations and temperas of William Blake, and there is no doubt that he exerted a major influence on Art Nouveau,[31] although the fervent feelings, conditioned by his visions, are not reflected. There is in *The Songs of Innocence* (page 15), for example, not only the smoothly flowing line, but also a comprehension of the page: the interrelationship of typography and ornament. Mackmurdo's *Hobby Horse* had a good many references to Blake, and the frontispiece of the first issue is "obviously a pastiche of Blake motifs."[32] It was Mackmurdo, the admirer of Blake, who produced the first work which combined all the characteristics of Art Nouveau: the chair designed in 1881,[33] and the second, the title page of his book *Wren's City Churches* (page 27) published in 1883.[34]

EXOTIC ART The nineteenth century, having managed to exhaust nearly all sources of inspiration in the Western past, turned at last beyond Europe and the Near East. Art Nouveau designers, for example, became interested in the flat batiks introduced by Dutch importers from Java. African sculpture was first reproduced as "art" when *Dekorative*

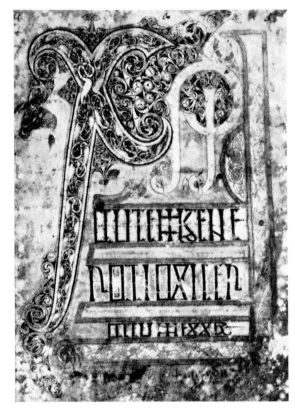

The Chi-Rho page of the St. Chad Gospels, Litchfield Cathedral, Staffordshire, England

13

St. Séverin, Paris. Window, 15th century

tween Japanese art and Art Nouveau.

Whistler was followed in his interest in Japanese art by Manet, Monet, Renoir, Degas, Gauguin, van Gogh, and Toulouse-Lautrec; each took what he needed. Japanese textiles, fans, lacquers, and prints began entering collections, and it is noteworthy that men as intimately connected with Art Nouveau as S. Bing, Arthur L. Liberty, Louis C. Tiffany, Aubrey Beardsley, Otto Eckmann, and Toulouse-Lautrec are to be counted among the important early collectors of Japanese art.

Most significant for Art Nouveau was the two-dimensional planar aspect of the Japanese color woodblock— itself an expression of a late cultural phase; its absence of central perspective in favor of broad, homogenous, receding planes; the division of the picture space into large, unified areas; the evocative quality of the line in establishing a linear rhythm; the expressive contour; the use of color for flat pattern effect instead of illusionistic modeling; the asymmetry of the composition and energetic diagonal movement of linear design, frequently originating in the corner of the picture; and the simplification of natural forms for the sake of the picture.

ART NOUVEAU AND NATURE The Japanese were able to deal intimately with nature without ever copying its surface appearance. The whole nineteenth century, of course, had great faith in the world of nature and the Art Nouveau artist, going to nature for a major source of inspiration, found in Japanese art a way to re-experience the very forces of nature in energetic, rhythmic line. Unlike the Impressionist, he was no longer concerned with momentary visual stimuli on the retina. Nature was still "the infallible code of all laws of beauty,"[37] but he wished to explore the forces of growth and to represent them symbolically. Art Nouveau artists were often careful students of botany: Gallé wrote scientific articles on horticulture, Grasset realized the applications of plant study for the new ornament,[38] Obrist started his career as a natural scientist. Ernst Haeckel, the German biologist and explorer who con-

Kunst published a number of Benin bronzes in 1899[35]— some five years prior to its discovery by the Expressionists in Dresden and the *Fauves* in Paris.

JAPANESE ART But of greatest importance especially in painting and the graphic arts was the impact of Japanese art.[36] Here was a completely new esthetic expression in which each Western artist could find inspiration for his own individual style. Whistler was the first major painter to show the direct influence of Japanese art. Japanese motifs are used in *La Princesse du Pays de la Porcelaine* of 1863-64; the famous Peacock Room of 1876-77 is entirely decorated in a design inspired by Japanese interiors. Moreover, Whistler also often placed his models against plain light walls and showed a similar preference for sophisticated simplicity in contrast to the burly heaviness of the arts and crafts of the day. Whistler was extremely important to men like Beardsley and was perhaps the chief intermediary be-

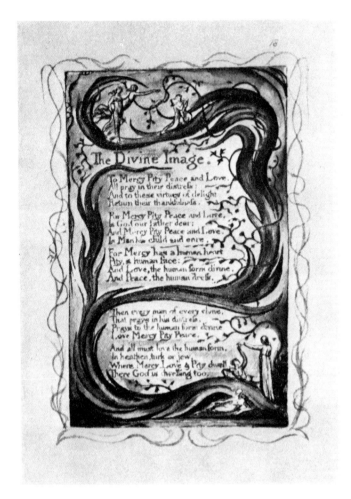

Blake, author and printer: Plate 18, *The Songs of Innocence.*
Wood engraving. 1789. The Metropolitan Museum of Art, New
York

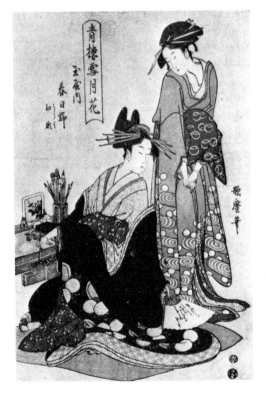

Utamaro (1753-1806): *Snow, Moon, Flowers
Compared to Women.* Color woodcut, Publ.
Murataya

15

tributed significantly to the theory of evolution and who wrote a great many monographs on lower forms of life, published in 1899 his epoch-making *Kunstformen der Natur*.[39] This work consisted mainly of greatly enlarged color drawings of amoebae, jellyfish, medusae, and polyps. Forms in nature which had never really been seen before were suddenly made available to the artist and were furthermore presented in a layout and graphic style that was very much in the visual idiom of the period. Haeckel says in his introduction that esthetic considerations played a major role in the compilation of the book, and he expresses the desire to be able to contribute motifs to the arts and crafts of his time.

Indeed, the Art Nouveau interior at its culmination—Horta's house for Baron van Eetvelde, Mackintosh's Willow Tearoom, Guimard's Humbert de Romans Building, Endell's Atelier Elvira, with their sinuous shapes of iron, wood, stone and plaster, suggesting climbing stalks and clinging tendrils—produces the effect of a suddenly fossilized conservatory.

ICONOGRAPHY It was nature in its most unexpected aspects which appealed to the Art Nouveau artist. He welcomed motifs of creatures found at the bottom of the sea, especially if the shapes of their tentacles or general contours corresponded to his own feeling for the flowing curves. If he used a flower, it was not the ordinary garden or field variety but rather the languid, exotic hothouse plant, whose long stalks and pale blossoms he found exquisite. Certain motifs keep recurring in Art Nouveau iconography: the lily, peacock and sunflower are adopted from the Aesthetic Movement, but the sunflower with its regular, radial form is less frequent, the peacock's tail feathers occur more often than the whole bird, and soon the lily pad and stem take precedence over the flower. The tendril of the vine is more interesting than its leaves, the bud more intriguing than the blossom. The swan surpasses the peacock in popularity. Equally a symbol of pride, he is also capable of gliding with the utmost grace, and now everything be-

gins to flow, partakes of constant movement. Almost to the exclusion of men, it is the woman who dominates the Art Nouveau world and the aspect of woman which pre-occupies the artist is her hair—long, flowing hair which may merge with the drapery or become part of a general wavy configuration. Loie Fuller's serpentine dances—"The Butterfly," "The Orchid," "The Fire," "The Lily"—enjoyed the highest popularity and can be seen as the most apt expression of certain art impulses at the time. Her veils performed the same erotic function as the flowing tresses of the Art Nouveau female. This girl-woman, to a great extent descended from the hothouse creature of the Pre-Raphaelites, has the same ambivalent eroticism of a small-breasted, narrow-shouldered, virginal, indeed often boyish creature. Almost emaciated, her body is yet extremely languorous in its sexually suggestive poses. This is the woman who appears in different disguises in the world of Beardsley, Toorop, Thorn Prikker, Bernard, Denis, Grasset, Macdonald, Mackintosh, and Klimt.

The interest in the bud and the young girl suggests that the ideal world of the Art Nouveau artist was far removed from what is usually thought of as the "Gay Nineties." He seemed to prefer a melancholy, nostalgic expression to unbridled gaiety or joy. Everything remains in a state of unfulfillment; there is perhaps eager expectation, but it never seems to go beyond the threshold. And indeed the whole movement only makes beginnings. Toulouse-Lautrec, Beardsley, and Eckmann died early. Horta and Mackintosh, Toorop and Thorn Prikker, Bernard and Denis, even Edvard Munch, reverted to a conservative style and were never able to follow through on the brilliant promise of their youth. Hector Guimard continued in his Art Nouveau style, but his buildings of the twenties and thirties are anachronisms. Some of the architects, like Hoffmann, Behrens, and van de Velde, were able to develop beyond Art Nouveau to become important in the "Modern Movement" which followed, while painters such as Bonnard, Vuillard, Kandinsky, and Picasso found their own unique expressive forms after their Art Nouveau apprenticeship.

By 1900 the style had become generally accepted, even fashionably chic among the elite. Within the next two years it filtered down, and the international exhibition of decorative arts held in Turin in 1902 showed the popular triumph and the concomittant decline in taste. Art Nouveau was always an ornamental style, but at its best its ornament grew from a desire for symbolic-organic structure. But when it was merely applied, it tried to make up in ornateness for what it lacked in conviction.

Having been able to create a unified style and to shake off the heavy hand of nineteenth-century imitative compulsion, the avant-garde designers began to look in a different direction. With almost sudden deliberation the inventiveness of ornament, the playfulness, the organic feeling comes to a halt. "Organic" will now refer to the nature of the material, to fitness and to the function of the object rather than to vegetative growth. Whenever used, ornament becomes geometric: the right angle takes the place of the sinuous curve; the square, the circle, the rhomboid, the oval are preferred to the stalk, the wave, the hair. But buildings such as Mackintosh's House of a Connoisseur or Hoffmann's Palais Stoclet (pages 142-143), while partially abandoning the wavy line for a more rectangular ornamentation, still adhere to the Art Nouveau principle of a two-dimensional decoration whose evocative power rests on its linear rhythm.

Historically Art Nouveau fulfilled the liberating function of an "anti" movement. It discarded the old, outworn conventions and set the stage for the developments which followed with such extraordinary rapidity in the twentieth century.

PETER SELZ

Ernst Haeckel: *Palephyra Primigenia,* from *Kunstformen der Natur,* 1899. Bibl. 54. Collection New York Public Library

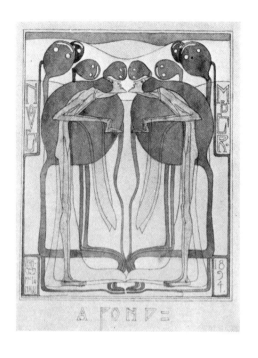

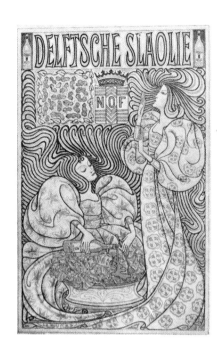

Left, Frances Macdonald: *A Pond.* 1894. Book cover

Jan Toorop: *Delftsche Slaolie.* 1895. Poster. 36¼ x 24⅜″. Stedelijk Museum, Amsterdam

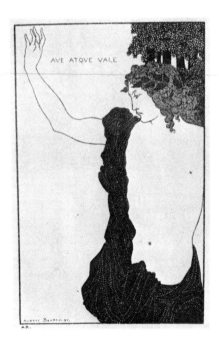

Left, Behrens: Dedication page for *Feste des Lebens und der Kunst,* 1900

Beardsley: *Ave Atque Vale* from *The Savoy* No. 7. 1896. Ink. Collection Mr. and Mrs. John Hay Whitney, New York

GRAPHIC DESIGN

Mackintosh: *The Scottish Musical Review.* 1896. Poster. 97 x 39". The Museum of Modern Art, New York

In the graphic arts, Art Nouveau was a tremendously varied style which encompassed a considerable diversity of expression ranging from the spidery, linear work of Mackintosh (left) and the Macdonalds through the rectilinear borders of Peter Behrens to the sinuous illustrations of Beardsley (opposite). In the hands of Toorop and a few other Dutch and Belgian artists, Beardsley's whiplash line proliferated and elaborated itself into a new expressive element, and such designers as Koloman Moser and Rudolf von Larisch (page 20) asserted the power of spatial and value contrasts in their lettering.

Through the work of graphic designers Art Nouveau extended beyond national boundaries into areas where, for reasons of economy or taste, the more elaborate works of the new style might never have been seen. The new posters, shop signs, and lettering for buildings became so much a part of the everyday scene that they could not fail to be noticed even by those who might try to avoid the new furniture and household objects. Books and magazines could be circulated far more easily than paintings or sculpture, and through work such as van de Velde's designs for the prepared food, *Tropon* (page 23), the artist entered into the field of industrial design where a characteristic decorative concept was imposed upon everything associated with a product.

Considering the interest of the Art Nouveau artist in transforming all things which might possibly be important in the visual world, it is scarcely surprising that he should have turned his attention to graphic design. Moreover, the Symbolist writers who were admired by so many of the artists of the 1890s had shown the expressive possibilities inherent in graphic design. The stock-in-trade of Huysmans and Oscar Wilde, for example, was the single object, exquisitely displayed, which served in their novels to elicit

19

Moser: Hand lettering. 1900

gleichen, der sich beim Buchstaben in seiner Doppeleigenschaft als Zierde und als Zweck ergibt und es wird in jedem einzelnen Falle die Frage zu lösen sein, ob der Zier- oder der Zweckgedanke zu betonen ist. Übrigens ist die Leserlichkeit ein mit der Zeit sich verändernder Begriff. Eine oder die andere Buch- stabengestalt, die noch vor wenig Jahren argen Anstoss erregte, hat sich heute völlig eingelebt und lässt sogar die damals gebräuchliche Form veraltet erscheinen. Das Ent- stehen einer neuen Schriftgattung bringt geradezu zeitweilig die gerin- gere Leserlichkeit einzelner Buch- staben mit sich. Man versetze sich z. B. in die Zeit der Entwickelung

der gothischen Schrift aus der Antiqua. ◦ ◦ ◦
Der ursprüngliche Plan, diese Samm- lung mit einem Anhange schul- mässiger Beispiele zu versehen, wurde im Interesse der Gesammt- wirkung des Werkes einstweilen unterlassen. So ansehnlich auch die Zahl der Künstler ist, die dem Werke ihre Kraft geliehen, so hoffe ich doch noch auf seine weitere Ausgestaltung. Dann wird sich auch das Lehrhafte — überdies auf einer breiteren Grundlage methodischer Erfahrungen — passender einfügen. Möge das Interesse der betheiligten Kreise bald die Möglichkeit bieten, diese Absichten zur That werden zu lassen. ◦ ◦ ◦

von Larisch: Hand lettering. 1900

Étant au lit tenz vous dans une position modeste, couché sur le côté droit, les bras, les jambes e le reste du corps couvert, un peu éloigné des personnes qui sont dans le lit par respect e pour ne point les incommoder, et gardez vous bien d'y parler e encore moins

La Civilité. Type face. French. 16th century

extraordinarily deep responses from the finely attuned ner- vous system of the sensitive beholder. Time and again in *A Rebours,*[1] or in *The Picture of Dorian Gray,*[2] this single object—a jewel, a bowl, a flask, a flower, or a book—sets off a chain of reflection and activity which carries the prota- gonist far from the everyday world of philistinism.

It is remarkable how often, in the works of the Decadent writers, this object is a book, and how often the binding of the book is even more important than its contents in the process of evocation. In *A Rebours,* Huysmans has his hero, Des Esseintes, concern himself with the typographical suita- bility of the books in his library on the basis of the different moods expressed by various type faces. Huysmans singled out *Civilité* (left), with its swelling curves and curious shapes, for special mention. The finicky Des Esseintes fitted the typography of his specially printed books to their texts according to a principle of aptness, so that *Civilité* ". . . whose peculiar hooks and flourishes, curling up or down, assume a satanic appearance," was used to print up a special edition of Barbey d'Aurevilly's *Les Diaboliques.* Huysmans' conception in 1884 anticipated by several years the formulation of the principles of visual symbolism which underlay the whole art of graphic design in Art Nouveau. Oscar Wilde went so far as to have Dorian Gray procure no fewer than nine copies of his favorite book (obviously *A Rebours*), bound in various colors and fashions to suit his changing moods and desires.

In this esthetic atmosphere, we can understand how it was that the bindings of Art Nouveau books are among the most lavish and impressive works of the style (right). Here the designer could indulge himself to the fullest in his love of expressive linear movement, elegant flat spacing, and masterful contrasts of color and materials, remaining quite free from the demands of textual reference or the limitations of advertising communication. The new de- signs, moreover, were not restricted to the costly, separately commissioned handbinding (opposite above, right), so close in conception to jewelry and other decorative objects, but were conceived as well for edition bindings (opposite below) to be done entirely by machine.

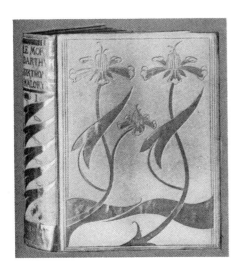

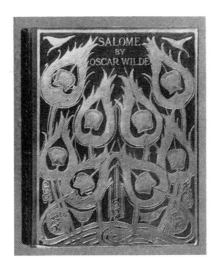

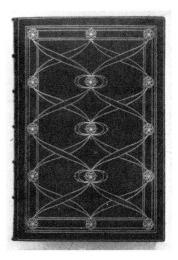

Beardsley: Binding for *Le Morte d'Arthur*. 1893. Klingspor Museum, Offenbach

Beardsley: Binding for *Salome*. 1907. Klingspor Museum, Offenbach

Cobden-Sanderson: Binding for *Areopagitica*. 1907-08. Museum für Kunsthandwerk, Frankfurt

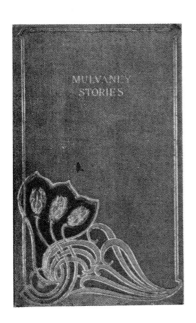

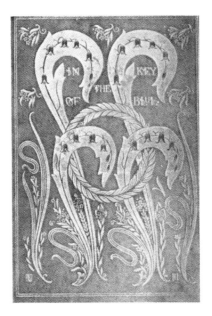

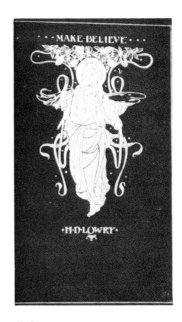

Binding for *Mulvaney Stories*. 1897. University of Chicago Library

Ricketts: Binding for *In the Key of Blue*. 1893. The University of Chicago Library

Robinson: Binding for *Make Believe*. 1896. John Lane. University of Chicago Library

THE CHARACTERISTICS OF ART NOUVEAU GRAPHIC WORKS

What is it that makes a book or poster Art Nouveau? Some observers[3] have suggested that the serpentine or whiplash curve is the one thing which most clearly characterizes these works. While this is tempting in its simplicity, and often is appropriate, the same kinds of curving lines are found in many other works which cannot be called Art Nouveau by any stretch of imagination or chronology. One example, out of many which might be cited, is the dotted print of *Christ as the Man of Sorrow with Four Angels* (below), done by an anonymous German printmaker of the fifteenth century. The serpentine curves are there, to be sure, but somehow they do not evoke the same response as the lines in Aubrey Beardsley's illustration for the *Morte d'Arthur* (below). The arabesques in the German print seem only to fill the spaces behind the figures of Christ and the upper two angels; although they are part of the over-all linear rhythm of the work they remain apart from the other elements in the picture. As Beardsley uses the curve, however, it becomes

a twisting, living thing, enclosing or even swallowing up whatever is nearby; the figure in the upper left of the illustration is engulfed by the curving branches which surround him, and each line in the border seems to loop in upon itself and then move out to entangle a neighboring form. Beardsley has evoked a feeling of sensual weirdness and exoticism; the German print, despite the curving lines it shares with Beardsley, is remarkably straightforward in its emotional effect and static in its composition. The mere presence of the serpentine curve is not sufficient to define the style. After all, the work of Mackintosh clearly fits into Art Nouveau (page 19) and yet the linear rhythms which he used are by no means similar to Beardsley's.

Mackintosh utilizes another of the characteristics which has been cited as peculiarly Art Nouveau: the flattening of space, and the consequent importance given (in two-dimensional works, such as prints and paintings) to the surface upon which the work is done.[4] In the Beardsley page this flattening of space can certainly be observed, especially in the border which seems to be a screen of interlocking white lines over a black background. In other works this is even

Far left, Anonymous, German: *Christ as the Man of Sorrow with Four Angels.* 15th Century. Dotted print. The Art Institute of Chicago

Left, Beardsley: Text and illustration from *Le Morte d'Arthur.* 1892

Van de Velde: *Tropon, l'Aliment le Plus Concentré* (Tropon, the Most Concentrated Nourishment). 1899. Offset facsimile of original lithograph. 31⅝ x 21⅜". The Museum of Modern Art, New York. Gift of Tropon-Werke

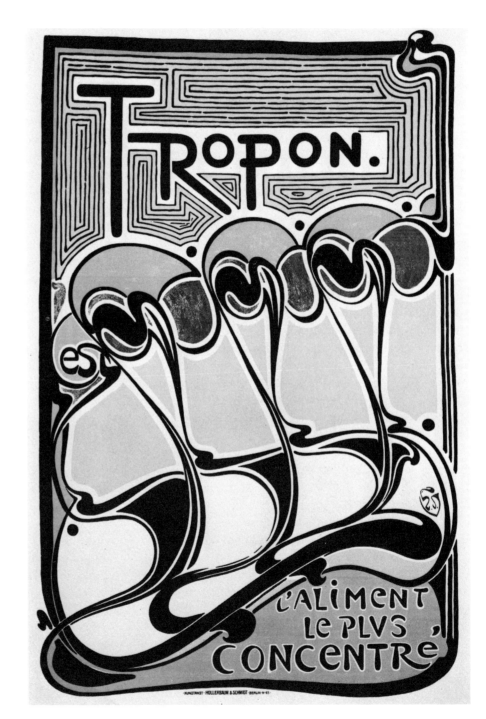

23

more evident, for example in Henry van de Velde's *Tropon* poster, where the powerfully repeated linear motifs pull the eye back and forth across the page without ever suggesting that the design might occupy a third dimension. Yet even this is not the exclusive property of Art Nouveau, as a look at a Celtic illumination of the eighth or ninth century (page 13) will establish. The Irish illuminator not only has rejoiced in the use of repeated linear motifs (with an abundance of serpentine lines), but has further confirmed the flatness of the design by using a whole series of small, over-all patterns to fill areas of his illumination.

Japanese prints often show the same tendency to suggest a shallow space, and to assert the integrity of the plane of the picture, and in a woodcut of two women by Utamaro (page 15) we can find still another formal characteristic in common with Art Nouveau graphic works. Some of the most telling forms in the Utamaro are the negative spaces: those white shapes, surrounded by lines or forms, which are nevertheless of more than accidental formal significance. The use of this technique is evident in both the Beardsley and the van de Velde works; in the Beardsley border the "lines" which intertwine are not really lines at all but are actually the spaces left between dark areas, and similarly in the *Tropon* poster some of the most important forms are really blank paper surrounded by closely related shapes and lines of contrasting value. There is a calculated ambiguity about the drawn line—equally present in the Japanese woodcut and in Art Nouveau graphic works— which makes it impossible for the observer to be sure of what the artist has drawn and what he has left for our eyes to construct. Moreover, in these works we constantly shift our attention from the drawn shape to the empty space (although not empty of visual meaning) which reinforces the feeling of flatness, and emphasizes the importance of the surface on which the work of art exists. In fact, the surface is no longer merely a support for the work of art but plays an active part in it. Again, this particular use of negative space is not peculiar to Art Nouveau, any more than are the serpentine line and flat spatial arrangement.

It should be clear by now that the secret of Art Nouveau will not be yielded by formal analysis alone. The characteristics already enumerated are revealing for an understanding of the style, but there appears to be something in the particular way these are handled by the Art Nouveau graphic designer which depends upon a desire, shared with few of his predecessors, to evoke a peculiar sense of movement and mood in his work.

Evocation, then, was of the utmost importance for the graphic designer of Art Nouveau, just as it had been a primary concern for Huysmans and Wilde. Yet one of the major figures in the revival of interest in the design and production of books was a man who was scarcely interested in projecting this evocative content in his works.

THE REVIVAL OF ORIGINAL DESIGN IN THE GRAPHIC ARTS

No single person had been more influential in the reawakening of interest in the decorative arts during the nineteenth century than William Morris.[5] Almost every Art Nouveau designer acknowledged a debt to him,[6] so it is of some importance that in the course of his career Morris turned his attention to the design and execution of printed books. During his more than two decades of work as a designer of textiles, household objects, wallpaper, and furniture, Morris had been an enthusiastic collector of incunabula and medieval manuscripts. As a writer, he had paid more than the usual attention to the form in which his poems and stories were printed and, inspired by his collection of books, he had even attempted some manuscript writing. Until 1888 these excursions into the graphic arts were for him little more than the avocation of a busy man; but when in that year he looked over his books to decide whether any were suitable for inclusion in the first exhibition of the Arts and Crafts Exhibition Society, he was forced to the realization that none would qualify. He saw for the first time that printing had lagged far behind the

other crafts, and that the books of his time were as shoddy and poorly designed as furniture had been thirty years before.

Under the guidance of his friend and fellow-socialist, Emery Walker, Morris designed a type face (below) (the first of three he was to do) based on the Roman letter of Nicolas Jenson, and set about purchasing a press, paper and inks. In 1891 his first book[7] appeared, bearing the imprint of the Kelmscott Press.

Morris' printing was very much in keeping with his other work. His love of pattern and rich design was manifested in the flowered borders and dense areas of type, all printed in rich black on roughened handmade paper of superlative quality. It is obvious that in designing his type, Morris had striven to bring the over-all value of picture and text into harmony; the letters contain no striking thick and thin elements, but rather are of even weight throughout. Composed with little space between words and lines, the areas of type hold their own with the bold borders,

elaborate initial letters, and woodcut illustrations. Every two-page spread in a Kelmscott Press book is composed as a single unit. The book is a series of related units which combine into a total work of art.

Although Morris asserted that a book existed first of all to be read, the lavish volumes which he designed and printed almost overpower the texts which they contain. But despite this inconsistency, and despite the interest which Morris demonstrated in imitating the appearance of books of the fifteenth century, his work was extremely influential. He had shown that it was proper for a designer to concern himself with the appearance of books, and that by controlling the design of every element of the book, including the type face, a book could become a work of art. It had taken years for artists and craftsmen to realize the necessity for reform in the design of other decorative arts; but almost as soon as Morris and his contemporaries had begun to work with books, the revival of printing spread throughout Europe and America.

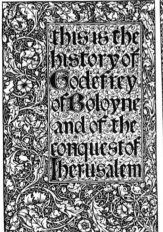

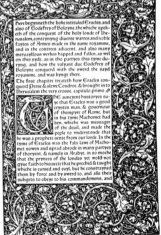

Morris: *Golden Type.* 1890

Morris: Border decoration and text for *The History of Godefry of Boloyne.* 1893. Kelmscott Press

PROTO-ART NOUVEAU: BLAKE, MACKMURDO AND OTHERS

During the nineteenth century, even before Morris had started his "typographical adventure," a number of other artists were exploring the possibilities of new expressive means in the graphic arts. Some of them seem almost to forecast the work of Art Nouveau. Dante Gabriel Rossetti, with his friends of the Pre-Raphaelite Brotherhood, had undertaken a study of the ways in which objects of nature might be given their maximum decorative meaning in a work of art, and this had led him to become most sensitive to the rhythmic distinctions which give plants their particular forms.[8] He explored the way in which the growth and abundance of nature might become a subject for the arts. These lines of investigation, suggested to him by Ruskin, give him a new foundation for his painting, but Rossetti's paintings themselves, although admired by many Art Nouveau designers, are scarcely in the spirit of Art Nouveau. However, in his bookbinding designs (below)

he utilized some of these forms in a context where he felt no need to suggest literary subject-matter, spacing the floral forms in such a way as to give the viewer a strong sense of the rhythmic and linear harmonies which constitute the decorative motifs.

Rossetti had deeply admired the work of William Blake, which seems even more closely related to Art Nouveau, but the first instance of real connection between Blake and the Art Nouveau graphic arts must be found elsewhere.[9] Artistic and literary journals played an important role in the development and spread of Art Nouveau; in the first of these journals, *The Hobby Horse*, we can trace the impact of Blake's work on the later nineteenth century.

The Hobby Horse was the journal of the Century Guild of Arts and Crafts, a group which was founded in 1880-81 and grew out of William Morris' efforts in the decorative arts. *The Hobby Horse* was dedicated to the exploration of significant work in the literary, visual and musical arts of all periods; in keeping with their interest in putting forth the best and most meaningful work in a form which would

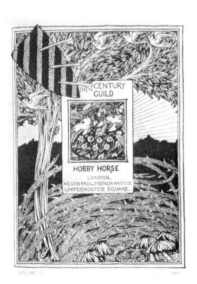

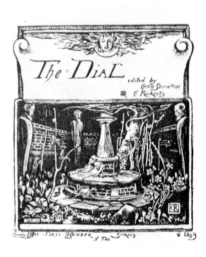

26

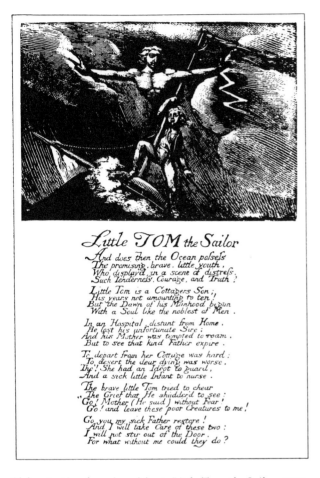

Blake: Section from broadsheet, *Little Tom the Sailor*. 1800

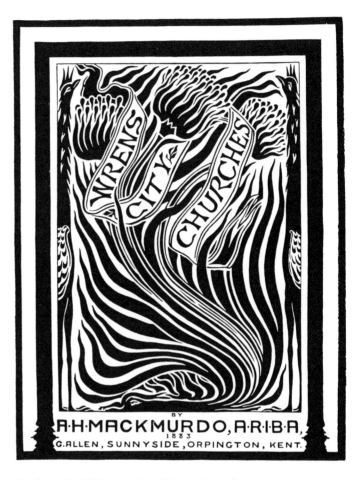

Mackmurdo: Title page for *Wren's City Churches*. 1883. Victoria and Albert Museum, London

Opposite left, D. G. Rossetti: Binding for *Atalanta in Calydon*. 1865

Opposite center, Image: Cover for *The Hobby Horse*. 1887

Opposite right, Ricketts: Cover for *The Dial*. 1889

Whistler: Butterfly mark

Mackmurdo: Monogram
for *The Century Guild*. 1884

express their feelings about the necessity of fine craftsmanship, the editors decided to make their magazine attractive in appearance as well as in content. Foreshadowing Morris' active interest in designing for print, the editors of *The Hobby Horse* commissioned a newly-designed type for the text of the magazine, and issued it in a large format, printed on handmade paper, with wrappers of new design (page 26).

In the second number of *The Hobby Horse,* which appeared in 1886, Arthur H. Mackmurdo published an article by Herbert H. Gilchrist on Blake. Mackmurdo reproduced a broadsheet poem (page 27), and Gilchrist wrote: "What a marvelous sample of typewriting is the Ballad written out with a brush, . . . while as legibile as ordinary types, every letter has naive expression, capital letters flaunt capriciously down the page each giving a defiant little kick of its own. With all the charm of decorative fitness the print answers directly its purpose as a broadsheet."[10]

Mackmurdo, one of the founders of the Century Guild, had designed some of the decorative vignettes for *The Hobby Horse,* and even before his association with the journal had designed a chair and title page (page 27) which are astonishing anticipations of Art Nouveau considering that they were made ten years before the style itself became widespread.[11] It seems obvious that in his own work, Mackmurdo tried to incorporate some of the vitality and expressiveness he had found in Blake's work, while keeping within the framework of fitness and functionalism to which all the followers of Morris had assented. Mackmurdo knew Whistler more than casually,[12] and it is possible that Whistler showed him the way to achieve the decorative power which he desired. Whistler was interested in Japanese woodcuts, and his famous butterfly mark (above) shows how well he had understood the Oriental use of space and outline. By placing a few lines against a few areas of tone, the insect is conjured up; it has character, it has movement, it relates to the surface of the paper on which it is drawn but also has a life of its own.[13]

Whistler's influence upon Mackmurdo may possibly be

seen in the latter's monogram (opposite) for the Century Guild designed in 1884, which was used on the back covers of *The Hobby Horse.* As with Whistler's butterfly, Mackmurdo's vignette exists entirely in terms of the contrasts of black and white shapes, and also utilizes a rhythmically curving line which weaves through the design. The lines have a more purely decorative force than Whistler's, and since the vignette is a woodcut (intended to accompany material printed on the letterpress) its contrasts of value are even more striking than those in Whistler's mark.

As the Arts and Crafts movement came to be better known, *The Hobby Horse* grew in reputation. In 1888 a group of young Englishmen founded a journal, *The Dial* (page 26), which was based largely on *The Hobby Horse* but carried to the public the work of a very different group of artists. The guiding force of *The Dial,* Charles Ricketts, shared with the Century Guild people an admiration for Morris.[14] Like Whistler, Ricketts admired Japanese art, but his enthusiasms went far beyond that. He was interested in the art of the Greeks, the painting of Gustave Moreau and Sandro Botticelli, and he was intrigued with fifteenth-century German woodcuts. Even in the work of his private press, he departed from Morris by introducing an element of visual poetry through the non-literal use of line and form,[15] a notion which followed naturally from his enthusiasms for earlier art. In this he came close to the ideas of a group of Continental artists who more directly shaped the graphic art which we know as Art Nouveau.

MAURICE DENIS: SYMBOLISM IN THE GRAPHIC ARTS

In 1890 a group of young French painters called the *Nabis* became interested in the decorative arts as an outlet for their talents. One of their most vocal and intellectual members, Maurice Denis, set down his ideas in a series of essays[16] in which he observed (as Morris had) that the pictures in most illustrated books competed unpleasantly with the text, and in so doing destroyed the feeling of the

book as a whole. A book, Denis asserted, ought to be a work of decoration and not simply a neutral (or even unpleasant) vehicle for transmitting a text. Books had been decorative in the distant past; the artist could again make them decorative if he took account of the true nature of art.

Decoration as we use the word today, tends to be a term of deprecation. For Denis and his associates it was precisely the opposite, signifying the highest degree of unity and beauty possible in a work of art. Baudelaire once wrote, "L'art est-il utile? Oui. Parce qu'il l'art."[17] This statement, much quoted by the artists of the nineties, indicates with economy the basis of Denis' esthetic. Meaning, like utility, was a quality intrinsic to the work of art, not something brought to it from another aspect of life. The purpose of a work of art, for Denis, was to arouse feeling in the beholder, but the feeling must result from something which is within the work and not from some literary allusion or collection of subjects which the artist represents.

In evaluating his predecessors, the Impressionists, Denis objected to the absence of a formal method in their work. They had purposely avoided too strict a formulation of fixed principles, fearing that in so doing they might compromise their independence and temperamental sincerity, but Denis felt that this caused their work to lack meaning and coherence. He preferred the more rigorous technique of Seurat and his group who, following Charles Henry and others, had evolved a linear language in which various kinds of lines and forms served as equivalents for a few rather general experiences. Upward-moving lines were expressive of joy, downward-curving lines were inhibiting and depressing, and so forth. Denis felt that this could be carried even further; elaborating on the ideas of Gauguin and several of the Symbolist writers, he asserted that for each emotion, each thought, there exists a plastic equivalent, a corresponding beauty. This, suggested Denis, is what makes the work of a fifteenth-century book illustrator seem so meaningful; unconcerned with exact representation or with an overly strict attempt to put literary meaning into his work, the earlier artist had allowed the lines and forms

Denis: Illustration for *Sagesse,* Vollard edition.
1911

of his initial letters and borders to carry an emotional message to the viewer.

When Denis stated that a line, a color, or a shape has the power to arouse specific feelings in the observer, he was not restricting himself to paintings; this power of form could be present in a vase, or chair, or wallpaper just as well. To the extent that painting became literary, it ceased to be painting; to the extent that a useful object was composed of visually meaningful forms, it became a work of art. Ideally, suggested Denis, there was no difference between the fine and useful arts in this respect.

William Morris may have been instrumental in establishing this unity of the arts, but Graham Hough is correct in observing that Morris was in the position of ". . . one who keeps alive an obsolete skill, which hardly seems likely to mean much to the world he lives in, but which may nevertheless be keeping the door open for some necessary

re-expansion of the artist's range."[18] Denis was among those who undertook this re-expansion, and he was one of the first to attempt it systematically in the graphic arts. It was precisely in Denis' conception of the decorative content of the work of art that the way was shown for the Art Nouveau artist to carry illustration and graphic design into a new range of expressiveness.

In 1890 when the first of his theoretical essays appeared, Denis was at work on a series of illustrations for Verlaine's *Sagesse* (left), which embodied his ideas. The drawings for *Sagesse,* which are among the earliest Art Nouveau book illustrations,[19] are daring in the simplicity of their conception. The forms used are never round or massive, but are expressed entirely in flat shapes. Only the simplest contours are used, and no variation of value occurs within any shape. Since this method is applied to everything in the picture, the distinction between near and distant objects is obliterated; the image remains a part of the picture-plane, and its value contrasts are scarcely more complicated than those of the accompanying printed text. In the illustration reproduced, there is a sense of almost mystical peacefulness, of quiet contemplation, and of harmony, which is evoked without exact reference to the text but results instead from our experiencing the shapes and values of the picture. In the poems of *Sagesse,*[20] Verlaine glimpsed the peace and comfort of deep religious feeling through the formlessness, sadness, and evil of everyday life, and aspired to join those who have already found that peace. Denis has evoked the depth of Verlaine's image of the religious experience without depending upon story-telling details. The unity of the book thus occurs not only through the visual harmonization of its parts but also through the similar processes of evocation used by both poet and illustrator.

This new concept of visual meaning is the basic characteristic of Art Nouveau graphic design and illustration. A wide variety of expression is possible, but whatever the expressive content of the work, it results from a recognition of the evocative power of the formal qualities which were isolated and described earlier in this essay. Significantly,

this particular embodiment of meaning in form originated in graphic design and painting, where difficulties of production and cost were least vexing; later—although not much later—the new style began to affect architecture and other areas of design, and by the mid-nineties the dream of a new style for all things was near to realization. As the reader can see elsewhere in this book (pages 54-61), the work of Denis and his circle would have been impossible without the guidance of Gauguin and Seurat, but even more important for the development of Art Nouveau was the impact of these French artists upon a small Belgian exhibition society called *Les Vingt.*

VAN DE VELDE AND THE BELGIAN CONTRIBUTION

In 1884-85 Henry van de Velde had come into contact with the work of the Impressionists in Paris; in 1889, when he first exhibited at *Les Vingt,* he became acquainted with the work of Seurat, Signac, and the other French painters who appeared in the international exhibition of the society.[21]

Like Denis, van de Velde came to admire Seurat's theoretical principles, and in his own painting adopted the formal techniques which the Neo-Impressionists had developed. The other members of *Les Vingt,* not all of whom were followers of Seurat, brought other new ideas to bear on the work they did for the society. A catalogue cover by Khnopff (above), for example, done in 1890, shows a new aspect of the influence of Oriental art in the decorative handling of the lettering (especially the word "Bruxelles") and in the massing and overlapping of the several rectangular areas of the composition. Much closer to Mackmurdo's work is Lemmen's catalogue cover (right) for the exhibition of 1891 in which sea and sun are rendered as swirling curves with swelling and shrinking lines. Coming before the Beardsley illustrations of 1892 for the *Morte d'Arthur,* and at the same time as Robert Burns's *Natura Naturans,*[22] Lemmen's catalogue is among the earliest truly Art Nouveau works.

DE LA VII^e EXPOSITION ANNUELLE

Khnopff: Cover for *Les XX,* 1890

Lemmen: Cover for *Les XX.* 1891

Van de Velde: Illustration for *Dominical.* 1892

31

In 1889, van de Velde himself had been forced by a mental breakdown to stop painting for a time; during his period of convalescence, he developed a strong and decisive interest in the decorative arts. His first work in graphic design was done in 1892, even before he showed his first designs for tapestries and furniture; this was a title vignette for Max Elskamp's *Dominical* (page 31). In contrast to most of the other works we have examined so far, the forms of this vignette are scarcely explicable in terms of natural objects. We sense that we are invited to experience a reference to sea, sky, and shore, but as in the Lemmen catalogue cover the abstract quality in the *Dominical* vignette is such that we cannot tell exactly what force it is that penetrates into the composition. We respond more and more to the rhythmic repetition of actively curving lines—an activity in which the lettering also plays a part—and are less concerned with the recognition of the objects represented.

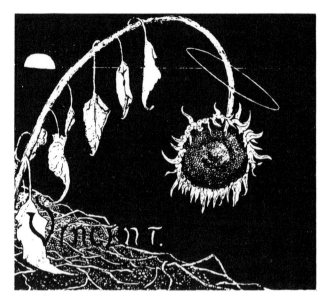

Roland Holst: Cover for van Gogh catalogue. 1892. Museum Boymans-van Beuningen, Rotterdam

Van de Velde: Ornaments for *Déblaiement d'art*

Van de Velde: Initials for *Van Nu En Straks,* 1893

Like Denis, van de Velde was concerned with the unity of form and meaning in the work of art, but he carried this even further in his writing than Denis did, asserting that through these means a new decorative totality of the arts would result which would provide a new and healthier environment for contemporary life.[23] Ruskin and Morris were his heroes, for they had shown the way towards a formulation of the relationship between art and life, and Denis and Seurat had led him to realize the significative qualities of line and form.

The excessive refinement and sensibility so much a part of the world of Decadent writers such as Huysmans was deeply offensive to van de Velde, particularly because he found their dependence upon past works of art lazy and enervating.[24] Van de Velde was concerned with the creation of the "healthy human understanding"[25] of the world through the visual arts. In his essay, *Déblaiement d'art,* written in 1894, he urged the formulation of a new art (*"un art nouveau"*—perhaps the first use of the phrase in reference to the work we are discussing) which would be vital and moral, in the spirit of the great decorative art of the past without copying older forms.[26]

Looking about him for inspiration in this new art, he cited a number of works in the graphic arts: the illustrations of Walter Crane, the posters of Jules Chéret, which captured a childlike gaiety and flamboyance, and the type faces of William Morris ". . . which surpass all the older Roman characters in decorative beauty."[27]

For a reprinting of *Déblaiement d'art* van de Velde designed a series of initial letters and page ornaments (opposite) which are perfectly consonant with Denis' demand that such work provide ". . . an embroidery of arabesques on the page, an accompaniment of expressive lines."[28] In the *Tropon* poster of c. 1899 (his only poster), and in the designs for *Van Nu en Straks* of 1893 (opposite) we see van de Velde carrying this as far as it can go, swallowing letter forms in the compelling linear rhythm of the work, and creating almost entirely non-objective shapes.

At the other extreme from van de Velde and Denis, some

artists who worked in the new style turned their attention towards a more obvious kind of evocation and relied upon a more literary sort of symbolism. For example, R. N. Roland Holst's catalogue cover for a memorial exhibition of van Gogh's work (opposite) contains the most simple and direct kind of literary reference to the deceased painter, in the drooping sunflower and halo. Clearly Holst did not expect the reader of his van Gogh catalogue to respond to the subtle visual suggestion of his forms alone. This problem of the accessibility of content seems not to have concerned van de Velde and Denis, but there are situations such as poster design in which more direct appeal of a literary sort seems indicated.

POSTERS AS A SOURCE FOR ART NOUVEAU

Considering van de Velde's importance as a graphic artist it is most revealing that he should have mentioned Chéret as one of the sources for the new style; for Chéret did more than any other artist towards originating the modern art of poster design.[29]

About fifteen years before Mackmurdo or Morris or Denis had turned to the graphic arts, Chéret had started to use the infant art of poster design as his vehicle for personal expression. By its nature, the poster does not take its part in a harmonious and unified scheme of things, but calls out for particular attention—demanding to be seen in contrast with all that surrounds it.

Even in one of Chéret's early posters (page 34), it is obvious that he realized how effectively this could be accomplished by the use of strong color harmonies, vibrant linear rhythms, and bold, free lettering. The process of color lithography was ideal for this kind of work; the artist could work unrestrained by technical problems, almost as if he were drawing on paper, and he need not restrict himself to using the available type faces if he felt that his own hand-lettering would be more harmonious and effective.

Chéret did not derive his poster style directly from any of the other arts;[30] he, and the other men who made posters

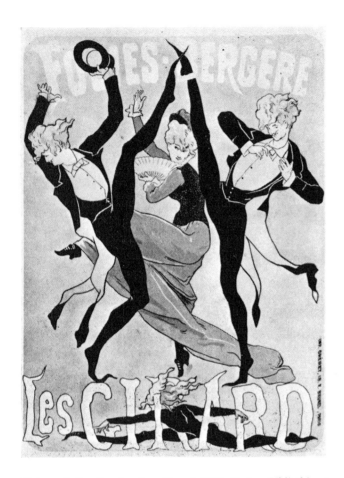

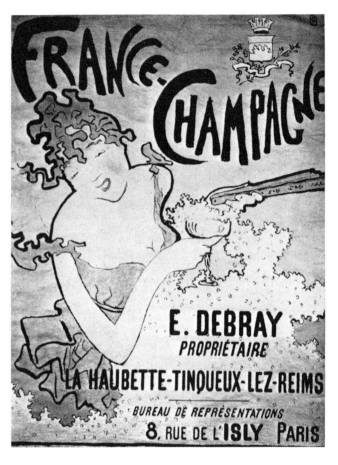

Chéret: *Folies-Bergère, Les Girard.* 1877. Poster. Bibliothèque Nationale, Paris

Bonnard: *France-Champagne.* 1891. Lithograph. 30⅛ x 23″. The Museum of Modern Art, New York

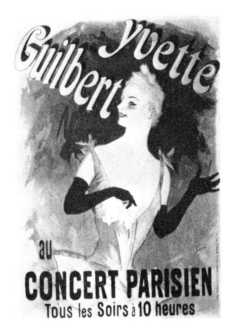

Chéret: *Yvette Guilbert au Concert Parisien*. 1891. Lithograph. 48¾ x 34½".
The Museum of Modern Art, New York.
Gift of Lillian Nassau

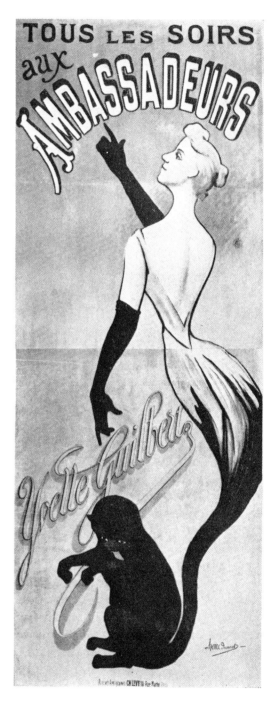

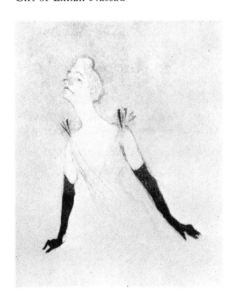

Toulouse-Lautrec: *Yvette Guilbert*. Lithograph.
1894. Metropolitan Museum of Art. Rogers fund

Dumont: *Tous les Soirs* . . . Lithograph. c. 1900.
82 x 32". The Museum of Modern Art, New York

35

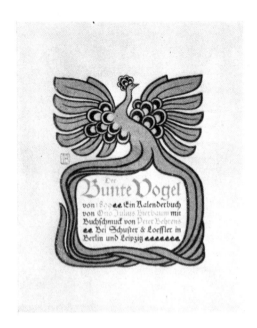

Behrens: Title page for *Der Bunte Vogel.*
1899. Klingspor Museum, Offenbach

before 1885, seem to have evolved their formal language as they worked, without apparent adaptation of style from painting or print making. Thus, the fact that Art Nouveau elements are present in poster designs cannot be explained by reference to any theories on the total design of arts and crafts, or by a search for the relationship between form and meaning in book illustration. As the formal language of Art Nouveau developed, it naturally found expression in the poster as in everything else; but on the other hand, some of the formal elements of Art Nouveau entered into the style from posters, where they had long been evident. And since it is possible to show that the actual influence of posters on the other arts could scarcely have been strong before 1890,[31] it seems clear that we have a case of an independent development which later joins, and reinforces, Art Nouveau.

Goldwater and Koch[32] have discussed the international character of poster styles, and have chronicled the spread of exhibitions, articles, and collections through the late 1880s and into the nineties. There were few national boundaries of poster art; Toulouse-Lautrec designed a poster for an English bicycle maker; Grasset was commissioned by an American magazine publisher to design both covers and posters. Furthermore, many artists who were primarily interested in other things turned to poster design (beginning around the end of the 1880s) as a means of earning extra money, and in this way became familiar with the work of Chéret and his colleagues.

Bonnard's first poster, *France Champagne* (page 34), is obviously a direct outgrowth of Chéret's work. Where Chéret had delighted in using complicated shapes which move out from the figures in his posters to activate the background spaces, Bonnard translated these rhythms into twisting lines which enclose areas of texture or flat tone. The movement in Chéret is around the form of the figure and into a background which we sense as existing in depth (page 34); the movement in Bonnard's poster is across the surface of the design, as we follow the rolling activity of the heavy lines which at once simplify and complicate the shapes of objects depicted.

Since Bonnard was closely allied with Denis and the *Nabis* at the time he did *France Champagne,* it is likely that this modification of Chéret's style was partly the result of the influence of his friends upon Bonnard; at least, we can observe in his work the next stage in the movement from the posters of the 1880s towards a fully-developed Art Nouveau style. Bonnard may have introduced Toulouse-Lautrec to the art of poster making;[33] Lautrec began to make posters in 1891, shortly after Bonnard had done his first. With Lautrec the art of the poster perhaps reached its highest point of development. No other artist had dared to simplify so far, to depend so much upon a few lines and shapes to command the viewer's attention.

The full force of Lautrec's power can be experienced most directly by comparing one of his lithographs of Yvette Guilbert (page 35) with posters for her by two other artists. Both Chéret and Dumont (page 35) have relied

Toulouse-Lautrec: *Jane Avril*. 1899. Lithograph. 22 x 14″. The Museum of Modern Art, New York. Gift of Abby Aldrich Rockefeller

Bonnard: *La Revue Blanche*. 1894. Lithograph. 31¾ x 24⅜″. The Museum of Modern Art, New York

upon the singer's famous black gloves to suggest the personality they advertise, and Dumont has even made a visual pun out of the skirt of Yvette's costume which at the bottom of the design elongates into the tail of a black cat. The transformation of objects is characteristic of Art Nouveau and another instance is found in Peter Behrens' title page for O. J. Bierbaum's *Der Bunte Vogel* of 1899 (page 36) in which the tail of a peacock changes into a border for the type on the page. The Art Nouveau artist was able to do this without destroying the unity of his composition, by rendering typographical border and illustration with the same strong linear rhythms. But in Lautrec's portrayal of Yvette Guilbert, she assumes a personality totally different from anything suggested by the other artists. Her gloves become part of a tense system of strong linear movements; her face is no longer conventionally pretty, but is twisted grotesquely by her arching eyebrows and the footlighting of the stage.

Lautrec's art celebrated the demi-monde of Paris, and his world is populated by strong personalities powerfully depicted. Nothing could be more different from the elegant decoration of van de Velde, or the vaguely unhealthy sensualism of Beardsley, than Lautrec's virile art, yet in its transformation of content by form it clearly belongs to Art Nouveau.

More even than Bonnard, Lautrec used the silhouetted shape to give impact to his posters (page 37), and he often took an unusual viewpoint in order to give maximum freedom of combination to the various shapes he was using and to make depth one of the expressive qualities of his design. It is perhaps worth noting here that both Lautrec and Bonnard were deeply concerned with harmonizing lettering in the total scheme of their posters; compare Bonnard's *France Champagne* with his *La Révue Blanche* (page 37) to see how different kinds of proportions and rhythms in letters themselves can be made to reinforce the composition and become part of the visible poetry of the whole work, not just the message-carrying part of a poster.

ART NOUVEAU TYPE FACES AND LETTERING

One aspect of the book, as well as poster design, which had to be controlled was the appearance of the type face itself, which in 1890 had not yet yielded to the new style. Morris and the Century Guild had shown that it was possible to re-design types, but their work seemed conservative compared to the letter-forms which were being used in posters and on hand-lettered title pages. One of the first new style designers to show the way towards an Art Nouveau type face was another famous poster designer, Eugène Grasset.[34]

Grasset had been at work since 1880 evolving the style which burst forth in his first poster of 1885. In his designs for the *Histoire des Quatre Fils Aymon* (opposite), Grasset displayed his virtuosity in the use of spatial division as an expressive element; an overlapping rectangular panel, clearly in imitation of Oriental scrolls, cuts across the whole design. Behind it, and almost completely independent in movement, the flattened pattern of horses, riders, and clouds surges to the right of the composition. Weaving over and under the long panel and the main illustration, borders with Celtic and classical motifs close in the entire design, and assert the proportion of the page on which it is placed. Grasset's lettering is closely tied in with the compositional movement of his design; the artist has used letter forms derived from Celtic models, which allow him to echo in the letters themselves the linear movements (horizontal, and from lower left to upper right) of the pictorial design. In his posters, Grasset was somewhat more restrained in his use of lettering, but remained keenly aware of the necessity to relate the bold, clear lines of his pictorial matter with a comparable kind of lettering. His work was exceedingly influential;[35] a poster-like cover for *Harper's Magazine* in 1889 was one of the milestones in the development of poster art in the United States. The American artist, Will Bradley, was one of the earliest and most forceful exponents of the new style in his country, and Grasset's work served as an influence. The young Bradley was also

tremendously impressed by the work of Lautrec, Bonnard, and Beardsley (page 40), and in his book designs his interest in the work of Morris, Ricketts, and the other private press designers can be seen. By 1894 about the same time that Bradley did his first Art Nouveau designs, Grasset's reputation had spread so far that he was given a one-man show of posters (below) in Paris by *La Plume,* the Symbolist magazine, which also published an issue devoted entirely to his work.[36]

The year before, in 1893, Grasset was commissioned by the publishers of the *Revue illustrée* to design a drawn title for the journal. This first effort towards evolving a letter style which would be appropriate for an Art Nouveau type face[37] was further refined, and in 1898 the casting of this type began.[38] The Grasset type (page 41) is only a subtle departure from previous type faces; it is closely related to Old Style types in that it does not utilize strong contrasts of thick and thin lines (a characteristic possibly suggested by Morris' types), but in its sloping lines atop the lower-case d, l, i, etc., it is clearly related to hand lettering.

The informality we sense in Grasset's type is seen even more strongly in a type design of c. 1901 (page 41) by Georges Auriol, which obviously was meant to imitate brush lettering. The rhythmic freedom and swelling lines of Auriol's types made them particularly useful to the Art Nouveau designer, and for many years after Art Nouveau had ceased to be a living style, they were among the standard faces for French compositors who wished to appear "up-to-date."

As Grasset and Auriol must have discovered, there are considerable difficulties in the way of the artist who wishes to transform letters into new forms, not the least of which is that the alphabet is made up of highly traditional forms, admitting of little variation, if the process of communication through words is to occur at all. In a poster, where only a few words are used, this problem may be relatively unimportant; Grasset ranged far afield in his search for unusual and expressive display letters, as in his cover for

Grasset: Cover for *Histoire des Quatre Fils Aymon.* 1879-83. Rijksmuseum Library, Amsterdam

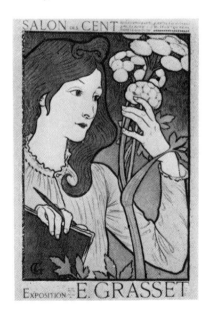

Grasset: Poster for Exposition, Salon des Cent. 1894. 23⅞ x 16¼″. The Museum of Modern Art, New York

Histoire des Quatre Fils Aymon; but when he came to design a type face, which would appear in massed form on a page, he seems to have realized that he could not expect his readers to struggle with unfamiliar letter forms.

The Art Nouveau letter designer looked with envy at his Oriental colleague, who had the option of radically altering the rhythms and forms of his written symbols for purely expressive purposes, as in "grass writing" (opposite), provided only that he preserve a fundamental relationship of strokes in each ideogram. Khnopff had specifically imitated the Oriental extension of strokes to enliven his letters, but clearly this would not do for a type face intended for use in the printing of textual matter. Huysmans' concern for the expressive character of typographic design helped focus attention on some of the most intriguing type faces of the past. But now the need was for contemporary forms in type as well as in illustration; the new types had to be at once more readable than the obsolete *Civilité* and more harmonious with Art Nouveau borders and illustrations than Morris' types were.

Yet another ancestor of Art Nouveau types is the German *Centralschrift* (page 42) of 1835 which was an early attempt to modify the traditional *Fraktur* so that it was not so different from Roman letter forms.[39] The *Centralschrift* had considerable expressive character, with its swelling lines, rhythmically ascending and descending elements, and heavy color. As the work of designers from other countries penetrated into Germany, the need for replacing the spiky and debased *Fraktur* became more pressing; in 1888, König produced the *Römische Antiqua*[40] types, based on the same materials which Morris and *The Hobby Horse* designers had used, and from this time on, the way was clear for newly designed German types.

In France, Grasset and Auriol had led the way; in Germany a few years after Grasset's *Revue illustrée* design was published, a young German artist named Otto Eckmann began to publish vignettes and borders in the magazines *Jugend* and *Pan*. Eckmann, like many of his contemporaries

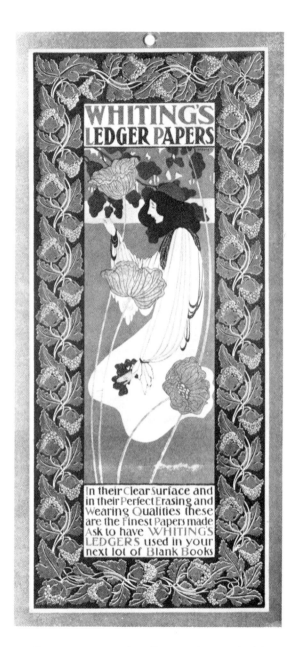

Bradley: Whiting's Ledger Papers. (c. 1900.) Advertisement. 20 x 9¼". The Art Institute of Chicago

40

Auriol: Type face. (c. 1901)

Part of a Japanese scroll showing "grass writing," an elongated, cursive style. 18th-19th century. Kunstgewerbe Museum, Basel

Grasset: Type face. 1898

41

in Germany, had enthusiastically admired the work of Beardsley, and furthermore had become deeply interested in Japanese woodcuts.[41] Around 1896, just when he was beginning to work in the graphic arts, Eckmann made his first studies for a type face which was utterly different from anything ever done before. His lettering became famous after he executed the title page for *Die Woche* in 1900 (below), and as a result of this he was commissioned by Karl Klingspor,[42] the head of the Rudhard'schen Schrift-giesserei in Offenbach-am-Main, to design a type face which would be appropriate for the printing of books in the new style. Eckmann's type (opposite) could only have been produced in Germany. Clearly based on the Roman alphabet, it shared with the *Centralschrift* a few borrow-ings from other alphabets; notice, for instance, that to maintain rhythmic activity in every letter, Eckmann used a lower-case a, h, m, and n in the upper-case alphabet. He also took over the upper-case T from unical lettering. Most of the letters are not closed forms, but contain a channel which connects the white paper of the page with the smaller open spaces within the letters, a play of positive and nega-tive spaces exactly comparable to what is found in Art Nou-veau posters and illustrations. The shapes of the letters, once based on regularly curved and straight lines, are here undoubtedly derived from the serpentine curves of Beards-ley and van de Velde. The swelling and thinning of Eck-mann's line in these types adds further to the linear activity he desired, and stands in striking contrast to the regular lines of even the most distorted earlier type faces such as *Ebony* and *French Antique* (opposite).

Obviously letters such as Eckmann's could be just as well executed in metal or stone and used for lettering on buildings (opposite). With their broad flat forms, the type designs provided no problems of translation into different ma-terials, and harmonized perfectly with Art Nouveau archi-tecture. This translation was not limited to letter forms either; the borders designed by Behrens (page 18) and Mackintosh were conceived in a way which would allow them to be executed equally well in wrought iron. Even

Schoppe: *Centralschrift.* 1835

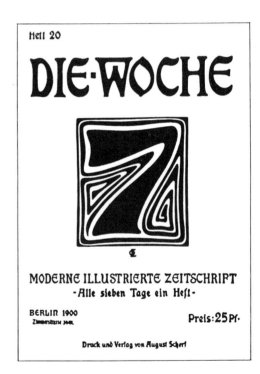

Eckmann: Title page for *Die Woche.* 1900

42

Eckmann: Letters from alphabet. 1896

furieuse tempête dans les mers du sud

IMPRESO COMERCIAL, PUBLICITARIO

INTELLIGENZBLATT

ITALIENNE

Type face, *French Antique.* 1820

Chicago Type

Type face, *Ebony.* 1890

Horta: *224.* Numerals for Hotel Solvay, Brussels

Eckmann-Schmuck

Eckmann: Studies for type face *Eckmann Schmuck*

43

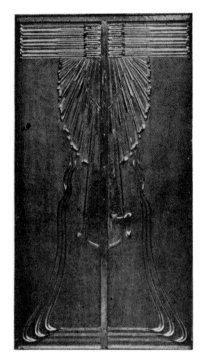

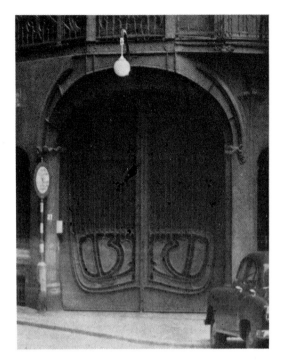

Behrens: Doorway for house at Mathildenhöhe, Darmstadt. 1901

Horta: Maison du Peuple, Brussels. 1897-99. Façade

Pankok: Border illustration

Horta's portal of the Maison du Peuple in Brussels might have been a design for a title page rather than a part of an architectural scheme.

Van de Velde's initials for *Van nu en Straks* (page 32) are intimately related to his jewelry (below) in their use of coordinated positive and negative spaces and expressively swelling areas, and even Mackmurdo's chair and book cover display this interchangeability of the design elements.

Thus, the graphic arts do not follow an independent course through Art Nouveau. Through the formal innovations worked out in the graphic arts, the arts of design and architecture were enriched. Just as Pankok had surrounded an illustration utilizing traditional spatial organization with a radically different border, so the same conception of framing by contrast was used in architecture (opposite). The unity of the arts went further in Art Nouveau than just the adaptation of decorative motifs; the whole sense of composition and feeling seemed to spring from similar sources in architecture, furniture design, jewelry, and the graphic arts.

Some of the innovators of Art Nouveau were soon to repudiate it. Walter Crane, whose work had impressed van de Velde, saw nothing healthy about what he called "that strange decorative disease."[48] Maurice Denis, within a few years after writing his essays setting forth a basis for the new art, decided that in the form it had taken Art Nouveau had become only a display of "pretentious facil-ity" lacking in the esthetic and moral meaning it should have had.[44]

The artist of Art Nouveau, whatever his views on the relation of art to society, began his work with the desire to evoke meaning and intense feeling through the forms of the work itself. William Morris' dictum, "Have nothing in your houses which you do not know to be beautiful,"[45] might have been rewritten by the Art Nouveau designer, "Have nothing in your world which you do not feel to be meaningful."

To a certain extent the Art Nouveau designers succeeded in doing this; but especially in the graphic arts the meaningful use of new forms soon degenerated into mere stylism. However, the "straight line" style of Behrens and Mackintosh and the Viennese Secessionists seems to connect directly to the architecture of Frank Lloyd Wright and to the Dutch work of the 1920s.[46]

But perhaps it is a mistake to see in the graphic arts of Art Nouveau only a few outmoded forms which seem, today, to be delightful or horrible or redolent of a period long past. Actually, the positive contribution of Art Nouveau far surpasses this; through the work of these artists came an expansion of the range of expressive possibilities available to the graphic artist. Through Art Nouveau, the graphic artist was encouraged to re-examine the function of materials and forms he used. This is still going on today, and may be one of the main sources of the vitality of the graphic arts in our time.

ALAN M. FERN

Van de Velde: Design
for a pendant. 1899

Redon: *"La Mort: Mon ironie dépasse toutes les autres!"* (After 1905.) Oil on canvas, 21½ x 18½". Collection Mrs. Bertram D. Smith, New York

"Art Nouveau," "Jugendstil," "Secessionsstil," "Stile floreale,"—whatever one calls the style, it belongs to the decorative arts. It was largely a way of *designing,* not of painting, sculpting, or building. Yet many Art Nouveau elements—the emphasis on the evocative power of an undulating line, the insistence on creating a two-dimensional decorative surface, the affinity to Symbolism in the artist's desire to suggest rather than to describe—were anticipated in painting before being used in the applied arts. Moreover, if there was no Art Nouveau painting as such, the style was so encompassing that it did have a great impact on a good many painters born in the sixties and seventies, no matter what direction their work was ultimately to take.

Impressionism was no longer the unchallenged protagonist of the avant garde when in 1884 two highly consequential exhibition societies were formed: *Les Vingt* in Brussels and the *Societé des Artistes Indépendants* in Paris. The *Indépendants* was broad enough to include both Odilon Redon and Georges Seurat in its leadership. Redon was on intimate terms with the Symbolist poets and, like them, used the dream for inspiration. While still working with the visible world, he endowed his reality with fantasy, proposing to "use the logic of the visible in the service of the invisible."[1] Redon felt that the Impressionists were "parasites of the object." As Mallarmé was concerned with the "mysterious meaning of life" and Lautréamont and Rimbaud with the exploration of the irrational world, so Redon was fascinated by the "little door opening on mystery."[2] Still in touch with Romantic sensibility, he created a visionary imagery in his graphic work. There he introduced black as an essential color and established his form by definite contour. His drawings and lithographs, on the frontier of reality and fantasy with their combination of the precise and the vague, were to lead him to the glowing colored pastels of his maturity. They no longer narrated but evoked a mood: in this they became important precursors of the style of the nineties.

Less evident but equally important was the contribution of Seurat, who exhibited his first masterpiece, *The Bathers,* at the *Indépendants* in 1884. In this as in his later work he used a quasi-scientific method to investigate the structural elements of color and line for the sake of constructing pictures which, instead of producing an effect of verisimilitude, would make the viewer conscious of a deliberately tectonic organization. Impressionism, the sensitive but literal recording of visual data, was transformed by the application of these analytic theories into a more rational investigation of visual experience. Art was no longer Zola's "corner of nature seen by a temperament," but a conscious attempt to stimulate a predetermined emotion by the direction of lines and the juxtaposition of color. This deliberate use of line and color and the geometric arrangement of forms in a flattened space in Seurat's late canvases—*La Parade, Le Chahut, Le Cirque*—seemed to provide a solution to the prevalent search for a new style.

In 1884, the same year as the foundation of the *Indépendants, Les Vingt* was formed in Brussels under the perceptive leadership of the lawyer, Octave Maus, who sought out advanced work in all countries of western Europe. The exhibitions of *Les XX* provided meeting places for the innovators of the time. Ensor, Toorop, and Khnopff were charter members who exhibited regularly. Seurat's *A Sunday Afternoon on the Island of La Grande Jatte* had been shown as early as 1887, arousing violent opposition from the public but an enthusiastic response from the artists. The adoption of the Neo-Impressionist technique by Theo van Rysselberghe and Henry van de Velde dates from this event. Redon's drawings and lithographs had appeared in

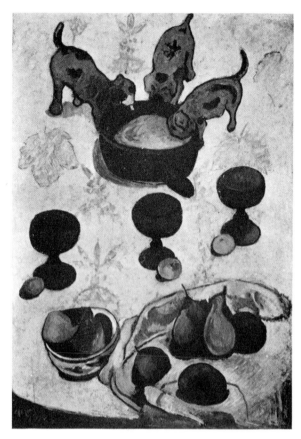

Seurat: *Le Cirque*. (1891). Oil on canvas, 73¼ x 59⅝". Musée du Louvre, Paris

Gauguin: *Still Life with Three Puppies*. 1888. Oil on wood, 36⅛ x 24⅝". The Museum of Modern Art, New York, Mrs. Simon Guggenheim Fund

1886; Toulouse-Lautrec exhibited in Brussels in 1888. In 1889 Gauguin showed twelve canvases, including his Symbolist *Vision after the Sermon*. The following year Cézanne, who had not shown in Paris since 1877, sent pictures to Brussels, and van Gogh had the one important show of his lifetime at *Les XX*. In 1892 and 1893 the decorative arts were shown, probably for the first time, on equal terms with painting and sculpture, a policy which was emphasized even more strongly by *La Libre Esthétique,* the successor to *Les XX*.

The enterprising spirit of these exhibitions, together with the process of industrialization then sweeping Belgium and the accompanying awareness to new building needs and materials, were largely responsible for Brussels taking the lead in the Art Nouveau movement. It was there, indeed, that in 1893 the first full-fledged Art Nouveau building, Victor Horta's Tassel House (page 129) was erected.

DEVELOPMENTS IN FRANCE

Paul Gauguin, whose *Vision after the Sermon* had made such a strong impression on the Belgian public in the *Les XX* exhibition of 1889, had the great advantage—rare in the nineteenth century—of having never suffered an academic training. Starting to paint at a mature age, he had worked in the most advanced style, Impressionism, almost from the beginning. Early in 1888 he returned from Martinique to Pont-Aven in Brittany where the rural surroundings allowed him to work in comparative isolation from the Paris art world and where it was possible for him to indulge in his romantic craving for a more primitive way of life. In the summer he was joined by the youthful Emile Bernard who, together with his friend Anquetin, had been working in a rigorously simplified and boldly patterned style, called "Cloisonisme" after the medieval enamel technique. Bernard was in close touch with the Symbolist poets and critics and familiar with their artistic program as it was expressed, for instance, in the *Revue Wagnérienne,*

founded and edited by Edouard Dujardin, writer, musician, Aesthete, and close friend of Mallarmé and Debussy. The whole period points in many aspects toward an integration of all the arts.

Bernard's painting and probably even more his ability for theoretical formulation made a great impression on the older Gauguin, who was moving in the same direction. The two men admired each other's work. Like the Symbolist poets they believed that ideas and emotional experiences could be suggested by "equivalents" or "correspondences" in sound and rhythm, or in color and line, respectively. They evolved a style of painting which was first called Synthetism but became known as Symbolism after 1890 and which must be recognized as one of the important components of the Art Nouveau movement.

Among Gauguin's paintings, the *Still Life with Three Puppies* (opposite) shows the transition from his earlier style to his Symbolist manner of this period. The fruit and tablecloth in the lower part of the canvas with the visible brushmarks and the use of advancing and receding color still show Cézanne's influence, whereas in the upper part of the painting, the three goblets, three apples, three puppies, set against the steep plane of the tablecloth are simplified in a child-like fashion. In a disarmingly naive way a flower on the tablecloth is repeated in the head of a dog. Gauguin and his friends developed an art of bold, abstract outline. They abandoned local colors in favor of nonnaturalistic color harmonies. They allowed no foreshortening, no modeling, and when shadows were used, they were employed for their ornamental interest. They reduced depth of composition to a flat plane on which a decorative pattern was applied in rhythmic lines. "Don't copy nature too much," Gauguin wrote to his friend Schuffenecker, "Art is an abstraction; derive this abstraction from nature while dreaming before it, but think more of creating than of actual result. The only way to rise towards God is by doing as our divine Master does, create. . . ."[3]

In 1888 and 1889 Gauguin affirmed the principle of two-dimensionality in the Symbolist *Vision after the Ser-*

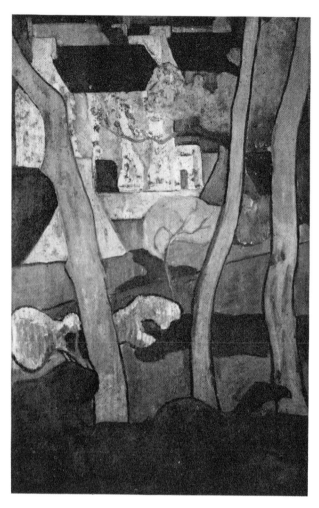

Gauguin or School of Pont-Aven: *Decorative Landscape.*
(1889). Oil on wood, 33⅞ x 22½″. Nationalmuseum,
Stockholm

Above right: Gauguin: *Leda.* 1889. Design
for a plate. Lithograph, 11¹⁵⁄₁₆ x 10³⁄₁₆″. The
Metropolitan Museum of Art, Rogers Fund.

Gauguin: Vase. Glazed stoneware, 11⅜″
high. Musées Royaux d'Art et d'Histoire,
Brussels

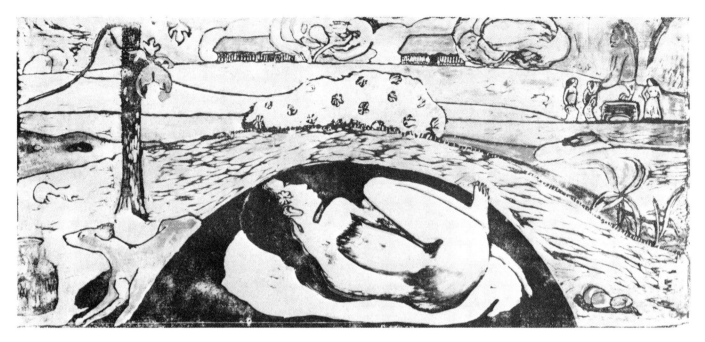

Gauguin: *Manao Tupapau (Watched by the Spirits of the Dead)*. (c. 1893-95). Woodcut, printed in black and colored by hand, partly with stencils, 9 x 20⅜". The Art Institute of Chicago

mon and the *Yellow Christ*. It becomes even more evident in the *Decorative Landscape,* originally a door panel in Gauguin's studio at Le Pouldu and probably painted by himself. Here decorative flatness is carried to an extreme. There is no horizon, the surface is piled up with tree trunks, outlined trees and houses, and the seemingly arbitrary choice of colors helps to emphasize the effect of the plane, relating the whole to Art Nouveau in spirit. At this time Gauguin made, in fact, designs for decorative plates and painted bucolic scenes on vases, among them the one made by the famous ceramist Ernest Chaplet, whom he knew well. A convincing argument has been advanced that Gauguin's work in this field, where the simplification of form was conditioned by the technique, may have affirmed in

him the wish to extend this new style into his painting.[4]

In his woodcuts, too, he abandoned the conventional method of making prints and began to cut and gouge his blocks to give them a coarse, hard-hewn appearance, resulting in designs of unusual expressive power. Gauguin's craftsman-like preoccupation with the material in these prints relates him as closely to Art Nouveau as does his starkly formalized stylization.

There was a tendency among the painters at Pont-Aven to extend their activities beyond easel painting. Emile Bernard, for instance, was designing glass windows and carved polychrome furniture (page 52). Often the subject matter for the decoration of these objects was derived from local peasant motifs. By redesigning their physical environment

and distorting figures and landscapes, the artists responded to their inner need of expressing states of mind. Bernard's painting, *Bathers,* of 1889 (opposite) reminds us of the sixteenth-century Florentine Mannerists with its piling up of figures whose stance is not defined in space; with the repoussoir of cut-off figures in the frontal planes; with the elongation of bodies, the use of the lost profile, the erotic symbolism. Objects change their meaning in this picture: a root or garment becomes an erotic symbol. We observe in amazement that the lawn on which the nudes stand or recline suddenly becomes a wall for the figure in the upper margin of the painting. A similar flattening of space takes place in Gauguin's *Still Life with Three Puppies* in which the tablecloth is interchangeable with wallpaper. There is an ambiguity, or rather, a conscious desire on the part of Bernard to play with dichotomies of depth and flatness, horizontality and verticality, lightness and darkness; a tendency to suspend definition of an object in order to express the purely decorative value of its two-dimensional shape. These factors become extremely important in Art Nouveau decoration, while figures like the seated woman in the upper right make their reappearance in the early work of Matisse who will, however, recast the scene in a more joyous, less constrained manner.

The esthetics of Gauguin and Bernard were carried on by Paul Sérusier, to whom the purpose of art was the "evocation of an idea without expressing it."[5] He did not arrive at this concept independently. In the summer of 1888 he returned from Brittany with a landscape painted on a cigar box lid, which he called his "talisman." It represented for him the product of a lesson by Gauguin who had demonstrated to him the importance of the free reign of the artist's thought in which emotions and impressions were translated into constructions of simplified forms, eloquent outlines, structural color, slow movement. The pictures painted following these rules, rather than repeat visual impressions, evoked the spectator's quiet contemplation and led to what

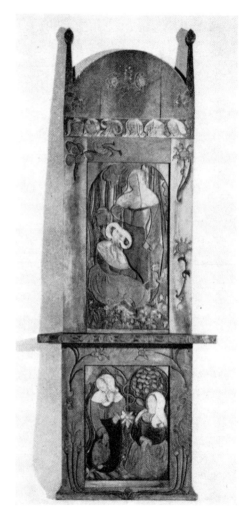

Bernard and Gauguin: *Bretonnierie.* Corner cabinet. (1888). Carved polychromed wood, 9′ high. Josefowitz Family Collection, Lausanne

52

Bernard: *Bathers*. (1889). Oil on canvas, 36 x 28″. Private collection, Paris

Denis: *April*. (1892). Oil on canvas, 14¾ x 24″. Rijksmuseum Kröller-Müller, Otterlo, The Netherlands

Gauguin called "the mysterious centers of thought."

Sérusier, who, together with Denis, Bonnard, Ibels, and Ranson, had been a student of Bouguereau at the Académie Julian, was instrumental in forming upon his return to Paris a group which called itself the *Nabis*. They were soon to be joined by Vuillard, Roussel, Séguin, Vallotton, while Maillol was close to their circle. *Nabi* is derived from the Hebrew word for Prophet, and the *Nabis* considered themselves a pure brotherhood of initiated artists who felt the need to renew art in their time. In the beginning they deliberately courted the influence of Gauguin. They also admired Redon, Cézanne, and the Japanese printmakers. In the famous formulation by Denis, "a picture—before being a battle horse, a female nude or some anecdote—is essentially a flat surface covered with colors assembled in a certain order."[6]

It is true that a painting like *April* (above) is still very close to the allegorical symbolism of Puvis de Chavannes, and Puvis was indeed greatly admired by the younger generation. But Denis, whose importance as a theorist for the new style has already been pointed out (pages 29-31), went beyond the literal allegory of the older master by composing a scene which expressed a major mood through a decorative equivalent. White-clad ladies walk quietly, bending, gathering flowers—restful white shapes set against a joyous yellow-green lawn—along a broad, amply curved path. A contrast is created by the complementary orange color of the horizontal fence, zigzagging sharply across the painting, and by the linear agitation of the bush in the lower left. But these are only minor disturbances that point up more effectively the essential meaning of the painting,

which is pastoral, measured harmony.

Denis stressed the primacy of the flat surface, and it actually mattered little whether this was a canvas or a screen, a low relief, designs for stained glass, mosaics, tapestry, posters or stage sets. In fact, most of the *Nabis* made stained glass designs for S. Bing's *L'Art Nouveau,* which were executed by Louis C. Tiffany in 1895. Whenever possible, they wished to go beyond the limitations of easel painting in their endeavor to make painting part of a total environment. This desire was vividly expressed by one of the *Nabis,* Jan Verkade: "About the beginning of the year 1890, a war cry was issued from one studio to the other. No more easel paintings! Down with these useless objects! Painting must not usurp the freedom which isolates it from the other arts. . . . Walls, walls to decorate. . . . There are no paintings, there are only decorations."[7]

Largely because of their close connection with the Symbolist writers most of the *Nabis* were passionately involved in the small, experimental theater of their time. They made marionettes for the avant-garde puppet theatres and they designed scenery and programs for plays by Rimbaud and Maeterlinck, Ibsen and Strindberg, Hauptmann, Wilde, and Gide. Perhaps the climax of their concern with the stage was the performance of Alfred Jarry's *Ubu Roi* with Claude Terrasse's music at Lugné-Poë's Theatre de L'Oeuvre in 1886: Sérusier, Bonnard, Ranson, Vuillard and Toulouse-Lautrec—all worked on the decor and costumes of this extraordinary play.[8]

Bonnard, in his activities as a painter, sculptor, book illustrator, lithographer, and designer of decorative screens and posters, is perhaps typical of the all-embracing attitude towards the arts of this period. An early painting such as *Le Peignoir* (right) is primarily a piece of wall decoration, painted thinly on heavy cloth. The gold robe is embellished with a repeat pattern of brown crescents, which merge at the top of the garment into the background, suggesting lily pads floating on water. Its sumptuous jewel-like execution, held to the plane without any depth, and the motif of the white flower petals are close to Japanese

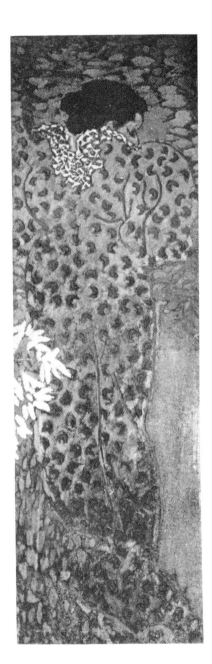

Bonnard: *Le Peignoir.* (c. 1892). Oil on velvet, 60⅝ x 21¼". Musée National d'Art Moderne, Paris

Bonnard: *Screen.* Color lithograph (published in 1899). Four panels, 54 x 18¾" each. The Museum of Modern Art, New York, Mrs. John D. Rockefeller, Jr. Fund

decoration. The *Nabis* had nicknames for their members—Denis was called the "Nabis aux Belles Icones" and Bonnard was the "Nabi Japonard." Bonnard, following a long line of painters since the 1860s to come under Japanese influence, had a profound understanding of the esthetic sense of Japan. While his first poster for *France Champagne* (page 34) still shows Chéret's influence, the famous one for the *Revue Blanche* of 1894 (page 37) is closely related to Japanese woodcuts. In the decorative screen, (painted 1892-94, first published 1894), which is composed of four mounted color lithographs, the geometrically ordered design is sparse and leaves large areas blank. Color is subdued and spaced with incredible sensitivity. The verticality comes to a subtle but definite stop with the horizontal frieze of the carriages. This screen no longer relates to a single Japanese print, but in its restraint and understatement it gives the viewer the effect of an entire Japanese interior.

A close kinship to the earlier work by Bonnard is found in the four decorative panels which Armand Séguin painted for the inn at Le Pouldu (opposite). These panels are especially interesting in this context because here Art Nouveau characteristics are pronounced so emphatically. A free arabesque is the essential element: the figures of the women, the skaters on the ice, the sheet of music, the fowl, leaves, lampshade, hats. Flowing water and cigarette smoke, usually associated with fleeting transparency, have become curvilinear shapes, firmly embedded in the decorative scheme. All forms relate to each other much like the wildly indented, yet carefully cut out pieces of a picture puzzle. Within these contours, Séguin has applied bright and strong colors in a rather improvised fashion. A few years after these panels were painted, on the occasion of an exhibition of Séguin's work in 1895, Paul Gaugin wrote in the preface to the catalogue that Séguin "is above all a cerebral—I do not say 'literary'—artist, that he expresses not what he sees but what he thinks by means of an original harmony of line which becomes part of an over-all arabesque."[9]

Ranson: *Women Combing Their Hair.* 1892. Distemper, 63 x 51⅛″. Collection Mme Sylvie Mora-Lacombe, Paris

The arabesque is also the predominant factor in Paul Ranson's work, but here the curves move more slowly, are less nervous, and suggest a perpetual serpentine movement which extends beyond the picture frame. These undulating lines, like running water or burning flames, keep moving apart and coming together again, but never rest. Fully conscious of the decorative quality of his work, Ranson as early as 1890 made cartoons for tapestries which were executed in embroidery by his wife, France Ranson.

Maillol, who was also primarily engaged in tapestry design before 1895, achieved the desired flatness but gave

Séguin: *The Pleasures of Life.*
(1890-91). Two of four panels.
Oil on canvas, 60 x 22½″ each.
Private collection, New York

his wall hangings a richer surface with more resonant color. His space, much more complex than Ranson's, consists of a series of overlapping and autonomous planes. Much like late medieval *mille-fleurs* tapestries which he must have studied, he assigns his figures to a space quite separate from the flowered background and relies on color and texture for his unifying effect (opposite).

Trouble with his eyes forced Maillol to abandon tapestry design and painting. His first sculptures—reliefs carved in wood—were similar to his tapestries. When he began modeling in the round at the turn of the century, he radically simplified his forms. His small bronze *Washerwoman* (right) is conceived in large, basic planes. These planes with their definite curvature and undulating rhythm recall Art Nouveau, but even more important is the stress on the clearly outlined, negative space enclosed by the girl's arms, head and garment which becomes as essential an element in the sculpture as the solid mass, acting as its necessary complement. The firm but swinging curve of the contour formed by the back and skirt of the kneeling woman seems to have been particularly dear to Maillol since it also occurs almost identically in a painting of the same year (opposite).

Sculpture of a very different kind was produced by Georges Lacombe, known as "Nabi sculpteur." Also eager to extend his activities beyond the confines of *l'art pour l'art,* he carved, around 1892, four decorative reliefs for a

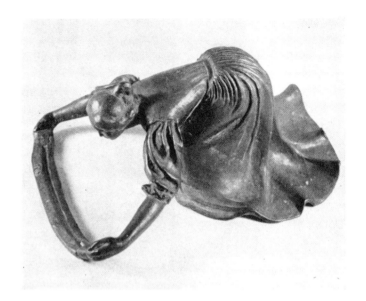

Maillol: *Washerwoman.* (c. 1893). Bronze, 8″ high. Collection Mr. and Mrs. John Hay Whitney, New York

Lacombe: *The Dream.* Headboard of bed (1892). Carved wood, 27¼″ high x 55″ long. Musée National d'Art Moderne, Paris

bed with human life as its symbolic theme. Birth forms the subject of the footboard, copulation and death the sides, the headboard provides a "dream," indicating, no doubt, the belief that the irrational and mysterious preside over life. *The Dream* (left) is represented by the ancient metaphor of the serpent biting its own tail. The serpent rolls itself into a face by forming the eyes in a great double loop. Nose and mouth are fitted in below to complete the monster face, which is surrounded by linear and wavy decorations. Influenced directly by Gauguin—particularly Gauguin's sculpture—this low relief is one of the earliest pieces of sculpture which shows the awakening interest in primitive art during the last decade of the nineteenth century. We know that the Councillor Coulon, close friend and patron of the *Nabis,* had brought a collection of Pre-Columbian art from South America as early as 1880.[10] Pre-Columbian art was again seen—still as a curiosity, to be sure—at the Paris World's Fair of 1889. All this confirmed the anti-classical attitude of Gauguin and his friends: the

Maillol: *Women Playing Guitars.* (c. 1897).
Tapestry. Det Dansk Kunstindustrimuseet, Copen-
hagen

Maillol: *The Washerwomen.* (c. 1893). Oil on
canvas, 25¼ x 31½". Josefowitz Family Collec-
tion, Lausanne

exotic forms are used in a decorative way almost immediately—they become part of a feeling for flat and linear ornament which, although very different in style, is yet related to Art Nouveau.

The undulating movement of Art Nouveau appears again in Vallotton's *Waltz.* Félix Vallotton, who was born in Lausanne in 1865 and came to Paris in 1882, was drawn into the *Nabi* circle around 1890. This painting of 1892, done in a pointilist technique of rather large dots, abstracts the dancers into rhythmic S-curves, which keep gyrating in a continuous whirl. The head, placed off center in the lower right-hand corner, as well as the dancing couple sliced off by the right margin, proves again the strong hold which Japanese composition had on these artists.

Never a *Nabi,* Toulouse-Lautrec was studying in 1887 in the private studio of Fernand Cormon together with van Gogh, Bernard, and Anquetin. The four painters had a small joint exhibition in a little restaurant on the Avenue Clichy during that year and referred to themselves as the "Ecole du Petit Boulevard." The following year van Gogh left for Arles and Bernard for Brittany, while Lautrec steeped himself ever more deeply in the life of Paris, more interesting to him than earnest discussions about the purpose of art and the language of form. His unprejudiced mind and incisive eye cut through taboos and depict the life of this period which gave birth to Art Nouveau.

Like his friends, like most of the important painters of his generation, Lautrec became absorbed by the expressive possibilities of line. Indeed he went further than most of his contemporaries. In his *At the Nouveau Cirque: The Dancer and the Five Stiff Shirts* he yields completely to an Art Nouveau arabesque, which moves here with a spirited and vivacious flow. Hat, hair, and dress of the lady have taken on bizarre shapes, as has the dancer bending her body backwards to create a sharply exaggerated curve. The broad handling of the flat areas and the highly decorative pattern of this painting lead us to the conclusion that it was probably a design for a stained glass window or for a poster. In his paintings Lautrec modeled his figures more solidly than in his posters and lithographs, and the paintings usually retain a more tonal quality.

In his graphic work he was able to suggest the total character of an individual, or the quickest gesture, by the slightest modulation of line. Here the line, precise and delicate, becomes an almost independent carrier of the emotion. The lithograph of Loie Fuller (page 64) indicates her dance by a contour which is distilled to the essence of movement. At first glance the viewer seems to be looking at a flame or a puff of smoke rather than at a dancer. Indeed, Loie Fuller in her long iridescent veils, which she would swing while multicolored lights played on their serpentine movements, must have appeared to be a phantom of the dance rather than an actual performer. Loie Fuller's phenomenal success on every European stage during the nineties may be due to the fact that in her performances the dance seems no longer a physical act, but the embodiment of arabesque, of sinuous decoration. When she danced, "sculptured by the air, the cloth rose and fell, swelled and contracted . . . recalling the fluid, tenuous lines of *art nouveau* designers with their predilection for goblets shaped like tulips, grills like ramblers, and frames of desks and screens like espaliered trees."[11]

Soon the sculptor Pierre Roche was to make a small bronze of La Fuller in which her scarfs pour upward in an irregular billowing rush, transforming the object into a symbol of movement.

The world of Loie Fuller and the art of Toulouse-Lautrec were no surprise to Picasso when he arrived in Paris in 1900. He had been part of the Barcelona avant garde which discussed Nietzsche and Wagner, recited French Symbolist poetry and was familiar with the most progressive art of the time. Gaudí had been working on the Church of the Sagrada Familia since 1884. Picasso's first drawings were published in *Joventut,* a magazine modeled after the Munich *Jugend,* and he was a friend of Ramón Casas, the man who successively edited *Quatre Gats, Pel y Ploma,*

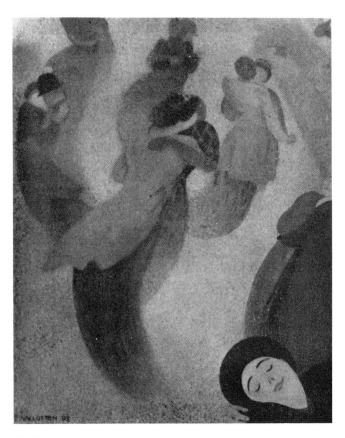

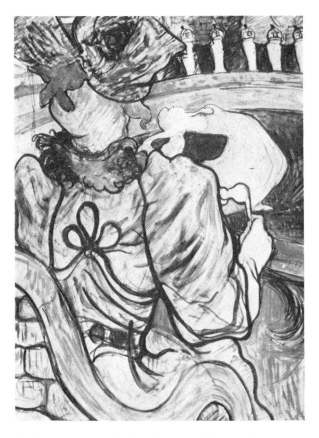

Vallotton: *The Waltz.* (1893). Oil on canvas, 24 x 19¾". Private collection, Paris

Toulouse-Lautrec: *At the Nouveau Cirque: The Dancer and the Five Stiff Shirts.* (1891). Oil on paper on canvas, 45¾ x 33½". Philadelphia Museum of Art

Toulouse-Lautrec: *Loie Fuller*. (1893). Color lithograph, 14¼ x x 10⅜". The Ludwig and Erik Charell Collection

Roche: *Loie Fuller*. (c. 1900). Bronze, 21⅝" high. Musée des Arts Décoratifs, Paris

Opposite: Picasso: *The End of the Road*. (c. 1898). Watercolor, 17¾ x 11½". Mr. and Mrs. Justin K. Thannhauser Collection, lent through The Thannhauser Foundation

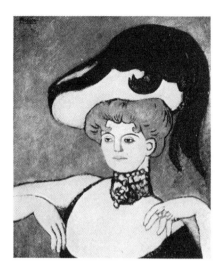

Picasso: *Courtesan with Jeweled Collar.*
(1901). Oil on canvas, 25¾ x 21½".
Los Angeles County Museum of Art.
Mr. and Mrs. George Gard de Sylva
Collection

and *Forma,* and whose own portraits resembled those by Lautrec and especially Steinlen. Picasso's friends, Isidor Nonell and Carlos Casagemas, worked in this manner and it is not surprising that Picasso pinned Lautrec's poster of Jane Avril to the wall of his Paris studio in 1901.

His *Courtesan with Jeweled Collar* (left) has this bold, linear, decorative character and shows the great interest in the play of positive and negative areas typical of Art Nouveau. Yet we can consider this early work as being only peripheral to Art Nouveau. The form is still the same but the purpose, it seems, has changed. While he must have enjoyed the daring curve of the feather, Picasso was also occupied with the human solitude of the woman and with the statuesque, plastic forms of her head, shoulder, and arms.

The earlier *End of the Road* (below), however, is in the full spirit of the Art Nouveau movement with its steep two-dimensional plane, its great emphasis on the curvilinear contour, and its heavy symbolic content. It is out of this feeling for universal tragedy, expressed here before the end of the century, that the somber figures of Picasso's Blue Period were to grow.

THE BRITISH CONTRIBUTION
England lacked the brilliant expressions of French Symbolist poetry and painting. The Aesthetic Movement in London occurred later, was less original and certainly less virile. Yet, there is no minimizing the influence of the English Pre-Raphaelites after their first exhibition in Paris at the World's Fair of 1855. The Symbolists, and especially Mallarmé and Verlaine, showed much interest in their work, while Huysmans was most enthusiastic. They most admired Edward Burne-Jones who had discarded the minute naturalism of the early Pre-Raphaelites in favor of an elaborated surface design. His gentle melancholy and languid silences were esteemed on both sides of the Channel, and as late as 1911 Burne-Jones and his teacher Dante Gabriel Rossetti are mentioned by such an advanced artist as Wassily Kandinsky as "searchers for the inner life by way of the external."[12]

Burne-Jones was the outstanding connecting link between the Pre-Raphaelites and the new style. Life-long friend and collaborator of William Morris and partner of Morris & Co., he was a painter who, in the spirit of the time, made cartoons for stained glass and designs for tapestry and needlework, painted wall panels, did mosaic decorations and illustrated books, the most important of which was the Kelmscott Chaucer.

In 1892, Aubrey Beardsley, then a nineteen-year old insurance clerk, showed a series of drawings to Sir Edward Burne-Jones and was so delighted by the older artist's encouragement that he referred to him as "the greatest living artist in Europe."[13] He then managed to complete 350 illustrations for Sir Thomas Malory's *Morte d'Arthur,* which were still to some extent in the medievalist style of Morris and Burne-Jones. Yet the liberating influence of the Japanese print is already visible. Soon Beardsley was also to see and use the most recent work of Whistler and Lautrec.

By 1893 when he did the drawings for Oscar Wilde's *Salome* he had matured into an accomplished draftsman in complete command of both line and concept. His drawings no longer illustrate specific scenes in the play but are commentaries which start where the text ends. His cold, biting line no longer delineates realistic forms, but leads a life of its own. The disposition of the white areas of the paper in relation to the filled-in black areas creates a most intriguing interrelationship of negative and positive shape. This formal meaning of the voids, creating an abstract pattern of black and white as a vital part of the composition, had never before been so important. Its significance in Art Nouveau typography has already been noted (page 42), and it was an essential phenomenon of Art Nouveau prints beginning with the woodcuts of Félix Vallotton.

Beardsley's work, like that of his French contemporaries, consists primarily of flat decorative patterns, but it differs in content. Beardsley was a satirist who loved the grotesque. Preoccupied with eroticism, he unmasked the suppressed aspects of late Victorian culture, not exposing its corruption so much as entering more fully into the intellectual indulgence of the *fin de siècle.* And, as his contemporary Arthur Symonds had already recognized, Beardsley transfigured "sin" by the abstract beauty of his line. He intellectualized evil and made degradation seem attractive in these sardonic drawings where a stunning facility and a penetrating archness act to exclude emotion.

In 1894 the young artist became successively art editor of *The Yellow Book,* which he left after one year because of the tensions resulting from the Wilde trial, and the newly founded *Savoy,* contributing drawings to these brilliant and sophisticated journals of Aesthetes, Symbolists, and Decadents.

His style underwent several more changes. Always an eclectic, he continued to incorporate elements of past styles, such as Greek vase painting or eighteenth-century illustrations into his work, which by the time of his early death in 1898 had already become less typically Art Nouveau.

Beardsley's illustrations were quickly known throughout Europe and the Western world. He had given visual definition to The Decadence, or, as Max Beerbohm called it, "The Beardsley Period." Almost simultaneously the impact of his drawings was felt by Klimt in Vienna, Bradley in Chicago, Horta in Brussels, Toorop in Antwerp, Vallotton in Paris, Bakst in St. Petersburg, and by a few adventurous young men and women in Glasgow.

This latter group, "The Four," as Charles Rennie Mackintosh, Herbert MacNair, and their future wives, the Macdonald sisters, were called, were evidently also familiar with the work Toorop was doing in Holland, and the illustrations by Carlos Schwabe for Zola, besides sharing the current interest in Celtic and Japanese art. All these elements had repercussions in their work which, however, develops a remarkably independent and original character. Their drawings, book plates, gesso panels, repoussoir metal work, murals, all show a stylized linear pattern which must be seen as an integral part of a total ensemble.[14] The Beardsley line recurs in their work, but while it is virulent with Beardsley, it has become coolly sophisticated in the work of the Scots. The line is stretched vertically, making the

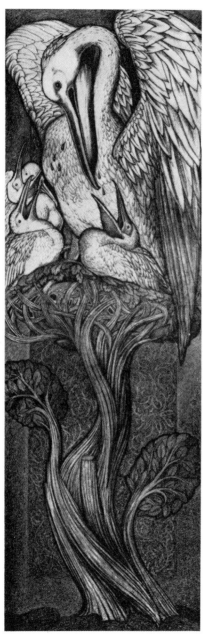

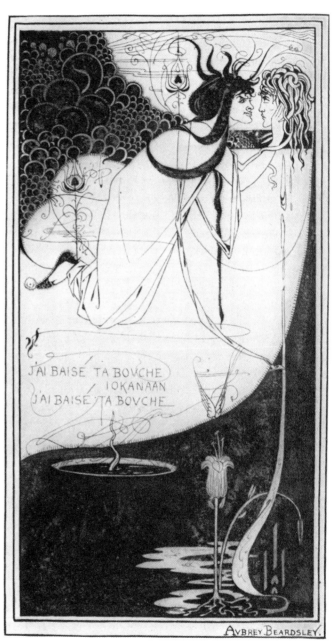

Burne-Jones: *The Pelican.* (1881). Pastel, 5′ 7½″ x 22″. The William Morris Gallery, Walthamstow, Essex

Beardsley: *"J'ai baisé ta bouche Jokanaan."* Preliminary drawing for *Salome* by Oscar Wilde. (1893). Ink and watercolor, 10⅞ x 5¾″. Princeton University Library, Princeton, New Jersey

figures quite abstract; indeed, it seems that the female figures themselves often derive from the ornamental line. The attenuation is due to a strong sense of verticality within the rectilinear design. The same elongation appears in Mackintosh's furniture, and a representation of the human figure becomes simply a part of the linear pattern.

When Mackintosh designed the first of a series of tearooms,—in themselves nuclei of the Reform Movement—for Miss Cranston on Buchanan Street in Glasgow, he stenciled on the wall large murals in which tall, stern women, with roses and other conventionalized flowers as their attributes, are surrounded by an *entrelac* line and carefully spaced so as to leave a major part of the wall blank. Identical figures appear at regular intervals in a rhythmic repeat pattern which reminds us of the "parallelism" developed by Ferdinand Hodler (page 76).

The light colors—"The Four" preferred pale olive, mauve, and especially white—are an essential part of the delicacy of the murals and the whole interior, an ensemble which arouses a feeling that can best be described as a measured austerity. A visitor to one of Miss Cranston's tearooms designed by Mackintosh must have responded also to the extraordinary grace and refinement of the space—a total decorative effect of the kind alluded to by another contemporary Glasgow designer, Jessie Newbery, who wrote in 1898: "I believe in everything being beautiful, pleasant, and if need be, useful."[15]

BELGIUM AND HOLLAND

Henry van de Velde, who, more than any other single individual, was responsible for both the theory of the Art Nouveau style and for its dissemination throughout Europe, began his career as a painter. After a brief period of study at the academy of his native Antwerp, where Vincent van Gogh was his fellow student, he went to Paris. There he studied painting with the academic portraitist Carolus-Duran but established personal contact with the Symbolist

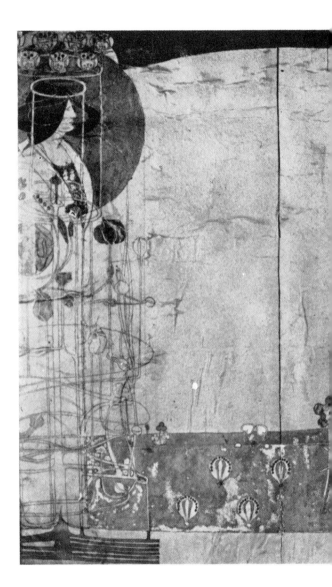

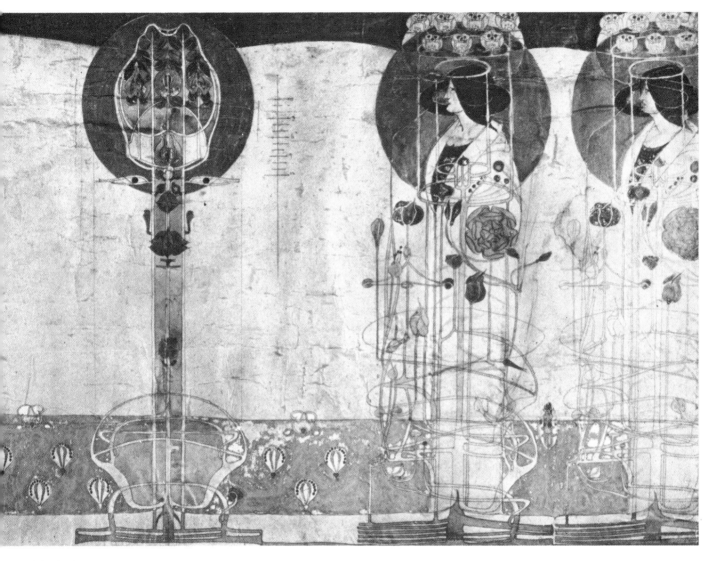

Charles Rennie Mackintosh: Preliminary design for mural decoration of Miss Cranston's Buchanan Street Tearooms, Glasgow. (1897). Watercolor on tracing paper, 14 x 29¼". University of Glasgow, Department of Fine Arts

poets and the Impressionist painters. When, after his return to Antwerp in 1885, he began painting on his own, he followed the most recent trend of Neo-Impressionism. No doubt this style appealed to him because it seemed to be based on a rational system, and while van Gogh's dynamic line did impress him, he tried to reconcile it with his own rational outlook. All his life van de Velde believed in the power of reason and man's ability to solve the problems of creating a better environment by applying his logical mind to the creation of better forms.

A prodigious reader, van de Velde was undoubtedly familiar with Charles Henry's hypotheses on the direct psychological effects of color and line (see page 29). He soon abandoned the demanding technique of pointillism, and as early as 1892 he seems to have arrived at almost total abstraction. The *Abstract Composition* in the Kröller-Müller Museum (opposite) still appears to derive from nature and suggests gourd and bulb motifs. It is a pastel in strong shades of orange-yellow, purple, green, black, blue, and pink, yet these colors have no descriptive function. The relationship of elliptical planes and sinuous rootlike forms creates a picture suggesting organic growth. Abstract shapes shift in an ambiguous space. Here, as in the almost totally non-objective woodcuts he contributed to the Flemish periodical *Van Nu en Straks* in 1893 (page 32), van de Velde achieves the culmination of the Symbolist attitude of evoking an emotion without resorting to literal statements or allegorical description, and indeed, this was the furthest the Art Nouveau group moved toward non-objective art. In his theoretical writings, also, he declared his opposition to naturalistic decoration and championed a new abstract ornament, which he felt to be intellectually and emotionally invigorating.[16]

While almost totally abstract, the *Abstract Composition* and certainly the vignettes for *Van Nu en Straks* still belong in the realm of decoration rather than of pure painting. "Little by little," he recalls, "I came to the conclusion that the reason why the fine arts had fallen into such a lamentable state of decay was because they were being more and more exploited by self-interest or prostituted to the satisfaction of human vanity. In the form of 'easel pictures' and 'salon statuary', both were now being executed as often as not without the least regard to their eventual destination as with any other kind of consumer goods."[17]

As a matter of fact, it was not long before van de Velde gave up easel painting altogether. A social moralist, he followed the example of William Morris and entered the field of the industrial arts in almost all its aspects. He worked as architect, educator, writer, and designer. His importance as the international ambassador and spokesman for the new style (van de Velde preferred not to call it Art Nouveau) cannot be overestimated. Working in Belgium, France, Germany and later also in Switzerland and Holland, he devoted his life to designing objects, or rather an environment, which would lead to a more liberal and a more rational life (see page 95).

When, in 1900-1902 van de Velde designed the interior for the Folkwang Museum for Karl Ernst Osthaus in Hagen, he had Georges Minne's *Fountain with Kneeling Boys* installed in the main gallery where the attenuated lines and geometric structure form an integral part of van de Velde's design.

A comparison of one of these kneeling figures of 1898 with an earlier bronze by Auguste Rodin, *The Sirens* of 1889 (page 72), dramatically points at two seemingly opposite aspects of Art Nouveau: the earlier, curvilinear and the slightly later rectilinear or "counter-Art Nouveau."[18] The almost rigid angularity of Minne's figure seems to be in complete contrast to the fluid, light-reflecting bronze of Rodin. Yet both sculptures share an essential linearity, a great emphasis on the contour which outlines an unbroken mass. It is precisely this linearity which evokes a specific emotional response in the viewer. Both Rodin and Minne left the naturalism of their predecessors in their concern for expressing a symbolic idea. While this idea may be sensuousness in Rodin's group and ascetic austerity in Minne's adolescent boy, they do share a mood of weariness and passivity, so typical of the *fin de siècle*.

Van de Velde: *Abstract Composition.* (1890). Pastel, 18¾ x 20″. Rijksmuseum Kröller-Müller, Otterlo, The Netherlands

Minne: *Kneeling Boy at the Fountain.*
(1898). Bronze, 30¾" high. Musée des
Beaux-Arts, Ghent, Belgium

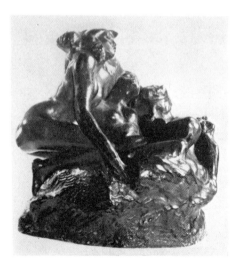

Rodin: *The Sirens.* (1889). Bronze, 17"
high. The Cleveland Museum of Art

Minne, who illustrated plays by Maeterlinck and poetry
by Verhaeren, was, like his compatriot van de Velde, inti-
mately connected with the Symbolist movement emanating
from Paris. In contrast, the Dutch painters of the period
owe their greatest debt to England: the work of Toorop
and Thorn Prikker would be unthinkable without Blake,
the Pre-Raphaelites, and Beardsley.

Jan Toorop, who was born in Java in 1858, divided his
time in the eighties between London, where he was subject
to the same influences as Aubrey Beardsley, and Brussels,
where he exhibited with *Les XX* as early as 1884 and be-
came a friend of Maurice Maeterlinck, who inspired him
to work in a Symbolist manner.

His drawings of the early nineties—perhaps his greatest
contribution and certainly the most important in this con-
text—suggest the mood of melancholy mystery achieved
by ambiguously combining an elaborate literary metaphor
with evocative form. Renouncing color almost entirely, his
powerful drawings might almost be a programmatic illus-
tration of Symbolism. In the most significant of these, the
large *Three Brides* (opposite) of 1893, in chalk and pencil
on brown paper, line is used not only to delineate the
figures but also to denote sound and at the same time to ex-
press its own abstract force. In order to read the mystic
content of this picture, representing the contrast between
good and evil, an almost literal analysis is necessary:

The three brides stand for the nun bride of Christ on
the left, the lilies as attribute; the human, innocent, virgin
bride in the center, surrounded by roses; and the bride of
Satan on the right with a collar of skulls and a basin of
blood. Below, female figures with closed eyes—clearly de-
rived from Javanese shadow puppets—are shown as if
floating around a stylized chrysanthemum. Above in the
background a frieze is formed by heads of young girls—
a chorus of disembodied spirits—and in the corner the ring-
ing bells from which long skeins of maidens' hair are flow-
ing, seem to allude to the prophetic tolling of the bells in
the writings of Maeterlinck and Poe whose work Toorop
was illustrating at the time. But the hair strains translate

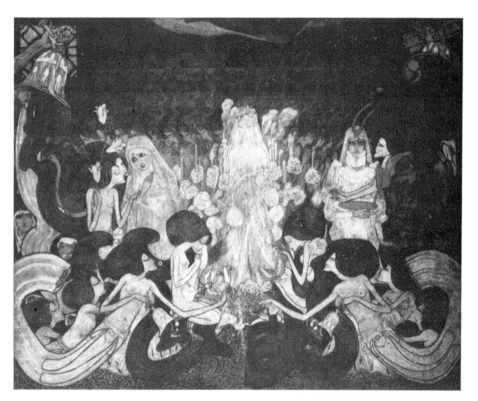

Jan Toorop: *The Three Brides*. 1893.
Black chalk and pencil, 30¾ x 38½".
Rijksmuseum Kröller-Müller, Otterlo,
The Netherlands

into visual terms the waves of sound: softly rounded and rising on the left they indicate "the good," while on the right the dropping, shrill, angular "noise lines" embody "the evil" in an apparently downward falling movement. The iconography of a medieval Last Judgment representation clearly finds its echo in this pedantic Symbolist composition.

The picture as a whole—which certainly strikes us today as both too sentimental and too literal, particularly when contrasted with the simple directness of van de Velde's *Abstract Composition,*—had, however, an immediate in-fluence on its time. Its strictly symmetrical composition, attenuated curves, all-over pattern, sparse use of color, slender bodies, unrealistic grouping of figures and objects, and mysterious mood corresponded well with the demands of the Art Nouveau movement. It was illustrated in the first volume of the *The Studio,*[19] and the early drawings of Frances Macdonald and C. R. Mackintosh are directly traceable to this source.[20]

The younger Thorn Prikker who painted in a dark Im-pressionist vein before turning to religious symbolism in the winter of 1892-93 he painted *The Bride,* which relies

considerably less on figurative allegory than did Toorop's painting and depends upon the suggestive use of form. The clustered shapes in the background are not actually candles, but suggest them; there is no bridal wreath, but twining lines infer it. There are no facial expressions, and the bride herself is implied by a long shape in a veil-like garment patterned with decorative forms derived from flowers. A spiral line connects her on the one hand with the larger form symbolizing the crucified Christ and on the other with the flanking group of oversized bud shapes. The picture is painted in soft greys and greens and light violets, and a gentle sensuality is evoked by the melodiously curving lines and budding shapes. Its undefined growing forms, its rotating motion, subdued color, and general mood, suggest the paintings which Marcel Duchamp was to do some twenty years later.

There were strong cross-influences among Thorn Prikker, Toorop, and van de Velde. Thorn Prikker was the last of these artists to exhibit with *Les XX* in 1893, when he first met van de Velde and contributed drawings to *Van Nu en Straks*. Van de Velde also stimulated him to engage in the applied arts: he did batik designs as well as wallpapers and furniture. In his paintings and drawings at the turn of the century, however, he renounced what he considered the Symbolist fallacy. In 1904 he moved to Germany and began to devote himself primarily to work for the Catholic Church, designing stained-glass windows and painting murals. Jan Toorop also became more conservative in his later work, was converted to Catholicism in 1905, and turned to more conventional liturgical painting.

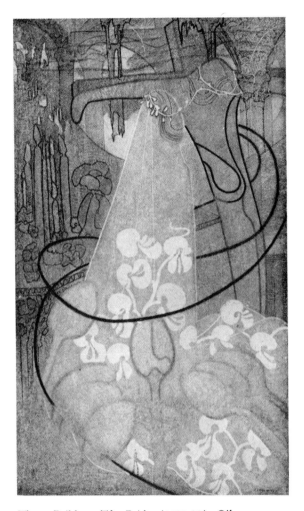

Thorn Prikker: *The Bride.* (1892-93). Oil on canvas, 57½ x 34¾". Rijksmuseum Kröller-Müller, Otterlo, The Netherlands

HODLER, KLIMT, AND MUNCH

The general revival in religious feeling and the turn toward mysticism in the nineties accounts for the success of the Rosicrucian movement under the leadership of the Sàr Peladan. With the financial backing of the Count de la Rochefoucauld, the Sàr Peladan brought together transcendentalists and Aesthetes, spiritualists and charlatans and succeeded in holding his *Salon de la Rose-Croix* at Durand-Ruel's in 1892, mingling paintings by the *Nabis* and Symbolists with more academic exercises. Ferdinand Hodler, born of Swiss peasant stock in Berne and active in Geneva, painted, after naturalistic beginnings, the large Symbolist composition *The Night* in 1890. When he followed his canvas to Paris in 1891, he was greatly admired and fêted by the Rosicrucians for his allegory of sleep, love, and death, and, in turn, came briefly under their spell. Philosophically inclined, Hodler strove for a transcendental art that, he felt, should express his mystical feelings of pantheism in the universe.

Hodler created several large figure compositions, such as *The Chosen One* (page 76) which may be interpreted as a cryptic commentary on the "Adoration of the Child." Like van de Velde's earlier tapestry, *Angels' Guard* (page 94) which was on the same theme, Hodler wanted to avoid any reference to a specific time or place, even to the Biblical event. A small nude boy is seen kneeling in a symbolic garden, planting a small tree and praying for its growth. He is fenced in by a group of angels, standing sturdily on the air, who seem almost to be fastened to their columnar garments. They hold tender flowers as if in answer to the supplication of the "chosen" boy before the leafless tree.

The ritualistic figures and their garments are simplified to the utmost, eliminating everything that is accessory, transitory, or accidental. The landscape background elicits no feeling of atmosphere, avoids all naturalistic space concepts, and is used only as a foil to set off the rhythmic pattern of the figures. The light color serves merely to fill in the clearly delineated contour which again puts supreme emphasis on the repeat pattern of the stylized figures. Hodler saw in man and nature a constant recurrence of the same phenomena which led him to develop his theory of "parallelism." According to this concept, the repetition of forms serves to intensify emotion by creating a unified rhythm and thus give an image to his idea of human solidarity within a pantheist cosmos. "We know and we all feel in certain moments that that which unifies us human beings is stronger than that which separates us."[21]

Often Hodler's large figure compositions strike us as overburdened with rhetorical, passive gestures. The idealist purpose and allegoric imagery still relate Hodler to the world of the Pre-Raphaelites. They are essentially an expression of a philosophy of life, rather than an intensely-felt visual experience. Yet, like his Art Nouveau contemporaries, Hodler worked in terms of the plane enriched with a decorative pattern, where a tense line becomes the important carrier of emotion. *The Chosen One* was placed in the Hohenhof,[22] which van de Velde designed for Karl Ernst Osthaus in Hagen, where it acted as an integral part of a unified Art Nouveau composition. His large, mural-like compositions with their severe symmetry and precise linear structure tried, in fact, to transpose Art Nouveau from the realm of the decorative into that of the monumental.

A retrospective exhibition of Hodler's large figure pieces at the Vienna Secession in 1904 was so successful that thereafter his fame was assured. The way for his great triumph in Vienna had been prepared for him by Gustav Klimt and his other friends of the Secession. The Vienna Secession was founded in 1897, and the following year its brilliant and colorful official organ, *Ver Sacrum,* began publication. From then on developments in Austria, starting later than in Western Europe, succeeded one another with great rapidity. In the mid-nineties Austrian design was still in the grip of heavy-handed eclecticism. A few years later, at the Universal Exposition in Paris in 1900, the Austrian pavilion, designed by Hoffmann and Olbrich, was the best example of the new style and in itself a remarkably elegant structure. Klimt, the president of the Se-

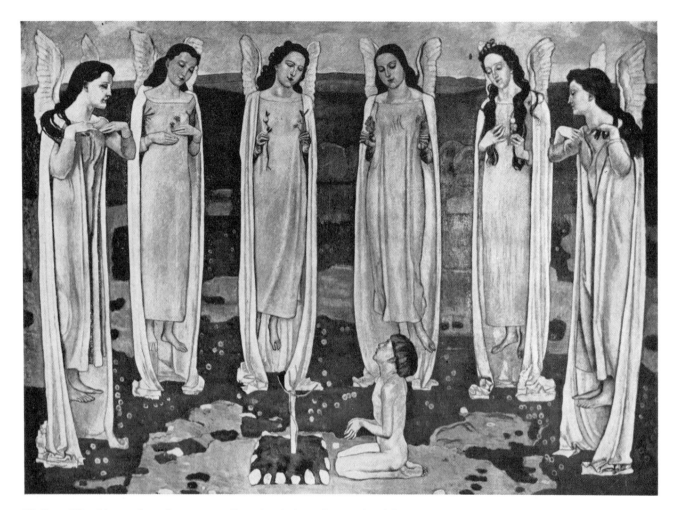

Hodler: *The Chosen One.* (c. 1903, replica of painting of c. 1894). Oil on canvas, 7' 2½" x 9' 10". Karl Ernst Osthaus Museum, Hagen, Germany

Opposite: Klimt: *Salome.* (1909). Oil on canvas, 70⅛ x 18⅛". Galleria Internazionale d'Arte Moderna, Venice

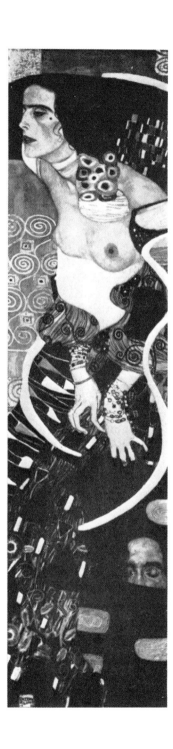

cession, had worked originally in the fashionable academic manner of Hans Makart and had not become familiar with contemporary European art until 1895. The foundation of the Secession immediately opened the doors to advanced European artists. Klimt was especially impressed by Jan Toorop, the Belgian Symbolist Fernand Khnopff, and Franz von Stuck, who worked in a similar vein in Munich. Most important, however, was the influence from Britain: Burne-Jones, Beardsley, and especially Mackintosh.

By 1900 Klimt had established his own style. He was "famous well beyond the borders of his own country . . . an artist so typical of *art nouveau* that a more characteristic example of that international style could hardly be found. If *art nouveau* was an art of the surface—and a beautifully ornamented surface—of flowing curves and delicate figures, of ephemeral beauty and rich ornamentation of poetical, sometimes symbolic subjects, a feminine and decadent art—Klimt was its quintessence."[23]

Klimt was in great demand as a painter of mutedly elegant portraits; and he painted allegorical pictures of voluptuous young women set off against richly textured backgrounds, often applying gold and silver sequins to the canvas. This application of metal to the picture plane was probably inspired by Byzantine mosaics, but in some ways it anticipates the modern collage. He did landscapes and flower pieces, covering the picture with a linear, strongly colored carpet in which representational elements are interwoven with freely invented geometric ornaments—the whole canvas being executed with a festive ornateness suggestive of the handicraft products of the other Secessionists.

Klimt had ambitions for making large wall decorations. Between 1900 and 1903 he created imposing murals for the faculties of philosophy, medicine, and jurisprudence at the University of Vienna, which met with severe popular disapproval because of the radical character of their symbolism. Then, to surround Klinger's Beethoven Monument at the Secession in 1902, Klimt made an allegorical frieze whose sentimentality is as refined as Klinger's is bombastic. His most successful work, however, was the frieze he de-

77

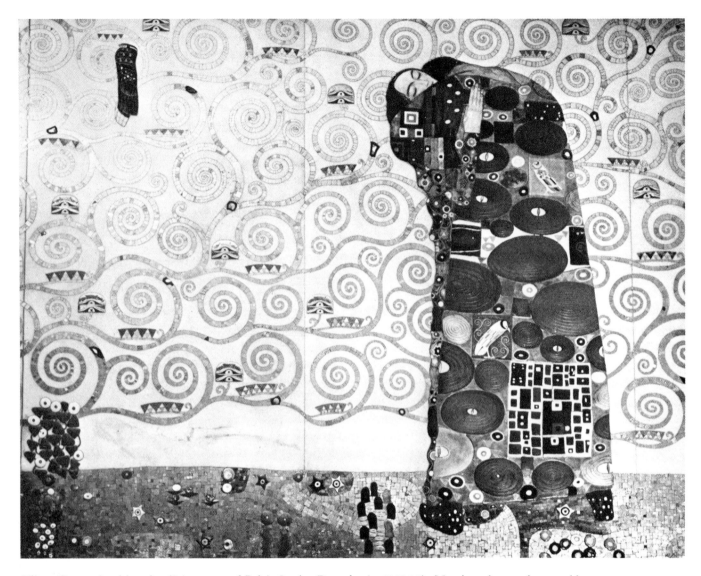

Klimt: Decorative frieze for dining room of Palais Stoclet, Brussels. (c. 1905-08). Mosaic and enamel on marble.

signed for Josef Hoffmann's Palais Stoclet (opposite). In keeping with the quiet elegance of Hoffmann's designs, Klimt's murals for the dining room possess a restrained and graceful repose achieved through the rhythmic repetition of geometric forms. To stress the value of the wall as wall, Hoffmann framed his plain white surfaces with a heavy gold border. Similarly, there is no longer any three-dimensional illusion in Klimt's mural. The motifs—tree of life, dancer, lovers—are subordinated to a flat, ornamental structure of triangles, ovals, curves, volutes, and free arabesques. The designs were executed in a mosaic of glass and semi-precious stones, majolica, white marble, metal, and enamel. They approach the decorative splendor of Byzantine mosaics and, indeed, the stylized tree with its spirals brings to mind the work of the Orthodox Baptistry in Ravenna. But compared with the majestic dignity of the Ravenna mosaics, Klimt's beautiful and delicate frieze hardly rises beyond arts-and-crafts embellishment.

The decorative nature of Art Nouveau was not truly conducive to a monumental conception. However, there were examples in which the emotional quality of the whiplash line could rise beyond the purely decorative to a genuine expression of deep psychological involvement. This was true of the work of Edvard Munch.

As a young man, Munch was part of the intellectual fermentation and libertine radicalism of Oslo's bohemia. Then, coming to Paris in 1889, he made contact with the most advanced painting in France. He saw the work of Seurat and Lautrec and at Theo van Gogh's gallery he looked at van Gogh's paintings, and was especially impressed by Gauguin. He began working on a series of paintings—the *Frieze of Life*—dealing with man's emotional life and his suffering. In 1892 he traveled to Berlin for an exhibition of these paintings, only to see the show close within a few days after precipitating one of the great controversies of this period which is notorious for the number and the intensity of its art scandals. Munch, however, remained to become a central figure of the progressive cultural life of Berlin. His paintings and prints express not only the general melancholy of the *fin de siècle,* but an additional intense anxiety, whether of man-woman relationships fraught with desire and suffering, or of individual figures threatened by the forces of life and confronted by the terror of death.

"Perhaps Edvard Munch came closest to a pictorial realization of the symbolist's endeavor to evoke an immediate response through the use of the plastic form itself without the intermediary factor of didactic allegory. *The Cry* (page 80) of 1893 uses a minimum of descriptive or narrative elements. A writhing figure emerges from the picture plane, and its convoluted form is repeated throughout the landscape in the sinuous line of the shore and the equivalent rhythm of the clouds. The curved line is strongly emphasized by its contrast to the straight, rapid diagonal cutting through the imaginary space of the painting. The cry that the central figure seems to be uttering pervades the landscape like a stone creating centrifugal ripples in water. Munch has painted what might be called sound waves, and these lines make the human figure merge with the landscape to express a total anxiety that evokes an immediate response from the observer."[24]

Unlike Toorop's *Three Brides* of the same year, *The Cry* was able to communicate emotion through the visual elements themselves. Munch then proceeded to exploit these elements by repeating the same themes in various painted versions or by turning to graphic reproduction. He began experimenting with the different print media in 1894 and, impressed by Séguin's prints, he made drypoint and aquatint etchings in which he managed to recapture the atmospheric quality of his oils. In his woodcuts he profited by the pioneer work of Vallotton and Gauguin, became greatly intrigued by the nature of the medium itself, and, stressing the grain of the woodblock, he reached a remarkable virtuosity. The breadth and freedom of lithography, however, permitted him the closest approach to recasting the flowing qualities of his paintings.

The *Madonna*—certainly a startling title for the languid nude painted in 1894—was repeated in a color lithograph

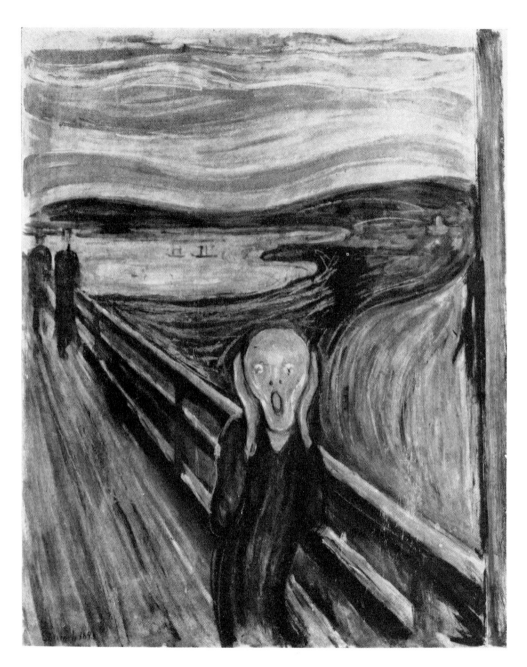

Munch: *The Cry.* (1893). Oil on cardboard, 33 x 26½″. Nasjonalgalleriet, Oslo

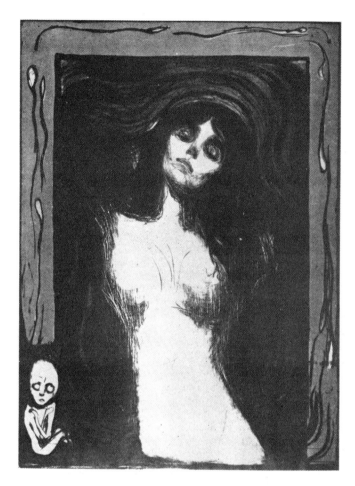

Munch: *Madonna.* (1895). Color lithograph, 23¾ x 17½". The Museum of Modern Art, New York.

the following year. But in the lithograph a border is added in which a foetus and spermatozoa appear shockingly to allude to the role of the Madonna as the creator of life. The sperms, while resembling the cells seen under the microscope, serve to form the decorative border and have assumed the sinuous line of Art Nouveau. When Munch returned to Paris in 1896, it was S. Bing who exhibited his paintings at his new gallery, *L'Art Nouveau,* and it seems significant that Munch's friend August Strindberg wrote a review of the show in the most important organ of the *Nabis,* the *Revue Blanche.*[25]

THE SITUATION IN GERMANY

Germany produced no truly outstanding painting or sculpture during its Jugendstil period. This is probably because the Germans took certain principles of Art Nouveau too literally and too seriously. Much in the manner of the earlier Arts and Crafts Movement in England, the German artists in the nineties felt a great moral responsibility for the creation of objects of fine workmanship and individual value to counteract the cheap products of a debased mass culture. Historicism, which had remained firmly entrenched in Germany so much longer than it had across the Rhine, was finally rejected and academic convention repudiated. Functional and beautiful objects were made which would carry the personal imprint of the artist's hand. The arts and crafts, therefore, became the center of interest for some of the best German artists—Peter Behrens, Otto Eckmann, August Endell, Hermann Obrist, Bernhard Pankok, Richard Riemerschmid—most of whom had begun their careers as painters. The level of the applied arts, to which they devoted most of their activities, was raised to meet the highest standards. Painting itself was to become mostly embellishment of a well-appointed space, and was to "fit into a room like a gem into a ring."[26]

Periodicals which covered literature, politics, and social satire as well as art became the rallying points of the new

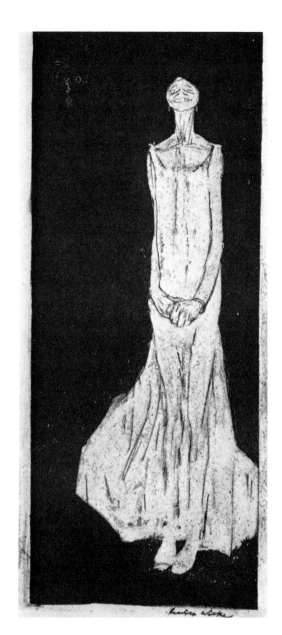

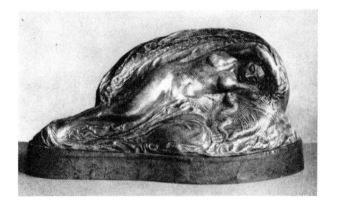

Barlach: *Cleopatra.* (1904). Ceramic, 9″ high.
Kunsthalle, Bremen. Dora and Kurt Reutti Foundation.

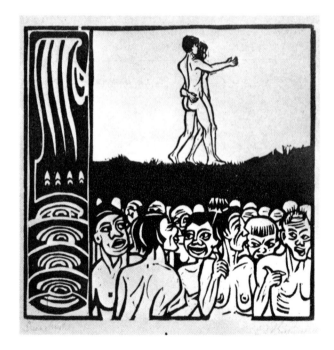

Wilke: *Ueberbrettl.* Drawing for *Simplicissimus,*
1903. Ink, tempera and watercolor, 18½ x 11½″.
Staatliche Graphische Sammlung, Munich

Kirchner: *Before the People.* (1900). Woodcut, 7¹⁵⁄₁₆ x
7¹⁵⁄₁₆″. Allen Art Museum, Oberlin College, Oberlin, Ohio

movement. The erudite vanguard quarterly *Pan,* which Julius Meier-Graefe founded in Berlin in 1895, was followed in 1896 by the more popular Munich weeklies *Jugend* and *Simplicissimus.* These magazines sponsored a whole group of extraordinary illustrators, among whom Thomas Theodor Heine, Olaf Gulbranson, Bruno Paul, and Rudolf Wilke produced some of the most vigorous work. Many of the talented artists of the time contributed cartoons, illustrations, and ornaments, and it was in *Jugend,* for example, that Ernst Barlach began his career. Soon after his Jugenstil drawings and covers for *Jugend,* Barlach began doing sculpture, designing plaques, small fountains, and decorative ceramics. His *Cleopatra* (opposite) of 1904, with its typical Art Nouveau kidney shape, is a sensuous nude completely surrounded by a sweeping cloak in which the busy movement of its delicate ripples opposes the smooth surface of the figure. These early decorative Art Nouveau sculptures, however, bear little resemblance to the monumental carvings of archetypes for which Barlach is remembered and which began after his trip to Russia in 1906.

Many of the German painters who like Barlach became leading figures in the German Expressionist movement had their start in Jugendstil. For example, Ernst Ludwig Kirchner's early woodcuts—which he later refused to acknowledge—were typically Art Nouveau. In his *Before the People* (opposite) the man and woman are dancing on a ridge above the crowd. This scene finds a symbolic linear equivalent on the left side of the print in the abstract forms suggesting dance movement and a group of staring eyes.

Isolated in the artists' colony of Worpswede, yet in close contact with the art of Paris, Paula Modersohn-Becker evolved her own personal Art Nouveau forms in this German Pont-Aven. In her *Still Life* of c. 1900 (page 84) she had already gone far beyond the regional lyric naturalism of Worpswede and was describing objects with what she referred to as "runic writing." In her enthusiastic treatment of the decorated tablecloth, the convoluted curves of the embroidery take on an organic life of their own. Later she simplified her forms and hardened her structure but never lost her understanding of symbolically decorative form.

Typical of the Jugendstil artists of Munich, which had become the center of the movement, was the tendency to restrict every form to a two-dimensional plane, reducing even the human figure to nothing but an ornamental design. The *Kiss* by Behrens (frontispiece) of 1898 is a good example of this. The two severe, almost classical profiles, surrounded by a dense arabesque of hair, are drawn in a delicate rhythm of dynamic balance. Nothing of the warm, life-like embrace of Rodin's *Kiss* of 1886 remains; all that is left is an intricate interlace of lines in which the pointed meeting of the mouths forms the abstraction of a kiss.

It was in Munich in the nineties that the philosopher Theodor Lipps, advocate of the theory of empathy, held lectures at the University on the evocative meaning of line and performed experiments on the effect of linear movements on the human psyche. There Hermann Obrist, who had been trained as a natural scientist, used organic forms abstractly in his embroideries, like *The Whiplash* (page 113), and then again in his sculpture designs for fountains and funerary monuments. He made the declaration, revolutionary for 1901, that the human form is no longer the end-all of sculpture and urged sculptors to parallel nature in creating growing forms. His *Design for a Monument* (page 84) is a diagonally rising wedge with a swift continuous spiraling movement. The figures—the angel on the summit of the spiral, for instance—are banal literary vestiges which the next generation (cf. Tatlin) could easily eliminate.

August Endell, a student of Lipps in philosophy and under Obrist's influence as an artist, designed the imaginative relief on his Atelier Elvira (page 138). Based on a dragon motif, the purple form floats with exuberant fury on its green wall. It is still architectural decoration—not yet free abstract sculpture—but Endell already foresaw the development of a new non-representational art form (see page 10).

Modersohn-Becker: *Still Life.* (c. 1900). Oil on cardboard, 14⅞ x 11½". Collection Stephen Radich, New York

Obrist: *Design for a Monument.* (Before 1902). Plaster. Kunstgewerbemuseum, Zurich

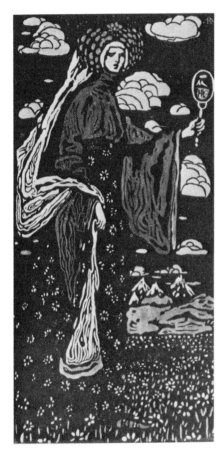

Kandinsky: *The Mirror.* (1903). Wood-
cut, 12¼ x 6⅛″. Städtische Galerie und
Lenbachgalerie, Munich

"It was a great time of artistic renewal when I came
to Munich to study in 1901," Gabriele Münter remembers.
"Jugendstil began in its own way to destroy the old natural-
ism and to devote itself to pure line."[28]

Gabriele Münter's friend and teacher, Wassily Kandin-
sky, made a series of woodcuts based on romantic, medieval
fairy-tales. In these he must have been influenced by the
ballet design and stage décor of Bakst, Benois, and Somov,
whose work he saw on his frequent return visits to Russia.
In *The Mirror* of 1903, the two-dimensionality of the pic-
ture plane is predominant; almost all vestiges of perspec-
tive are eliminated. But an intricate play between fore-
ground and background is stressed by the use of positive and
negative forms. The white of the paper, for instance, serves
at the same time to shape the clouds in the sky behind the
fairy-queen and the long veil floating down in a zigzag line
advancing in front of the figure. Yet the small broken-up
curvilinear forms of its folds tie up with the grey ones on
the hanging sleeves, located somewhere between veil and
clouds. Again, an all-over pattern of white flowers spreads
evenly over skirt and lawn; it is only by means of these
flowers that the shape of the skirt is recognizable since no
line separates its black from the black of the sky. It is this
interpenetration of multiple space values creating suspen-
sion of space and tension of surface which is so characteris-
tic of Art Nouveau design from Vallotton to Kandinsky.
This was one of the means of visual expression which
Kandinsky was to explore further in his breakthrough from
Art Nouveau to Non-Objectivism.

Many of the Art Nouveau artists of Germany made con-
tributions to this unified style. As in the rest of Europe,
there were those who came to their peak during their par-
ticipation in the movement, but sank back again into
mediocrity, after the hold which the vital elements of the
new style had on their talents had weakened. But there
were also those who, beginning their careers, took aspects
of Art Nouveau as a starting point, to leave the movement
itself far behind them on their way to artistic maturity.

PETER SELZ

Victorian drawing room. Residence of the Hon. Hamilton Fish, New York. (c. 1880)

Riemerschmid: Music room. German Art Exhibition, Dresden. 1899

DECORATIVE ARTS

In the 1880s a living room of the upper bourgeoisie in almost any European or American home was likely to contain an odd assortment of upholstered, heavily carved furniture. A large table draped with a tasseled rug, and a set of high-backed chairs, dominated the center of the room (opposite). One corner might be transformed by a balustrade into a romantic "room within a room" draped with shawls. The windows, sheathed in velvet and lace, allowed only a trickle of diffused light. Vases, potted palms, assorted lamps, and copies of Greek statuary filled the empty spaces. This mixture of all periods and styles formed the basis for High Victorian design.

A decade later a visitor to one of the influential international exhibitions, in which new tendencies in design and decoration were shown to an eager public, would find a room of quite different character: in a large, comparatively bare space, the table and chairs had been moved from the center to a large, undraped window which flooded the room with clear, even light (opposite). The window had been set into a deep, softly curved wall embrasure, its shape accentuated by parallel wood frames and thin lead strips gracefully following the fan-shaped upper section. The table was not a separate element but was instead part of a wide window sill extended deeply into the room. Armchairs around the table contributed elegantly flowing lines to the total composition. Wallpaper patterned with horizontal swirls covered the lower part of the wall; the upper section carried a stenciled frieze of gently swaying vertical lines. Designed for this particular room, like all the other elements in it, was the lighting fixture suspended from the center of the ceiling: a circle of individual bulbs swung from thin brass rods. Hanging from their electric wires, they seemed like the ribs of a tent.

This room, created by Richard Riemerschmid for the applied arts section of the 1899 German Art Exhibition in Dresden, must have appeared bare and cold to the average visitor; to the followers of the New Style it revealed, as it does to us today, an uncommon degree of coherence through the coordination and interrelation of its elements. Riemerschmid, a Munich painter who had become a designer of furniture and decorative objects, was eventually well known as an architect.

This New Style, an outcome of a great process of rejuvenation affecting attitudes towards all the arts, had begun simultaneously in several European countries in the early 1890s. Its specific characteristics differed from country to country, but certain generalities were to be noted. In essence, it was a style of ornament; its center of gravity was the applied arts. Because it was basically planar, its purest manifestation appeared in graphic design and surface decoration. It was for this reason that wallpapers, stencils, stained glass, mosaics, inlaid woods, tapestries, and embroideries, all important elements in the furnishing of a room, received much attention. However, their use differed basically from that in earlier "period" rooms. Previously they had served to create an illusion of depth through overlapping. In the New Style, they heightened the sense of the two-dimensional—an effect achieved through continuous curvilinear movement and through a combination of shadowless flat shapes.

These shapes, given a highly evocative outline, cut into the surrounding space in such a way that the space too became a shape. Color played an important role; flat and contrasting color tones were placed next to each other without shading. Form was often indicated by a mere outline or by two parallel lines of different weights. In fact, parallel lines became a common device serving equally well for abstract embellishment or the evocation of a specifically poetic content.

Since these efforts to develop a new and unified style

were to affect every aspect of man's environment, the conditions for urban living were probed and re-examined. Here were the roots of the return of the decorative or "minor" arts to the level and importance which the fine arts had occupied. It helps to explain why painters were willing to leave their easels to turn craftsmen, using their talents to design the objects and environment of daily life.

ENGLAND

Industrialization in the nineteenth century provided goods which previously few people had been able to own. Easily produced in quantity by machines, such things as textiles and household furnishings, heretofore reflecting the craftsman's close contact and personal understanding of his customer's needs and tastes, were now generally available. The visual form of these objects continued in the manner of earlier styles. The wealthier part of the new population— the substantial bourgeoisie who owned the factories and directed industry—used more costly versions of the same prototypes in furnishing their elaborate homes.

In protest against this insensitive imitation and mixing of styles, John Ruskin had declared that such imitation is the destruction of all art and that the foundation of art is truth. William Morris, the first to translate Ruskin's philosophy into action, aimed at the re-establishment of the artist-craftsman as a member of the community. He wished to reunite all the arts much as had been done in the Middle Ages.

Ruskin and Morris recoiled from what they regarded as the destructive effects of the industrial revolution, but they failed to see the advantages to the arts made possible by the new technology. To them, salvation from what they considered a debased civilization lay in the return to the principles of hand craftsmanship. In their preference for historic styles—the arts of the Middle Ages and the early Renaissance—they remained true to the esthetic conceptions of the early nineteenth century.

The artists of the next generation were prolific writers on

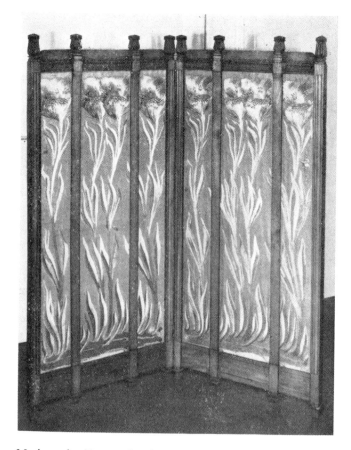

Mackmurdo: Two-sectioned screen. 1884. Embroidered silk panels, satinwood frame, 28 x 24". Made by the Century Guild. William Morris Gallery, Walthamstow, Essex

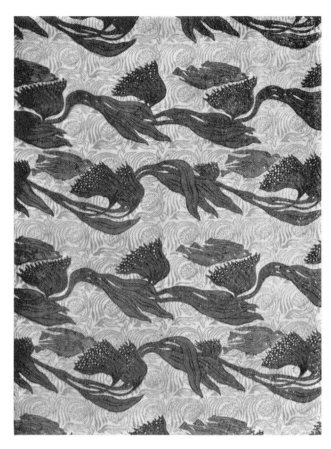

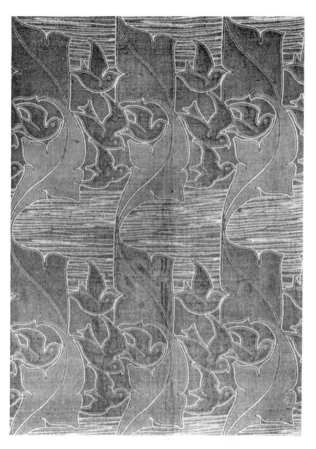

Mackmurdo: *Cromer Bird*. (c. 1884). Printed cotton fabric. William Morris Gallery, Walthamstow, Essex

Voysey: Woven silk and wool fabric. 1897. Victoria and Albert Museum, London

these problems. In interminable discussions, they eventually denounced Ruskin and Morris for having withdrawn from the present, but they accepted Morris' theories for the unification of the arts. These ideas soon led to the establishment of craft guilds, among them Arthur H. Mackmurdo's Century Guild in 1880-81 and C. R. Ashbee's Guild and School of Handicrafts in 1888.

Mackmurdo remains one of the most surprisingly original personalities of his time. While traveling on the Continent he had made extensive studies of plants, which he drew from nature, and of the stylized foliage of Gothic and Romanesque decoration. His art reached an unconventional freedom of expression. In his design for a chair back in 1881, followed by a similar design for the title page of *Wren's City Churches* (page 27), he anticipated the maturity of the New Style, which on the Continent would come to full flowering a decade later. Similarly unprecedented in its free rhythmic feeling is his embroidered screen decoration of 1884 (page 88). Exaggeratedly long flower stalks with thin leaves and wind-swept petals are set within narrow framed panels, where they undulate like tongues of flame.

The 1884 *Cromer Bird* textile design (page 89) has perhaps the strongest quality of fantasy. Its strangely proto-surrealist motif produces an air of excitement unexpected in so modest an object as a simple cotton cloth and marks Mackmurdo as a prophet of one of the most significant aspects of the New Style. The design recalls the spirit of the Pre-Raphaelites, and is also an example of his extraordinary talent for decoration. Over a light-toned background of geometrically arranged flower patterns, rows of darker-colored seaweed float from left to right, accompanied by groups of small swift birds. However, the blossoms of the floating plants strain in the opposite direction, providing a disquieting counter-rhythm. The design is organized on two planes: a swaying but stationary background and a moving foreground pattern with its own internal rhythm.

Another textile, by the architect Charles F. Annesley Voysey, is much more simplified in detail and perhaps more

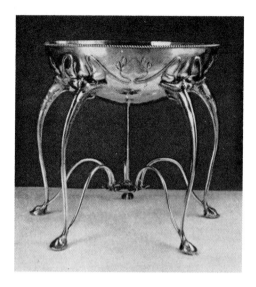

Ashbee: Bowl. (c. 1893.) Silver, 8″ high. Made by the Guild of Handicrafts. Victoria and Albert Museum, London

smoothly dynamic in its elements (page 89). Flat outlines of birds and leaves are arranged in wide horizontal bands against a striated background, dissected by the tips of leaves reaching out from each band to flow together across the striated area. Voysey, one of the pioneers of modern architecture, created for his homes graceful, undecorated furniture which greatly inspired Continental artists by its new uncluttered "English" character.

Equally well known on the European continent was the architect C. R. Ashbee. How closely the continent followed developments in England can be seen in the many exhibitions held during the last decade of the nineteenth century and from the constant flow of articles in European magazines. In the *Dekorative Kunst* of 1898, Herman Muthesius, attached to the German Embassy in London to study and report on English housing, described a visit to Ashbee's Guild and School of Handicrafts where students were trained as craftsmen to execute his designs under his

personal supervision. Muthesius remarked on the fact that through such guilds the long existing gap between studio and workshop had been closed. In his appraisal of Ashbee's work, he commented on Ashbee's preference for forms based on the actual function of the object (opposite).

The English Arts and Crafts movement acted as a catalyst on the creative forces in Europe and America, where in fact subsequent work seems unthinkable without the English impetus. Continental commissions received by English architects and designers contributed significantly to the spread of a new style. Baillie Scott, an important architect who had received many commissions on the Continent, also designed furniture for the Grand Duke of Hesse in Darmstadt in 1898. This much-publicized commission was probably responsible for the Duke's invitation to seven German and Austrian artists to form an artists' colony in Darmstadt, called Mathildenhöhe (page 116).

At the time of the great Paris 1900 Exhibition, the English public was unaware of the fact that a New Style, now fully matured, was sweeping the Continent. For this reason George Donaldson, an English member of the Paris jury, made a considerable bequest of money to the Victoria and Albert Museum for the purchase of furniture from the exhibition, because he felt that it displayed a "superior ingenuity and taste" which he wanted to bring to his country's attention.[1]

SCOTLAND

A small group of artists in Glasgow, working independently of the English movement, produced an original interpretation of the arts and crafts idea. Through them an element of pure geometry was added to the New Style's floral and abstract-linear trends.

Of this Glasgow group, the architect Charles Rennie Mackintosh emerged as the most powerful, imaginative personality. Not only his architecture, but with equal lucidity his interiors, furniture, and decorative objects recall that "sense of fitness" which permeated interiors by

Voysey. Mackintosh's furniture (below) was primarily rectilinear, simple, squarish, and subordinate to the ensemble concepts underlying his room designs. The character of his furniture distinctly stems from Gothic chairs and cabinets, prototypes which had also served as inspiration for the furniture designs of William Morris. But in Mackintosh's hands these designs underwent fascinating transformations. Some of them were painted white and adorned with a kind of decoration for which no precedent existed. Supporting elements, joints, and the centers of doors were often accentuated by the spare but unerring use of white orna-

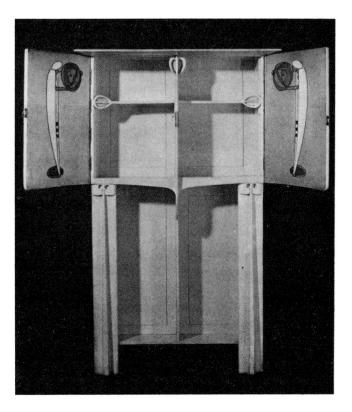

Mackintosh: Cabinet. (c. 1903.) Wood, painted white, decorated with carvings and inlaid figures of enamel and leaded glass, 5' high. The University of Glasgow Art Collections, Glasgow

Horta: Electric light fixture from a fireplace, Hôtel Solvay, Brussels. 1895-1900. Gilded bronze. Collection L. Wittamer-de Camps, Brussels

ments, rising from a flat white surface, trefoil or softly oval in form. Rectangular chairs are like thrones, over-scaled in size, often decorated with stenciled flowers, and designed for formal elegance rather than comfort. Together with subtly colored mural decorations, light fixtures suspended from beaded strings, and vitrines with doors which, like those of shrines, conceal their delicate ornamentation on their insides, they contributed to the symbol-laden, fairy-tale atmosphere of Mackintosh's interiors.

Most of the decorative elements were the work of the Macdonald sisters—Margaret, who married Mackintosh, and Frances, who became the wife of his partner, Herbert McNair. The sisters executed, in glass, gesso, and repoussé metal, strange thin figures from a dream world, with small enigmatic faces and expressively clasped hands. Their stylistic origin reaches back to the Pre-Raphaelites, but their literary content is diffused and vague (pages 68-69). Ubiquitously found in Mackintosh interiors, these figures in thinly flowing draperies move among stylized rose bowers and trickling fountains symbolically dripping tears or blood. The glittering decorations suggest precious gems but were achieved with commonplace, often cheap materials. Gilded and sculptured gesso was inlaid with string, jet beads, and metal plaques and tinted with soft greys, pinks, apple green, olive, and shades of rose and blue. Yet these rooms in their severely architectonic arrangement and sophisticated color combinations revealed a continuity and control of means. Even with all their rich detail, they retained a delicate, carefully controlled linearity, which fused each part into a unified whole. This sense of unity was perhaps the one characteristic found in each of the national versions of the new style.

BELGIUM

Like a stepping stone between England and continental Europe, Belgium became for a time a moving force in the development of the New Style. One of the first to arrive at a fully developed mastery of the New Style was the

architect Victor Horta (see 125-135). In the staircase of the Tassel House (page 129), completed in 1893, Horta achieved an intensity of expression comparable to the equally unprecedented Mackmurdo title-page design of ten years before. The stair hall is framed on all sides by exuberantly curving and snapping ribbons which rise like flames from the bottom of the stairs, asymmetrically covering a section of the wall and reaching up to the next landing. This painted decoration is paralleled in the open wrought-metal stair rail of similar design, and echoed in clusters of lines painted on the ceiling and repeated in a mosaic pattern on the floor. The supporting cast-iron center column sprouts cast iron tendrils intertwined with the ceiling decoration. All materials are subordinated to the demands of a linear decoration. This continuity suggestive of organic growth eventually became Horta's chief interest.

In the Hôtel Solvay even stone relinquished its natural reticence, bending and softening at the architect's command. The interior shows a remarkable unity inasmuch as the completely furnished house reflects a single creative impulse even in the smallest details.

All the lighting fixtures were consistently designed as flowering plants; they climb up and wind themselves around stair rails, rise gracefully from the sides of fireplaces, or droop in elaborate clusters from ceilings, pouring light over the carved wood furniture and walls (opposite). Horta's decorative elements are like bundles of individual strands bound together by interwoven ribbons. A footstool, a photograph stand, and an inkwell (right) become ornaments of complex abstract design. Their function is almost completely subordinated to the expression of willful elegance and sophisticated whimsy.

The work of the architect and furniture designer Gustave Serrurier-Bovy provided a link between Belgium and England. In his furniture shop in Liège he sold English designs as well as his own. The latter, unlike Horta's plastically conceived inventions, were flat two-dimensional surfaces into which he inserted tensely drawn curved arches (right). The visual tension thus expressed was a

Wolfers: Inkstand. 1895-1900. Gilded bronze. Collection L. Wittamer-de Camps, Brussels

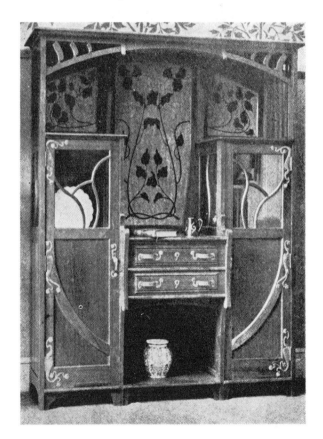

Serrurier-Bovy: Dining room buffet. 1898

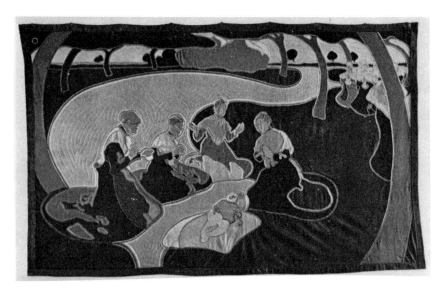

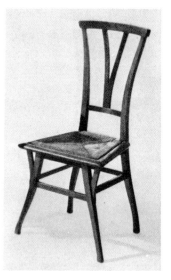

Van de Velde: *Angels' Guard.* 1893. Wall hanging: wool and silk embroidered appliqué. 55 x 91¾". Kunstgewerbemuseum, Zurich

Van de Velde: Side chair from the artist's house in Uccle. 1895. Museum of Modern Art, New York

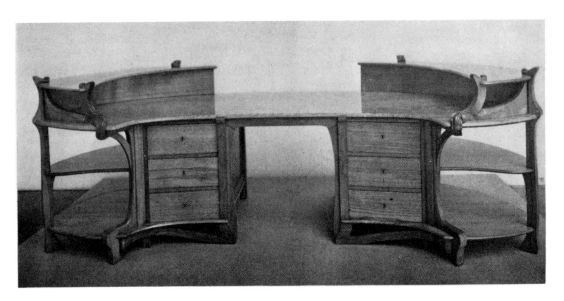

Van de Velde: Desk. 1897. Ashwood. Österreichisches Museum für Angewandte Kunst, Vienna

feature taken over by van de Velde and transformed by him into one of his most characteristic design elements. Van de Velde rightfully considered Serrurier a precursor of Belgian interior design. The latter's studies in London in the fields of wallpaper, textiles, etc., seriously influenced his work after he returned to Belgium.[2]

An article in *Dekorative Kunst,* one of the magazines so important in the propagation of the New Style, made the observation that Serrurier, like Horta, had been trained as an architect; this training, although technically of great advantage, created difficulties in terms of esthetics. On the other hand, van de Velde, Alfred William Finch, and Georges Lemmen, who were well-trained painters, originally lacked technical understanding. The article went on to say, "It will be difficult to decide which of these two is the more valuable background. No doubt, it is only by combining both elements that something worthwhile can be created, and at this moment to do so appears to be as necessary as it is rare. It is to this combination that van de Velde, who with great forcefulness has appropriated the technical basis, owes his brilliant development."[3]

Henry van de Velde was a gifted painter who became a designer and architect because he felt that in this way he could best fight against what he considered the world's ugliness. Deeply absorbed in the doctrines of Ruskin and Morris, he found a personal fulfillment in the creation of an environment made liveable with beautiful furniture, objects, even clothing. Calling for new esthetic ideas in the avant-garde of *Les XX* and *Le Libre Esthétique,* he became one of the pioneers in the complete renewal of form and ornament in the applied arts. Van de Velde's gifts were twofold: his creative talents were matched by his intellectual abilities. His work cannot be separated from his theories. In emphatic and emotion-charged language, he projected ideas which carried the organic away from the imitation of nature toward the abstract. He became the proponent of the curvilinear abstract variation of the New Style. Although he had discarded easel painting in favor of utilitarian pursuits, he designed and exhibited in 1893 an appliqué wall hanging, *Angels' Guard* (opposite), which is still essentially a picture. Simplified flat planes with strong areas of unbroken color are used to intensify the meaning of the story. The winding road is a foreshortened curve of color, contrasting with other areas of flat color. This curved shape is filled with vibrating parallel lines which completely envelop the kneeling figures. There are stylistic resemblances which can be traced to Gauguin and the Symbolists. The dynamic play of lines and surfaces, however, foretell much of van de Velde's mature work.

In 1895 van de Velde built his first house, Bloemenwerf, in Uccle near Brussels. In this house he created an all-encompassing style of living, new in spirit and free from inherited conventions. Life at Bloemenwerf was a complete unit designed by its owner, even to the styling of his wife's clothes (page 9). The interiors created for Bloemenwerf are his first interiors which indicate the New Style. The chairs, for instance, are a characteristic example of the furnishings (opposite). Made entirely from individual staves with rush seats, their somewhat harsh form goes back to peasant prototypes; each line and joint exists because of structural necessity. These skeletal shapes already possess the characteristic springiness and energy of his later designs. In this chair the eye perceives the surrounding space as a complementary form, fusing the solid members and voids into a complex entity. The furniture is undecorated; its ornamental quality is inherent in the movement of the lines.

These same principles are more forcefully expressed in a large ashwood desk of c. 1897 (opposite). Here, too, no surface ornamentation has been applied. The large structure consists of two inner consoles with outer open shelf sections at each end; a sweeping oval top is surmounted by tapering shelf-boards at both ends and forces unity by a sculptured heavily flowing outer band. This curving outline not only holds all parts together but also serves as brace and support to carry the shelves while it models the shape.

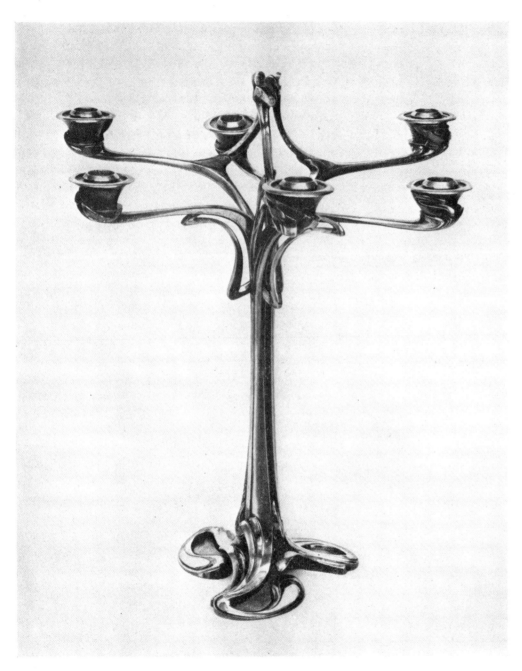

Van de Velde: Candelabrum. (c. 1902.) Silver-plated bronze. 21¾″ high. Nordenfjeldske Kunstindustrimuseum, Trondheim

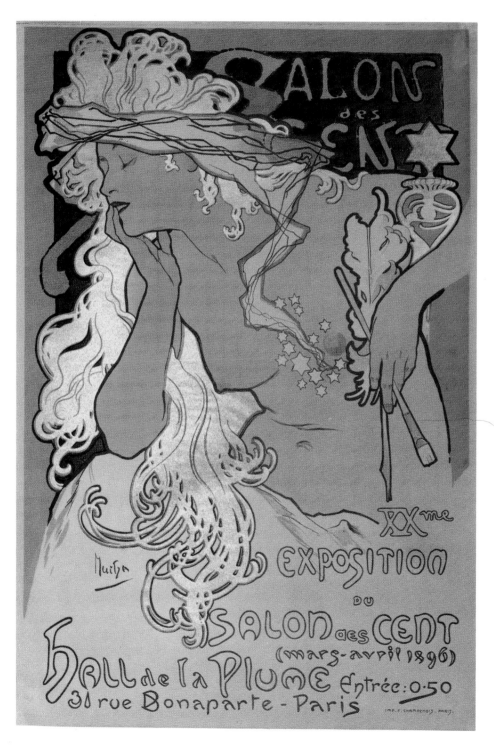

Mucha: *XXme Exposition du Salon des
Cent.* 1896. Lithograph, 25¼ x 17″. The
Museum of Modern Art, New York. Gift
of Ludwig Charell

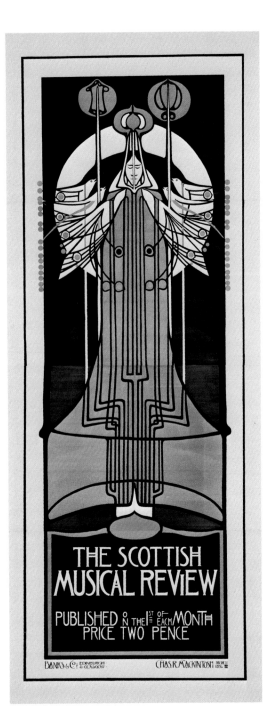

Mackintosh: *The Scottish Musical Review*. 1896. Poster, 97 x 39″. The Museum of Modern Art, New York

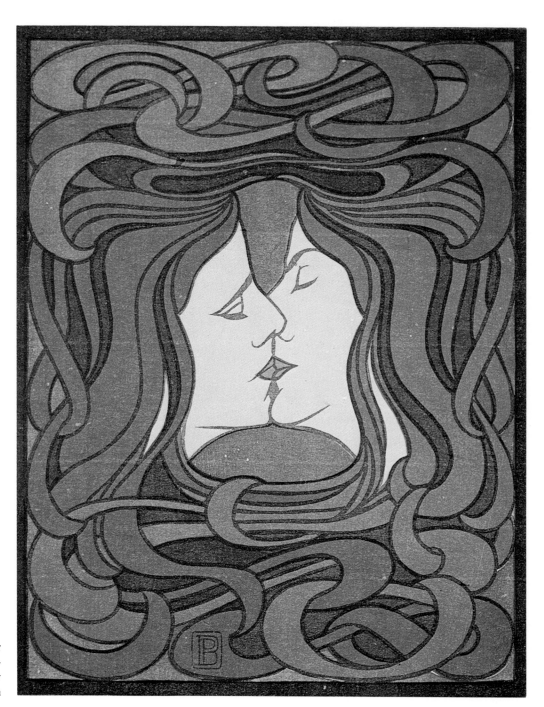

Behrens: *The Kiss.* 1898. Color woodcut, 10⅝ x 8½". The Museum of Modern Art, New York. Gift of Peter H. Deitsch

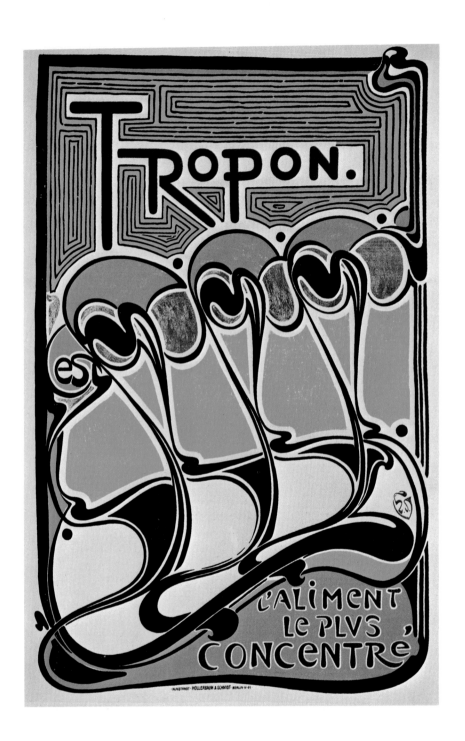

Van de Velde: *Tropon, l'Aliment le Plus Concentré* (Tropon, the Most Concentrated Nourishment). 1899. Offset facsimile of original lithograph, 31⅝ x 21⅜". The Museum of Modern Art, New York. Gift of Tropon-Werke

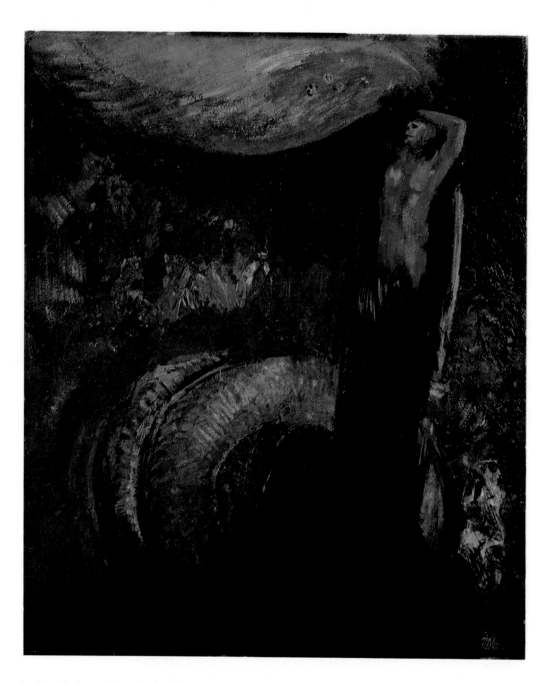

Redon: *La Mort: Mon ironie dépasse toutes les autres!* (after 1905). Oil on canvas, 21½ x 18½". Collection Mrs. Bertram D. Smith, New York

Séguin: *The Pleasures of Life.* 1890-91. Oil on canvas, 4 panels, each 60 x 22½″. Private collection, New York

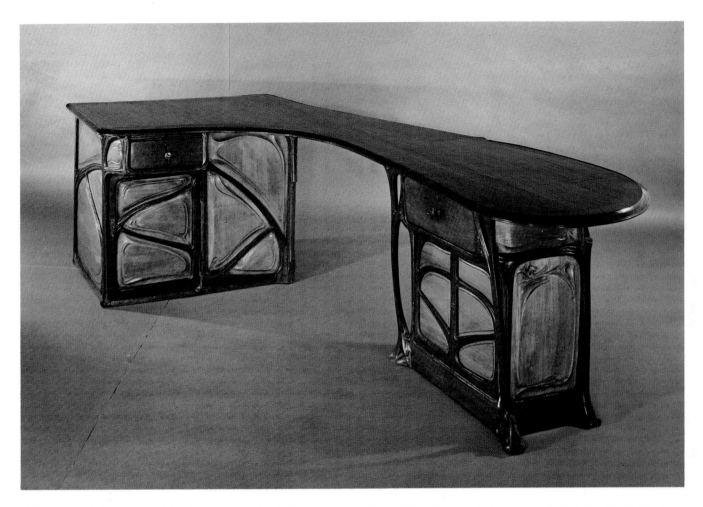

Guimard: Desk from the architect's own house (c. 1899; remodeled after 1909). Olive wood with ash panels, 29¾" x 8'4½". The Museum of Modern Art, New York. Gift of Mme Hector Guimard

Knox: Jewel box. c. 1900. Silver, decorated with mother-of-pearl, turquoise and enamel, 11¼ x 6 x 3¼". The Museum of Modern Art, New York. Gift of the family of Abby Aldrich Rockefeller

Van de Velde's silver candelabrum of c. 1902 (opposite) is almost a pure sculptural arabesque, with flowing, curving and upward-thrusting elements. Exploding outward from the stem are six individual candle holders which are an integral part of the design.

Bloemenwerf attracted wide attention, and van de Velde found himself in the center of an internationally spreading movement. Introduced by Julius Meier-Graefe to S. Bing, van de Velde was invited in 1895 to design four complete room settings for the newly opened shop. Bing was one of the men instrumental in spreading knowledge of the New Style to a Europe which was ready to absorb its message. For several years Bing's Paris shop in the rue de Provence (remodeled by the architect Bonnier) was the center of the new movement and, in fact, its activities became so completely symbolic that the shop's name, L'Art Nouveau, was finally given to the movement.

The rooms which van de Velde created for Bing had nothing of the sparse lightness of his Bloemenwerf designs. They were rich and sonorous in their ornamentation and of a unity which was completely new and extraordinary. Stained glass decorations which Bing commissioned from the *Nabis* artists (see page 55) became a part of the design. The rooms at Bing's galleries shocked the ultra-conventional upper bourgeoisie. De Goncourt's term, "Yachting Style" with which he described the rooms in his newspaper reviews was quoted to ridicule the Belgian imports. As a matter of fact, the term was well taken since the rooms had a striking resemblance to ship interiors, where as a result of a logical appraisal of functional requirements furniture had become an inseparable part of the wall.

FRANCE

Many French artists had been working in the new idiom before van de Velde arrived in Paris. Two distinct centers of the New Style were formed in France—one in Paris around Bing's L'Art Nouveau and the other in Nancy—

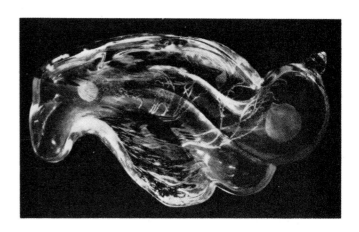

Gallé: Shell-shaped crystal bowl engraved with seaweed and shell designs. 1899. 11½″ diameter. Musée de l'Ecole de Nancy

with its glass industry dating back to the fifteenth century —where it developed around the work of Emile Gallé. In the eighteenth century under the reign of Stanislas Leczinski the center of Nancy had been transformed by rococo façades and gilded iron grill work into a beguiling maze of linear fantasies. This architectural setting became a stimulating background for the new movement. Gallé's studies included work in philosophy, literature, and botany; his training included the sketching of plants and practical experience in his father's workshop for ceramic and glass and in the Meisenthal glass factories in the Saar Valley. Returning from further studies in Germany and England, he opened his own workshop in Nancy in 1874.

Art Nouveau was one of the last great craft movements in which the skill of execution matched and enhanced artistic invention. Gallé had studied the technique of Chinese and Japanese glass snuff bottles during his visit to the Victoria and Albert Museum in London. He further developed and refined this technique, known as overlay glass. The top layer of colored glass was cut away in parts to become a raised decoration on the surface of the bottom layer. Gallé used many layers of glass to achieve various

color combinations. The cutting was done with small wheels, or layers were eaten away by acid. This simpler technique was largely used in his later production when his shops employed well over 300 workers. A third technique consisted of fusing onto the multi-colored layers small drops of glass, or bits of metal or mother-of-pearl, treated further by engraving and polishing to create immensely rich and variegated surfaces. Gallé's plant forms, insects, and floating seaweeds seem to have a life of their own, as if responding to a force outside the viewer's realm. Executed in delicate tones they are completely blended within the shapes to which they are applied (page 97). Unlike the abstract arabesques of van de Velde's designs, Gallé's pieces create a poetic mood. Often evocative words are engraved on the surface and float like tendrils attached to the organic images whose moods they parallel.

Less daring in concept than his glass, Gallé's furniture in general follows the French styles of the eighteenth century—it is always precious and fragile (right). But he reveals his originality by the way in which he uses the decorative quality of the background wood, combining raised, carved, and flat inlaid patterns of plants in freely asymmetrical arrangements.

Gallé's style was soon adopted by other Nancy glass factories. Daum Frères produced designs which in shape and decoration closely approximated those of Gallé but were often sentimental in feeling and coarser in execution. However, their painted vases with long drawn necks and sculpted asymmetrically-shaped bodies are surprisingly bold and original. They resemble in form and in their textured surfaces the natural rock from which they seem to be hewn.

Louis Majorelle, the other noteworthy furniture designer in Nancy, produced neo-rococo adaptations and began to work in the Gallé idiom about 1897. However, the shapes Majorelle employed were less traditional, and in the sculptured, smoothly flowing silhouettes of his furniture, braces and structural elements became shoots and branches (opposite). Metal details were purely ornamental, and in these

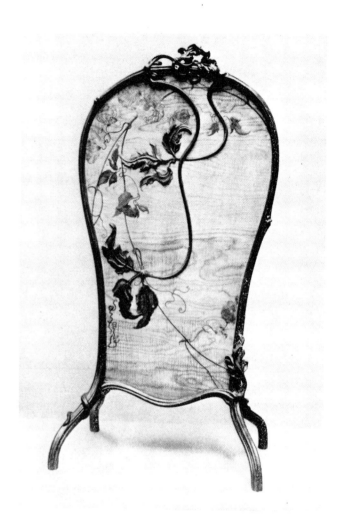

Gallé: Screen. 1900. Ashwood, carved and inlaid with various woods. 3′6″ high. Victoria and Albert Museum, London

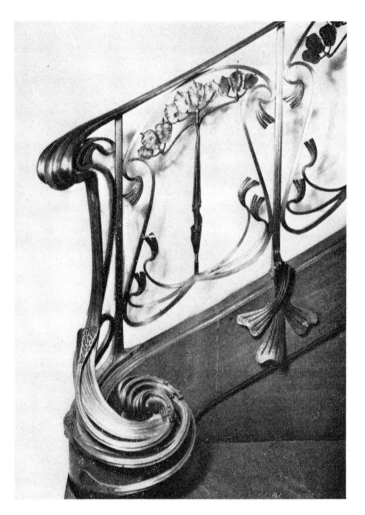

Majorelle: Banister. (c. 1900). Forged iron. Musée des Arts Décoratifs, Paris

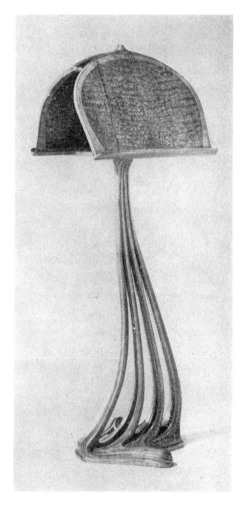

Charpentier: Revolving music stand. (c. 1900.) Carved hornbeam. 48″ high. Musée des Arts Décoratifs, Paris

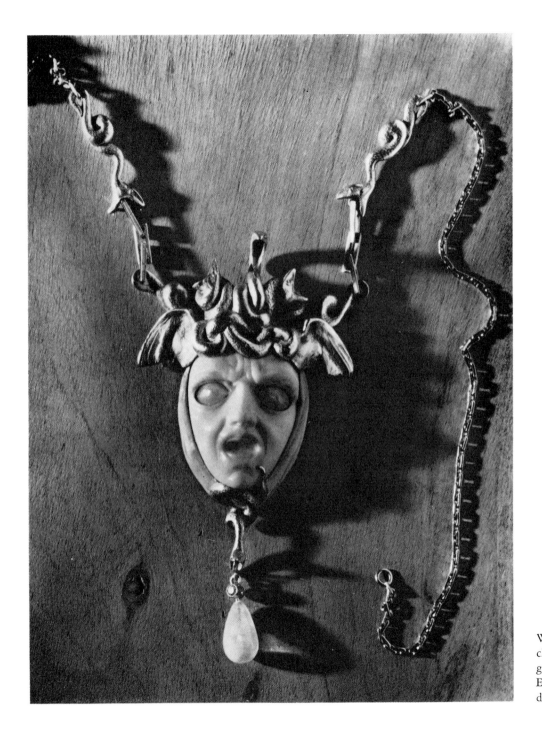

Wolfers: *Medusa.* Pendant on gold chain. 1898. Carved ivory, enameled gold and opal. c. 4″ high. Signed P.W. Ex. Unique. Collection L. Wittamer-de Camps, Brussels

he revealed his debt to Japanese stylization as well as to common local flora.

On the whole, French Art Nouveau had two major roots: the art of Japan and its own eighteenth-century form. While in other centers of the new movement the battle for the rejuvenation of the applied arts involved moral as well as esthetic re-examination, Paris was more concerned with a new expression of beauty in the applied arts rather than with their social values. Without ever relinquishing completely the formal elegance and sophistication of eighteenth-century design, the new form proved to be equally elegant and much more sensuous. The dynamic world of organic growth introduced by the theoretical writings of Grasset and others was used in a manner that stemmed from Japanese art: seemingly distributed at random, plant forms were controlled with care for fresh, poetic, and visually graceful effects. Traditional craftsmanship made it possible to embody the most evanescent images in any medium. Such extreme refinement also attracted those *fin-de-siècle* tendencies through which the period, not without justification, became known as "the mauve decade."

Designs of entire rooms and their accessories by de Feure, Gaillard, Colonna, Selmersheim, and Plumet were produced in Bing's workshops to be sold later in his gallery. In the same way that French Impressionists had created pure painting, French Art Nouveau artists had produced some of the purest examples of the style in the field of applied art. Sophisticated and sensuous, their work has a lyric quality unhampered by the edifying and occasionally overwrought content with which it was charged in other countries. Furniture and objects remained individual artistic statements and never merged completely into a unity.

Charpentier's music stand is a good example of this complete mastery of the New Style (page 99). The problem of providing slanting shelves for music scores at a fixed height was solved with powerful, furrowed strands, like the stalks of a plant, rising from a coil to hold aloft the double shelves.

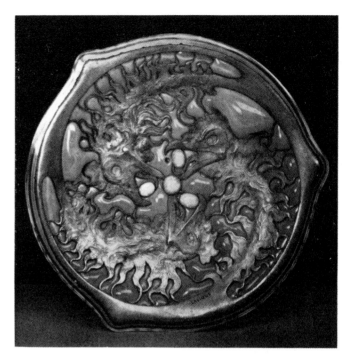

Lalique: Shallow bowl. 1900. Opal glass with silver mounting, opals. 9″ diameter. Österreichisches Museum für Angewandte Kunst, Vienna

Jewelry permitted another pure expression of the New Style. Purpose and scale allowed the most intricate and fanciful play of lines. Plant and insect motifs were used with the greatest freedom. Materials were chosen for their subtle colors and because they lent themselves to symbolic imagery. In many instances jewelry was also treated like miniature sculpture (opposite).

The most original jewelry designer was René Lalique. At the age of twenty-five he opened a workshop in Paris. Although he had exhibited anonymously at the 1889 World's Fair in Paris, his first real recognition came at the 1895 *Salon du Champ de Mars,* where since 1891 the ap-

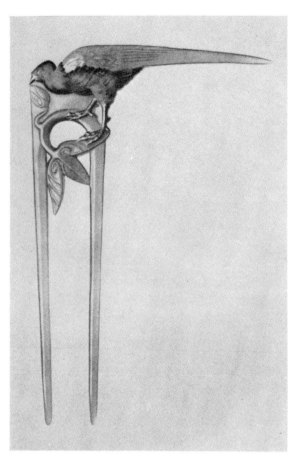

Lalique: Decorative comb. (c. 1900.) Carved horn, gold and enamel. 6⅛" long. Det Danske Kunstindustrimuseet, Copenhagen

plied arts had been shown side by side with painting and sculpture. From 1895 on, Lalique's exhibitions, like Tiffany's, were vital attractions in the international shows which were so characteristic at the turn of the century.

In response to the opening up of the new African diamond fields, jewelry design of the Second Empire had concentrated exclusively on the massing of brilliantly cut diamonds. Lalique re-introduced the beauty of semi-precious colored stones, particularly the shimmering opal. He used gold in many shades, enamels, both opaque and translucent, irregularly shaped pearls, as well as the modest horn which he handled with the same imagination as ivory (abundantly supplied by the African colonies). Combining these materials Lalique created designs whose emotional quality may be compared to Gallé's work. Unconventional freedom of expression is combined with formal arrangement of fantastic images and depends on complete mastery of a technique to make each piece an entity. This may be seen in one of Lalique's decorative combs (left), a favorite ornament of the period.

In contrast to Lalique's fanciful naturalism, van de Velde created jewelry based on abstract form. His pieces, three-dimensional translations of his flat ornament, are powerful plays of lines occasionally broadening into furrowed bands. They exercise an almost hypnotic attraction by the relentlessness with which they suggest motion (opposite). His work created a style of abstract linear jewelry which spread throughout Europe.

France's most important Art Nouveau architect was Hector Guimard whose powerfully expressive cast-iron orchid-like stalks for the Paris Metro stations were a part of the street scene in the late 1890s and today still form the entrances of several stations (page 136).

In an article in the June 1902 *Architectural Record* (a special issue acknowledging the New Style and introducing it to American readers), Guimard cited Horta and van de Velde next to himself as the co-founders of Art Nouveau.[4] This selection of artists is interesting considering the fact that all three employed as an essential structural element

the energetically flowing, tensely coiling line charged with power and force. Guimard, however, added exaggeration. Legs and braces of a casual side table, for example, no longer remain the simple plant forms carrying an Art Nouveau table top; they have become botanical specimens, a heightened expression of energy and tension (page 104).

Two pieces, designed for Guimard's own house in Paris, are especially noteworthy. The frame of a desk chair has completely shed traditional characteristics; branches thrust out from a center spine to form a bold curve for back and arm supports and continue downward to form the legs. The large top of the desk is an asymmetrically shaped plane of wood. The squarish left side narrows down into a center bridge, widening into an oval tongue at the extreme right. This early version of "free form" seems to be kept in endless rhythmic flow. The top rests on two free-standing pedestal cabinets which face each other at right angles. Their paneled walls in branch-like frames seem to be made of some ductile material pulled into a wave pattern which outlines the shape of the panel (page 104).

In the design of his upholstered furniture, Guimard also openly acknowledges inspiration from French eighteenth-century tradition. Uniquely his own, however, is the kind and degree of transformation: the voluptuously sculptured upholstery and the flowing quality of his wood frames and decorations. Guimard's furniture is eminently functional, "a complement of logic and harmony which leads by emotion to the highest expression of art."[5]

By 1900 the New Style had reached its zenith and dominated the enormous *Exposition Universelle* in Paris. Many countries were represented with national exhibitions clearly showing their variegated involvement with the new form language. It was obvious that the New Style had become generally accepted and indeed reached a popularity which made mass production profitable. Holding out for the principles of craftsmanship, S. Bing had built a small pavilion which was pure decoration rather than an architectural expression, a jewel case in which he exhibited the elegant, luxurious products of the artists around him.

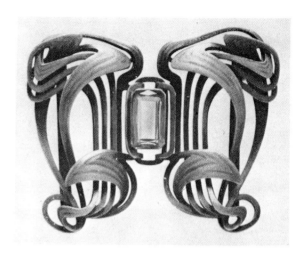

Van de Velde: Belt buckle. (c. 1898). Silver, amethyst. Die Neue Sammlung, Staatliches Museum für Angewandte Kunst, Munich

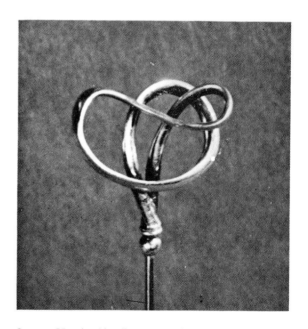

Stamp: Hatpin (detail). 1908. Silver. Made by Charles Horner, Ltd., Halifax. The Museum of Modern Art, New York. Gift of Helen Franc, in memory of Greta Daniel

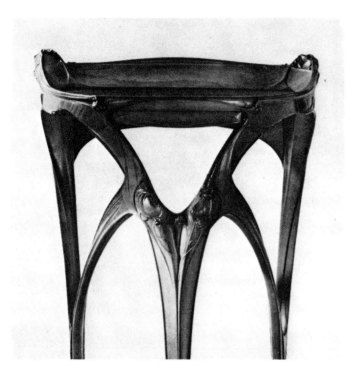

Guimard: Detail of side table from the artist's house in Paris. (c. 1908.) Carved pearwood. 43½" high. The Museum of Modern Art, New York. Gift of Mme Hector Guimard

Below, Guimard: Desk from the architect's own house. (c. 1899; remodeled after 1909.) Olive wood with ash panels. 29¾" x 8'4½". The Museum of Modern Art, New York. Gift of Mme Hector Guimard

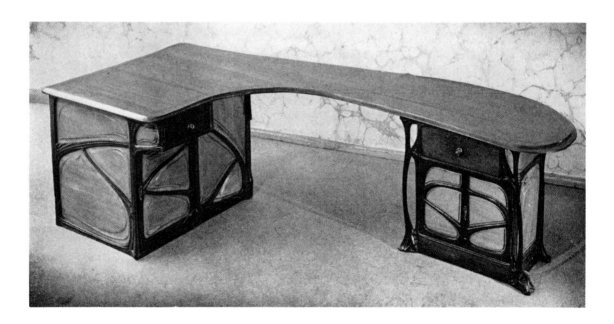

AMERICA

At the turn of the century Europe had already seen the most important American expression of the New Style. Bing had shown Tiffany glass in his Paris shop as early as 1895, and Tiffany was also prominently represented in the 1900 exposition.

In the United States, heads of industry, banking, and trade still commissioned the design and furnishings of their town houses and country estates in neo-Gothic, neo-Renaissance, and neo-rococo styles. In office buildings, department stores, and warehouses for which the new materials (steel and reinforced concrete) were used, a new architecture was coming into being.

Louis H. Sullivan, an exponent of this new architecture, used ornament importantly, placing it on his buildings in carefully selected areas. His horizontal bands of ornament, placed between the vertical elements of structure, were composed of scrolls, leaves, flower clusters, all symmetrically arranged within a defined space. But in spite of this symmetry, they were strangely alive in detail; they possessed a kind of organic flow and flourish which enlivened their deceptively traditional appearance (page 122). Sullivan arrived, in the 1880s, at a type of decoration which prophetically heralded European trends of a decade later.

Closer to the European trends, yet wholly original, is the work of Louis Comfort Tiffany. Beginning his career as a student of George Inness, Tiffany studied further in Paris and traveled in the Near East. A close association with the crafts (his father's firm, Tiffany & Company, produced and sold silverware and decorative objects) and fascination with the inherent beauty of materials led him to abandon painting for the decorative arts. In the 1876 Centennial Exhibition in Philadelphia, Tiffany saw decorative objects from many countries and found himself at this early date attracted by English and Japanese design. Tiffany's art, like Gallé's, originated with technique. He studied the chemistry of glass and worked with his friend, the painter

John La Farge, in the Heidt glass factories in Brooklyn. His early experiments with glass date from 1873; his first actual products were decorative windows, subtly opalescent in color. Eventually one branch of his expanding firm was devoted exclusively to the manufacture of memorial, religious, and decorative windows. The quality of his glass was considered superior to that produced in Europe. Windows executed in the Tiffany shops from designs by Toulouse-Lautrec, Bonnard, Vuillard, and other French painters were commissioned by Bing and shown in the Paris Salon in 1895.

Beyond the effect of opalescence he tried to achieve those glowing colors that erosion and exposure to mineral salts had caused on the surface of glass buried in the ground for centuries. In his shops and under his direction a complicated process of simultaneously blowing the glass and

Lemmen: Advertisement for Bing's L'Art Nouveau. 1898. From *Dekorative Kunst*

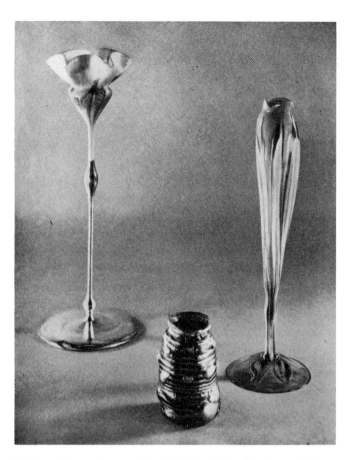

Tiffany: Group of vases. (c. 1900.) *Left:* Favrile glass and silver-plated bronze. *Center and right:* Favrile glass. The Museum of Modern Art, New York

exposing it to chemicals and fumes from molten metals resulted in brilliant hues and a ravishing iridescence.

Unlike Gallé, who cut decorations from various layers of colored glass superimposed on each other, Tiffany's technique was to control the way in which the layers of color were made to flow either transparently or opaquely over each other, bringing about an abstract play of line and color (left). He would often go back to traditional oriental and European prototypes for the shapes of bowls and vases, but most forms he used were uniquely his own and as extraordinarily inventive and unconventional as the iridescent colors with which they were decorated. Graceful images of exotic flowers on attenuated stems, twisted fruit forms or lumps of oddly shaped glass with casual openings created a dream world in which proportion and detail had been strangely transformed. In Tiffany glass the exotic and the irregular became the norm. When Tiffany combined metal with glass, he produced objects in which structure and decoration were eloquently integrated (opposite). Tiffany's work affects the viewer's sensibilities through an evocative sophistication. His colors and forms suggest the quality of a mood as summer is suggested by the pearly iridescence on the wings of a butterfly. The idiom of the New Style was reflected in the products of many workshops like those of Rookwood in Cincinnati and Grueby in Boston, but Tiffany remains the American master of the style.

HOLLAND

The work of the Dutch artists who formed the nucleus of the New Style in The Hague and Amsterdam was expressed mainly in painting and graphic design. It was different in character from other expressions on the Continent and so were its sources.

The nineteenth century was shaped not only by scientific discoveries and industrialization, but also by the enormous wealth which poured into Europe from colonial possessions. This wealth included rare African and eastern woods,

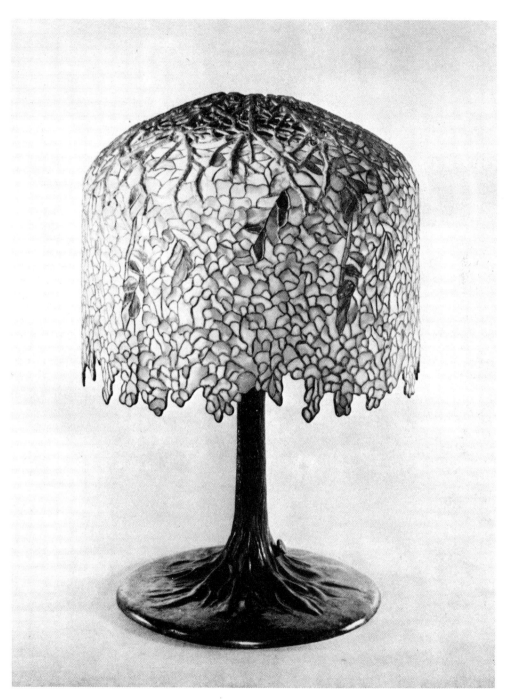

Tiffany: Table lamp. 1892-93. Favrile glass and bronze. 27″ high. Lillian Nassau, New York

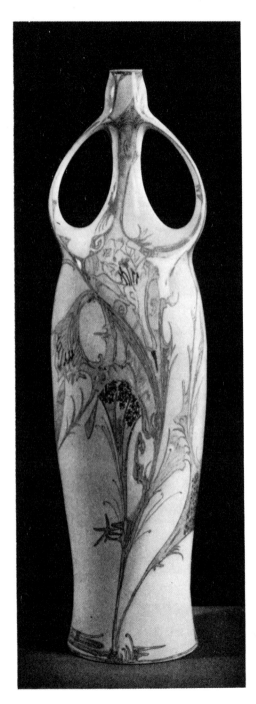

Colenbrander: Plate. 1886. Glazed pottery, abstract plant design. 10⅞″ diameter. Made by Rozenburg, The Hague. Gemeentemuseum, The Hague

Kok (form) and Shelling (decoration): Bottle-vase. Made by Rozenburg, The Hague. Österreichisches Museum für Angewandte Kunst, Vienna

opals from India, and ivory from the Congo. The influx of foreign cultures was equally evident, and soon the museums of archeology and anthropology at home became storehouses for artifacts from the colonies.

The old Dutch colonies, particularly Java, provided for Dutch artists a new idiom in the ancient technique of batik printing on textiles. This technique produced flat patterns with wavy outlines of markedly abstract quality streaked over with an erratic network of thin veins formed by the folding lines where the fabric had been sectioned off for the dyeing process. These batik designs corresponded to the concepts of the New Style and inspired fresh variations. Workshops and group enterprises styled after the English craft guilds of the post-Morris period sprang up in various Dutch centers. Among them were a number of pottery firms whose decorated wares became one of Holland's most characteristic contributions. Best known of these companies was Rozenburg in The Hague which was in operation from 1894 until 1916 and had its first foreign showing in the Paris 1900 Exhibition. T. A. C. Colenbrander, the company's most important designer, was the first to realize that the batik style could also be applied to the decoration of objects. His pottery consists of heavy forms and strongly colored exotic decoration on white glaze (opposite). His ornament combines solid abstract shapes with trailing and tapering strands which merge with each other in complicated patterns. These forms range freely over the white surface causing the white to appear as form rather than background.

Another derivation is represented by a type of bottle-vase which J. Juriaen Kok designed for Rozenburg. It is made of extremely thin and glassy ceramic which had to be blown rather than poured into the mold and is characteristic of an entire group of pottery (opposite). These designs depart from traditional Far Eastern forms by the addition of flat handles which seem to be pulled away from the main body in a convex curve. They flow back into the central form and the empty space between body and handle becomes part of the sculptured shape. The decoration by

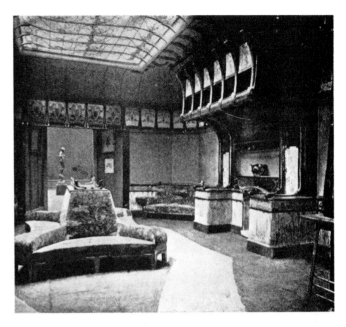

Van de Velde: Lounge. Decorative Arts Exhibition, Dresden. 1897. Executed by S. Bing, Paris

J. Shelling further stresses the fluidity of the total form. Strands of plant forms glide up from the bottom and are like feathery trails of smoke.

GERMANY

In 1897 Bing exhibited at the Decorative Arts Exhibition in Dresden the four rooms which van de Velde had originally designed for his Paris Art Nouveau shop. There they received the enthusiastic response they had missed at their first showing in the more tradition-bound Paris. For the Dresden exhibition a central lounge was added which embodied many of the basic ideas of the New Style as van de Velde had conceived them (above). Around the walls ran a stenciled frieze divided into identical rectangles. Above

Eckmann: *Five Swans.* 1896-97. Wall-hanging. 7' 10" x 30". Webschule, Skaer-baek, Denmark. Det Danske Kunstindus-trimuseet, Copenhagen

the doors the rectangles were filled with colored glass panels separated from each other by protruding ribs which curved into the ceiling. The main motif of the room was a fireplace boldly projected from the wall. All furnishings were subject to the general scheme; the curves of the sofas corresponded to those of the ribbed frieze, the undulating pattern of their upholstery to the abstract ornament of the stenciled pattern. The curving walls led to a decorated skylight which shed an even light over the entire room. There had already been many signs of the new movement in Germany, but van de Velde's lounge was the first example seen in that country of a room conceived as a unified whole. It was not until 1899 that the earlier mentioned music room by Riemerschmid achieved an even greater harmony, in which controlled daylight was an important part (page 86).

While the Dresden exhibition made the German public fully conscious of the New Style, it was Munich which was the center of the new movement in Germany. There at about 1895—two years before van de Velde's introduction to Dresden—a group of young artists had been working to achieve similar results. The nucleus of this group was formed by Otto Eckmann, Hermann Obrist, August Endell, Richard Riemerschmid, Bruno Paul, Bernhard Pankok, and Peter Behrens. Many of them had been painters who, escaping from the decline of easel painting in Germany, had turned toward the applied arts, thus repeating a phenomenon of the period we have already observed in other countries.

To mark the turning point in his career, Otto Eckmann had auctioned off his paintings in 1894. He became one of Germany's foremost graphic artists of the New Style (see page 43), but during his short lifetime he was equally prolific as a designer of textiles, wallpapers, metal work, rugs, and furniture. His ornamental style, based on natural forms, differs radically from that of van de Velde or Horta but is also impressive and original. Often identified as the purest example of Jugendstil,[6] Eckmann's narrow vertical wall-hanging (woven in 1897 in the north German tapestry

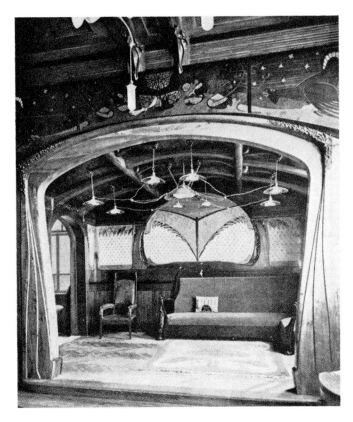

Pankok: Smoking room, International Exposition, Paris 1900. Executed by the Vereinigte Werkstätten für Kunst und Handwerk, Munich

signers, especially through the example of his rooms at the 1897 Dresden exhibition. Above all, the desire these German artists felt to participate in all aspects of life could be expressed through interrelated design. To conceive a room, the space it encloses, and all the furniture and objects belonging to it—the most modest part being as important as the whole—gave a new meaning to their vocation as artists. The 1897 Dresden exhibition was followed by one in 1899 where, in addition to the already discussed Riemerschmid music room (page 86), there were important rooms by Pankok and Bruno Paul. These examples of interrelated design took their place alongside similar accomplishments by van de Velde and the Glasgow group.

The large smoking room which Pankok created for the Paris 1900 Exposition, and which was later shown in the Decorative Arts Exposition in Turin in 1902, was heavily sculptural (left). Its paneled walls with carved decorations of plant motifs were tightly bound into the composition of the room, as was the ribbed ceiling. Light fixtures, suspended by chains and wires from carved ribs, added to the effect of fantasy.

An armchair by Pankok illustrates his preference for sculptural, undulating shapes with all elements flowing into one another (page 112). The sides are laced through and in part formed by carved plants. The front legs flow into the arms, on whose surface is carved ornamentation. The back has two large tear-shaped openings whose pointed ends slant toward the center. This is another example of that characteristic Art Nouveau shape, suggesting growth and organic life, so often used by the Glasgow group (page 91).

August Endell, best known for the bold, completely free decoration of the façade of the Atelier Elvira (1897) (page 138), designed furniture which is basically simple in shape but made fantastic through heavily sculptured elements (page 112). An example is an armchair in which these elements are ostensibly used to mark the joints. But each detail is symbolic: the joints become claws and knees. This disquieting aspect of an otherwise rational design is

workshops of Scherrebek) uses a serpentine form as the central motif (opposite). Whereas in van de Velde's appliqué tapestry the winding road becomes a bold abstract form, here the image is more literally conceived. The poetic mood in Eckmann's silent forest interior with its color harmonies of autumn yellows and browns comes close to the sentimentality which is a recurring element in German art of this period.

Even before van de Velde had moved permanently to Germany in 1900, his convictions about the relationship of art to daily life had considerable influence on German de-

 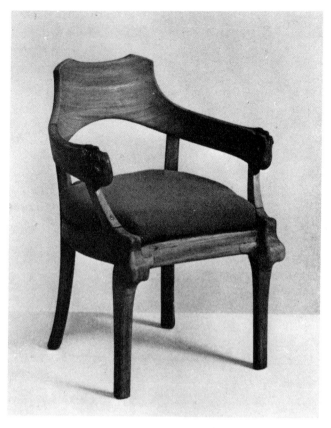

Pankok: Armchair. 1899. Mahogany, woven tapestry seat. Made by the Vereinigte Werkstätten für Kunst und Handwerk, Munich

Endell: Armchair. 1899. Carved elmwood, wool upholstery. 33½″ high. Collection Dr. Siegfried Wichmann, Starnberg

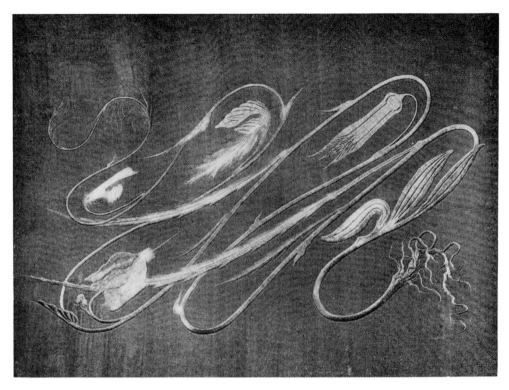

Obrist: *Whiplash.* 1895. Wall hanging, silk embroidery on wool. 46⅞ x 72¼" Münchner Stadt-museum, Munich

Endell: Decorative metal mounting on a bookcase. 1898

Von Debschitz: Inkstand. 1906. Bronze. 2″ high.
Landesgewerbemuseum, Stuttgart

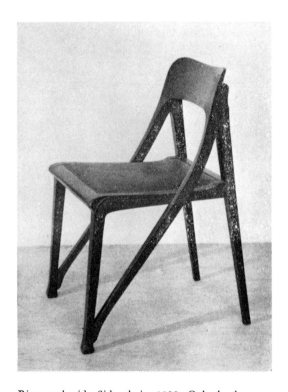

Riemerschmid: Side chair. 1899. Oak, leather upholstery. 30¾″ high. The Museum of Modern Art, New York. Gift of Liberty & Co., Ltd., London

characteristic of Endell's proto-surrealist work.

The same resemblance to the rhythmically moving marine world that characterizes his Elvira "dragon" pervades his extraordinarily animated furniture mountings, which often made the furniture itself become merely a background (page 113). Here the inventiveness of the artist was matched by the craftsman's skill in executing designs that seem two-dimensional but are in fact alive with intricately sculptured detail.

Closer to naturalistic forms are the energy-laden embroidered plant fantasies which the Swiss Hermann Obrist developed as early as 1892. Originally trained as a sculptor, Obrist had turned to embroidery as a means of expression before returning to sculpture in his later years. In 1894 he moved his embroidery workshops from Florence to Munich where his unusual work soon drew the attention of the younger generation of artists. His large wall-hanging (page 113) depicting a winding cyclamen plant (called "The Whiplash" by a critic) is an impressive example of naturalistic detail used to form an abstract composition. Like the springy curves of van de Velde's abstract line patterns Obrist's "Whiplash" is tense with an energy not to be found in the plant on which the design is based.

In 1902 in Munich, Obrist, together with the sculptor Wilhelm von Debschitz, opened workshops devoted to training and experimentation in the fine and applied arts. While this school based much of its design on a dynamic stylization of nature, it could also include such abstract work as a bronze inkwell by von Debschitz, which is less a decorative object than a sculpture in the round (left).

The Seventh International Art Exhibition of 1897, following the Paris example, devoted two small rooms in the Munich Glaspalast to the applied arts. Richard Riemerschmid was one of the thirty artists represented. Originally a painter he too turned to designing furniture, metal, glass, textiles, wallpapers, and typography. His lettering for the German Reichsbahn is still in use today.

In the spirit of the English arts and crafts reform movement, workshops were formed in Munich and later in other

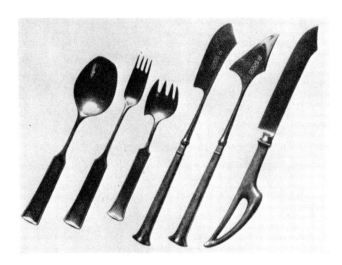

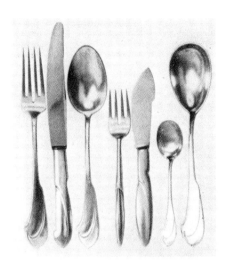

Riemerschmid: Table flatware. 1900. Silver. Landesgewerbe-museum, Stuttgart

Van de Velde: Table flatware. 1902-03. Silver. Made by Theodor Müller, Weimar. Karl-Ernst-Osthaus-Museum, Hagen

parts of Germany where artists, craftsmen, and manufacturers joined in the production of everyday goods. Riemerschmid, who was one of the founders and a most active contributor to two of these organizations, possessed artistic sensitivity but also a sober mind. To him design was a mission. The period's tendencies toward functional design and honesty of materials led him to the study of peasant furniture. The unself-conscious "rightness" and functional logic inherent in these designs became the basis for his own work. Riemerschmid's solutions are straightforward and sometimes original, as for example the small side chair—designed in 1899 for the Dresden exhibition and subsequently used in room settings in the Paris 1900 Exhibition (opposite). The chair has a deep but traditional seat and a highly unconventional broadly curving back which the rear legs slant upward to support. The front legs turn and frame the entire seat. The back flows down to become the bracing which acts like a vise and holds the structure together. The emphasis on clarity of structure in this design

was exceptional for the period. In this respect it may be compared with such later solutions as the cantilevered tubular steel chair of the 1920s and the molded plywood chair of the 1940s.

Riemerschmid's 1900 silver flatware, with its rounded knife handles and flat, bevel-edged spoon and fork handles, seems plain when compared to the set designed by van de Velde in 1902-03 (above). In the latter design, low relief abstract ornamentation is modified to the size and shape of the individual piece. The van de Velde flatware appears to offer traditional solutions while the Riemerschmid design is surprisingly functional as well as decorative. It anticipated the contemporary analysis of use. Riemerschmid's dinner fork with short tines and bowl, the cake fork with a cutting edge, the squared-off spoon, the halberd-shaped cheese knife, and the grip-handled dinner knives correspond to contemporary concepts.

With the spread of the movement throughout Germany the Munich group gradually dispersed; teaching assign-

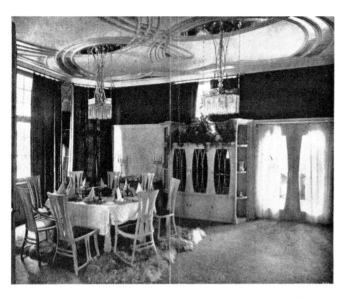

Behrens: Dining room in the house of the artist, Darmstadt. 1901

designed the building for the Vienna Secession.

The Mathildenhöhe group showed publicly for the first time at the Paris 1900 Exhibition, for which Olbrich had designed a reception room with furnishings by the other artists. Their formal presentation, however, occurred in 1901 when the Mathildenhöhe colony was officially opened with an exhibition called "A Document of German Art." Instead of still another international exposition in specially designed temporary buildings, it was the colony's permanent villas at the outskirts of the town which stood review. Olbrich, the only professional architect in the group, was responsible for the architecture of all the buildings with one exception, while the other members had shared in the design of the interiors. Only Peter Behrens had both designed and furnished his own house. The work of Behrens and Olbrich differs significantly from the curving, richly floral style characteristic of Jugendstil.

Peter Behrens' house—the work of an untrained architect—shows him in marked contrast to the elegant and imaginative Olbrich. Behrens, like the others, was a painter, a designer of furniture, metal, glass, graphics, and typography (frontispiece, pages 18, 36, 44). He still used flowing lines in the design of his interiors, but these were contained in areas sharply defined as rectangles, squares, and circles, and they no longer moved onto adjacent areas. There is unity in the design of his dining room (left), but it is a unity of a modular nature. The straight-sided wall cabinets were painted white, as were the doors and chairs. Made of flat rectangular boards, these chairs assumed a strangely affected stiff grace which pointed back to van de Velde's 1895 Uccle chairs (page 94).

This other pole of the New Style—designing with precise geometric elements in rhythmic patterns—had already proved its attraction to the Glasgow group as it did to the artists of the Vienna Secession where Mackintosh exhibited with acclaim in 1900. Behrens's rich and somewhat ponderous style, although similarly geometric, seems to have developed simultaneously and to have led him toward the restraint and clarity of the modern movement.

ments called many of the artists to other cities. Berlin, where van de Velde worked from 1898 to 1900, became an important center. In the important industrial towns of Hamburg and Krefeld, museum directors encouraged the dissemination of the New Style through exhibitions and lectures. In 1901 van de Velde was invited by the Grand Duke of Saxe-Weimar to head the Weimar School for Arts and Crafts, the immediate predecessor of the Bauhaus which opened under the direction of Walter Gropius in 1919 in the building which van de Velde designed.

A special place in the history of the movement was occupied by the city of Darmstadt (page 91). In 1899 the young Grand Duke Ernst Ludwig of Hesse called together seven young artists to work and live as a group. Among those invited to the artists' colony at Mathildenhöhe were Peter Behrens who came from Munich and Joseph Maria Olbrich who came from Vienna where in 1898 he had

AUSTRIA

The modern movement in Austria was almost entirely concentrated in Vienna. As early as 1897 Arthur von Scala, Director of the Austrian Museum for Art and Industry, exhibited copies of recent English furniture made by local craftsmen under his direction, in an effort to break with tradition and inspire enthusiasm for the new style. In reviewing these exhibitions Adolf Loos wrote his scathing exhortations comparing the technically perfect and functionally sound examples of English and American design to the ornamental fantasies of his Viennese contemporaries, with whom nevertheless he shared the same principal ideas about the regeneration of life through the arts.[7]

The architect Otto Wagner, in his publication *Moderne Architektur* (1895), had expounded on the interrelationship between modern life and architecture and his students, among them Josef Hoffmann, Joseph Maria Olbrich, Alfred Roller, and Koloman Moser, responded with enthusiasm to his theories and work. They were among the founders of the Vienna Secession, which in 1897 united the avant-garde artists into a central organization and exhibited local and international art in carefully designed installations reflecting the Viennese taste.

The elegance characteristic of this Viennese corollary of the New Style appears not only in Olbrich's architecture but also in his decorative objects. His pewter candelabrum has a tapering silhouette embellished only by abstract line decoration (page 118). This is a revealing example of the way in which Olbrich arrived at a fresh formal solution of a design problem that van de Velde was to solve perhaps more brilliantly (page 96) but also more traditionally. Gertraud von Schnellenbühel offered a solution (page 119) which was a peculiarly Germanic exaggeration of the New Style's fantasy.

The Vienna Secession, with its headquarters in Olbrich's cube-shaped building, and its publication, *Ver Sacrum,* distinctive for its square format as well as its advanced use of graphics, became an international center of new directions

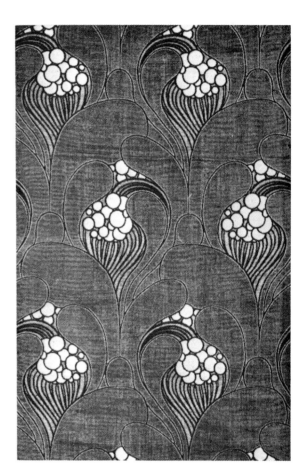

Moser: Woven silk and wool fabric. 1899. Made by Backhausen & Söhne, Vienna. Österreichisches Museum für Angewandte Kunst, Vienna

117

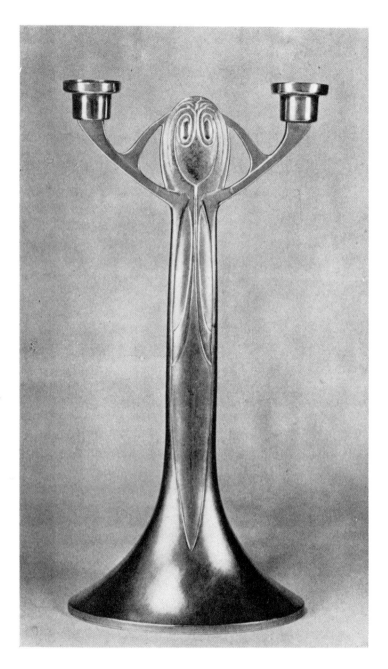

Olbrich: Two-armed Candelabrum. 1901. Pewter. 14¼″ high. The
Museum of Modern Art, New York. Philip Johnson Fund

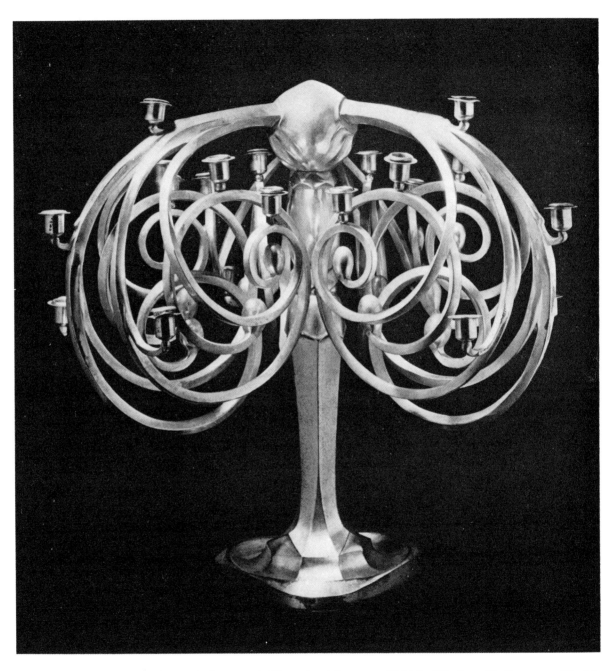

Von Schnellenbühel: Candelabrum. (After 1911.) Silver-plated brass. c. 19″ high. Münchner Stadtmuseum. Munich

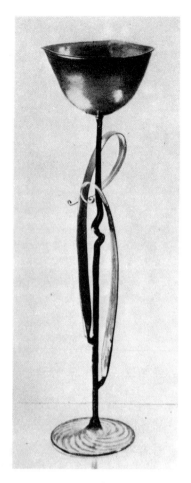

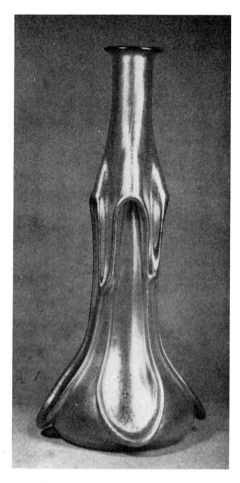

Moser: Liqueur glass. (c. 1900.) Clear glass bowl, red stem and base. 6¼" high. Österreichisches Museum für Angewandte Kunst, Vienna. Gift of R. Steindl

Köpping: Decorative flower glass. 1895-96. Tinted blown glass. c. 12" high. Det Danske Kunstindustrimuseet, Copenhagen

Lötz Witwe: Bottle-vase. (c. 1902.) Gold iridescent glass. 14⅛" high. Österreichisches Museum für Angewandte Kunst, Vienna

in art and design. Koloman Moser, a talented designer of posters and decorative objects, was Austria's closest parallel to the French and Belgian exponents of curvilinear form, as is evident in his suave textile design (page 117). Another Moser design, a liqueur glass, is stripped of ornament but made decorative by the shallowness of its clear bowl perched on an attenuated stem rising from a flat, burgundy-red base (opposite). This amusing form may be compared to a similarly undecorated but delicately tinted decorative glass by the Berlin graphic artist Karl Köpping (opposite). With its unexpectedly twisted stem erratically sprouting leaves, Köpping's too-fragile glass shows a personal inventiveness characteristic of the New Style. At the turn of the century the European glass industry tried to emulate the shapes and colors of Tiffany glass. Only the factory of Lötz Witwe in Klostermühle, Bohemia, arrived at interesting solutions (opposite) which, however, did not quite measure up to Tiffany's free-flowing fantasies.

Although his early work included beautiful examples in the curvilinear vein, Josef Hoffmann's work is on the whole geometric. His interior spaces are rectangular; there is no evidence of the characteristic Art Nouveau device by which the wall glides into the ceiling or curves into another wall by omitting right-angled intersections (page 143). Hoffmann's furniture also is angular in design; the fronts of sideboards or vitrines are articulated by flat rectangular planes and decorated with rows of identically framed glass squares. His wall decoration consists of small geometric forms placed in rows on otherwise white walls. His fabrics are usually striped, and the decoration of his famous jewelry and silver is often a grid of rectangles framing characteristically heart-shaped leaf patterns (below).

The rich ornamentation of so much of Art Nouveau depended on a continuous flow of invention, with each object being treated as a unique event. The simpler relationships of flat surfaces, such as Hoffmann favored, pointed the way to the next generation's esthetic of unembellished geometric form.

GRETA DANIEL

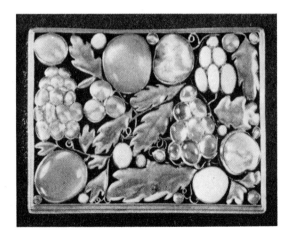

Hoffmann: Brooch. (c. 1908.) Gold, moonstones, opals, pearls. 1¾ x 2⅜". Made by Wiener Werkstätte, Vienna. Collection Mrs. F. Beer-Monti, New York

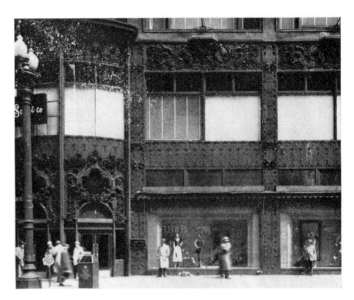

Sullivan: Carson Pirie Scott & Co., Chicago.
1903-04. Main entrance

Sullivan: Carson Pirie Scott & Co., Chicago.
1903-04. Detail

ART NOUVEAU ARCHITECTURE

For all the fragility of its fluttering forms the Rococo of the eighteenth century was a sturdy plant, surviving for half a century. In comparison, Art Nouveau, although initiatory of a major change in architectural style, had a very brief and uncertain life. The architects involved in this *fin de siècle* episode, which lasted only for some fifteen years (c. 1890-1905) or even less in most of the countries of western Europe, shared with other contemporary innovators little but a general desire to break with the past. Many of them, moreover, soon came to regard their early work as the wild oats of youth.

It is actually possible to recount the history of modern architecture over the last seventy or eighty years without paying much attention to Art Nouveau (and until a few years ago most writers did just that). The individual contributions of Voysey in England, of Berlage in Holland, of Wright in America, of Perret in France, of Behrens in Germany, and of Loos in Austria, beginning around 1890 and especially after 1900, certainly seem more relevant to the architecture that was to become widely accepted in the western world by the mid-thirties of this century. Even the rather similar architecture of Sullivan in America (opposite), almost contemporaneous in its major phase with Art Nouveau, and that of Gaudí in Spain (pages 124-125) whose peak of achievement came somewhat later, are parallels to, rather than integral parts of, the international Art Nouveau movement.

However, no matter how circumscribed the Art Nouveau episode in architecture is considered to be, there exist a certain number of buildings of real distinction which belong exclusively to that stylistic category. Yet a full generation passed before anyone could look again at the architectural productions of Art Nouveau with either pleasure or approval. Scholarly and popular interest increased notably since World War II, leading to a series of exhibitions in several countries and also to detailed historical studies.[1]

A precise definition of Art Nouveau is difficult to set down nevertheless, especially as it was known in its own day by a great variety of names in different countries and each of those names suggests a somewhat different aspect. Among the more descriptive designations, usually applied in derision, such as "Paling (eel) stijl" in Belgium and "Style nouille" in France, or "Schnörkelstil" and "Bandwurmstil" in Germany, only the Italian "Stile floreale" has retained any general currency, while the genetically more accurate terms, "Ligne belge," "Belgische stil," or "Stile inglese," have long been forgotten. Except in Belgium, which was certainly the locus of birth if not of conception of Art Nouveau architecture, the contemporary critics in each country seem, in naming what they early recognized as a novel and original artistic manifestation, to have emphasized the feeling that it was alien to their own national traditions by using terms such as "Art Nouveau" in English, "Modern Style" in French, and "Stile inglese" (or, more usually, "Stile Liberty") in Italian. The Spanish and Catalan term "Modernismo" however, has no such connotation. The situation is also rather different and also more complex as regards Germany and Austria. One cannot simply accept the local names "Jugendstil" and "Secessionstil" as alternative terms identical in meaning to Art Nouveau, nor even as national variants like the Italian "Stile floreale," rather they are independent though related entities.

Eels, noodles, and tapeworms do all serve to suggest, however, if in a humorous and pejorative way, the characteristically sinuous linearity of Art Nouveau. Eels and tapeworms, moreover, suggest also the biomorphic qualities of the semi-naturalistic, semi-abstract decorative elements that generally affected certain structural elements as well. The floral, if it is considered to refer to the total forms of plants including leaves, stalks, and roots and not merely to their

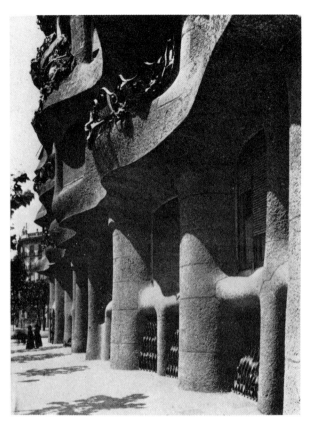

Gaudí: Casa Milá, Barcelona. 1905-07. Detail of façade

blooms, still better epitomizes conceptually (if not always visually) the sort of organic expression that was always aimed at and fairly often achieved.

In contrast to the static qualities of most traditional nineteenth-century architecture, Art Nouveau was, both in intent and in form, an art of growth. In writing about Art Nouveau one is torn between two approaches: to present this floral-eel-and-noodle style in its purest state as an architectural episode that was very brief and very confined; or to look forward to what happened a bit later. After 1900 many European architects who had been more or less deeply involved in Art Nouveau in their youth turned sharply away—both in their handling of large architectural forms and in their attitude toward decoration—from the linear to the planar, and from the sinuous to the geometric.

Wright's organic architecture of the "Prairie" years after 1900 is "organic" in a sense very different from Art Nouveau even though he still used rather rich curvilinear ornament derived from Sullivan as late as 1899 in his Husser house in Chicago. Behrens in his youth, before he became an architect, was a painter and a distinguished Art Nouveau designer of decorative and graphic art. Yet within a year or two after settling in Darmstadt in 1901 he went well beyond his Austrian rival, Olbrich, in rejecting organic curves in favor of plane-surfaced cubic forms in his buildings. In justice to the complicated and often ambiguous life stories of many of the protagonists it is wiser, therefore, to allow a fuller definition of Art Nouveau to develop from a description of a few characteristic monuments rather than to attempt to set down verbally anything of the sort at this point.

In evaluating the general importance of Art Nouveau its wide and long-continued survival in some countries down to World War I should not be ignored. Such periferal continuation balances to a considerable extent the serious failure of Art Nouveau to win convinced adherents among the architects of England and America, despite the notable contribution that the graphic and decorative work of at least one Englishman, Mackmurdo (pages 26, 27), made

in the 1880s and the closely related approach of the American, Tiffany, whose activity was also largely restricted to the fields of design and decoration (see pages 106, 107).

The small selection of Art Nouveau buildings discussed and illustrated in this essay are among those that may be considered to have equal rank, say, with the Casa Milá of Gaudí[2] of 1905-07 in Barcelona or even with Sullivan's Guaranty Building of 1894-95 in Buffalo.

With the exception of the department stores in Brussels and other European cities (pages 126-128), which are most readily measured against Sullivan's big buildings, the largest and the most prominent architectural monument of Art Nouveau was Horta's Maison du Peuple of 1897-99 in Brussels (page 131). Although not perfectly maintained, this long served its multiple purposes as the headquarters of the Belgian Socialist Party. It also made evident that Art Nouveau was not considered suitable only for millionaires' mansions, as Horta's houses for the head of a great chemical enterprise and for the entrepreneur of the Belgian interests in the Congo might seem to indicate. Its demolition in 1967 was inexcusable.

The ideals of Morris appealed strongly to most of the innovators of Art Nouveau, both as regards the inclusiveness of his principles and his emphasis on the social purpose of design. So also did the ideals of Viollet-le-Duc as regards the frank use of modern materials and the development of new forms of expression appropriate to those materials. But theory alone rarely *creates* an architecture; nor do the implications of theory have much to do with the quality of that architecture's visual aspects—at least as that quality is evaluated by later generations.

The multiple ingredients of Art Nouveau have been much analyzed of late years and most of them specifically identified, particularly by the Norwegian art historian Madsen.[3] Its essential novelty is attested, however, by the fact that no amount of analysis[4] can wholly explain how Art Nouveau came into being in architecture, five years before the Maison du Peuple was begun, when Horta designed his epoch-making Tassel house. An English Century

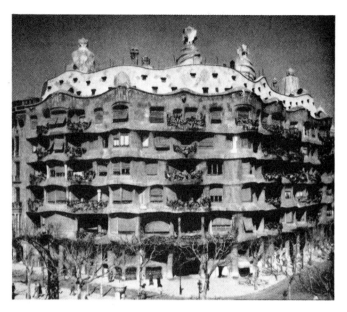

Gaudí: Casa Milá, Barcelona. 1905-07. General view

Guild wallpaper by Heywood Sumner, one of those shown in Antwerp that winter of 1892-93 and praised in two Belgian magazines[5] by van de Velde, was actually used by Horta in the Tassel dining room. This fact proves no more than that Horta was familiar with English proto-Art Nouveau design, although to the art historian it is suggestive of a major source of influence. But otherwise Horta, who had been trained by the Brussels Academy professor Balat, and for some years actually employed by him, seems to have owed his inspiration more to Viollet-le-Duc than to the English. The stair hall of the Tassel house follows Viollet-le-Duc in the emphasis given to the metal elements, which are at once structural and decoratively elaborated (page 129). But the character of the linear decoration in the stair rail, on the floor, and especially on the wall, is beyond the nineteenth-century medievalist's creative range. Here we must accept that something quite new began.

Close relationship to Viollet-le-Duc's ideas for a new

125

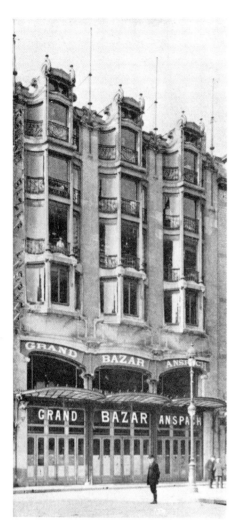

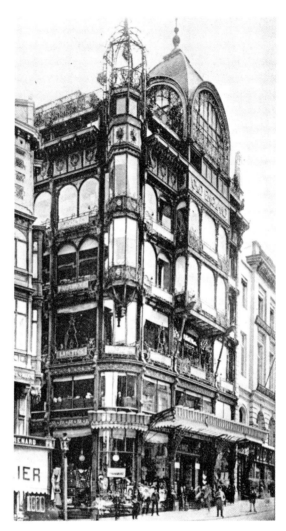

Horta: Grand Bazar Anspach, Brussels. 1895 (demolished)

Saintenoy: Old England Store, Brussels, 1899

126

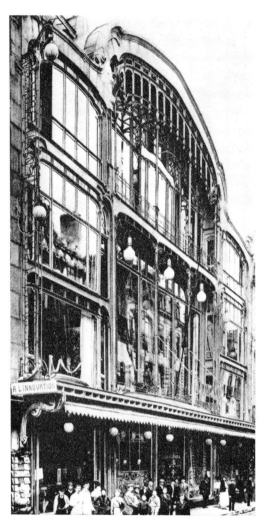

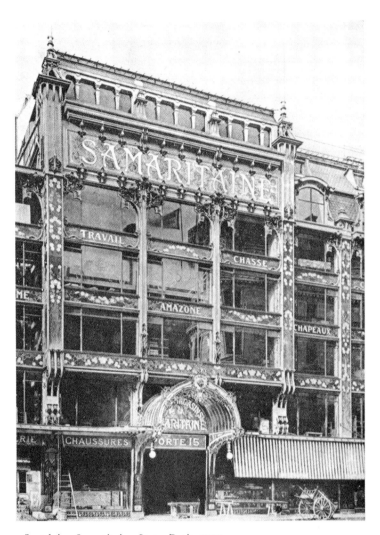

Horta: A l'Innovation, Brussels. 1901 (destroyed by fire, 1966)

Jourdain: Samaritaine Store, Paris. 1905

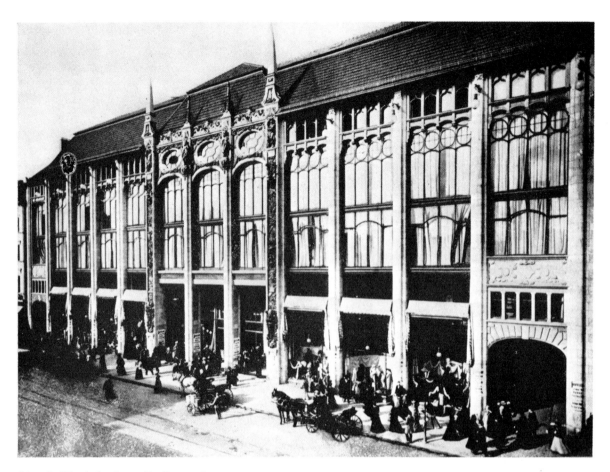

Messel: Wertheim Store, Berlin. 1896

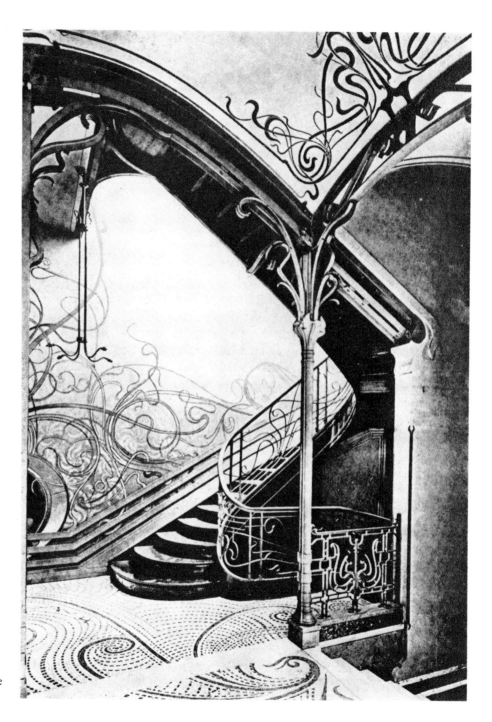

Horta: Tassel house, 6 rue Paul-Emile
Janson, Brussels. 1892-93. Stair hall

129

architecture—conceptual, fortunately, rather than visual—is still very evident in the frankness with which exposed metal construction was used both on the façade and in the auditorium of the Maison du Peuple. As is generally true of Art Nouveau buildings, the auditorium (opposite) inside was more successful than the exterior. There the slanting supports, carrying the side galleries at half their height, bent gracefully across the top in curves that were even more structurally expressive and boldly decorative than the metal elements in the Tassel stair-hall. Yet there was a clear distinction between the firm lines of these major architectural members and the lusher and more foliate patterns of the balcony railing. The actual enclosure of space was handled very simply with what was, in effect, the "curtain-wall," destined to become such an architectural commonplace sixty years later. Thus the emphasis, visually as well as structurally, was on the openwork metal principals, and solid elements played no part in the general composition.

Compared to the only other large building of this period which incorporates similar curves in the external periphery, Gaudí's Casa Milá (page 125), Horta's façade was far less arbitrary and also far more open (opposite). Even granted the unusual site, Viollet-le-Duc would hardly have known how to exploit the irregular sequence of curves provided by a section of the circular Place Van de Velde and two entrant streets in the positive way of Horta. Here Art Nouveau, generally considered to be linear and two-dimensional, became wholly plastic; not plastic in the decorative sense but at full architectural scale. If the whole façade was a continuous undulant curve in plan, few curves interrupted the matter-of-fact structural pattern of metal stanchions and girders or the narrow but solid stone-and-brick piers that marked the major subdivisions of the façade. The main entrance, it is true, had a clumsy arch of metal awkwardly rising out of plant-like carved stone imposts, and the longer horizontal metal members had a slightly rising bottom line; but elaborate Art Nouveau decoration was restricted to the railings and the entrance grill (see page 44).

Thus this major work of Horta lent some support to two negative contentions concerning Art Nouveau: one, that it is not an architectural "style," but only an interior mode;[6] and two, that it is only a form of applied decoration. Yet it also provided answers to these contentions. However justly they may be applied to much of the production of the period, there is no other way to define the architecture of such a large-scale work, outside as well as inside, except as Art Nouveau; and the same was *a fortiori* true of Horta's other large building in Brussels, the department store A l' Innovation of 1901 (page 127) in the rue Neuve. Here the structural elements of the metalwork, externally as well as internally, were even more considerably affected by a curvilinear esthetic.[6a]

It is nevertheless true that except for these two examples, the Art Nouveau of Horta is seen at its best not in whole buildings but in particular features, such as the early stair hall of the Tassel house (pages 92, 129), the salon of the Van Eetvelde house (page 132), or the balcony and the studio windows of his own house of 1898 in the rue Américaine (page 133). Moreover, when he ceased to use metal externally and drastically restrained his use of curvilinear detail, as in the Gros Waucquez Building of 1903-05 in the rue du Sable (page 133) or the Hallet house of 1906 in the avenue Louise, the inventor of Art Nouveau architecture himself seemed already to be leaving Art Nouveau behind.

Some architects of distinction outside Belgium were more loath than Horta to desert Art Nouveau. Gaudí may not be, strictly speaking, an Art Nouveau architect; yet certainly his most extreme use of curved forms dates from precisely these years well after the opening of the new century (page 124, 125). Guimard, the leading exponent of Art Nouveau architecture in France, continued faithful to it as late as 1911 in the apartment houses he built at 17-21 rue La Fontaine in Paris and occasionally even after that. These are, however, considerably chastened compared to his finest Art Nouveau work, the Métro entrances of 1900 and the interior of 1902 in the demolished Humbert

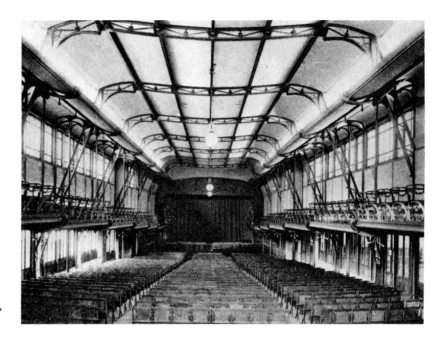

Horta: Maison du Peuple, Place Van de Velde, Brussels. 1897-99. Auditorium (demolished)

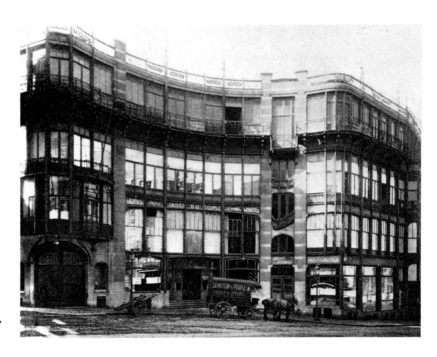

Horta: Maison du Peuple. Place Van de Velde, Brussels. 1897-99. Façade (demolished)

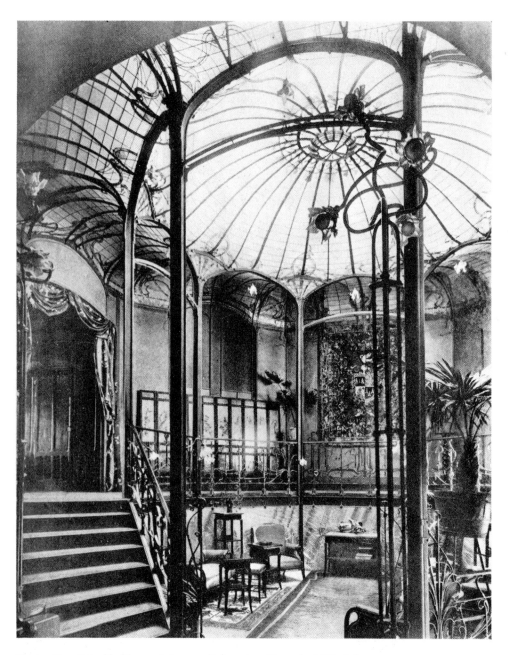

Horta: Van Eetvelde House, 4 Avenue Palmerston, Brussels. 1895. Salon

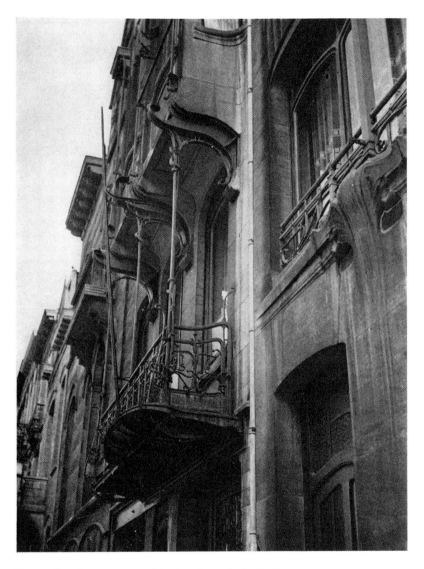

Horta: Own house, rue Américaine, Brussels. 1898. Balcony

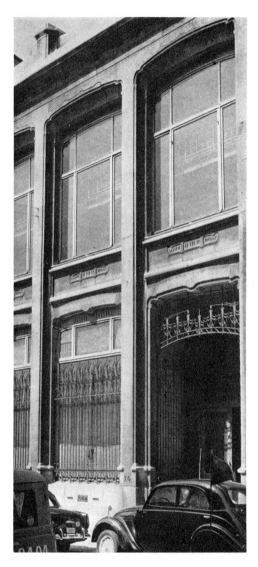

Horta: Gros Waucquez Building, rue du Sable, Brussels. 1903-05. Façade detail

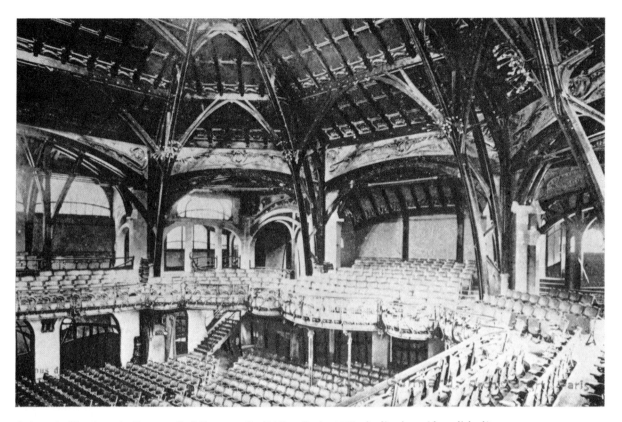

Guimard: Humbert de Romans Building, rue St. Didier, Paris. 1902. Auditorium (demolished)

de Romans Building in the rue St. Didier.

The latter rivaled Horta's auditorium in the Maison du Peuple. With its centralized plan and markedly curved supports, it was perhaps a more striking manifestation of Art Nouveau (opposite). The exterior, however, was clumsy and ambiguous, not unlike his earlier Castel Béranger at 16 rue La Fontaine completed in 1897, which shared with Bing's Maison de l'Art Nouveau the responsibility for introducing the Belgian "Modern Style" into France.

Although some of the finest of them have disappeared, and one at least has reached America to rise again in New York[7] (below), Guimard's claim to fame as an Art Nouveau architect has largely rested on his Métropolitain stations. These are certainly *not* primarily interiors, yet the larger of them, such as those which used to be at the Place de la Bastille and at the Place de l'Etoile (page 136), were definitely buildings. As in Horta's work, construction in metal and glass encouraged full exploitation of Art Nouveau ideals; while at this modest scale a close integration of structural and decorative forms was more feasible than in Horta's larger buildings.

Similar qualities are present, if less consistently developed, in two Paris department stores of the opening years of the century, Jourdain's Samaritaine on the rue de la Monnaie of 1905 (page 127) and Gutton's Grand Bazar de la rue de Rennes (now Magasins Réunis). The Samaritaine combines colored faience marquetry with the metalwork, thus employing a material especially popular in Paris, not only among vulgarizers of Art Nouveau such as Lavirotte and Schoellkopf, but even used on one notable occasion by Perret.[8] Moreover, the relative lushness and realism of the floral decoration on the Samaritaine links this Parisian work with that variant of the Art Nouveau known as "Stile floreale" in Italy. This flourished very widely in the first decades of the new century and achieved considerable autochthonous distinction at the hands of such architects as D'Aronco, Sommaruga, and Campanini.

The situation is rather different and also more complex as regards Germany and Austria, as has been said earlier. Some aspects of the Jugendstil and of the "Secessionstil" are certainly true manifestations of Art Nouveau, whether represented by the work of the Belgian Van de Velde or by the work of the Munich and Hamburg Schools. But what is as true of the missionary from Brussels and Paris as of native practitioners like Eckmann, Obrist, Pankok, and Riemerschmid is that the most characteristic production of all of them in the nineties was in the field of the decorative and graphic arts, not in architecture. Several of them were quite active as architects after the height of the Art Nouveau movement was over; Behrens and Olbrich became real leaders of advanced German architecture after the opening years of the twentieth century. Their buildings of those later years, although usually described as Jugendstil, bear

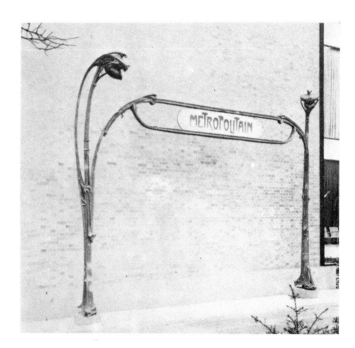

Guimard: Métropolitain entrance gate. c. 1900. Collection The Museum of Modern Art, New York

135

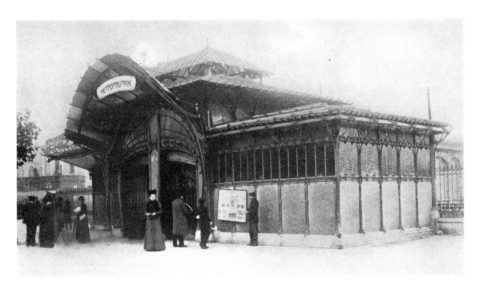

Guimard: Métropolitain Station, Place
de la Bastille, Paris. 1900

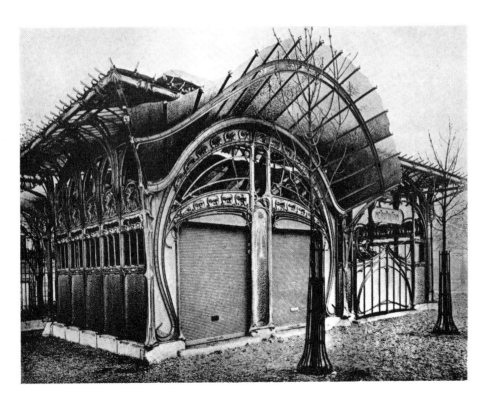

Guimard: Métropolitain Station, Place
de l'Étoile, Paris. 1900 (demolished)

little resemblance to the decorative work of the nineties that imitated and rivaled—and may even in some instances have preceded—the Art Nouveau production of Brussels and Paris. Such German designers have a place in the general story of Art Nouveau because of their early contribution, but as architects they belong rather to the next phase of the history of modern architecture.

Very much the same must be said of other Viennese beside Olbrich. Although Otto Wagner was a long-established academic architect by the nineties and even a professor at the Akademie, he was strongly though briefly influenced by Art Nouveau. Among his Stadtbahn stations in Vienna, that at the Karlsplatz (right) with its light metal frame, thin panels, curved outlines, and floral stencilings is especially comparable to Guimard's in Paris and even a year or two earlier in date. The bold floral ornament on the façade of his Majolika Haus of 1898 is also Art Nouveau; but the smooth flat plane that the shiny faience tiles produce (so different from the plasticity of the glazed terra cotta façades by French architects around 1900 with neo-Rococo and neo-Baroque leanings), not to speak of the rectilinearity of the ironwork, are premonitory of the later style of his major works of 1904-06, the Postal Savings Bank in Vienna and Sankt Leopold nearby in Hietzing.

The young men associated with the revolt of the Secession against the academy went much further than Wagner. The pages of their magazine *Ver Sacrum,* which first appeared in 1898, are full of evidence of the acceptance of Art Nouveau by such men as Olbrich, Hoffmann (right), and Moser, and even perhaps by Loos, but very little of it is architectural. Like their German contemporaries, most of these young men were still primarily designers and decorators, not yet architects. When they began to build, they left Art Nouveau behind—Loos completely in his Goldmann haberdashery shop as early as 1898, Olbrich more gradually just before and just after his move to Darmstadt in 1900, and Hoffmann and Moser a year or two later.

There is one German work of architecture of the nineties

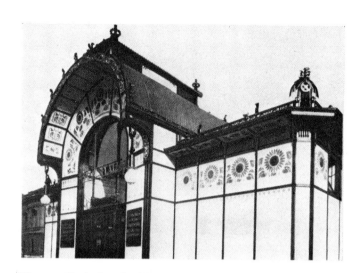

Wagner: Karlsplatz Stadtbahn Station. Vienna. c. 1897

Hoffmann: Project for an entrance. *Ver Sacrum,* July 1898

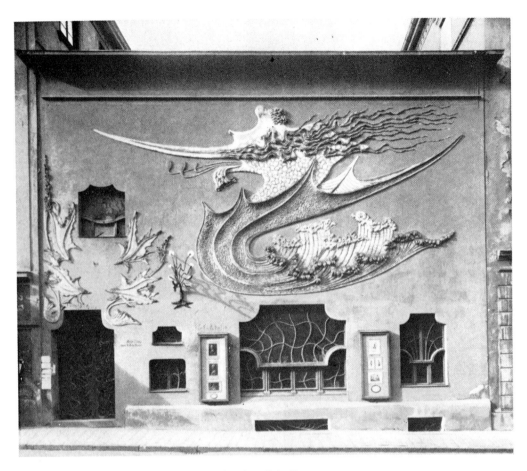

Endell: Atelier Elvira, Munich. 1897. Façade (demolished)

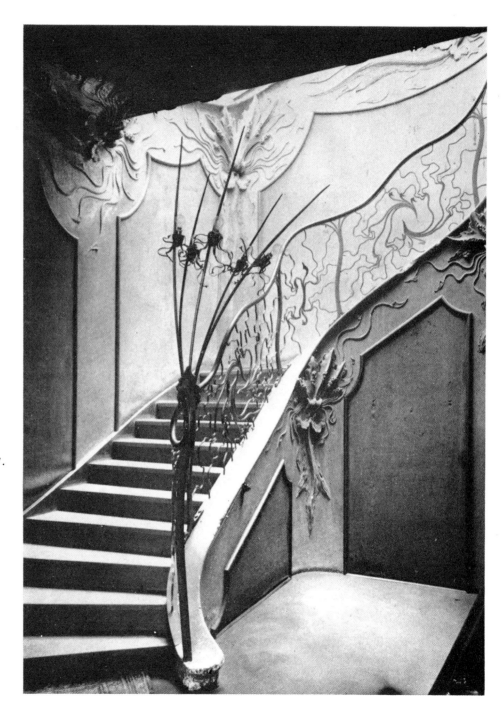

Endell: Atelier Elvira, Munich. 1897.
Stair hall (demolished)

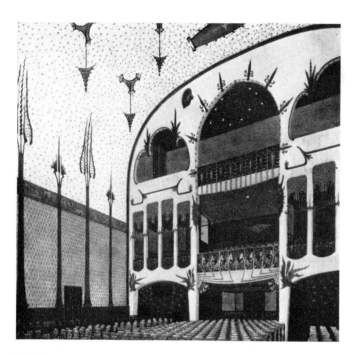

Endell: Buntes Theatre, Berlin. 1901

that deserves more extended discussion, if as much for its ambiguities as for its virtuosity, the Atelier Elvira of 1897 in Munich by Endell (page 138). Remove the enormous decorative relief, abstract and yet strangely suggestive of several sorts of natural forms and forces, and the smooth flat stucco surface, with its crisp cornice and sharp-cut openings asymmetrically disposed, is far more characteristic of a certain stage of what Pevsner has called the "Modern Movement" than of the Art Nouveau of Horta and Guimard. The decorative panels on the Castel Béranger by Guimard may well have inspired the decoration here but inside, with the eyes half closed, one seems to see in the stair hall (page 139) the lively, spiky Rococo of the mid-eighteenth century in Germanic lands, despite the specifically Art Nouveau characteristics of particular elements such as the lighting fixture. But this was a tour-de-force all the same, much superior to the conspicuous works of the

day by French architects who attempted to make their revival of the Rococo fresher and more piquant by introducing coarse reflections of certain aspects of Art Nouveau.

The façade of the Atelier Elvira, which has long been recognized as the most striking example of Art Nouveau in Germany, offers an even more cogent example than Wagner's slightly later Majolika Haus in Vienna of how the new modes of the nineties in Germany and Austria, Jugendstil and "Secessionstil," both overlapped and also moved rapidly away from the international style of the day as centered in Brussels and Paris. Schmalenbach in 1935 referred to the Jugendstil in his title as "Flächenkunst," that is, an art of surfaces. What the Germans and Austrians certainly retained for about a decade in architecture from their early Jugendstil of the nineties was an emphasis on flat surfaces. But very shortly they dropped from those surfaces the large-scale curvilinear ornament that links such things as the Atelier Elvira and the Majolika Haus to Art Nouveau. Considered as architecture, therefore, even early manifestations of Jugendstil differ in their basic conception from Belgian and French work in which the structural elements themselves are always organic and often curved as well.

Yet the relief on the façade of the Atelier Elvira, although developed from modest embroidery patterns by Obrist of some years earlier under the reinforcing influence of Brussels and Paris, is fully architectural in scale and certainly pulls that building well within the orbit of Art Nouveau. In Endell's Buntes Theater (left) in Berlin of four years later the Art Nouveau relationship remained clearly evident. After that, influence from Brussels and Paris rapidly disappeared, even in the work of those most involved in importing that influence into Germany such as van de Velde.

Although Wagner was responsible for the major Austrian architectural monuments of the early years of the twentieth century, his pupil Hoffmann was the continuing leader of the "Secessionstil." His executed architectural work, beginning soon after 1900, seems at first sight to offer no such potent links with Art Nouveau as are evident

in the Atelier Elvira and the Majolika Haus. Yet the basic conception of the decorative workshops that he founded in 1903, the *Wiener Werkstätte,* in continuing the line of the English Arts and Crafts movement, continued also the similarly derived Art Nouveau ideal of extending the sanctions of art to all fields of design. As regards architecture, however, Hoffmann offered in his first large-scale work, a Convalescent Home at Purkersdorf of 1903-04, an even more stripped example of "Flächenkunst" than anything by Wagner. This is what the Majolika Haus would be like if the Art Nouveau floral patterns were removed from its flat geometrically crisp surface.

Yet Hoffmann's finest work, the Palais Stoclet (pages 142, 143) which he began in Brussels a year later, is less ascetic by a long shot. The flat surfaces consist of marble plates, like those Wagner was also using at this point, but they are framed by rather rich moldings of gilded bronze modeled in small curvilinear patterns even though their bounding lines are rigidly straight. But what most definitely links this house back to Art Nouveau are various aspects of the interior decoration, particularly the mosaics inset in the smooth marble walls of the dining room which are perhaps the masterpiece of Klimt (pages 78, 143). The more revolutionary architecture of Loos during these years, and even his richest interiors, include no such continuing echoes of the curvilinear decoration of the nineties.

Mackintosh in Glasgow is a figure whose development is at once parallel to and divergent from Art Nouveau in a fashion quite as embarrassing to critics and historians as that of the Germans and Austrians whom he influenced; for that influence on the Continent, from about 1900, was all against the continuance of Art Nouveau in architecture. Mackintosh's Glasgow School of Art (page 145), precisely contemporaneous with Horta's Maison du Peuple, has very few points in common with the Brussels building. Built of stone, with concrete lintels over the regular ranges of large matter-of-fact studio windows, the architectural treatment of the entrance recalls not Horta's work but rather Webb's in its semi-traditionalism. Only the ironwork, of which

there is very little, has a positively Art Nouveau flavor, especially the curious curved members with knotted tops that lean inward from the sills against the windows.

Mackintosh's more purely decorative work of these early years, however, notably the murals executed in collaboration with his wife in Miss Cranston's Tearooms (pages 68-69) from 1897 on, is closer to the continental Art Nouveau even though it seems to derive in the main from various British sources.

Whether a few major works, such as those selected for discussion and illustration in this essay, will persuade anyone not already interested in and familiar with Art Nouveau of the importance of this brief episode in the early history of modern architecture is hard to guess. The early rejection of what seemed after 1900 only a fashion or fad; the more considered rejection in the 1920s of what was judged a false turning from the straight path "vers une architecture"; the Surrealist acceptance by a few in the thirties of an architecture reputedly instinct with Freudian undertones; the more scholarly acceptance of the 1940s and fifties of a phase of recent art history considered worthy of objective and unemotional study—none of these attitudes is quite relevant any more.

The march of time has carried Art Nouveau through the valley of disrepute that follows almost every artistic episode and given it the prestige of at least relative age. Moreover, critics and amateurs of the arts are on the whole less puritanical and singleminded about architecture than they had been in the twenties and less naively Freudian than in the thirties. Historians were perhaps still ahead of the public in their acceptance of Art Nouveau but current developments in architecture and the decorative arts are lending a new relevance to a re-examination and re-evaluation of Art Nouveau.

The relationship of these trends to Art Nouveau lay more in a rejection of the International Style of the thirties than in any consistency of ideals or real similarity of forms. One could note in recent buildings the return of curves in section, in plan, and even in elevation, and the preference for types

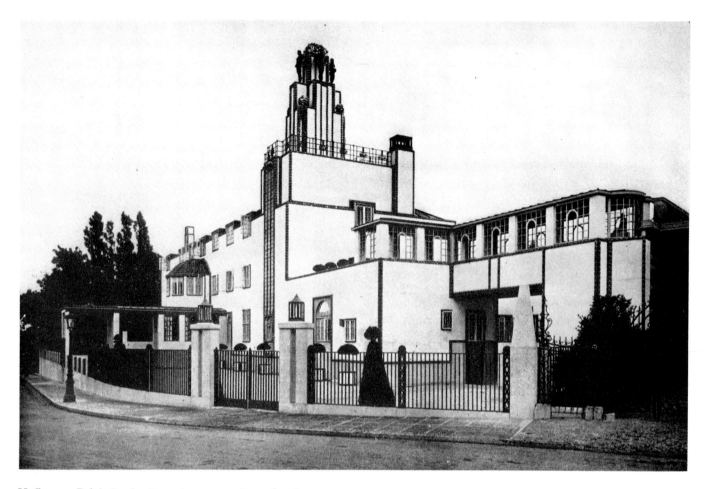

Hoffmann: Palais Stoclet, Brussels. 1905-11. Street façade

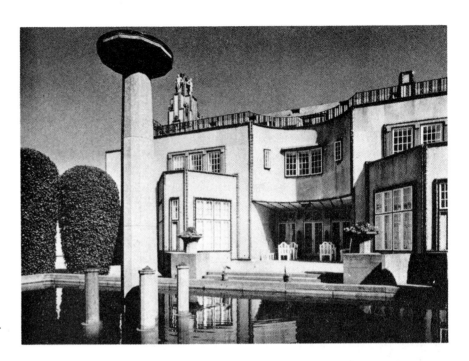

Hoffmann: Palais Stoclet, Brussels. 1905-11.
View from rear

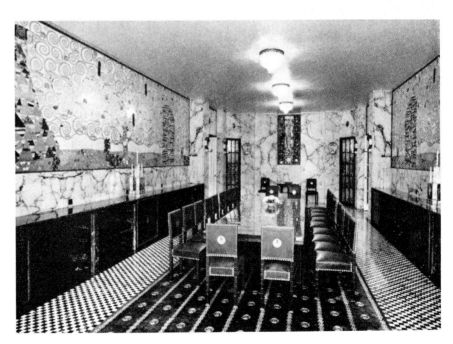

Hoffmann: Palais Stoclet, Brussels. 1905-11.
Dining room with Klimt mosaics on walls

of expressive structure more organic in appearance, if not in fact, than the reticulated cage. In this looser and more eclectic climate of taste that came with the mid-century it was possible to appreciate more fully the virtues of Art Nouveau architecture. But it is well to consider here why it was so brief an episode and also why so few major works were produced; otherwise Art Nouveau may easily be dismissed as no more than an irrelevant historical fluke.

It is a commonplace of modern theory, curiously inapplicable to the greater part of the advanced production of the last thirty-five years, that architecture is primarily an art of space. This can justify a high esthetic evaluation of the larger Art Nouveau interiors—not only those of leading designers such as Horta and Guimard, but of more commercial architects such as René Binet—and not as mere "interior decoration" (like the rooms contributed to various exhibitions by Art Nouveau artists in the late nineties and early 1900s) but as architecture in the fullest sense. The spatial qualities of the auditoriums of the Maison du Peuple (page 131) and the Humbert de Romans Building (page 134) or even of the salon in the Van Eetvelde house (page 132) are not tentative or premonitory of later modern architecture but wholly mature and assured in their own right, more satisfying to the observer than most comparable later interiors. The thin lines of the isolated metal structural elements, curving organically where they are joined at the top, the transparent or patently screen-like elements of enclosure stretched like membranes at the outer confines of a volume that the structural elements penetrate—these novel and essential features were combined to create a kind of space unexploited earlier and not repeated since. The tall light-courts of the department stores, even though they had a technical lineage of two generations and more, share these novel qualities; they are also present in more dilute form in most of the interiors of Horta's houses.

Even in a building otherwise more representative of the Viennese reaction against Art Nouveau, Wagner's Postal Savings Bank of 1904-06, the principal interior space continues to manifest these qualities (page 146). The tapered aluminum supports penetrate the transparent planes of the glazed roof which rise in delicate curves to mold the space, and the surrounding walls are flat and apparently weightless. Yet the minimal decoration is all geometric, with no specifically Art Nouveau character at all. This interior was, however, rather exceptional so late as the mid-1900s. The more characteristic articulation of Hoffmann's two-storied hall in the Palais Stoclet of 1905-11 is in terms of solid, if slim, marble piers; and in the other interiors a link with Art Nouveau remains only in the mosaic or other decoration of some of the smooth and flat surfaces of marble (page 143).

As to Art Nouveau exteriors, only those largely of metal and glass offer an external expression parallel to and, as it were, symbolic of the new spatial qualities of the interiors. Even the largest of Guimard's Metró stations (page 136) had no interiors of independent consequence; but taken as a whole they were certainly closely related in their prime visual effects—that of the glass marquees, for example—to Horta's interiors. This is equally true of the best department stores, if somewhat less so of the Maison du Peuple (page 131).

If one thinks forward to the epoch-making glass and metal industrial work of Behrens and of Gropius dating from the years 1909, 1910, and 1911, the notable difference in esthetic principle will be evident. That difference does not lie merely in the disappearance of decoration and of all curves, but much more in the diminution of organic emphasis in the scaling and the profiling of the structural elements of metal.

Granted that Art Nouveau was capable on occasion of creating monuments almost wholly *sui generis*, neither to be passed off as late examples of nineteenth-century ferrovitreous construction nor as premonitions of later modern architecture, why are there so few that stand the test of time? It is in this respect that the transitional character of the episode is most apparent. Art Nouveau could be, and most often was, used even by the most conscientious designers merely as a superficial stylization of traditional

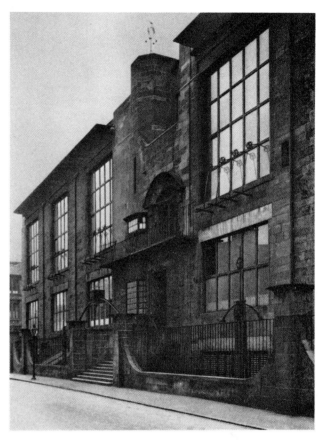

Mackintosh: School of Art, Glasgow. 1897-99

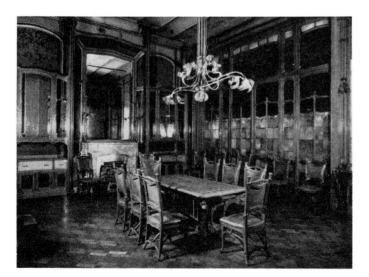

Horta: Hotel Solvay, 224 avenue Louise. 1895-1900. Dining room

Wagner: Postal Savings Bank, Vienna. 1904-06. Court

structure whenever they were obliged to build largely in masonry. Unlike the Late Gothic masters, the Art Nouveau architects had no talent for etherealizing stonework. It was the undeniable evidence of the unsuitability of Art Nouveau to stone and brick, still the most widely used building materials, that logically led to its early rejection. Solid walls could be most effectively made to appear light and thin by using plaquage (page 143, top) or some other device that stressed the flatness and smoothness of the surface as was, of course, to be done even more consistently a bit later in the twenties and thirties.

Equally important, very probably, was the excessive amount of invention that even a modest Art Nouveau structure required. Guimard, using members of metal cast in series, could produce his Métro stations in considerable quantity without any loss of quality. But one of Horta's houses, and *a fortiori* large buildings such as the Maison du Peuple or A l'Innovation, required a tremendous amount of special designing. Art Nouveau inevitably implied in the hands of devoted designers a custom-made, if by no means necessarily a handmade, method of production. The traditional architects and decorators of the period, although they had to adapt and not merely to copy the stylistic detail they borrowed from the past, nevertheless had little need to originate. Those architects of the period who were to be the spiritual fathers of later modern architecture were vowed almost from the first to simplicity, relative though that simplicity was to appear to critics in the twenties and thirties in the case of everyone but Loos. Even if such men had to design afresh every element of one of their early buildings, they were on the whole able to do it once and for all—at least that was increasingly the ambition of most of the new leaders after the opening years of the century, and even more of the next generation that came to the fore in the twenties.

But Art Nouveau architects had to design each element from a stanchion to a door-frame—not to speak of all the furniture and accessories—every time they undertook a new commission. Standardization would have been contrary to the organic ideal of their esthetic, and a mode that considered the smallest elements of domestic furnishing—silverware, glassware, pottery—capable of highly expressive treatment could hardly consent to deprive larger architectural elements of equal invention in design and equal perfection of execution. Most architects evidently grew rapidly tired of a method of design so inapplicable to much of the actual building they were required to do; while at the same time they were beginning to realize that their capacity for invention was flagging after only a few years of practice.

Such considerations are necessarily hypothetical, but they suggest that the early abandonment of Art Nouveau was only partly a reaction to the faddish vulgarization that set in around 1900. It may equally have been the extreme difficulty of living up to their own highest aspirations that led men like Horta and Van de Velde to turn away from it. At least, in looking at Art Nouveau architecture, it is well to consider the enormous difficulties that its integral production entailed, however easy it was to slap on to essentially traditional work a few quirks and squiggles that passed muster for a few years as in the latest fashion.

One must finally conclude that Art Nouveau, like certain style-phases of the earlier past—the Manoeline in Portugal and of course the French Rococo—very rarely reached full fruition in architecture, despite its extensive success in the minor arts. But there *was* an Art Nouveau architecture, and that architecture was capable of distinguished achievement, as the few buildings dealt with in this essay certainly illustrate. For all the relatively greater profusion of decorative design of the period in interiors, in furniture, in *objets d'art,* and in the graphic arts, the major monuments of that architecture at its best had qualities not seen before nor since. It therefore takes its proper place among the minor, but significant, phases of the *art maîtresse.*

HENRY-RUSSELL HITCHCOCK

NOTES TO THE TEXT

INTRODUCTION

1 Alexander Koch, "Aufruf an die Deutschen Künstler und Kunstfreunde," *Deutsche Kunst und Dekoration,* Vol. 1. 1897-1898, p. 1

2 First Proclamation of the Weimar Bauhaus, in Bayer, Gropius and Gropius, *Bauhaus,* New York, Museum of Modern Art, 1938, p. 16

3 Walter Crane, *Transaction of the National Association for the Advancement of Art and Its Application to Industry,* Liverpool, 1888, p. 216

4 Leo Tolstoy, *What Is Art?* Translation from the Russian by Aylmer Maude, New York, Crowell, 1899, p. 43

5 One of the important Symbolist reviews in Paris was the *Revue Wagnérienne,* founded in 1885 by Edouard Dujardin. Among its famous contributors were Stéphane Mallarmé, Stuart Merrill, and Theodor de Wyzewa.

6 Gerstle Mack, *Toulouse-Lautrec,* New York, Knopf, 1938, p. 319-320

7 See p. 44

8 Jean Moréas, "Le Symbolisme," *Figaro Littéraire,* Sept. 18, 1886

9 Stéphane Mallarmé, "Réponse à une enquête," in J. Huret, *Enquête sur l'évolution littéraire,* Paris, 1891, reprinted in *L'Art moderne,* Aug. 9, 1891

10 For a more thorough discussion of Symbolist theory see Guy Michaud, *La Doctrine Symboliste* (Documents), Paris, 1947 and Jacques Lethève, *Impressionistes et Symbolistes devant la presse,* Paris, Armand Colin, 1959

11 G. Albert Aurier, "Symbolism en peinture: Paul Gauguin," *Mercure de France,* March 1891

12 Robert Koch, "The Poster Movement and 'Art Nouveau'," *Gazette des Beaux-Arts,* Ser. 6, Vol. 50. November 1957, pp. 285-296

13 For a discussion of the relationship of Symbolist literature and painting: John Rewald, *Post-Impressionism from van Gogh to Gauguin,* New York, Museum of Modern Art, 1956, and Peter Selz, *German Expressionist Painting,* Berkeley and Los Angeles, University of California Press, 1957, Ch. VI

14 Crane, lecture delivered before the National Association for the Advancement of Art, 1889, *Transaction of the Art Congress,* Edinburgh, 1889, p. 202-220

15 Henry van de Velde, "Prinzipielle Erklärung," *Kunstgewerbliche Laienpredigten,* Leipzig, Hermann Seemann, 1902, p. 188. Van de Velde's theory of the expressive forces and emotional values of the line is preceded by the researches and the 1885 Sorbonne lectures of Charles Henry. The paintings of Seurat and Gauguin also antedate van de Velde.

16 August Endell, quoted in Selz, *op. cit.* p. 55-56

17 Van Gogh "was permitted to roam through Bing's entire building, including cellar and attic, and his enthusiasm knew no limits." Rewald, *op. cit.* p. 72

18 Robert Koch, "Art Nouveau Bing," *Gazette des Beaux-Arts,* Ser. 6, Vol. 53, March 1959, p. 179-190

19 Karl Ernst Osthaus, *Van de Velde,* Hagen, Folkwang Verlag, 1920, p. 19

20 S. Bing, "L'Art Nouveau," *The Architectural Record,* Vol. 12, No. 3, August 1902, p. 281

21 *Ibid.* p. 283.

22 Louis Sullivan, "Characteristics and Tendencies of American Architecture," *Inland Architect and Builder,* 6, Nov. 1885, p. 58

23 Otto Wagner, *Moderne Architektur,* Vienna, 1895 (4th edition published as *Die Baukunst unserer Zeit,* Vienna, 1914)

24 "Each time its art."

25 Preface to Vol. 1, No. 1 of *Jugend,* 1896

26 A. D. F. Hamlin, "L'Art Nouveau: Its Origin and Development," *The Craftsman,* Vol. 3, Dec. 1902, p. 129. The other articles in this series are: Irene Sargent, "The Wavy Line," *The Craftsman,* Vol. 2, June 1902, p. 131-142; Jean Schopfer, "L'Art Nouveau: An Argument and Defence," *The Craftsman,* Vol. 4, July 1903, p. 229-238; S. Bing, "L'Art Nouveau," *The Craftsman,* Vol. 5, Oct. 1903, p. 1-15; see also Hector Guimard, "An Architect's Opinion of L'Art Nouveau," *The Architectural Record,* Vol. 12, June 1902, p. 127-133.

27 Van de Velde, "Die Rolle der Ingenieure in der Modernen Architektur," *Die Renaissance im modernen Kunstgewerbe,* Berlin, Cassirer, 1903, p. 111

28 cf. to the contrary: Sigfried Giedion, *Space, Time and Architecture,* Cambridge, Harvard University Press, 1946, p. 224-225

29 S. Bing, "L'Art Nouveau," *Architectural Record, op. cit.* p. 285

30 Van de Velde, "Das Ornament als Symbol," *Die Renaissance im modernen Kunstgewerbe, op. cit.,* p. 94-96

31 The spirit of Blake's work was carried on by Samuel Palmer. Blake's illuminated books were exhibited in the Print Room of the British Museum from the 1850s on. Dante Gabriel Rossetti acquired Blake's Notebook (formerly in Palmer's possession) in 1847, and prints by Blake were reproduced in Alexander Gilchrist's *Life of William Blake* (2 vols., London, 1863). Swinburne's *William Blake* (London, 1868) must also

have had a considerable influence on writers and artists of the time. The influence of Blake on Art Nouveau is clearly traced in a recent article by Robert Schmutzler, "Blake and Art Nouveau," *Architectural Review*, Vol. 118, No. 704, August 1955, p. 90-92

32 Schmutzler, *op cit.* p. 92

33 Reproduced in Stephan Tschudi Madsen, *Sources of Art Nouveau*, New York, Wittenborn, 1956, p. 276, fig. 151

34 Nikolaus Pevsner, *Pioneers of Modern Design*, New York, The Museum of Modern Art, 1949, p. 55, and other scholars following Pevsner, such as Henry-Russell Hitchcock, *Architecture: Nineteenth and Twentieth Centuries*, Baltimore, Penguin Books, 1958, p. 285, and R. Schmutzler, *op cit.*, seem to indicate that the book, rather than the earlier chair is the first Art Nouveau object.

35 *Dekorative Kunst*, Vol. 4, No. 8, 1899, p. 81 ff.

36 For an early treatment of the Japanese influence on Art Nouveau see Ernst Michalski, "Die entwicklungsgeschichtliche Bedeutung des Jugendstils," *Repertorium für Kunstwissenschaft*, Vol. 46, 1925, p. 133-149. For a more recent and thorough treatment: Clay Lancaster, "Oriental Contributions to Art Nouveau," *Art Bulletin*, Vol. 34, No. 4, 1952, p. 297-310

37 S. Bing, "L'Art Nouveau," *The Craftsman*, Vol. 5, Oct. 1903, p. 3

38 Eugène Grasset, *La Plante et ses applications ornamentales*, Paris, Librairie Centrale des Beaux-Arts, 1897-1899

39 Ernst Haeckel, *Kunstformen der Natur*, Leipzig and Vienna, Bibliographisches Institut, 1899-1904.

GRAPHIC DESIGN

1 J. K. Huysmans, *A Rebours* 1884 translated by Robert Baldick as *Against Nature*, Penguin Books, 1959. This book was aptly called "The breviary of the decadence" by Arthur Symons.

2 Oscar Wilde, *The Picture of Dorian Gray*, London, Ward, 1891; reprinted in Penguin Books

3 Notably Henry F. Lenning, *The Art Nouveau*, The Hague, Nijhoff, 1951, and Stephan Tschudi Madsen, *Sources of Art Nouveau*, New York, Wittenborn, 1956.

4 This point is made most forcibly by Dr. Fritz Schmalenbach, in his pioneering study, *Jugendstil; Ein Beitrag zu Theorie und Geschichte der Flächenkunst*, Würzburg, Triltsch, 1935.

5 See J. W. Mackail, *The Life of William Morris*, New York, Oxford University Press, 1950, and H. Halliday Sparling, *The Kelmscott Press and William Morris Master-Craftsman*, London, Macmillan, 1924, for the best accounts of Morris's life and work.

6 Three of the many examples which could be cited are van de Velde's article, "Formes: de la forme pure utilitaire," *Das Werk*, Vol. 36, No. 8, August 1949, p. 244; Julius Rodenberg's article, "Karl Klingspor," *The Fleuron Number Five*, 1926, p. 3; and L. W. Rochowanski, *Josef Hoffmann*, Österreichische Staatsdruckerei, Vienna, 1950, p. 23.

7 Hammersmith, *The Story of the Glittering Plain*, The Kelmscott Press, 1891

8 William Gaunt, *The Pre-Raphaelite Dream*, London, The Reprint Society, 1943, p. 33. On Rossetti and the Pre-Raphaelite Brotherhood, see Robin Ironside, *Pre-Raphaelite Painters*, New York, Phaidon, 1948.

9 For a comprehensive treatment of the Proto-Art Nouveau, and the relationship of Blake to Art Nouveau, see Robert Schmutzler's two articles: "The English Origins of Art Nouveau," *Architectural Review*, Vol. 117, No. 698, February 1955, p. 108-117, and "Blake and the Art Nouveau," *Architectural Review*, Vol. 118, No. 704, August 1955, p. 90-97. See also Note 31, Introduction

10 Herbert H. Gilchrist in *The Century Guild Hobby Horse*, No. 1, 1886, *Nescio Quae Nugarum*, p. 160

11 This book, and its relationship to Art Nouveau, was first noticed by Nikolaus Pevsner, "A. H. Mackmurdo, a Pioneer Designer," *The Architectural Review*, Vol. 83, 1938, p. 142.

12 Roswitha Riegger-Baurmann, "Schrift im Jugendstil," *Börsenblatt für den Deutschen Buchhandel* (Frankfurter Ausgabe) Vol. 14, No. 31a, April 21, 1958 p. 495-7. Dr. Riegger-Baurmann cites Pevsner's article on Mackmurdo which appeared in the *Journal of the Royal Institute of British Architects*, Vol. 49, 1942, p. 94.

13 Clay Lancaster, "Oriental Contributions to Art Nouveau." *The Art Bulletin*, Vol. 34, No. 4, 1952, p. 300-301

14 Charles Ricketts and Lucien Pissarro, *De la typographie . . . William Morris et son influence sur les arts et métiers*, Paris, Floury; London, Hacon and Ricketts, 1898

15 *Ibid.*, p. 16-17

16 Maurice Denis, *Théories, 1890-1910*, Paris, Rouart et Watelin, 1920, p. 10-11

17 Quoted as the epigraph to Ricketts and Pissarro, *op. cit.*

18 Graham Hough, *The Last Romantics*, London, Duckworth, 1949, p. 133

19 Eleanor M. Garvey, "Art Nouveau and the French Book of the Eighteen-Nineties," *Harvard Library Bulletin*, Vol. 12, No. 3, Autumn 1958, p. 379. As printed in the 1911 edition of *Sagesse*, Denis' illustrations are rendered as woodcuts by Beltrand. John Rewald, in *Post-Impressionism from van Gogh to Gauguin*, New York, Museum of Modern Art, 1956, p. 519, reproduces one of the illustrations as a lithograph. The colophon of the 1911 book states that Denis originally made the drawings in 1889.

20 The illustration reproduced is for the poem "Sagesse d'un

Louis Racine," number IX of the first series in Verlaine, *Sagesse*, Paris, Vollard, 1911, p. 19

21 Van de Velde had shown with *Les Vingt* along with Walter Crane in 1891. Robert Koch, "A Poster by Fernand Khnopff," *Marsyas*, Vol. 6, 1950-53, p. 74

22 For a reproduction of the Burns illustration, see Madsen, *Sources of Art Nouveau*, p. 243.

23 Van de Velde, *Déblaiement d'art*, Brussels, Monnom, 1894, p. 15

24 *Ibid.*, p. 17

25 Van de Velde, *Persönlichkeit und Werk*, p. 14

26 Van der Velde, *Déblaiement d'art*, p. 18

27 *Ibid.*, p. 20, 24

28 Denis, *op. cit.*, p. 11

29 For example, see Charles Hiatt, *Picture Posters*, London, Bell, 1895, Ch. III, and Robert J. Goldwater, " 'L'Affiche moderne': A Revival of Poster Art After 1880," *Gazette des Beaux-Arts*, Ser. 6, Vol. 22, December 1942, p. 173-182

30 Goldwater, *op cit.*, p. 182

31 *Ibid.*, and Robert Koch, "The Poster Movement and 'Art Nouveau' ", *Gazette des Beaux-Arts*, Ser. 6, Vol. 50, November 1957, p. 285-296

32 Koch, "The Poster Movement and Art Nouveau," *op. cit.*, p. 285-296; Koch, "A Poster by Fernand Khnopff," p. 72-74; Goldwater, *op. cit.*

33 The date of Bonnard's poster is in question. Goldwater, *op. cit.*, p. 181, suggests that the poster may date from 1889 and not 1891 as commonly believed.

34 *Ibid.*, p. 180. As Robert Koch points out, in his article "The Poster Movement and 'Art Nouveau' " (p. 287), Grasset opposed Art Nouveau on the grounds that it represented a break with historical tradition; yet his works partake so strongly of the stylistic qualities of the period that they seem to deserve mention here. Besides, like so many of the other men who denied a connection with Art Nouveau, Grasset deeply impressed a number of artists who were more central to the movement.

35 Koch, *op. cit.*, p. 286, note

36 *Ibid.*

37 F. Thibaudeau, *Manuel français de typographie moderne*, Paris, Au Bureau de l'Edition, 1924, p. 119

38 This is the date given by Berry and Johnson, *Encyclopaedia of Type Faces*, London, Blandford, 1953, p. 75, presumably from information furnished by the typefounder.

39 Riegger-Baurmann, *op. cit.*, p. 486, pl. 3

40 Rodenberg, *op. cit.*, p. 6

41 Schmutzler, "The English Origins of Art Nouveau," *op. cit.*, p. 110, and Schmalenbach, *op. cit.*, p. 25

42 Karl Klingspor, *Über Schönheit von Schrift und Druck*, Frankfurt-am-Main, Schauer, 1949, p. 17-20

43 Walter Crane, *William Morris to Whistler*, London, Bell, 1911, p. 232.

44 Denis, *op. cit.*, p. 149

45 William Morris, "The Beauty of Life" (1880), quoted in *Selected Writings of William Morris*, ed. William Gaunt, London, Falcon, 1948, p. 42

46 Robert Koch, "Art Nouveau Bing," *Gazette des Beaux-Arts*, Ser. 6, Vol. 53, March 1959, p. 187

PAINTING AND SCULPTURE, PRINTS AND DRAWINGS

1 Odilon Redon, *A Soi-Même*, Paris, Floury, 1922, p. 30

2 *Ibid.*, p. 89

3 Paul Gauguin to Schuffenecker, August 14, 1888. Quoted in John Rewald, *Post-Impressionism from Van Gogh to Gauguin*, New York, The Museum of Modern Art, 1956, p. 196

4 Merete Bodelsen, "The Missing Link in Gauguin's Cloisonism," *Gazette des Beaux Arts*, Vol. 53, May 1959, p. 329-344

5 Paul Sérusier, *ABC de la peinture, correspondance,* 3rd ed. Paris, Floury, 1950, p. 164

6 Maurice Denis, *Théories 1890-1910*, Paris, Bibliothèque de l'Occident, 1913, p. 1

7 Jan Verkade, *Le Tourment de Dieu*, Paris, Librairie de l'Art Catholique, 1923, p. 94

8 Agnés Humbert in her book, *Les Nabis et leur époque*, Geneva, Cailler, 1954, evokes the life of the artists in a vivid manner.

9 Gauguin, Preface to exhibition catalogue, *Armand Séguin*, Paris, Barc de Boutteville, February-March 1895, p. 9-10

10 Humbert, *op. cit.* p. 106

11 Lincoln F. Johnson, Jr., "The Light and Shape of Loie Fuller," *The Baltimore Museum of Art News*, Vol. 20, No. 1, October 1956, p. 13

12 Wassily Kandinsky, *Uber das Geistige in der Kunst*, Munich, Piper, 1912, p. 30

13 Letter by Aubrey Beardsley to A. W. King. Quoted by Robin Ironside, "Aubrey Beardsley," *Horizon*, Vol. 14, No. 81, September 1946, p. 193

14 For an excellent recent analysis see Thomas Howarth, *Charles Rennie Mackintosh and the Modern Movement*, London, Routledge and Kegan Paul, 1952

15 Quoted by Gleason White, *"Some Glasgow Designers and Their Work,"* Part III, *The Studio*, Vol. 12, 1898, p. 48

16 Van de Velde, "Prinzipielle Erklärungen," in *Kunstgewerbliche Laienpredigten*, Leipzig, 1902

17 Van de Velde, "Extract from His Memoirs: 1891-1901," *Architectural Review*, Vol. 112, No. 669, September 1952, p. 146

18 The term "counter-Art Nouveau" was suggested by John M.

Jacobus, Jr. in his review of Madsen's *Sources of Art Nouveau* (*The Art Bulletin,* Vol. 40, No. 4, 1958, p. 371). It seems to be a very useful term for the rectilinear and later aspects of the style especially the work coming from Glasgow and Vienna, but it would also refer to a sculptor like Minne.

19 W. S. Sparrow, "Herr Toorop's: The Three Brides," *The Studio,* Vol. 1, 1893, p. 247-248

20 Thomas Howarth, *op. cit.,* p. 228. Toorop himself, as well as the Scots, were probably also influenced by Carloz Schwabe's illustrations to Zola's *Le Rêve,* which appeared in Paris in 1892.

21 Ferdinand Hodler, quoted in Fritz Burger, *Cézanne und Hodler,* Munich, Delphin, 1919, Vol. 1, p. 50

22 *The Chosen One* was completed in 1894 and shown at the *Champ de Mars* in Paris that year. It was exhibited again in Vienna in 1901 where it was greatly admired, and as the original version, now in the Kunstmuseum in Berne, was then in poor repair, Hodler made a replica for a Vienna patron about 1903, which soon reached the Osthaus collection and now belongs to the Karl-Ernst-Osthaus Museum in Hagen.

23 Edith Hoffmann, *Kokoschka,* Boston, Boston Book and Art Shop, 1947, p. 30

24 Peter Selz, *German Expressionist Painting,* Berkeley and Los Angeles, University of California Press, 1957, p. 52

25 August Strindberg, "L'Exposition d'Edward Munch," *Revue Blanche,* Vol. 10, 1896, p. 525-526

26 Arthur Rössler, *Neu-Dachau,* Bielefeld and Leipzig, Velhagen & Klasing, 1905, p. 85

27 Gabriele Münter, from "Bekenntnisse und Erinnerungen," quoted in *München 1869-1958 Aufbruch zur Modernen Kunst,* Munich, Haus der Kunst, 1958, p. 304

DECORATIVE ARTS

1 In the letter with which George Donaldson made his gift offer, he also stated: "However much this New Art may conflict with our Classical standards or ideas of architectural basis, I am forced to the conclusion that we are in the presence of a distinct development. Where it will lead to none can foretell. But, in these competitive days, . . . it occurs to me that it is of great importance to our people that the best models of the style called 'New Art' should be purchased and placed before them." Victoria and Albert Museum, Registry 1900. File No. 130, as quoted in Stephan Tschudi Madsen: *Sources of Art Nouveau,* New York, Wittenborn, 1956, p. 299

2 "Belgische Innendekoration," *Dekorative Kunst,* Vol. 1, 1898, p. 199-206

3 *Ibid.,* p. 201

4 Hector Guimard, "An Architect's Opinion of 'l'Art Nouveau'." *The Architectural Record,* Vol. 12, 1902, p. 127-133.

5 *Ibid.*

6 Gabriele Howaldt, "Bildteppiche," in Helmut Seling, ed., *Jugendstil, Der Weg ins 20. Jahrhundert,* Heidelberg, Keyser, 1959, p. 370-371

7 Adolf Loos, *Ins Leere Gesprochen* (a collection of articles written between 1897-1900). Paris, Crès, 1921.

ARCHITECTURE

1 In England and America the turn of the tide came with Pevsner's *Pioneers of the Modern Movement,* published in London in 1936. Pevsner's active interest reflected Schmalenbach's *Jugendstil,* published the previous year in Germany.

2 See H. R. Hitchcock, *Gaudí,* New York, The Museum of Modern Art, 1957, and George Collins, *Gaudí,* New York, Braziller, 1960

3 Stephen Tschudi Madsen, *Sources of Art Nouveau,* New York, Wittenborn, 1956.

4 A humble culinary analogy may help to explain this point: If you wish to describe the taste of curry, it does not help very much to know the ingredients. The flavor of curry is the flavor of curry; and Art Nouveau has a similar idiosyncratic identity: the whole is certainly something different from the sum of its parts.

5 *L'art moderne,* 13, 1893, p. 193-195; *L'Emulation,* 18, 1893, p. 150-151. The title of the article was in English: "Artistic wallpapers."

6 In *Architecture: 19th and 20th Centuries,* I wrote, "The Art Nouveau is not primarily an architectural mode." For correct emphasis, the word "primarily" and not, by implication, the word "architectural" should be italicized there. The question whether in architecture the Art Nouveau is a true "style" or merely a "mode" need not be explored here. It can most accurately be considered, I believe, as a style-phase, more specifically a subcategory of that long-continuing "Modern Style" of which it is an initiatory episode.

6a Masked by a new façade already in 1958, this has since been burnt out.

7 An original portion is installed in the garden of the Museum of Modern Art in New York.

8 His epoch-making apartment house of 1903 at 25 bis rue Franklin employs plain faience elements to clad the structural frame of reinforced concrete, but the foliate marquetry of faience that fills the wall-panels still suggests Art Nouveau.

A BIBLIOGRAPHY OF ART NOUVEAU

by James Grady

PREFACE

A bibliography of Art Nouveau is complex despite the short period of the movement. It must contain material that shaped the varied expressions of Art Nouveau, publications of the period, and an increasing number of studies which began appearing about thirty years ago after an interlude of some twenty years of indifference to the style.

The following bibliography has been grouped in three sections. The first indicates sources of Art Nouveau, and recent studies of these influences, as well as surveys of the movement and articles on specific aspects of Art Nouveau.

Several items, particularly those of the Secession, are contemporary with the movement. Perhaps of more interest are the assessments of Art Nouveau which began with Dali's courageous and perceptive article, "The Terrifying and Comestible Beauty of the Modern Style'," of 1932, when most advanced esthetic opinion was concerned with the geometries of Constructivism, Suprematism, and de Stijl, which by then had been given academic dispersal by the Bauhaus. Art Nouveau seemed a dead and completely unimportant episode of no interest to future developments. Dali, in opposition to this, declared that he was the first to consider Art Nouveau architecture as the most original and the most extraordinary phenomenon in the history of art. Art Nouveau slowly attracted the serious attention of scholars. Schmalenbach's doctoral thesis *Jugendstil,* of 1934, and Henry Hope's Harvard dissertation, *Sources of Art Nouveau,* of 1942, became essential documents in future research. Unfortunately, Dr. Hope's study has not been published. The chapters on Art Nouveau in the surveys of modern architecture by Pevsner and Giedion had a wider and more popular influence. By 1950 Art Nouveau was assuming an importance that would have seemed impossible thirty years before. Fels' *L'Art Vivant* is a comprehensive survey of Paris during the period and gives the ambiance of the style in most manifestations except architecture. Lenning's *The Art Nouveau* was the first book in English given to the movement. It is disappointing, with the illustrations of more interest than the text. The most complete investigation, within the limits set by the author and with architecture receiving minor attention, is *Sources of Art Nouveau,* by S. T. Madsen. A comprehensive study of Art Nouveau architecture is in Hitchcock's *Architecture, Nineteenth and Twentieth Centuries.* The most lavish recent publication is Cirici-Pellicer's *La Arte*

Modernista Catalán, produced with all the richness of an original Art Nouveau book.

Section II lists monographs on and writings by leading figures of Art Nouveau and its precursors. Many of these were written during the period, and the majority concern painters or decorative artists. Major publications on Art Nouveau architects are few. A notable exception is the excellent study of Mackintosh by Dr. Howarth. Such important men as Horta and Guimard have had only outline investigations.

Section III is devoted to a listing of the periodicals of the movement. These publications formed an essential part of Art Nouveau, not only from the point of view of graphic design itself, but also as exponents of the style. Here discussions about the nature of the new style were carried on, there were essays on the artists and reports on the multifarious national and international exhibitions. In fact, it was largely the magazines which spread the style beyond local and national boundaries.

Exact temporal and esthetic limits have not yet been defined for Art Nouveau, and this bibliography is in no sense comprehensive. Rather, it is set within the framework of the exhibition to give a survey of the movement.

JAMES GRADY
School of Architecture
Georgia Institute of Technology
Atlanta

As the first anthology in English treating the subject on a major scale, this publication has been fortunate to have its basic documentation prepared by an American scholar of Art Nouveau. Mr. Grady has already made available a comprehensive report on his literature in the *Journal of Architectural Historians* (bibl. 49). References used by the authors of this book and other relevant books and articles in the Museum Library have been added to his evaluated listing. Such addenda, as well as technical supervision of the bibliography, have been the responsibility of Mrs. Annaliese Munetic, Reference Librarian.

BERNARD KARPEL
Librarian, Museum of Modern Art

1 ABBOTT, THOMAS K. Celtic Ornament from the Book of Kells. 100 p. 50 pl. 9 parts Dublin: Hodges, Figgins, 1893-1895.

2 L'Affiche internationale illustrée. *Plume* no. 155: 409-462 ill. Oct. 1, 1895.

3 AHLERS-HESTERMANN, FRIEDRICH. Stilwende, Aufbruch der Jugend um 1900. 137 p. ill., pl. Berlin: Mann, 1941. *2d ed., 1956.*

4 ALEXANDRE, ARSENE and others. The Modern Poster. 117 p. ill. New York: Scribner, 1895.

5 L'Art Décoratif aux Expositions des Beaux-Arts, 1903. 4e série: le Mobilier. 71 ill. in folio. Paris: Guérinet, 1903.

6 L'Art Nouveau—what it is and what is thought of it—a symposium. *Magazine of Art (New York)* March—June 1904.

7 ASHBEE, CHARLES ROBERT. An Endeavour towards the Teachings of J. Ruskin and W. Morris. 52 p. London: Essex House, 1901.

8 BAHR, HERMANN. Sezession. 266 p. Vienna: Wiener Verlag, 1900.

9 BAJOT, ÉDOUARD. L'Art Nouveau—Décoration et Ameublement. Ser. 1-2. 48 pl. in 2 folios. Paris: Schmid, 1898.

10 BAYARD, JEAN EMILE. El Estilo Moderno. 367 p., 170 ill. Paris: Garnier Hermanos, 1919.

11 BEHRENS, PETER. Ein Dokument Deutscher Kunst: die Ausstellung der Künstler-Kolonie in Darmstadt, 1901. 47 p., pl. in folio. Munich: Bruckmann, 1901.

12 BENÉDITE, LÉONCE. Histoire des Beaux-Arts, 1800-1900. 738 p. ill., pl. Paris: Flammarion, 1909.

13 BING, S. Artistic Japan; Illustrations and Essays. 6 v. in 3. ill., pl. (pt. col.) London: Low, 1886.

14 BING, S. Salon de l'Art Nouveau. Catalogue no. 1. Paris: printed by Chamerot & Renouard, 1895. *Unpaged booklet, 662 exhibition items.*

15 BING, S. L'Art Nouveau. *Architectural Record* 12 no. 3: 279-285 Aug. 1902.

16 BINI, VITTORIO, and Trabuchelli. L'Art Nouveau. 123 p. ill. (pt. col.) Milan: Silvestri, 1957. *Bibliography.*

17 BRUXELLES. PALAIS DES BEAUX-ARTS. Le Mouvement Symboliste. 139 p. ill. Brussels: Ed. de la Connaissance, 1957. *Catalog to the exhibition.*

18 CHASSÉ, CHARLES. Le Mouvement Symboliste . . . 215 p., pl. Paris: Floury, 1947. *Chapters on Denis p. 147-170; Rodin p. 183-195.*

19 CHERBULIEZ, VICTOR. L'Art et la Nature. 324 p. Paris: Hachette, 1892.

20 CHERONNET, LOUIS. A Paris . . . vers 1900. 89 p. ill. Paris: Chroniques du Jour, 1932.

21 CHRIST, YVAN. Faut-il classer le modern'style? *Arts (Paris)* no. 727:16, ill. June 17-23, 1959.

22 CIRICI-PELLICER, A. El Arte Modernista Catalán. 475 p. ill. (4 col.) Barcelona: Aymá, 1951.

23 CITROEN, K. A. Collectie Citroen. Arnhem: printed by Jan Houtman, 1959. *Unpaged booklet, ill. (pt. col.) plus 2 supplements. Catalog to the exhibition of the collection at the Gemeentemuseum Arnhem and the Boymans van Beuningen museum, Rotterdam.*

24 COBDEN-SANDERSON, J. T. The Arts and Crafts Movement. 39 p. London: Chiswick, 1905.

25 CRANE, WALTER. The Claims of Decorative Art. 191 p. ill. London: Laurence & Bullen, 1892.

26 CRANE, WALTER. Ideals in Art. Papers . . . of the Arts and Crafts Movement. 287 p. ill., pl. London: Bell, 1905.

27 CRANE, WALTER. William Morris to Whistler. 277 p. ill. London: Bell, 1911.

28 DALI, SALVADOR. The terrifying and comestible beauty of the "modern style." *Minotaure* no. 3-4: 69-76 1932. *Reprinted in: Dali on Modern Art, p. 31-45, 113-127 (New York: Dial, 1957).*

29 DAY, L. F. Anatomy of Pattern. 4th ed. 56 p. ill., 41 pl. London: Batsford, 1895.

30 DENIS, MAURICE. Théories, 1890-1910. 3d ed. 270 p. Paris: Bibliothèque de l'Occident, 1913. *Also Paris: Rouart et Watelin, 1920.*

31 DESTRÉE, OLIVIER GEORGES. Les Préraphaélites. 111 p. Brussels: Dietrich, 1894. *Includes catalogue of works.*

32 Das Deutsche Kunstgewerbe 1906. 303 p. ill. Munich: Bruckmann, 1906. *3. Deutsche Kunstgewerbeausstellung, Dresden 1906.*

33 DINGELSTEDT, KURT. Jugendstil in der Angewandten Kunst. 46 p. ill. Braunschweig: Klinckhardt, 1959.

34 DORIVAL, BERNARD. Les Étapes de la Peinture Française Contemporaine. v. 1. Paris: Gallimard, 1943.

35 DRESSER, CHRISTOPHER. Japan—Its Architecture, Art and Art Manufacture. 467 p. ill. London: Longmans, Green, 1882.

36 EDWARDS, TUDOR. Art Nouveau, *Art (London)* 1 no. 9:5, Mar. 17, 1955.

37 FARMER, ALBERT JOHN. Le Mouvement Esthétique et Décadent en Angleterre (1873-1900). 413 p. Paris: Champion, 1931.

38 FELS, FLORENT. L'Art Vivant de 1900 à Nos Jours. 255 p. ill., pl. (16 col.) Geneva: Cailler, 1950.

39 FERRIDAY, PETER. The Peacock room. *Architectural Review* 75 no. 749:407-414 June 1959.

40 FIERENS-GEVAERT, H. Essai sur l'Art Contemporain. 174 p. Paris: Alcan, 1897.

41 FONTAINAS, ANDRÉ. Mes Souvenirs du Symbolisme. 4th ed. 220 p. Paris: Nouvelle Revue Critique, 1928.

42 FORUM (Amsterdam) 13, no. 10 and 11, 1958-1959. *Special issues: Jugendstil I and II, p. 304-367 ill., English summary.*

43 FREER GALLERY OF ART. The Whistler Peacock Room. 22 p. ill. Washington, D.C.: Smithsonian Institution, 1951. *Bibliography.*

44 FULLER, LOIE. Fifteen Years of a Dancer's Life. 288 p. ill., pl. London: Jenkins, 1913. *French ed.: Quinze Ans de Ma Vie (Paris: Juven, 1908).*

45 GARVEY, ELEANOR M. Art Nouveau and the French book of the eighteen-nineties. *Harvard Library Bulletin* 12, no. 3: 379 Autumn 1958.

46 GAUNT, WILLIAM. The Pre-Raphaelite Dream. London: Reprint Society, 1943.

47 GIEDION, SIGFRIED. Space, Time and Architecture. 3d ed. 601 p. ill. Cambridge: Harvard University, 1954.

48 GOLDWATER, ROBERT JOHN. L'affiche moderne; revival of poster art after 1880. *Gazette des Beaux-Arts* 22:173-182, Dec. 1942.

49 GRADY, JAMES. A bibliography of the Art Nouveau. *Journal of the Society of Architectural Historians* 14 no. 2:18-27, 1955.

50 GRADY, JAMES. Nature and the Art Nouveau. *Art Bulletin* 37 no. 3:187-194, 1955.

51 GRASSET, EUGENE. L'Art Nouveau. *Plume* 6:175-228, 1894.

52 GRASSET, EUGENE. La Plante et Ses Applications Ornementales. 144 col. pl. in 2 folios. Paris: Librairie Centrale des Beaux-Arts, 1897-1899.

53 GRAUL, RICHARD, ed. Die Krisis im Kunstgewerbe. 237 p. Leipzig: Hirzel, 1901.

54 HAECKEL, ERNST. Kunstformen der Natur, no. 1-10, suppl., pl. Leipzig, Vienna: Bibliographisches Institut, 1899-1904.

55 HAFTMANN, WERNER. Malerei im 20. Jahrhundert. 2 v. ill. (pt. col.) Munich: Prestel, 1954. *Bibliographic notes.*

56 HAMILTON, W. The Aesthetic Movement in England. 143 p. London: Reeves & Turner, 1882.

57 HAMLIN, A. D. F. L'Art Nouveau: its origin and development. *Craftsman* 3: 129-143, Dec. 1902.

58 HEVESI, LUDWIG. Acht Jahre Sezession. 526 p. Vienna: Könegen, 1906.

59 HEVESI, LUDWIG. Altkunst-Neukunst: Wien 1894-1908. 608 p. Vienna: Könegen, 1909.

60 HIATT, CHARLES. Picture Posters. 317 p. ill., pl. London: Bell, 1895.

61 HITCHCOCK, HENRY-RUSSELL. Architecture, Nineteenth and Twentieth Centuries. p. 281-306. Baltimore: Penguin, 1958. *Pelican History of Art, v. 15. Reviewed by J. M. Jacobus in Art Bulletin 41 no. 4: 339, Dec. 1959.*

62 HOPE, HENRY R. The Sources of Art Nouveau. Harvard University, 1952. *Unpublished Ph.D. thesis in typescript.*

63 HOUGH, GRAHAM. The Last Romantics. 284 p. London: Duckworth, 1949.

64 HUMBERT, AGNES. Les Nabis et Leur Époque 1888-1900. 152 p. 51 ill. Geneva: Cailler, 1954.

65 HUYSMANS, JORIS KARL. A Rebours. 284 p. Paris: Charpentier 1884. *Transl. as Against Nature, Penguin Books.*

66 IRONSIDE, ROBIN. Pre-Raphaelite Painters. 49 p. ill., 3 col. pl., 94 pl. New York: Phaidon, 1948.

67 JOEL, DAVID. The Adventure of British Furniture. London: Benn, 1953. *p. 53-63: L'Art Nouveau and Some Commercial Pioneers; ill.*

68 Jung Wien: Ergebnisse aus der Wiener Kunstgewerbeschule. 71 p. ill. Darmstadt: Koch, 1907.

69 KLINGSPOR, KARL. Uber Schönheit von Schrift und Druck. 155 p. ill. (pt. col.) Frankfurt/Main: Schauer, 1949.

70 KOCH, ALEXANDER. Aufruf an die deutschen Künstler . . . *Deutsche Kunst und Dekoration* 1:1 1897-1898.

71 KOCH, ALEXANDER. L'Exposition Internationale des Arts Décoratifs Modernes à Turin 1902. Text by G. Fuchs and F. H. Newbery. 340 p. ill. Darmstadt: A. Koch, 1903.

72 KOCH, ROBERT ALAN. Art Nouveau Bing. *Gazette des Beaux-Arts* 53:179-190 Mar. 1959.

73 KOCH, ROBERT ALAN. Poster movement and Art Nouveau. *Gazette des Beaux-Arts* 50:285-296 Nov. 1957.

74 LABO, MARIO. Tempo e gusto del liberty. *Emporium* 116 no. 695: 194-200 ill. Nov. 1952.

75 LAHOR, JEAN. L'Art Nouveau . . . 104 p. Paris: Lemerre, 1901.

76 LAMBERT, THEODORE. L'Art Décoratif Moderne. 40 pl. Paris: Schmid, 1900.

77 LANCASTER, CLAY. Japanese buildings in the U.S. before 1900: their influence upon American domestic architecture. *Art Bulletin* 35 no. 3:217-225 1953.

78 LANCASTER, CLAY. Oriental contributions to Art Nouveau. *Art Bulletin* 34 no. 4:297-310 1952.

79 LANCASTER, CLAY. Oriental forms in American architecture 1800-70. *Art Bulletin* 29 No. 3:183-193 1947.

80 LENNING, HENRY F. The Art Nouveau. 142 p. ill., pl. The Hague: Nijhoff, 1951.

81 LETHEVE, JACQUES. Impressionistes et Symbolistes Devant la Presse. 302 p. ill. Paris: Colin, 1959. *Bibliography.*

82 LILLEY, A. E. V. A Book of Studies in Plant Form. By A. E. V. Lilley and W. Midgley. 183 p. ill. London: Chapman; New York: Scribner's, 1907.

83 LOOS, ADOLF. Ins Leere gesprochen, 1897-1900. 167 p. Paris: Crès, 1921.

84 LOEVGREN, SVEN. The Genesis of Modernism: Seurat, Gauguin, Van Gogh and French Symbolism in the 1880's. 178 p. ill. Stockholm: Almquist & Wiskell, 1959. *Bibliography.*

85 LUX, JOSEPH AUGUST. Die Moderne Wohnung und Ihre Ausstattung. 174 p., 173 ill., 8 col. pl. Vienna: Wiener Verlag, 1905.

86 MADSEN, STEPHAN TSCHUDI. Sources of Art Nouveau. 472 p. ill. New York. Wittenborn, 1956. Translated under a Norwegian grant. *Reviewed by J. M. Jacobus in Art Bulletin 40, no. 4:364-373, Dec. 1958.*

87 MADSEN, STEPHAN TSCHUDI. Victoriansk dekorativ kunst, 1837-1901. *Nordenfjeldske Kunstindustrimuseum (Trondheim) Arbok* 1952:9-92 ill.

88 MAINDRON, ERNEST. Les Affiches Illustrées, 1881-1895. 251 p. ill. Paris: Boudet, 1896.

89 Les Maîtres de l'Affiche. Preface by Roger Marx. 5 v. of plates. Paris: Chaix, 1896-1900.

90 MAUS, MADELEINE OCTAVE. Trente Années de Lutte Pour l'Art. 1884-1914. 508 p. ill. Brussels: L'Oiseau Bleu, 1926.

91 MICHALSKI, ERNST. Die entwicklungsgeschichtliche Bedeutung des Jugendstils. *Repertorium für Kunstwissenschaft* 46:133-149 1925.

92 MICHAUD, GUY. La Doctrine Symboliste; Documents. 123 p. Paris: Nizet, 1947.

93 MICHEL, ANDRÉ. Histoire de l'Art. v. 8, pt. 3. Paris: Colin, 1925-1929. *p. 1205-1228: Paul Vitry. La Renaissance des Arts Décoratifs. . . .*

94 MORRIS, WILLIAM. Arts and Crafts Exhibition Society, London. 419 p. ill. London: Longmans, Green, 1899.

95 MORSE, EDWARD S. Japanese Homes and Their Surroundings. 372 p. ill. London: Sampson; New York: Harper, 1899. *Illustrated by the author.*

96 MOTTA, FLAVIO. São Paulo e i "Art Nouveau." *Habitat* no. 10:3-18 ill. 1953. *See also "Floreal," no. 12:58-61 ill. 1953.*

97 MOUREY, GABRIEL. Interview on Art Nouveau with Alexandre Charpentier. *Architectural Record* 12:121-125 ill. June 1902.

98 MUNICH. HAUS DER KUNST. Aufbruch zur Modernen Kunst. Munich: Haus der Kunst, 1958. *Exhibition catalog; ill.; p. 149-300: Vom Jugendstil zum Blauen Reiter.*

99 MUTHESIUS, HERMANN. Das Englische Haus. 3 v. ill. Berlin: Wasmuth, 1904-1908.

100 MUTHESIUS, HERMANN. Der Kunstgewerbliche Dilettantismus in England. 47 p. Berlin: Ernst, 1900.

100a NEW YORK. MUSEUM OF MODERN ART. Objects 1900 and Today. 15 p. New York, 1933. *Mimeograph copy containing catalogue to the exhibition and reprint of "Decorative art a generation ago," by Philip Johnson, Creative Art 12:297-299 Apr. 1933.*

101 PARIS. EXPOSITION UNIVERSELLE INTERNATIONALE DE 1900. Rapports du Jury International . . . Orfèvrerie, by T.-J. Armand-Calliat and Henri Bouilhet. 170 p. ill. Paris: Imprimerie Nationale, 1902.

102 PEVSNER, NIKOLAUS. Pioneers of Modern Design from William Morris to Walter Gropius. 2d ed. 151 p. ill. New York: Museum of Modern Art, 1949.

103 PICA, VITTORIO. L'Arte Decorative all'Esposizione di Torino del 1902. 388 p. 465 ill., 5 col. pl. Bergamo: Istituto Italiano d'Arti Grafiche, 1903.

104 PICA, VITTORIO. Attraverso gli Albi e le Cartelle: Serie 1-3 ill. Bergamo, Istituto Italiano d'Arti Grafiche, 1902-1916.

105 POLAK, BETTINA. Het Fin-de-siècle in de Nederlandse Schilderkunst. 415 p. 120 ill. The Hague: Nijhoff, 1955. *English summary.*

106 RAFOLS, J. F. Modernismo y Modernistas. 450 p. ill., pl. (pt. col.) Barcelona: Destino, 1949.

107 RATHKE, EWALD. Jugendstil. 32 p. ill., pl. Mannheim: Bibliographisches Institut, 1958.

108 REHME, WILHELM. Die Architektur der Neuen Freien Schule. 20 p. ill., 100 pl. Leipzig: Baumgärtner, 1901-1902. *Also 2 supplementary folios of plates.*

109 REWALD, JOHN. Post-Impressionism from Van Gogh to Gauguin. 614 p., 524 ill. New York: Museum of Modern Art, 1956. *Extensive bibliography. Includes section on Bernard, chap. 4, 9, bibl.*

110 RIEGGER-BAURMANN, ROSWITHA. Schrift im Jugendstil. *Börsenblatt für den deutschen Buchhandel (Frankfurt/Main)* 14, no. 31a:483-545 Apr. 21, 1958. *English excerpts: Art Nouveau script. Architectural Review 123 no. 737: 369-372 June 1958.*

111 ROH, FRANZ. Geschichte der deutschen Kunst von 1900 . . . 193 p. ill., col. pl. Munich: Bruckmann, 1958. *Deutsche Kunstgeschichte, v. 6.*

112 ROOKMAKER, H. R. Synthetist Art Theories. 284 p. Amsterdam: Swets & Zeitlinger, 1959. *Bibliography; supplement containing translations, explications, etc. 78 p.*

113 ROMAN, JEAN. Paris: Fin de Siècle. 105 p. ill. (pt. col.) Paris: Delpire, 1958.

114 SARGENT, IRENE. The wavy line. *Craftsman* 2:131-142 June 1902. *Supplementary text by J. C. Locke 201-204; A. D. F. Hamlin 3:129-143 Dec. 1902; S. Bing 5:1-15 Oct. 1903.*

115 SCHMALENBACH, FRITZ. Jugendstil. Ein Beitrag zur Theorie und Geschichte der Flächenkunst. 160 p., pl. Würzburg: Triltsch, 1935. *Dissertation, University of Münster, 1934.*

116 SCHMALENBACH, FRITZ. Kunsthistorische Studien. 139 p. Basel: Schudel, 1941.

117 SCHMUTZLER, ROBERT. Blake and Art Nouveau. *Architectural Review* 118 no. 704:90-97 ill. August 1955

118 SCHMUTZLER, ROBERT. The English origins of Art Nouveau. *Architectural Review* 117 no. 698: 108-117 ill. February 1955.

119 SCHMUTZLER, ROBERT. Jugendstil—Art Nouveau. 220 p. ill., col. pl. Stuttgart: Hatje, [Fall] 1960. *In preparation.*

120 SELING, HELMUT. Jugendstil. Der Weg ins 20. Jahrhundert. 459 p. ill. Heidelberg: Keyser, 1959. *Biographies; bibliographies.*

121 SELZ, PETER. German Expressionist Painting. 379 p. ill., pl. (pt. col.) Berkeley: U. of California, 1957.

122 SÉRUSIER, PAUL. ABC de la Peinture . . . 3d ed. 174 p. ill. Paris: Floury, 1950. *First edition, 1921.*

123 SIZÉRANNE, ROBERT DE LA. Ruskin et la Réligion de Beauté. 5th ed. 360 p. Paris: Hachette, 1901.

124 SPONSEL, JEAN LOUIS. Das Moderne Plakat. 316 p. ill., pl. Dresden: Kühtmann, 1897.

125 STERNBERGER, DOLF. Jugendstil, Begriff und Physiognomie. *Neue Rundschau* 255-271 Sep. 1934. *Also in his Über den Jugendstil und Andere Essays. 253 p. (Hamburg: Claassen, 1956.)*

126 STOCKHOLM. NATIONALMUSEUM. . . . Jugend. 63 p. ill. Stockholm, 1954. *Catalog to the exhibition.*

127 TRAPP, FRANK ANDERSON. Matisse and the spirit of Art Nouveau. *Yale Literary Magazine* 123:28-34, 1 pl.

128 TRIGGS, OSCAR LOVELL. Chapters in the History of the Arts and Crafts Movement. 198 p. pl. Chicago: Bohemia Guild of the Industrial League, 1902.

129 Um die Jahrhundertwende. *Kunstwerk* 6 no. 3 ill. 1952.

130 Um 1900. *Werk* 39 no. 12:381-406 ill. Dec. 1952.

131 WHITTICK, ARNOLD. European Architecture in the Twentieth Century. London: Lockwood, 1950. *p. 44-47: The Search for a Style—Art Nouveau.*

132 Wiener Neubauten im Stil der Sezession. 6 v. pl. Vienna: Schroll, 1908-1910.

133 Die Wiener Werkstätte, 1903-1928. Modernes Kunstgewerbe. 139 p. ill. Vienna: Krystallverlag, 1929.

134 WILDE, OSCAR. The Picture of Dorian Gray. London: Ward, 1891. *Reprinted in Penguin Books.*

135 ZEVI, BRUNO. Storia dell'Architettura Moderna. 2d ed. p. 75-88. ill. Turin: Einaudi, 1953. *Bibliography.*

136 ZUCKER, PAUL. The paradox of architectural theories at the beginning of the "modern movement." *Journal of the Society of Architectural Historians* 10 no. 3: 8-13 Oct. 1951.

137 ZURICH. KUNSTGEWERBEMUSEUM. Um 1900. Art Nouveau und Jugendstil. 48 p., pl. Zürich, 1952. *Exhibition June 28 to Sept. 28, 1952.*

II MONOGRAPHS AND INDIVIDUAL REFERENCES

Aronco, Raimondo d'

138 NICOLETTI, MANFREDI. Raimondo d'Aronco. 125 p. ill. Milan: II Balcone, 1955. *Architetti del Movimento Moderno, 14. Bibliography.*

Ashbee, Charles Robert.

139 ASHBEE, CHARLES ROBERT, ed. *Transactions of the Guild and School of Handicraft.* ill. 1, 1890. *See also bibl. 7.*

Barlach, Ernst.

140 SCHULT, FRIEDRICH. Ernst Barlach: das Graphische Werk. 190 p. ill. Hamburg: Hauswedell, 1958. *Werkverzeichnis, v. 2; bibliography.*

Beardsley, Aubrey.

141 BEARDSLEY, AUBREY. The Early Work of Aubrey Beardsley. 18 p., 157 pl. London, New York: Lane, 1899. *Also 1912 edition.*

142 BEARDSLEY, AUBREY. The Later Work . . . 6 p., 173 pl. London, New York: Lane, 1901. *Also 1912 edition.*

143 IRONSIDE, ROBIN. Aubrey Beardsley. *Horizon* 14 no. 81: 190-202 ill. Sept. 1946.

144 WALKER, R. A. The Best of Beardsley. 26 p., pl. London: Bodley Head, 1948. *Bibliography.*

Behrens, Peter.

145 CREMERS, PAUL JOSEPH. Peter Behrens: Sein Werk von 1909 bis zur Gegenwart. 168 p. ill. Essen: Baedeker, 1928

146 HOEBER, FRITZ. Peter Behrens. 249 p. ill. Munich: Müller & Rentsch, 1913. *Bibliography. See also bibl. 11.*

Bernard, Émile.

147 CHESNEAU, MARC. Emile Bernard. *Cahiers d'Art* no. 100: 1-25 ill. 1959. *Bibliography.*

148 JAMOT, PAUL. Émile Bernard. Paris: Galerie Charpentier, 1953. *Catalog to the exhibition with introduction by Jamot. Unpaged, ill. 260 exhibition items. See also bibl. 109.*

Bonnard, Pierre. see bibl. 234.

Bradley, William H.

149 BRADLEY, WILLIAM H. Will Bradley; His Chap Book. 104 p. New York: The Typophiles, 1955.

149a ETTINGER, PAUL. W. H. Bradley. *Zeitschrift für Bücherfreunde* N.F. 1 pt. 2:223-233 ill. 1909.

150 HIATT, CHARLES. On some recent designs by Bradley. *Studio* 4:166-168 ill. 1894.

151 STONE, HERBERT STUART. Mr. Bradley's drawings. *Chapbook* 2 no. 2:55-62 ill. Dec. 1, 1894.

Burne-Jones, Edward.

152 BELL, MALCOLM. Edward Burne-Jones. 151 p., pl. London: Bell, 1892.
153 WILSON, HENRY. The work of Sir Edward Burne-Jones more especially in decoration and design. *Architectural Review* 1:117-181, 225-233, 273-281. 1897.

Campanini, Alfredo.

154 SCHEICHENBAUER, MARIO. Alfredo Campanini. 37 p. ill., col. pl. Milan: Agnelli, 1958.

Charpentier, Alexandre.

155 MOUREY, G. A decorative modeller: Alexandre Charpentier. *Studio* 10:157-165 ill. 1896. *See also bibl. 97.*

Chéret, Jules.

156 BERALDI, HENRI. Les Graveurs du XIXième Siècle. v. 4, p. 168-203. Paris, 1885-1892. *Lists Chéret's works.*
157 VETH, CORNELIS. Jules Chéret. *Maandblad vor Beeldende Kunsten* 7:3-10 ill. 1930.

Christiansen, Hans.

158 SCHLIEPMANN, H. Hans Christiansen. *Deutsche Kunst und Dekoration* 2:289-299 1898. *Illustrations, p. 289-325 passim; autobiographical note, p. 323-325.*

Colenbrander, Th. A. C.

159 DE G., W. J. In Memoriam Th. A. Colenbrander 1841-1930. *Elseviers Geïllustreerd Maandschrift* 80:143, 1930.

Crane, Walter.

160 KONODY, PAUL GEORGE. The Art of Walter Crane. 147 p. ill., pl. (pt. col.) London: Bell, 1902. *See also bibl. 25-27.*

Debschitz, Wilhelm von.

161 WESTHEIM, P. Die Ausstellung der Debschitzschule im berliner Kunstgewerbemuseum. *Dekorative Kunst* 17:89-100 ill. 1913. *Also Die keramische Werkstätte von Debschitz, p. 273-278.*

Denis, Maurice see bibl. 18, 30, 218, 234.

Eckmann, Otto.

162 ECKMANN, OTTO. Neue Formen; Dekorative Entwürfe für die Praxis. 3 p., 3 col. pl. 1. Sammlung. Berlin: Spielmayer, 1897.

163 ECKMANN, OTTO. Berliner Kunst. 46 p. ill., pl. Berlin: Wasmuth, 1901. *Berliner Architekturwelt, Sonderheft 1.*

Endell, August.

164 ENDELL, AUGUST. Architekonische Erstlinge. *Dekorative Kunst* 3 no. 7:297-317 ill. 1900.
165 ENDELL, AUGUST. Gedanken: Formkunst. *Dekorative Kunst* 1:280 1898.
166 ENDELL, AUGUST. Die Schönheit der Grossen Stadt. 88 p., 3 pl. Stuttgart: Strecker & Schröder, 1908.

Feure, Georges de.

167 MOUREY, GABRIEL. Georges de Feure. *Studio* 12:95-102 ill. 1898.
168 PUAUX, RENÉ. Georges de Feure. *Deutsche Kunst und Dekoration* 12:313-348 ill. 1903.

Gallé, Emil.

169 FOURCAUD, LOUIS DE. Emile Gallé. 69 p. ill. Paris: Librairie de l'Art Ancien et Moderne, 1902. *Reprint from: Revue de l'Art Ancien et Moderne, 11:34-44, 171-186; 12:281-296, 337-352 ill. 1902.*
170 FRANTZ, HENRY. Emil Gallé and the decorative artists of Nancy. *Studio* 28:108-116 ill. 1903.
171 GALLÉ, EMIL. Écrits pour l'Art. 38 p. Paris: Laurens, 1908.
172 HENRIVAUX, JULES. Emil Gallé. *Art Décoratif* 13:124-235 ill. 1905.
173 Die Kristallkünstler Nancy. *Dekorative Kunst* 2:100-102 1899. *Illustrations, p. 126-130.*

Gaudí, Antonio.

174 COLLINS, GEORGE R. Antonio Gaudí. 136 p. ill. New York: Braziller, 1960. *Bibliography.*
175 HITCHCOCK, HENRY-RUSSELL. Gaudí. Foreword by Arthur Drexler. 47 p., 85 ill. New York: Museum of Modern Art, 1957.
176 RAFOLS, JOSÉ F. Antoni Gaudí 1852-1926. 289 p. ill., pl. Barcelona: Aedos, 1952. *Bibliography. Also 1938 edition.*

Gauguin, Paul.

177 BODELSEN, MERETE. The missing link in Gauguin's cloisonism. *Gazette des Beaux Arts* 53:329-344 ill. May 1959.
178 GOLDWATER, ROBERT JOHN. Paul Gauguin. 160 p. ill., pl. New York: Abrams, 1957. *Bibliography. See also bibl. 250.*

Guimard, Hector.

179 BAUS, G. Les gares métropolitain de Paris. *Art Décoratif* 7:38-40 ill. 1900.
180 GUIMARD, HECTOR. An architect's opinion of l'Art Nouveau. *Architectural Record* 12:127-133 ill. June 1902.

181 GUIMARD, HECTOR. Le Castel Béranger. 65 col. pl. Paris: Rouam, 1898.
182 MAZADE, FERNANDE. An "Art Nouveau" edifice in Paris . . . Hector Guimard, architect. *Architectural Record* 12:50-66 ill. 1902.

Heine, Th. Theodor.

183 CORINTH, LOVIS, Th. Theodor Heine. *Kunst & Künstler* 4:143-156 1906.
184 ESSWEIN, H. T. Th. Heine. Munich: Piper, 1904. *Moderne Illustratoren, 1.*
185 POPPENBERG, FELIX. Buchschmuck von T. Th. Heine. *Zeitschrift fur Bücherfreunde* 1:264-269 ill. 1897.

Hodler, Ferdinand.

186 BENDER, EWALD and Werner Y. Müller. Die Kunst Ferdinand Hodlers. 2 v. ill. Zürich: Rascher, 1922-1941. *v. 1 (1922); v. 2 (1941).*
187 BURGER, FRITZ. Cézanne und Hodler. 2 v. ill. Munich: Delphin, 1919.

Hoffmann, Josef

188 GIRARDI, VITTORIA. Joseph Hoffmann maestro dimenticato. *Architettura* no. 12:432-444 ill. Oct. 1956.
189 KHNOPFF, FERNAND. Joseph Hoffmann e la "Secession" viennese . . . *Architettura Cantiere* 21:51-54 ill. 1959.
190 KLEINER, LEOPOLD. Josef Hoffmann. 31 p., 89 pl. in folio. Berlin: Hübsch, 1927.
191 LEVETUS, A. S. A Brussels mansion designed by Prof. Joseph Hoffmann of Wien. *Studio* 61:189-196 ill. 1914.
192 ROCHOWANSKI, L. W. Josef Hoffmann. 67 p. ill. Vienna: Österreichische Staatsdruckerei, 1950.
193 ZUCKERKANDL, B. Josef Hoffmann. *Dekorative Kunst* 7:1-17 1903. *Illustrations, p. 1-32 passim. See also bibl. 200.*

Horta, Victor.

194 DELEVOY, ROBERT L. Victor Horta. 11 p., 30 pl. Brussels: Ministère de l'Instruction Publique, 1958.
195 GIRARDI, VITTORIA. Letture di Victor Horta: 1-8. *Architettura* no. 23-30 Sept. 1957-April 1958.
196 KAUFMANN, EDGAR. Victor Horta. *Architect's Yearbook* 8:124-136 ill. 1957. *Includes list of Horta's work.*
197 MADSEN, STEPHAN TSCHUDI. Horta: works and style . . . before 1900. *Architectural Review* 118:389-392 ill. 1955.

Jourdain, Franz.

198 FRANZ JOURDAIN. *Architecte* 2:13-20 ill. 1907.

Kandinsky, Wassily.

199 GROHMANN, WILL. Wassily Kandinsky. 428 p. ill., pl. New York: Abrams, 1958. *Extensive bibliography.*

Klimt, Gustav.

200 EISLER, MAX. Gustav Klimt. 57 p., 34 pl. (pt. col.) Vienna: Rikola, 1921. *Designed by Josef Hoffmann.*
201 FLEISCHMANN, BENNO. Gustav Klimt. Eine Nachlese. 20 p., 45 pl. (pt. col.) Vienna: Deuticke, 1946.
202 KLIMT, GUSTAV. 25 Handzeichnungen. 4 p., 25 pl. Vienna: Gilhofer & Ranschburg, 1919.
203 PIRCHAN, EMIL. Gustav Klimt. 55 p., pl. Vienna: Bergland, 1956.
204 VIENNA. VEREINIGUNG DER BILDENDEN KUENSTLER ÖSTERREICHS. Kollektivausstellung Gustav Klimt. 72 p. ill., pl. Vienna: Ver Sacrum, 1903. *Catalog to the exhibition. Supplementary pictorial material: Die Wiener Sezession und die Ausstellung in St. Louis. Ver Sacrum, 1904; Drawings by Klimt. Ver Sacrum, 1903, no. 22: 22 pl. Nov. 1903.*

Khnopff, Fernand.

205 KOCH, ROBERT ALAN. A poster by Fernand Khnopff. *Marsyas* 6:72-74 1950-1953.

Köpping, Karl.

206 GRAUL, RICHARD. Karl Köpping. *Graphische Künste* 17:28-35 ill. 1894. *Contains list of works.*
207 ROEPER, ADALBERT. Karl Köpping zum 60. Geburtstag. *Börsenblatt* 142:6855-6860, June 1908.

Lacombe, George see bibl. 234.

Lalique, René.

208 GEFFROY, GUSTAVE. René Lalique. 43 p., 12 pl. Paris: Mary, 1922.
209 MARX, ROGER. René Lalique. *Art et Décoration* 7:13-22 ill. 1899.

Lemmen, Georges.

210 NYNS, MARCEL. Georges Lemmen. 16 p., 24 pl. Antwerp: de Sikkel, 1954. *Bibliography.*

Mackintosh, Charles Rennie.

211 HOWARTH, THOMAS. Charles Rennie Mackintosh and the Modern Movement. 329 p. ill., 96 pl. London: Routledge and Kegan Paul, 1952. *Chronological table; bibliography.*
212 MCLELLAN GALLERIES, GLASGOW. Charles Rennie Mackintosh . . . Memorial Exhibition. 24 p., pl. Glasgow: McLellan, 1933.

158

213 PEVSNER, NIKOLAUS. Charles R. Mackintosh. 152 p. ill., pl. Milan: Il Balcone, 1950. *Architetti del Movimento Moderno, 8. List of works, bibliography.*

214 WHITE, GLEASON. Some Glasgow designers and their work. pt. 3. *Studio* 12:48 1898.

Mackmurdo, Arthur H.

215 MACKMURDO, ARTHUR H. Nature in ornament. *Hobby Horse (London)* 7:62-68 1892.

216 PEVSNER, NIKOLAUS. Arthur H. Mackmurdo. *Architectural Review* 83:141-143 ill. 1938.

Majorelle, Louis.

217 JUYOT, PAUL. Louis Majorelle: Artiste Décorateur, Maître Ébeniste. Nancy, 1926.

Maillol, Aristide.

218 DENIS, MAURICE. Aristide Maillol. 42 p., 42 pl. Paris: Crès, 1925.

219 REWALD, JOHN. Maillol. 167 p. ill. London, New York: Hyperion, 1939. *Extensive bibliography.*

Minne, Georges.

220 PUYVELDE, LEO VAN. Georges Minne. 85 p., 141 pl. Brussels: Cahiers de Belgique, 1930.

221 RIDDER, ANDRÉ DE. Georges Minne. 16 p., pl. Antwerp: De Sikkel, 1947. *Bibliography.*

Modersohn-Becker, Paula.

222 PAULI, GUSTAV. Paula Modersohn-Becker. 3d ed. 87 p., 59 pl. Berlin: Wolff, 1919. *Includes catalog of her work.*

Morris, William.

223 CROW, GERALD H. William Morris designer. 120 p. ill. London: Studio, 1934. *Special Studio issue, Winter 1934; bibliography.*

224 MACKAIL, J. W. The Life of William Morris. 792 p. New York: Oxford University Press, 1950.

225 MORRIS, WILLIAM. Selected Writings, ed. by William Gaunt. 64 p. London: Falcon Press, 1948.

226 SPARLING, H. HALLIDAY. The Kelmscott Press and William Morris, Master Craftsman. 176 p. ill. London: Macmillan, 1924.

227 VALLANCE, AYNER. William Morris. 462 p. ill. London: Bell, 1897.

228 VIDALENC, GEORGES. William Morris. 166 p., 19 pl. Paris: Alcan, 1920. *See also bibl. 7, 94.*

Moser, Koloman.

229 ZUCKERKANDL, B. Koloman Moser. *Dekorative Kunst* 7:329-344 ill. 1904. *Illustrations, p. 329-359 passim.*

Munch, Edvard.

230 DEKNATEL, FREDERICK B. Edvard Munch. 120 p. ill. (pt. col.) New York: Museum of Modern Art, 1950. *Bibliography by Hannah Muller, later enlarged for Oslo Kommunes Kunst Samlingers Arbok 1946-51.*

231 MOEN, ARNE. Edvard Munch. 3 v. ill. Oslo: Norsk Kunstreproduksjon, 1956-1958. *Bibliography.*

232 SCHIEFLER, GUSTAV. Edvard Munch, das Graphische Werk. Berlin: Euphorion, 1907-1928. *v.1 (1907); v.2 (1928).*

233 STRINDBERG, AUGUST. L'exposition d'Edvard Munch. *Revue Blanche* 10:525-526 1896.

Les Nabis

234 Paris. MUSÉE NATIONAL D'ART MODERNE. Bonnard, Vuillard et les Nabis. 110 p., 25 pl. Paris: Éditions des Musées Nationaux, 1955. *See also bibl. 64 for Bonnard, Denis, Lacombe, Ranson, Roussel, Sérusier, Vallotton, Verkade, Vuillard.*

Obrist, Hermann.

235 BODE, WILHELM. Hermann Obrist. *Pan* 1 no. 5: 326-328 ill. 1895-1896. *Preceded by: Fuchs, Georg. Hermann Obrist, p. 318-325.*

236 FRED, W. A chapter on German arts and crafts with special reference to the work of Hermann Obrist. *Artist* 31:17-26 1901.

237 OBRIST, HERMANN. Neue Möglichkeiten in der Bildenden Kunst. Aufsätze von 1896-1900. 170 p. Leipzig: Diederichs, 1903. *See also bibl. 247.*

Olbrich, Joseph M.

238 LUX, JOSEPH AUGUST. Joseph M. Olbrich. 134 p., pl. Berlin: Wasmuth, 1919.

239 OLBRICH, JOSEPH M. Architektur. 6 v. 450 pl. (pt. col.) Berlin: Wasmuth, 1902-1914.

240 OLBRICH, JOSEPH M. Ideen. 121 p. ill., pl. Vienna: Gerlach & Schenck, 1900. *2d ed., Leipzig: Baumgärtner, 1904.*

241 VERONESI, GIULIA. Joseph M. Olbrich. 168 p. incl. 100 pl. Milan: Il Balcone, 1948. *Architetti del Movimento Moderno, 7; bibliography.*

Pankok, Bernhard.

242 LANGE, KONRAD. Bernhard Pankok. *Dekorative Kunst* 8:125-160 ill. 1905.

Ranson, Paul E. see bibl. 234.

Redon, Odilon.

243 MELLERIO, ANDRÉ. Odilon Redon. 166 p., pl. Paris: Société pour l'Étude de la Gravure Française, 1923. *Bibliographie et expositions; catalogue de l'oeuvre gravé . .[et] . . lithographié.*

159

244 PARIS. MUSÉE DE L'ORANGERIE. Odilon Redon. 113 p., pl. Paris: Éditions des Musées Nationaux, 1956. *Exhibition catalog with documentation.*

245 REDON, ODILON. A Soi-Même. 179 p. Paris: Floury, 1922.

Riemerschmid, Richard.

246 MUTHESIUS, HERMANN. Die Kunst Richard Riemerschmids. *Dekorative Kunst* 7:249-283 ill. 1904.

247 OBRIST, HERMANN. Die Zukunft unserer Architektur. *Dekorative Kunst* 4:329-349 1901. *Illustrations, p. 329-373 passim.*

Rodin, Auguste.

248 GRAPPE, GEORGES. Le Musée Rodin. 151 p., pl. Monaco: Documents d'Art, 1944. *Bibliography.*

249 MAUCLAIR, CAMILLE. Auguste Rodin. 147 p., pl. London: Duckworth, 1909. *Translated from the French; bibliography. See also bibl. 18.*

Roussel, Ker Xavier see bibl. 234.

Seguin, Armand.

250 BARC DE BOUTTEVILLE. Paris. Exposition . . . Armand Séguin. Preface by Paul Gauguin. 21 p. Paris: Renaudie, 1895.

251 SÉGUIN, ARMAND. Gauguin. *Occident* no. 16-18 1903.

Sérusier, Paul see bibl. 122, 234.

Sommaruga, Giuseppe.

252 SOMMARUGA, GIUSEPPE. L'Architettura di Giuseppe Sommaruga. ill., 59 pl. Milan: Preiss & Bestetti, 1908.

253 SOMMARUGA, GIUSEPPE. The Palazzo Castiglioni, Milan. *Architektur des XX. Jahrhunderts* 5:22-23 ill. 1905.

254 TENTORI, FRANCESCO. . . . Giuseppe Sommaruga. *Casabella Continuità* no. 217:70-87 ill. 1957.

Sullivan, Louis.

255 MORRISON, HUGH. Louis Sullivan, Prophet of Modern Architecture. 391 p. ill., pl. New York: Museum of Modern Art, 1935. *Bibliography. Also reprint: New York: Peter Smith, 1952; supplementary bibliography.*

256 SULLIVAN, LOUIS. Characteristics and tendencies of American architecture. *Inland Architect and Builder* 6:58 ff. Nov. 1885. *Reprinted in his Kindergarten Chats, New York 1947.*

Steichen, Edward J.

257 CAFFIN, CHARLES H. Edward J. Steichen's work—an appraisal. *Camera Work* no. 2:21-24, 11 pl. April 1903. *Followed by: Allan, Sidney. A visit to Steichen's studio, p. 25-28.*

258 EDWARD J. STEICHEN. Preface by Maurice Maeterlinck. 16 pl. *Camera Work* April 1906. *Special Steichen supplement, unnumbered.*

259 GALLATIN, A. E. The paintings of Edward J. Steichen. *International Studio* 40:40-43 ill. 1910.

Thorn-Prikker, Jan.

260 CREUTZ, MAX. Jan Thorn-Prikker. 32 pl. München-Gladbach, 1925.

261 HOFF, AUGUST. Johan Thorn-Prikker. 54 p. ill. pl. (pt. col.) Recklinghausen: Bongers, 1958. *Bibliography.*

Tiffany, Louis Comfort.

262 KAUFMANN, EDGAR. At home with Louis Comfort Tiffany. *Interiors* 117:118-125 ill. Dec. 1957.

263 KOCH, ROBERT. Louis Comfort Tiffany 1848-1933. 47 p., 30 ill., 3 col. pl. New York: American Craftsmen's Council; Museum of Contemporary Crafts, 1958. *Catalog of exhibition; chronology; bibliography.*

264 SPEENBURGH, GERTRUDE. The Arts of the Tiffanys. 116 p. ill., pl. Chicago: Lightner, 1956.

265 TIFFANY, LOUIS. The Art Work of Louis Tiffany. 90 p., pl. (pt. col.) Garden City: Doubleday, 1914.

Toorop, Jan.

266 PLASSCHAERT, A. Jan Toorop. 8 p., 40 pl. Amsterdam: Vorst & Taš, 1929.

Toulouse-Lautrec, Henri de.

267 JOYANT, MAURICE, Henri de Toulouse-Lautrec, 1864-1901. 2 v. ill., col. pl. Paris: Floury, 1926-1927.

268 MACK, GERSTLE. Toulouse-Lautrec. 370 p., 58 ill. New York: Knopf, 1938. *Bibliography.*

Vallotton, Félix Édouard see bibl. 234.

Velde, Henry van de.

269 CASTEELS, MAURICE. Henry van de Velde. 16 p., 29 pl. Brussels: Cahiers de Belgique, 1932.

270 OSTHAUS, KARL ERNST. Van de Velde. Hagen: Folkwang, 1920.

271 VELDE, HENRY VAN DE. Amo. 25 p. Leipzig: Inselverlag, 1912. *Insel-Bücherei, 3.*

272 VELDE, HENRY VAN DE. Déblaiement d'Art. 33 p. ill. Brussels: Monnom, 1894.

273 VELDE, HENRY VAN DE. Extracts from his memoirs: 1891-1901. *Architectural Review* 112:143-155 ill. 1952.

273a VELDE, HENRY VAN DE. Kunstgewerbliche Laienpredigten. Leipzig: Herman Seemann, 1902.

274 VELDE, HENRY VAN DE. Der Neue Stil. 101 p. Leipzig: Inselverlag, 1907. *Laienpredigten, pt. 2.*

275 VELDE, HENRY VAN DE. Die Renaissance im Modernen Kunstgewerbe. 147 p. Berlin: Cassirer, 1903.

276 ZUERICH. KUNSTGEWERBEMUSEUM. . . . Henry van de Velde. 83 p. ill., pl. Zürich, 1958. *Exhibition catalog; bibliography.*

Verkade, Jan see bibl. 234.

Villon, Jacques.

277 PARIS. BIBLIOTHEQUE NATIONALE. Jacques Villon: L'Oeuvre Gravé. Preface by Jean Vallery-Radot. 75 p. ill. Paris, 1959. *Exhibition catalog with bibliography.*

278 VALLIER, DORA. Jacques Villon; oeuvres de 1897-1956. 120 p. ill. (pt. col.) Paris: Cahiers d'Art, 1957. *Text also in English; bibliography.*

Voysey, Charles Francis Annesley.

279 BETJEMAN, JOHN. Charles Francis Annesley Voysey: the architect of individualism. *Architectural Review* 70:93-96 1931.

280 JONES, JOHN BRANDON. C.F.A. Voysey. *Architectural Association Journal (London)* 72:239-262 ill. May 1957. *Chronology; bibliography.*

Vuillard, Edouard see bibl. 234.

Wagner, Otto.

281 LUX, JOSEPH AUGUST. Otto Wagner: eine Monographie. 167 p. ill., 79 pl. Munich: Delphin, 1914.

282 TIETZE, HANS. Otto Wagner. 16 p., pl. Vienna: Rikola, 1922.

283 WAGNER, OTTO. Einige Skizzen, Projekte und Ausgeführte Bauwerke . . . 4 v. ill., 216 pl. Vienna: Schroll, 1892-1922.

284 WAGNER, OTTO. Moderne Architektur. 138 p. ill. Vienna: Schroll, 1895. *4th ed.: Die Baukunst unserer Zeit, 1914.*

285 WAGNER, OTTO. 1902 Wagner-Schule. 84 p. ill. Leipzig: Baumgärtner, 1902.

286 WICK-WAGNER, LOUISE. Der Freiheit eine Gasse. *Baukunst und Werkform* 9:476-484 ill. Sept. 1959. *Preceded by Richard Neutra: Erinnerungen an Otto Wagner.*

Wolfers, Philippe.

287 PICA, VITTORIO. Philippe Wolfers. *Emporium* 27:1-23 1908.

288 PIERRON, S. Philippe Wolfers. *Revue des Arts Décoratifs* 21:153-160. 1900.

III SELECTED PERIODICALS

L'Art Décoratif, Paris, 1898-

Art et Décoration, Paris, 1897-

L'Art Moderne, Brussels, 1881-

The Chap Book, Chicago, 1894-1898

The Craftsman, Eastwood, N.Y., 1901-

Dekorative Kunst, Munich, 1897-

Deutsche Kunst und Dekoration, Darmstadt, 1897-

The Dial, London, 1889-1897

Die Graphischen Künste, Vienna, 1879-

Hobby Horse, London, 1884 (no. 1), 1886-1892, n.s. 1893

Die Insel, Berlin/Leipzig, 1899-1902

Jugend, Munich, 1896-

Die Kunst, Munich, 1897-

Kunst und Kunsthandwerk, Vienna, 1898-

Pan, Berlin, 1895-1900

La Plume, Paris, 1899-1913

Revue des Arts Décoratifs, Paris, 1880-1902

La Revue Blanche, Paris, 1891-1903

Revue Wagnérienne, Paris, 1885-1888

The Savoy, London, 1896

Simplizissimus, Munich, 1896-

The Studio, London, 1893-

Van Nu en Straks, Brussels, Antwerp, 1892-1901

Ver Sacrum, Vienna, 1898-1903

The Yellow Book, London, 1894-1897

Zeitschrift für Innendekoration. Darmstadt, 1890-

LENDERS TO THE EXHIBITION

Mrs. Alfred H. Barr, Jr., New York; Leonard Baskin, Northampton, Massachusetts; Mrs. F. Beer-Monti, New York; Mlle H. Boutaric, Paris; Stephan L. Bruce, New York; Dominique Denis, St. Germain-en-Laye, France; Joseph H. Heil, New York; H.R.H. Ludwig, Prince von Hessen u.b. Rhein, Wolfsgarten-Langen, Germany; Mme La Baronne Horta, Brussels; Thomas Howarth, Toronto; Louis James, New York; Mrs. Sidney Janis, New York; Mr. and Mrs. Samuel Josefowitz, New York; R. Stewart Kilborne, New York; Dr. and Mrs. Robert Koch, South Norwalk, Connecticut; Mme Sylvie Mora-Lacombe, Paris; Mr. and Mrs. Hugo Perls, New York; Robert Pincus-Witten, Chicago; Easton Pribble, Utica, New York; Stephen Radich, New York; Kurt Reutti, Berlin; John Rewald, New York; Gerd Rosen, Berlin; Hans Schmithals, Munich; Mrs. Bertram D. Smith, New York; Theodoros Stamos, New York; Herbert Stuart Stone, Jr., Wallingford, Connecticut; Mr. and Mrs. Justin K. Thannhauser, New York; Mr. and Mrs. Harold Uris, New York; Mrs. Charles Vidor, Beverly Hills, California; Carl Weinhardt, New York; The Hon. and Mrs. John Hay Whitney, London; Dr. Siegfried Wichmann, Starnberg, Germany; Mr. and Mrs. Harry Lewis Winston, Birmingham, Michigan; L. Wittamer-de-Camps, Brussels.

Rijksmuseum Library, Amsterdam; Stedelijk Museum, Amsterdam; Bibliothèque Royale de Belgique, Brussels; Musées Royaux d'Art et d'Histoire, Brussels; The Art Institute of Chicago; Newberry Library, Chicago; Cleveland Museum of Art; Deutscher Kunstrat, Cologne; Det Danske Kunstindustrimuseet, Copenhagen; Hessisches Landesmuseum, Darmstadt; Museum für Kunsthandwerk, Frankfurt-am-Main; Musée des Beaux-Arts, Ghent; The Glasgow School of Art; The University of Glasgow; Karl-Ernst-Osthaus-Museum, Hagen; Gemeentemuseum, The Hague; Museum für Kunst und Gewerbe, Hamburg; Victoria and Albert Museum, London; Los Angeles County Museum; Münchner Stadtmuseum, Munich; Städtische Galerie und Lenbachgalerie, Munich; Staatliche Graphische Sammlung, Munich; Musée de l'Ecole de Nancy; Butler Library, Columbia University, New York; Cooper Union Museum for the Arts of Decoration, New York; The Metropolitan Museum of Art, New York; Morgan Library, New York; Museum of the City of New York; The Museum of Modern Art, New York; New York Public Library, Berg Collection; Allen Art Museum, Oberlin College, Oberlin, Ohio; Klingspor Museum, Offenbach; Nasjonalgalleriet, Oslo; Rijksmuseum Kröller-Müller, Otterlo, The Netherlands; Musée des Arts Décoratifs, Paris; Musée National d'Art Moderne, Paris; Philadelphia Museum of Art; Princeton University Library; Museum Boymans van Beuningen, Rotterdam; Nationalmuseum, Stockholm; Landesgewerbemuseum, Stuttgart; Nordenfjeldske Kunstindustrimuseum, Trondheim; Galerie Internazionale d'Arte Moderna, Venice; Österreichisches Museum für Angewandte Kunst, Vienna; The William Morris Gallery, Walthamstow, England; Kunstgewerbemuseum, Zurich.

Peter Deitsch Gallery, New York; Hirschl and Adler Galleries, Inc., New York; Lillian Nassau Antiques, New York; Wildenstein & Co., New York.

BIOGRAPHIES AND CATALOGUE OF THE EXHIBITION

Works marked with an asterisk are illustrated. In the dimensions of the objects, height precedes width. Architecture photographic enlargements are listed on page 185.

UNKNOWN

1 Belt buckle. (c. 1900.) Abstract arabesque of silver-plated metal, decorated with multicolored enamel. 5¼" long. Collection Mrs. Sidney Janis, New York

UNKNOWN

2 Letter opener. (c. 1900.) Ivory, with maple seed decoration in green enamel. 9⅛" long. Collection Joseph H. Heil, New York

UNKNOWN

3 Café sign. (1900.) Bronze. 16 x 26". The Museum of Modern Art, New York. Gift of Joseph H. Heil

UNKNOWN

4 Figurine; girl throwing ball. (c. 1900.) Bronze. 5⅛" high. Signed "Burger." Collection Joseph H. Heil, New York

UNKNOWN (United States?)

5 Necklace. (c. 1900.) Gold, enamel, pearls, diamonds, aquamarines. 15" long x 5½" wide. Collection Dr. and Mrs. Robert Koch, South Norwalk, Connecticut

UNKNOWN (Austria?)

6 Wall hanging. (c. 1900-10.) Appliqué embroidery of

silk metal and silk cord on grey satin. 87½ x 49½″. Öster reichisches Museum für Angewandte Kunst, Vienna

UNKNOWN (Austria)
7 Miniature chest. (1905-06.) Inlayed macassar, ebony, and maple, with enamel plaques showing two women seen in profile. 16⅛″ high x 17¾″ wide. Österreichisches Museum für Angewandte Kunst, Vienna

UNKNOWN (Austria)
8 Table lamp. Iridescent glass. 21¼″ high. Collection Easton Pribble, Utica, New York

UNKNOWN (Birmingham, England)
9 Sconce. (c. 1900.) Gilded brass with three faïence plaques. 19¾″ high x 12½″ at base. Collection Louis James, New York

UNKNOWN (England?)
10 Printed cretonne. (c. 1900.) Multicolored pattern of trees and flowers on white background. 31½″ long. Landesgewerbemuseum, Stuttgart

UNKNOWN (France?)
11 Ink stand. (c. 1900.) Bronze. 2″ high x c. 8¾″ long. The Museum of Modern Art, New York. Phyllis B. Lambert Fund

UNKNOWN (France)
12 Miniature picture frame. (c. 1895-1905.) Silver with chrysoprase. 2¾ x 2⅞″. Collection Carl Weinhardt, New York

UNKNOWN (Germany)
13 *Die Halbinsel.* 1900. Single issue of a satirical magazine published by the *Cococello* artists' club in Munich. Book size 12⅞ x 6⅞″. Collection Gerd Rosen, Berlin

UNKNOWN (Germany?)
14 Decanter. (c. 1900.) Engraved crystal; silver-plated metal mounting. 15″ high. Collection Mrs. Sidney Janis, New York

UNKNOWN (Germany?)
15 Rug. (c. 1900.) Knotted wool; abstract feather design on green background. 12′7″ x 9′8″. Museum für Kunsthandwerk, Frankfurt am Main

ASHBEE, CHARLES ROBERT (1863-1942)
English architect, designer and writer. Influenced by Morris, but advocated the use of the machine in applied art. Concentrated on all aspects of interior design, including furniture and silverware. One of the original members of the Arts and Crafts Movement. Influential in the improvement of factory workshops. In 1888 founded the Guild and

School of Handicraft, of which he was chief designer, and in 1904 the School of Arts and Crafts which continued until 1914. He ran the Essex House Press, for which he designed a type face. From 1919-23 he was Civic Advisor to the Palestine Administration.

*16 Bowl. (c. 1893.) Silver, embossed and chased with a leaf design, and with cast legs. 8″ high. Made by the Guild of Handicraft. Victoria and Albert Museum, London. *Ill. p. 90*

17 Mustard spoon. (c. 1900.) Silver, decorated with turquoise. 4″ long. Made by the Guild of Handicraft. Kunstgewerbe Museum, Zurich

AUDIGER & MEYER, KREFELD
18 Pillow case. 1908. Woven silk; Japanese abstract wave pattern in shades of brown and olive. 23½ x 17″. Made by Audiger & Meyer, Krefeld. Landesgewerbemuseum, Stuttgart

BARLACH, ERNST (1870-1938)
German sculptor, printmaker and playwright. Received his education in Hamburg, Dresden and Paris. Contributor to *Jugend* from 1897 to 1902, Barlach worked at first in the German Art Nouveau style. Developed his own style after a trip to Russia in 1906. Lived mainly in North Germany and became one of the great Expressionist sculptors.

*19 *Cleopatra.* (1904.) Ceramic. 9″ x 26⅛″. Kunsthalle, Bremen. Dora and Kurt Reutti Foundation

19a Commemorative plaque of Justus Brinkmann. c. 1902. Glazed ceramic. Museum für Kunst und Gewerbe, Hamburg

BAZEL, KAREL PETRUS CORNELIS DE (1869-1923)
Dutch architect, designer and graphic artist. Studied with P. J. H. Cuypers. With Nieuwenhuis, Lauweriks and Cachet he created the Dutch version of Art Nouveau. His book illustrations show some influence of Egyptian design and the impact of Symbolism in Holland is evident in his woodcuts done around 1894.

20 Prospectus for *Tydschrift voor Ercieringskunst.* 1896. Woodcut. 6¼ x 4″. Gemeentemuseum, The Hague

BEARDSLEY, AUBREY VINCENT (1872-1898)
English graphic artist and illustrator. Self-taught; as a young boy made caricatures and illustrations. At the age of nineteen, after a visit to Burne-Jones' studio, decided to dedicate himself completely to his art. Illustrations for Malory's *Morte d'Arthur* (1892), show the influence of the Pre-Raphaelites and William Morris. Fully developed his own style in the illustrations for Oscar Wilde's *Salome.* 1894 art editor of the *Yellow Book,* and, following his dismissal after the Wilde case, of the *Savoy* in 1895. Prolific production until his early death at the age of 26.

*21 *"J'ai baisé ta bouche Jokanaan."* Preliminary drawing for *Salome* by Oscar Wilde. (1893.) Ink and watercolor. 10⅞ x 5¾". Princeton University Library. *Ill. p. 67*

22 *The Black Cape.* Illustration from *Salome* by Oscar Wilde. (1893.) Ink. Princeton University Library

*23 *Ave Atque Vale* from *The Savoy,* No. 7. (1896.) Ink. 6⅜ x 4⅛". Mr. and Mrs. John Hay Whitney, New York. *Ill. p. 18*

24 *Publisher. Children's Books.* Poster. 30 x 11⅜". The Museum of Modern Art, New York. Purchase

*25 *Morte d'Arthur* by Thomas Malory. 1893. Book size, 9¾ x 8". Klingspor Museum, Offenbach. *Ill. p. 22*

*26 Binding for *Salome* by Oscar Wilde. 1907. Book size, 8½ x 7". Klingspor Museum, Offenbach. *Ill. p. 21*

27 Binding for *Under the Hill.* Book size, 10¼ x 7¾". Newberry Library, Chicago

BEHMER, MARCUS (1879-)

German graphic artist. Noted as master of German book design. In 1903 designed a luxury edition of Wilde's *Salome* for the Insel Verlag in Leipzig. Developed a very rich and delicate style full of fantasy in his designs for book plates, greeting cards and books. Contributed to *Simplicissimus, Insel, Ver Sacrum.* Also painter, designer, and watercolorist. Still active in 1950.

28 Title page and binding for *Rubaijat des Omar Chajjam.* 1907. Book size, 8¼ x 6½". Klingspor Museum, Offenbach.

BEHRENS, PETER (1868-1940)

German architect and designer. 1893 one of the founders of the Munich Secession. First active as a painter, later as a graphic artist and designer. 1896-97 made a series of color woodcuts and book jackets in the Art Nouveau style of curving lines on a flat-patterned surface. 1898 first work in applied art—glassware, porcelain, jewelry and furniture. Represented in the exhibition of the Munich Vereinigte Werkstätten für Kunst im Handwerk at the Glaspalast in 1899. Member of the artist's colony of Mathildenhöhe in Darmstadt from 1899-1903. The original group "Die Sieben" also included Olbrich, Habich, Bosselt, Bürck, Christiansen, and Huber. His first building was his own house in Darmstadt for which he also did the interior design and furniture. Here his style begins to turn away from the curvilinear to the more simple and geometrical. This is evident in the type face he designed in 1902. Represented at the Turin Exposition of 1902 where he came in contact with the work of Mackintosh. Through Muthesius was appointed head of the Düsseldorf Kunstgewerbeschule, where he remained from 1903-07. Active in all aspects of architecture, interior and landscape design, and represented in

important expositions in Europe and at the St. Louis World's Fair in 1904. 1907 appointed director of design for A.E.G., the German electrical combine in Berlin. He was in charge of all advertising and typography, as well as designer of street lamps, appliances such as electric fans, heaters and kitchen utensils. 1909 built the A.E.G. turbine factory which was the first monumental building of glass and steel in Germany, a pioneer work in modern construction, using exposed steel beams, and also designed many other buildings for A.E.G. 1922 he became head of the School of Architecture at the Vienna Academy and in 1936 taught advanced architecture at the Prussian Academy of Art in Berlin. Among his pupils were Le Corbusier, Walter Gropius and Mies van der Rohe.

*29 *The Kiss.* 1898. Color woodcut. 10⅝ x 8½". The Museum of Modern Art, New York. Gift of Peter H. Deitsch. *Frontispiece*

30 Vignettes for *Pan.* Published in Vols. IV and V, 1899. Ink. Museum für Kunst und Gewerbe, Hamburg

*31 Title page for *Der Bunte Vogel.* 1899. Book size, 8¼ x 7⅜". Klingspor Museum, Offenbach. *Ill. p. 36*

32 Title page for *Schrift und Zierat.* 1902. Published by Rudhard 'sche Giesserei, Offenbach. Book size, 11 x 8¾". Klingspor Museum, Offenbach

33 *Darmstadt Mai-Okt. 1901. Ein Dokument Deutscher Kunst: Die Ausstellung der Künstler Kolonie.* Poster. 49¾ x 17". Deutscher Kunstrat, Cologne

34 Two banners. Painted oilcloth. 25' x 3', each. Made for the Behrens house at the opening of the Mathildenhöhe artists' colony, Darmstadt, 1901. Collection Ludwig Prince von Hessen u.b. Rhein, Wolfsgarten-Langen

35 Bench. 1901. Pine, painted white, with embroidered seat. 45¾" high x 48½" wide. Replica of bench in Behrens house dining room at Mathildenhofe Artists Colony. Museum für Kunsthandwerk, Frankfurt am Main

36 Two wine glasses. 1898. Clear crystal. 8¼" high, each. Made by B. v. Poschinger. Collection Dr. Siegfried Wichmann, Starnberg

BERNARD, EMILE (1868-1941)

French painter. 1884 pupil at the Académie Cormon, where together with van Gogh and Toulouse-Lautrec, he formed the "Ecole du Petit Boulevard" in 1887. Joined the Pont-Aven group in 1888; close collaboration with Gauguin. One of the originators of Synthetism and Symbolism; also close friend of Cézanne. After 1893 long trips through the Mediterranean countries. Later turned to conventional naturalistic painting.

*37 *Bathers.* (1889.) Oil on canvas. 36 x 28". Private collection, Paris. *Ill. p. 53*

*38 (Made with Paul Gauguin.) *Bretonnierie.* Corner cabinet. (1888.) Carved polychromed wood. 9′ high. Josefowitz Family Collection, Lausanne. *Ill. p. 52*

BINDESBØLL, THORVALD (1846-1908)

Danish architect, graphic artist and designer. He was distinguished in the development of modern Danish arts and crafts. Working in ceramics, bookbinding, furniture design, metalwork, embroidery. Principal architectural work: Society for Post Office and Telegraphic Employees in Copenhagen, 1901.

39 Plate. 1893. Glazed pottery with incised abstract decoration. c. 17⅛″ diameter. Signed and dated "Th.B. 1893." Made at Lervarefabrik, Valby. Det Danske Kunstindustrimuseet, Copenhagen

BOCCIONI, UMBERTO (1882-1916)

Italian painter. 1898 came to Rome where he met Balla, who introduced him to Neo-Impressionism. Friendship with Severini. 1902-04 in Paris and Berlin. From 1907 in Milan. 1909 met Marinetti and joined the Futurist movement. 1910 signed the "Manifesto of Futurist Painting." Chief theoretician and leading painter of Futurism.

40 *The Recital.* (c. 1903.) Ink. 7 x 7¼″. Collection Mr. and Mrs. Harry Lewis Winston, Birmingham, Michigan

41 *Swans and Lovers.* (c. 1905.) Color etching. 8¼ x 12⅛″. Lydia and Harry Lewis Winston Collection (Dr. and Mrs. Barnett Malbin, New York)

BONNARD, PIERRE (1867-1947)

French painter. After earlier law studies he enrolled at the Académie Julian in 1888 where he met Denis, Vuillard, Ranson and Sérusier and became a member of the *Nabi* group. 1890 shared a studio with Vuillard and Denis, later joined by Lugné-Poë. Besides painting, he did some sculpture, worked on decorative panels and theater decorations together with the other *Nabis.* Designed posters as early as 1891 and in 1893 contributed lithographs to the *Revue Blanche.* First large one-man show of paintings at Durand-Ruel's in 1896. In the following years participated in all major group exhibitions at Vollard's and Bernheim-Jeune's. Dividing his time between the Seine valley and the south of France, he developed an original style, somewhat apart from the avant-garde currents of the Paris School, in a prolific production of paintings, illustrations and graphic works.

*42 *Le Peignoir.* (c. 1892.) Oil on velvet. 60⅝ x 21¼″. Musée National d'Art Moderne, Paris. *Ill. p. 55*

43 Table centerpiece. (c. 1904-05.) Bronze. 5⅞″ high x 32″ diameter. Musée National d'Art Moderne, Paris

*44 Screen. (Published in 1899.) Color lithograph. Four panels. 54 x 18¾″, each. The Museum of Modern Art, New York. Mrs. John D. Rockefeller, Jr. Fund. *Ill. p. 56-57*

45 *Horse Cabs.* (1897.) Color lithograph. 7¾ x 17¾″. The Museum of Modern Art. Gift of Mrs. John D. Rockefeller, Jr.

*46 *La Revue Blanche.* 1894. Lithograph. 31¾ x 24⅜″. The Museum of Modern Art, New York. Purchase. *Ill. p. 37*

BONVALLET

Designer for the Silversmiths Cardeilhac in Paris.

47 Bottle-vase. (c. 1900.) Dark brown porcelain. 8⅝″ high. Silver mounting by Bonvallet for Silversmiths Cardeilhac. Musée des Arts Décoratifs, Paris

BOSSELT, RUDOLF (1871-1938)

German sculptor. 1891-97 studied at the Städelsche Kunstinstitut in Frankfurt am Main and at the Académie Julian in Paris. 1899 called by Grand Duke Ernst Ludwig of Hesse-Darmstadt to join the artists' colony at Mathildenhöhe ("Die Sieben") in Darmstadt. From 1904 professor at the academies of decorative arts in Düsseldorf (1904-1911), Magdeburg (1911-1925), and Braunschweig (1928-1931); then settled in Berlin. Mainly worked in small sculpture, bronzes, medallions, plaques and jewelry, but later also in large sculpture.

48 *Girl Disrobing.* (c. 1900.) Bronze. 13″ high. Hessisches Landesmuseum, Darmstadt

BRADLEY, WILL (1868-)

American graphic designer and typographer. Born in Boston, the son of a cartoonist, he began work as a printer's devil in 1879 and worked in printing plants in northern Michigan and Chicago. In 1893 opened a studio in Chicago from which his posters and designs won him international acclaim; exhibited at the World Columbian Exposition in Chicago. Following early influence of Beardsley, he attained great originality. He contributed to the *Chapbook,* edited in Chicago by Stone & Kimball, along with Beardsley, Beerbohm and Toulouse-Lautrec. In 1895 founded his own printing press, the *Wayside Press,* in Springfield, Mass., which published seven issues of his magazine *Bradley: His Book* and which, three years later, moved to Cambridge and was made part of the University Press, John Wilson & Sons. He then worked for the American Type Founders Company, setting styles in typography for decades, and was active as art director of the *Century Magazine.* In 1904 he wrote and designed twelve *American Chapbooks* for the American Type Founders Company and in 1906 he wrote, illustrated and designed the type for *Peter Poodle, Toy-*

maker to the King for Dodd, Mead. He became art editor of *Collier's* in 1907 and in 1910 organized a service to re-style and handle art direction for many magazines. In 1915 was appointed supervising art director of the Hearst publications and motion pictures, after which he worked in the motion picture industry, and continued to write books. He retired in 1930, but has remained active in his field. 1954 awarded gold medal by the American Institute of Graphic Arts. Lives in California.

49 *Three Dancing Girls.* 1894. Ink. 9½ x 6″. Collection Herbert Stuart Stone, Jr., Wallingford, Connecticut

50 *The Chap-Book.* 1894. Poster. 19 x 13″. Collection Herbert Stuart Stone, Jr., Wallingford, Connecticut

51 *The Chap-Book.* Thanksgiving number. 1895. Poster. 20¾ x 14″. The Museum of Modern Art, New York

52 Charles Scribner's Sons, New York. *The Modern Poster.* 1895. Poster, 20 x 12½″. The Art Institute of Chicago

BROUWER, WILLIAM COENRAAD (1877-1933)

Dutch potter and sculptor. Studied in Leiden and after working for an interior decorator and learning pottery in a pipe manufactory, specialized in that craft and founded his own pottery works in 1901 in Leiderdorp, which developed into a flourishing business and produced innumerable decorative terracotta sculptures for buildings all over Holland, among them the Peace Palace in the Hague.

53 Milk pitcher. (1901-03.) Pottery, glazed dark brown with raised geometric design in green. Pouring lip in form of owl face. 5⅞″ high. Made by earthenware factory Vrede-lust, Leiderdorp. Gemeentemuseum, The Hague

BURNE-JONES, EDWARD (1833-1898)

English painter. Belonged to the second generation of Pre-Raphaelites; close friend of William Morris and Dante Gabriel Rossetti with whom he shared an admiration for William Blake. Influenced the French Symbolist movement between 1884 and 1893, during which time he exhibited major works in Paris. Greatly admired by Aubrey Beardsley.

*54 *The Pelican.* Design for stained glass at Brampton Church, Cumberland. (1881.) Pastel. 67½″ x 22″. The William Morris Gallery, Walthamstow, England. *Ill. p. 67*

CACHET, C. A. LION (1864-1945)

Dutch graphic artist. Learned the batik technique from Dijsselhof about 1890. Designed advertisements, book covers, woodcuts, posters, bank notes.

55 Binding for Oranje Nassau catalogue. 1898. Book size, 8¾ x 7¼″. Stedelijk Museum, Amsterdam

CARRIÈRE, EUGÈNE (1849-1906)

French painter. 1870-76 studied in Paris at the Ecole Nationale des Beaux Arts with Cabanel. Founding member of the Société Nationale des Beaux Arts in 1890. 1896 exhibited at S. Bing's gallery L'Art Nouveau. Very close to the Symbolist movement in painting, as well as in literature and music, he developed a style in which a fog-like transparency seems to envelop his figures, eliminating all lines and restricting his palette to dark colors, highlighted by sharp contrasts.

56 *Woman's Head.* Lithograph. 13¼ x 16¾″. The Museum of Modern Art, New York. Gift of Peter H. Deitsch

CHARPENTIER, ALEXANDRE (1856-1909)

French sculptor, graphic artist and furniture designer. Famous for his bronze plaques and active in the early 1890s in the applied art field. Exhibited decorative objects with *Les XX* in Brussels in 1893. In 1895, with Jean Dempt, Félix Aubert, Tony Selmersheim and Moureau-Nélaton, formed the group in Paris called *Les Cinq,* which the following year was joined by Charles Plumet and the name was changed to *Les Six.* Charpentier's furniture, at first simple and rectilinear, influenced by the Arts and Crafts Movement, took on Art Nouveau decorative elements and he often added carved reliefs of nude figures.

*57 Revolving music stand. (c. 1900.) Carved hornbeam. 48″ high. Musée des Arts Décoratifs, Paris. *Ill. p. 99*

58 *Sonatines Sentimentales.* Poèms de Maeterlinck. C. Mauclair. 1894. Poster. 19½ x 12⅞″. Museum für Kunst und Gewerbe, Hamburg

CHÉRET, JULES (1836-1932)

Born in Paris. French graphic artist and scenery painter. First worked in a lithographic printing plant, and established his own printing press in 1866. Known as the originator of the modern poster. From 1893 under the influence of Toulouse-Lautrec he turned toward decorative flat patterns. After 1900, however, he reverted to a mid-impressionist style.

59 *Loie Fuller.* Poster. 47¼ x 32⅜″. Victoria and Albert Museum, London

CISSARZ, JOHANN VINCENZ (1873-1942)

German painter, graphic artist and designer. 1903 joined the artists' colony at Darmstadt. 1906 to Stuttgart where he served as professor of book design at the Lehr-und Versuchswerkstätte. 1916 head of advanced painting class at the School of Applied Art in Frankfurt am Main. Cissarz did mural decorations and stained glass for churches and public buildings in many German cities. His graphic work

includes designs for posters, bookbinding and illustrations. He also designed furniture and household utensils.

60 *Unterstrom,* the story of Helene Voight-Diedericks. 1901. Book size, 8 x 6″. Klingspor Museum, Offenbach

61 Type specimen sheet. (1896-1900.) Klingspor Museum, Offenbach

COBDEN-SANDERSON, T. J.

English bookbinder, illustrator and printer. Friend of Morris and Crane. Active in development of modern English book design. 1900, with Emery Walker, founded the Doves Press, which advocated the use of the plain unadorned type face. Designed and executed parchment book covers, ornamented in gold. Illustrated for *Dekorative Kunst* and *Deutsche Kunst und Dekoration.*

*62 Binding for *Areopagitica* by John Milton. (1907-08.) Book size, 9⅜ x 5⅝″. Museum für Kunsthandwerk, Frankfurt am Main. *Ill. p. 21*

COLENBRANDER, THEODORUS A. C. (1841-1930)

Dutch pottery and textile designer. One of the leaders of the modern applied-art movement in Holland. Early work in architecture, but by mid-1880s had created a new style derived from Javanese batik for the Rozenburg porcelain works in The Hague. His highly refined style combined exotic elements with bold linear patterns and colors. 1895 became head of the Amersfoorter wall-paper factory.

*63 Plate. 1886. Pottery decorated with abstract plant design in brilliant colors on white. 10⅞″ diameter. Made by earthenware factory Rozenburg, The Hague. Gemeentemuseum, The Hague. *Ill. p. 108*

64 Saucer. 1886. Pottery decorated with abstract design in brilliant colors on white. 6″ diameter. Made by earthenware factory Rozenburg, The Hague. Gemeentemuseum, The Hague

COLONNA, EUGENE

French interior and furniture designer and decorative artist. Lived in Paris and worked for S. Bing. In 1900 together with Eugène Gaillard and Georges de Feure designed S. Bing's *L'Art Nouveau* pavilion at the Paris Universal Exposition. Participated in the Secession exhibition in Munich in 1899 and in the Turin International exhibition in 1902.

65 Pendant. (c. 1900.) Gilded metal, green agate, pearl and translucent enamel. 2¾″ high. Made for L'Art Nouveau shop in the S. Bing work rooms. Musée des Arts Décoratifs, Paris

ROYAL PORCELAIN FACTORY, Copenhagen

Founded in the eighteenth century, it gained world recognition in the last decades of the nineteenth century.

66 Vase. (c. 1899.) Porcelain; decorated with green-black crystal glaze. 6¾″ high. Österreichisches Museum für Angewandte Kunst, Vienna

CORINTH, LOVIS (1858-1925)

German painter and printmaker. Studied at the academies of Königsberg, 1876-80, and Munich, 1880-84. After spending a few years first in Paris, then in Königsberg and Munich, he finally settled in Berlin in 1902. One of the outstanding representatives of German Impressionism, he later turned to Expressionism. It was at this time, from 1918 on, that he painted, during the summers, his famous Walchensee landscapes.

67 *Dancers.* (1895.) Soft-ground etching. 5¾ x 7¾″. Städtische Galerie und Lenbachgalerie, Munich

DALPAYRAT, ADRIEN-PIERRE (1844- ?)

French ceramist. Born in Limoges. The firm, Dalpayrat et Lesbros in Bourg-la-Reine specialized in pottery with sculptured shapes and highly developed glazes. He was awarded a gold medal at the World Columbian Exposition in Chicago in 1893.

68 Plate. (c. 1900.) Pottery with multicolor glaze. 13″ diameter. Musée des Arts Décoratifs, Paris

69 Vase. (c. 1900.) Pottery; sculptured shape, grey-red speckled glaze, c. 6″ high. Made in Bourg-La-Reine, probably by Dalpayrat. Österreichisches Museum für Angewandte Kunst, Vienna.

70 Vase in the shape of a squash. (1908.) Stoneware with rough-textured glaze (grès flammé). 8″ high. Musée des Arts Décoratifs, Paris. Gift of S. Bing

DAUM FRÈRES

August Daum (1854-1909) and his brother Antonin, French glass manufacturers of the Nancy group, which was founded by Emile Gallé. The Daum glass was less extravagant than Gallé's and the technique less refined. Typical floral motifs were poppies and snowdrops.

71 Group of vases. (c. 1900.) Sculptured glass, hand painted. Designed and made by Daum Frères, Nancy. The Museum of Modern Art, New York. Phyllis B. Lambert Fund

DEBSCHITZ, WILHELM VON (1871-1948)

German painter, illustrator and designer. Mainly self-taught, but knew the work of Morris and Crane. 1902 with Obrist in Munich founded the Lehr-und Versuchsateliers für freie und angewandte Kunst, which became widely known as the Debschitz School with workshops for metalware, textiles and ceramics. The work of this school was shown at the Jubilee Exhibition in Nuremberg in 1906 and won a gold medal. c. 1908 Debschitz established, with

H. Loehner, the Ateliers und Werkstätten für Angewandte Kunst in Munich. He later became director of the Stadt Handwerkers u. Kunstgewerbeschule in Hanover.

*72 Ink stand. (1906.) Bronze, triangular shape. 2″ high x 8⅝″ wide. Landesgewerbemuseum, Stuttgart. *Ill. p. 114*

DEMACHY, ROBERT (? -1938)

French photographer. One of the greatest influences in pictorial photography in the 1890s and the early twentieth century. With C. Puyo led the French section of the Linked Ring Brotherhood, one of the secession groups which concentrated on photography. Specialized in landscapes and figure studies. 1894-95, with A. Rouillé Ladêveze brought gum bichromate process to high perfection; exhibited at the Paris Photo Club in 1895. Introduced modern transfer method in oil printing, 1911.

73 *In Brittany.* (c. 1900.) Gum print photograph. 5½ x 8⅜″. The Metropolitan Museum of Art, New York. Gift of Alfred Stieglitz, 1933

DENIS, MAURICE (1870-1943)

French painter, graphic artist and theoretician. 1888 pupil at the Acadêmie Julian. Leader and theoretician of the *Nabi* group. Joined the Pont-Aven painters in whose Symbolist style he participated. Contributed to the *Revue Blanche.* Developed a neo-Catholic style in connection with the painting school of Kloster Beuren. Close friend of Claudel and Gide.

74 *Portrait of Mme Paul Ranson.* (c. 1890.) Oil on canvas. 35 x 17¼″. Collection Dominique Denis, St. Germain-en-Laye, France

*75 *April.* (1892.) Oil on canvas. 14¾ x 24″. Rijksmuseum Kröller-Müller, Otterlo, The Netherlands. *Ill. p. 54*

76 *Women in a Landscape.* (c. 1894.) Lithograph. 6⅜ x 3½″. Collection Robert Pincus-Witten, New York

77 Design for wallpaper. (c. 1900.) Color lithograph. 35⅝ x 19⅝″. The Museum of Modern Art, New York. Purchase

*78 *Sagesse* by Verlaine. Colored wood engravings by Denis. (1889-1910.) Vollard edition, 1911, copy no. 76. Book size, 11¼ x 8⅞″. Collection Dominique Denis, St. Germaine-en-Laye, France. *Ill. p. 30*

DUMONT, HENRI (1859- ?)

French painter and printmaker. Active in Paris as painter, poster designer and etcher (signing his work at times *Henry*). From 1893 on almost exclusively dedicated to paintings of flower still life. Exhibited at the Exposition Universelle in Paris in 1900.

*79 *Tous les Soirs aux Ambassadeurs. Yvette Guilbert.* Litho.

c. 1900. 82 x 32″. The Museum of Modern Art, New York. Gift of Pierre Beres. *Ill. p. 35*

FRAU DUNSKY

80 Tablecloth. (1901.) Woven linen with stylized peacock feather pattern in yellow and white. 50 x 45¾″. Made by Carl Faber, Stuttgart. Museum für Kunsthandwerk, Frankfurt-am-Main

ECKMANN, OTTO (1865-1902)

German graphic artist and designer. Began as a landscape painter. Studied in Hamburg, Nuremberg and at the Munich Academy. After 1894 abandoned painting and concentrated on applied art. Belonged to the Munich school of Art Nouveau. The influence of Japanese prints is evident in graphic work he did for the magazines *Pan* and *Jugend.* He was the leader of the German "floral style"; his illustrations of stylized plant motifs in his own publication *Dekorative Entwürfe* of 1897 exerted a great influence on German graphic artists. He was the designer of the best known Art Nouveau typeface and he also designed tapestries, furniture and metalwork. 1897 he became a teacher at the Kunstgewerbeschule, Berlin.

81 Sketch for book cover. (c. 1896-98.) Crayon and ink. 9 x 6″. Museum für Kunst und Gewerbe, Hamburg

82 Initials designed for *Pan.* 1895. Museum für Kunst und Gewerbe, Hamburg

83 AEG Prospectus for the Paris 1900 Exhibition. 1899-1900. 9¾ x 12⅝″. Museum für Kunst und Gewerbe, Hamburg

84 Group of marbleized endpapers. (c. 1898-1902.) 21⅛ x 14½″ each. Museum für Kunst und Gewerbe, Hamburg

85 Book jacket for *Johannes* by Sudermann. (c. 1896.) 7⅜ x 4⅝″. Klingspor Museum, Offenbach

86 Page from *Schriften und Zier-Material,* published by Rudhard'sche Giesserei. (c. 1903.) Book size, 11¼ x 8¾″. Klingspor Museum, Offenbach

87 Page from type-specimen book *Schriften und Zier-Material,* published by Rudhard'sche Giesserei. (c. 1903.) 11¼ x 8¾″. Klingspor Museum, Offenbach

88 Plant forms. Design from portfolio *Neue Formen.* (c. 1900.) 17½ x 13⅜″. Klingspor Museum, Offenbach

89 Announcement of Eckmann tapestry exhibition. (c. 1898-1903.) Klingspor Museum, Offenbach

90 Announcement for *Die Woche.* (c. 1898-1903.) Klingspor Museum, Offenbach

91 Woven silk fabric; grey-blue wave pattern on grey-blue background. (c. 1900.) 27⅛ x 21⅝″. Det Danske Kunstindustrimuseet, Copenhagen

92 Woven silk fabric; black flower pattern on black background. (c. 1900.) 27⅛ x 21⅝″. Det Danske Kunstindustrimuseet, Copenhagen. Both fabrics were part of a series called "Künstlerseide," commissioned from artists by the manufacturer, Deuss & Oetker, Krefeld

ENDELL, AUGUST (1871-1925)

German architect and designer. Self-taught as an artist. Strongly influenced by Obrist in Munich where he belonged to the group of architects and interior designers in the Vereinigte Werkstätten. Principal buildings in Art Nouveau style: Elvira Studio, 1897-98, designed for a Munich photographer; Sanatorium in Föhr, 1901; Buntes Theater, Berlin, 1901. Also designed textiles, jewelry, furniture, and was a writer. 1918, Director of Akademie für Kunst und Kunstgewerbe in Breslau.

*93 Armchair. (1899.) Carved elmwood with upholstered seat. 33½″ high. Collection Dr. Siegfried Wichmann, Starnberg, Germany. (Exhibited in New York only). *Ill. p. 112*

94 Wrought-iron ornaments from a desk designed for H. Heiseler, Munich. (c. 1899.) Mounted on board. Executed by R. Kirsch. 28¾ x 37″. The Museum of Modern Art, New York
See list of architecture photographic enlargements on page 185.

ENSOR, JAMES SYDNEY (1860-1949)

Belgian painter and graphic artist. 1877-1880 studied at the Brussels Academy, under Portaels and others. 1880 returned to his native town, Ostend, where he lived all his life. 1884 founding member of *Les XX* in Brussels, but in 1889, a major work of his, *The Entry of Christ into Brussels,* was refused exhibition by *Les XX.* 1898 exhibited in Paris under the auspices of *La Plume.* Edgar Allan Poe was his favorite author. Developing out of sixteenth-century Flemish painting, but influenced by Impressionism and Symbolism, he painted a haunted world of make-believe in which the ironic use of masks played a major role. Although acknowledged as a master in his own country, being named baron by the Belgian King in 1929, it is only recently that he has gained full world-wide acclaim as a true originator.

95 *Self Portrait with Demons. Salon des Cent.* Poster. 1898. 20⅞ x 15⅝″ (without lettering). The Museum of Modern Art, New York. Gift of Ludwig Charell

EVENEPOEL, HENRI (1872-1899)

Belgian painter. Early studies in Brussels; 1892 pupil of Gustave Moreau in Paris; friendship with Matisse; frequented the studios of many painters; under the influence of Manet, Toulouse-Lautrec, Forain and Steinlen. 1897

important long trip to North Africa. Died at the age of 27 before reaching a mature style.

96 *In the Square.* (c. 1895.) Color lithograph. 13 x 9″. Private collection, New York

GAILLARD, EUGÈNE

French interior and furniture designer and decorative artist. Designed, in 1900, together with Eugéne Colonna and Georges de Feure, S. Bing's *L'Art Nouveau* pavilion at the Paris Universal Exposition. Wrote *A propos du Mobilier,* Paris, 1906. One of the foremost furniture designers of Art Nouveau.

97 Velour with printed flower pattern in four colors. (c. 1899.) 60¼ x 34¼″. Purchased from Universal Exposition, Paris 1900. Museum für Kunst und Gewerbe, Hamburg

GAILLARD, LUCIEN (1861- ?)

French jeweler. Contemporary of René Lalique; used insect and flower forms in his silver work. Participated in the Glasgow International Exhibition of 1901.

98 Decorative comb. (c. 1900.) Horn, carved in the shape of blossoms with pearl centers. 6⅜″ long. Marked: "L. Gaillard." Museum für Kunsthandwerk, Frankfurt am Main

99 Decorative comb. (c. 1900.) Carved horn with gold mounting in the form of maple seeds. 6¼″ long. Exhibited at Salon des Artistes Français, 1906. Musée des Arts Décoratifs, Paris

100 Magnifying glass. (c. 1900.) Silver frame in the shape of a beetle. 5″ long. Musée des Arts Décoratifs, Paris

GALLÉ, EMILE (1846-1904)

French designer-craftsman and pioneer in glass-making. Early studies in philosophy and botany. Trained in his father's pottery works in Saint Clément and at glass works in Meisenthal. 1874 added faïence workshop to the family plant, which by 1900 employed approximately 300 workers in glass production and furniture, ending operations in 1913. Founder of Nancy School, a center for decorative art influenced by the Symbolist movement and based on a deep belief in nature as the source of inspiration. Gallé's glass work is unconventional in form, with original techniques such as relief decoration, etching with acid, and overlaying of colors. His furniture was noted for inlay work. In both glass and furniture he incorporated inscriptions of Symbolist poetry. He was an important and prolific contributor to Bing's Paris shop L'Art Nouveau. With Gallé's death in 1904 the vitality of the Nancy School diminished.

*101 Screen (1900.) Ashwood with carved plant decoration and marquetry in various woods. 42″ high. Shown at Universal Exposition, Paris, 1900. Signature in marquetry, lower left. Victoria and Albert Museum, London. *Ill. p. 98*

102 Side table. 1898. Carved supports, triangular top decorated with marquetry in various woods. 34⅝″ high. Signed. Musée de l'Ecole de Nancy

103 Vase. (c. 1900.) Glass, engraved, colored violet, yellow, white and brown. Decorated with engraved sheaf of oats. 11⅜″ high. Signed. Musée de l'Ecole de Nancy

104 Hand, covered with sea plants. (c. 1900.) Colored glass paste (pâte de verre). c. 10″ high. Signed. Musée de l'Ecole de Nancy

*105 Shallow bowl in the shape of a shell, engraved with seaweed and small shells. (1899.) Clear crystal. 11½″ long. Signed. Musée de l'Ecole de Nancy. *Ill. p. 97*

106 Vase in the shape of a fish head, glass, carved and decorated with seaweed in relief. 1900. 5½″ high. Inscription on back: "Et nul vent ne détruit son fragile univers. Rodenbach." Signed underside: "Gallé Expos 1900." Nordenfjeldske Kunstindustrimuseum, Trondheim

107 Vase in shape of flat-sided oil jug. 1900. Glass, carved, grey-green, decorated with carved sea fauna, shells and spots of artificial erosion. 9⅞″ high. Inscription: "Descendre au fond de son propre destin, savoir ce se qui se passe en cette mer sans fin." (Rodenbach.) Signed and marked: "Expos. n. 1900." Det Danske Kunstindustrimuseet, Copenhagen

108 Vase. (c. 1900.) Glass, carved, translucent, amber; decorated with dragonfly and water lillies. 8″ high. Signed. Collection Joseph H. Heil, New York

GAUGUIN, PAUL (1848-1903)

French painter and printmaker. Began his painting career around the age of thirty-five, after having been a sailor in his youth and then a business man. Friendship with Pissarro; from 1880, he participated in the exhibitions of the Impressionists. Friendship with van Gogh. 1886 first sojourn in Pont-Aven. 1887 trip to Martinique. 1888 again in Pont-Aven, close relationship to Bernard and a group of artists including Denis and Sérusier. Visited van Gogh in Arles in 1888. 1889-90 sojourns in Pont-Aven and Pouldu. Back to Paris in 1891, departed for Tahiti. Came back once more to France in 1893, but then returned to Tahiti in 1895 and settled finally in the Marchesas Islands where he died in 1903.

*109 *Still Life with Three Puppies.* 1888. Oil on wood. 36⅛ x 24⅝″. The Museum of Modern Art, New York. Mrs. Simon Guggenheim Fund. *Ill. p. 48*

*110 *Manao Tupapau (Watched by the Spirits of the Dead).* (c. 1893-95.) Woodcut, printed in black and colored by hand, partly with stencils. 9 x 20⅜″. The Art Institute of Chicago. *Ill. p. 51*

111 *Human Misery.* (1895.) Woodcut. 9 x 11⅞″. The Metropolitan Museum of Art, New York. Whittlesey Fund, 1952

*112 *Leda.* Design for a plate. Cover for Dessins lithographiques. 1889. 11⅞ x 10⅛″. The Metropolitan Museum of Art, New York. Rogers Fund, 1922. *Ill. p. 50*

*113 Vase. Glazed stoneware. 11⅜″ high. Made by Ernest Chaplet. Musées Royaux d'Art et d'Histoire, Brussels. (Exhibited in New York only). *Ill. p. 50*

*114 Gauguin or School of Pont-Aven: *Decorative Landscape.* (1889.) Oil on wood. 33⅞ x 22½″. Nationalmuseum, Stockholm. *Ill. p. 50*

STUDIO GLATIGNY, Versailles. Artists' colony in Glatigny near Versailles.

115 Coffee service. (c. 1900.) Coffee pot; creamer; sugar bowl; cup and saucer. Glazed blue, shaped like sea fauna. Signed "Glatigny." Det Dansk Kunstindustrimuseet, Copenhagen

GRASSET, EUGENE (1841-1917)

French graphic artist. Born in Lausanne, Switzerland where he was trained as an architect. To Egypt in 1869 and Paris in 1871. Studied with Viollet-le-Duc, and also a student Japanese art. Worked in various fields of applied art. Published articles and books on typography and ornament and as a theorist, advocated respect for materials and utility of objects, but in his decorations he used motifs derived from nature. In 1883 he designed the illustrations for the medieval poem by de Montauban, *Histoire des Quatre Fils Aymon.* Grasset was one of the originators of poster design.

116 *Exposition E. Grasset. Salon des Cent.* (c. 1894.) Poster, 23¼ x 14¾″. The Museum of Modern Art, New York. Gift of Ludwig Charell. *Ill. p. 39*

*117 *Histoire des Quatre Fils Aymon, très nobles et très vaillans chevaliers* by de Montauban. 1883. Paris, H. Launette edition. Color lithographic illustrations by Charles Gillot after designs in color by Grasset. Book size, 10⅞ x 9″. Rijksmuseum Library, Amsterdam. *Ill. p. 39*

GUIMARD, HECTOR (1867-1942)

French architect and furniture designer. Studied at École des Arts Décoratifs and Ecole des Beaux-Arts, Paris, where he also taught. Though influenced by Horta, he was one of the most original and interesting Art Nouveau architects. His style is based on nature with decorations that are functional parts of the construction. His furniture and jewelry display a similar harmony of design and sophistication of detail. Guimard's three principal architectural works are the Castel Béranger, a group of apartment houses at 16 rue de la Fontaine, Paris, 1894-98, the cast-iron en-

trances to the Paris *Métro* stations, 1900, and the Humbert de Romans Building, rue St. Didier, Paris, 1902. He came to the United States in 1938 and died in New York in 1942.

118 Corner cupboard from a bedroom suite. (1900.) Carved pearwood. 67″ high. Musée des Arts Décoratifs, Paris

*119 Desk from the architect's own house. (c. 1899; remodeled after 1909.) Olive wood with ash panels. 29¾″ x 8′4½″. The Museum of Modern Art, New York. Gift of Mme Hector Guimard. *Ill. p. 104*

120 Desk chair from the architect's own house. (c. 1905.) Carved walnut, with leather upholstery. 32¼″ high. The Museum of Modern Art, New York. Gift of Mme Hector Guimard

*121 Side table from the architect's own house. (c. 1908.) Carved pearwood. 43½″ high. The Museum of Modern Art, New York. Gift of Mme Hector Guimard. *Ill. p. 104*

122 Vase. (c. 1908.) Glazed porcelain. 10⅝ x 5¼″. Made by Manufacture Nationale de Sèvres. Cooper Union Museum for the Arts of Decoration, New York

123 Umbrella stand from the architect's own house. (c. 1902.) Bronze. 32¾″ high. The Museum of Modern Art, New York. Gift of Mme Hector Guimard

124 Balcony railing. (1907.) Cast iron. 39⅜″ high x 63″ long. Made by Maison B. Bottet Père, Lyon. The Museum of Modern Art, New York. Phyllis B. Lambert Fund

125 Oval frame from the architect's own house. (c. 1909.) Gilded bronze. 21 x 10⅝″. The Museum of Modern Art, New York. Gift of Mme Hector Guimard

126 Standing cabinet frame with photograph of the artist. 1907. Bronze. 10½″ high x 6⅝″ wide. Signed and dated. Cooper Union Museum for the Arts of Decoration, New York
See list of architecture photographic enlargements on page 185.

HABICH, LUDWIG (1872-1949)

German sculptor and medalist. Studied at Städelsche Kunstinstitut in Frankfurt am Main, and at the academies of Karlsruhe and Munich. 1900-06 member of the Darmstadt artists' colony. From 1910 professor at the Academy of Fine Arts in Stuttgart.

127 *Bathing Woman.* (1900.) Bronze. c. 6″ high. Collection H. R. H. Ludwig, Prince von Hessen, u.b. Rhein, Wolfsgarten-Langen

HEINE, THOMAS THEODOR (1867-1948)

German draftsman, illustrator, painter and writer. Studied at Düsseldorf Academy. After 1889 in Munich as contributor to *Fliegende Blätter* and *Jugend*. 1896 founder and co-editor of *Simplicissimus* with Albert Langen and Ludwig Thoma. Remained with this publication until its

ban by the Nazis in 1933. Master of satirical illustration, he was noted for his cartoons. 1898 imprisoned for political offence. 1933 emigrated to Prague, and worked for a newspaper. Later connected with journals in Oslo and Stockholm, where he died.

128 *Feuerbestattung.* (1908.) Ink. 11¾ x 8½″. Städtische Galerie und Lenbachgalerie, Munich

129 *Frühlingsgedichte, eine Redaktionsidylle.* 1897. ink. 9½ x 15¾″. Städtische Galerie und Lenbachgalerie, Munich

130 *Die Lebensmueden.* (1895.) Four ink and crayon drawings. Städtische Galerie und Lenbachgalerie, Munich

131 *Die Einzige Möglichkeit.* 1900. Published in *Simplicissimus* 1910. Ink. 10½ x 9″. Städtische Galerie und Lenbachgalerie, Munich

132 Advertising design for *Simplicissimus.* (c. 1900.) Watercolor, 6⅝ x 13⅝″. Städtische Galerie und Lenbachgalerie, Munich

HODLER, FERDINAND (1853-1918)

Swiss painter. Studied with Swiss landscape painters in Thun and Geneva. Participated in the World's Fair exhibition of 1889 in Paris. Sojourns in Paris and Belgium. Member of the Rosicrucian esthetic movement in whose exhibition at Durand-Ruel's he participated in 1892. Exhibited in Munich and Vienna and became Switzerland's most important artist. Painted landscapes, portraits and major Symbolist compositions of simplified form and bold outline. Major muralist of his generation.

*133 *The Chosen One.* (c. 1903, replica by the artist of painting of c. 1896.) Oil on canvas 7′2½″ x 9′10″. Karl-Ernst-Osthaus-Museum, Hagen, Germany. *Ill. p. 76*

134 Secession. XIX Ausstellung der Vereinigung Bildender Künstler Österreichs. 1904. Poster. 37¾ x 25¼″ Österreichisches Museum für Angewandte Kunst, Vienna

HOFFMANN, JOSEF (1870-1955)

Austrian architect, graphic artist and designer. Studied painting at Munich Academy and architecture with Otto Wagner in Vienna. Took prominent part in the founding of the Vienna Secession in 1897, and became leader of the new art movement. His illustrations for *Ver Sacrum* first showed his characteristic ornamentation, stressing geometric forms. This was also evident in his designs for architecture, furniture and decorative objects, paralleling the work of Mackintosh in Glasgow but retaining his own Viennese style. 1899 appointed Professor of Architecture at the Wiener Kunstgewerbeschule; he was a brilliant teacher of great influence throughout Central Europe. With Olbrich he designed the Austrian pavilion at the 1900 Paris Universal Exposition. In 1903, with Moser and Wärendorfer

founded the Wiener Werkstätte. Two important early works in architecture are the Sanatorium at Purkersdorf, 1903-04 and the Palais Stoclet, Brussels, 1904-11, for which he also did the interior decoration, furnishings, and gardens. In 1912 he founded the Österreichische Werkbund which he left in 1920 to take the lead of the "Gruppe Wien" of the Deutsche Werkbund. He continued to practice and teach until 1950 and died at the age of 85 in 1955.

135 Table flatware. (c. 1903.) Handwrought silver. Spit; serving fork; fish fork; dinner knife; dinner fork; dessert spoon; sherbet spoon. Made by Wiener Werkstätte. Collection Mrs. F. Beer-Monti, New York

136 Ring. Gold, with flat round opal. Made by Wiener Werkstätte. Collection Mrs. F. Beer-Monti, New York

*137 Brooch. (c. 1908.) Gold, with moonstones, milk opals, baroque pearls and handwrought gold leaves. 2⅜" wide. Made by Wiener Werkstätte. Collection Mrs. F. Beer-Monti, New York. *Ill. p. 121*

138 Flower container. (1903-04.) Perforated pewter, painted white. 8½" high. Made by Wiener Werkstätte. Kunstgewerbemuseum, Zurich

139 Flower container. (1903-04.) Perforated pewter, painted white. 9¾" high. Made by Wiener Werstätte. Kunstgewerbemuseum, Zurich
See list of architecture photographic enlargements on page 185.

HORTA, VICTOR (1861-1947)

Belgian architect. Early studies in Ghent and Paris, and at Académie des Beaux-Arts, Brussels. Worked in office of the classicist architect Alphonse Balat. The constructive principles of Viollet-le-Duc, neo-baroque elements of form, and plant-motifs were his chief sources of inspiration. 1892-93 designed a house for Professor Tassel at 12, rue de Turin (now 6, rue Paul Emile Janson), Brussels. With this first example of Art Nouveau architecture Horta's style was established and much imitated for its refinement of ornamentation. His use of iron enabled great freedom of form, especially notable in the staircase of the Tassel house. Other buildings in Brussels in the mature Art Nouveau style include the Hotel van Eetvelde, Avenue Palmerston, 1898, the Hôtel Solvay, 224 Avenue Louise, 1895-1900, two houses for himself, 22-23, rue Américaine, 1898; and the Maison du Peuple, 1895-1900, a building for a group of cooperatives for working-class organizations, important architectually for its façade of iron and glass. 1902 represented at the Turin Exposition. About 1905 Horta abandoned the Art Nouveau style. 1913 became director of the Brussels Academy, which he reorganized. 1914 plans approved for the Palais des Beaux-Arts, Brussels, built after World War I, between 1923-28.

140 Foot rocker from Hôtel Solvay. (c. 1895-1900.) Carved cherry, with wool tapestry. 16½" high x 22" long. Collection L. Wittamer-de-Camps, Brussels

141 Photograph display stand from Hôtel Solvay. (c. 1895-1900.) Gilded bronze. 60⅝" high. Collection L. Wittamer-de-Camps, Brussels

142 Wall light fixture in the shape of two flowers from Hôtel Solvay. (c. 1895-1900.) Gilded bronze and glass. 18½" high. Collection L. Wittamer-de-Camps, Brussels

143 Door handles from Hôtel Solvay. (c. 1895-1900.) Gilded bronze. 17¾", 11", 7" high respectively. Collection L. Wittamer-de-Camps, Brussels

See list of architecture photographic enlargements on page 185.

KANDINSKY, WASSILY (1866-1944)

Russian painter, and printmaker. Worked in Germany and France. After early law studies in Russia, he settled in Munich in 1896 where he studied under Azbé and Stuck. 1900-1903 teacher at and president of the private art school Phalanx. Member of the Berlin Secession since 1902. 1903-1908 traveled in France, Tunisia and Italy. Settled in Munich and Murnau in 1908; 1909 founded the Neue Künstlervereinigung and in 1911 was co-founder (with Franz Marc) of *Der Blaue Reiter*. First non-objective painter (1910). Returned to Moscow in 1917. Professor at the Moscow Academy 1918. Emigrated to Berlin in 1921. Teacher at the Bauhaus 1922-33. Emigrated to France in 1933 and settled in Neuilly-sur-Seine, where he died in 1944.

*145 *The Mirror.* (1903.) Woodcut. 12¼ x 6⅛". Städtische Galerie und Lenbachgalerie, Munich. *Ill. p. 85*

146 *Phalanx: First Exhibition.* 1901. Poster. 18 x 23¼". The Museum of Modern Art, New York. Gift of Mme Wassily Kandinsky

KINDEREN, ANTOON JOHANNES DER (1859-1925)

Dutch painter, muralist and illustrator. 1880-82 studied at the academies of Amsterdam, and (together with Toorop) of Brussels. 1887 trip to Italy and Paris, where he was strongly impressed by Puvis de Chavannes. Mainly active in monumental mural painting and stained glass window designs, but also as book illustrator, especially during the nineties.

147 Two-page fly-leaf for *Gedenbock, Keuztentoonstelling von Hollandsche Schilderkunst.* 1893. Lithograph page one: 13½ x 8¾"; lithograph page two: 12¾ x 8½". Gemeentemuseum, The Hague

KING, JESSIE MARION (Mrs. E. A. Taylor) (1876-1949)

Scottish illustrator and decorative artist. 1894-1900 studied at the Glasgow School of Art. Won a traveling scholarship to Germany and Italy. Taught bookbinding at the Glasgow School of Art. Designed mural decorations for schools in Lanarkshire and specialized in book illustrations, among them for works by Kipling, Morris, Milton, Spenser and Wilde. Also designer of jewelry, pottery, and batik work.

148 Binding for *Le Rêve* by Zola. (c. 1900.) Book size, 11½ x 8". (This edition contains an original ink drawing frontispiece by Jessie King and illustrations by Carloz Schwabe.) Collection Thomas Howarth, Toronto

KIRCHNER, ERNST LUDWIG (1880-1938)

German painter and printmaker. After early studies in architecture in Dresden (1901-03), he turned to painting. Mainly self-taught but studied also with Hermann Obrist in Munich (1903-04). Greatly impressed by seeing Dürer's woodcuts in Nuremberg, he began making woodcuts around 1900 and became one of the most important printmakers of the century. Co-founder with Ernst Heckel and Karl Schmidt-Rottluff of *Die Brücke* in 1905. Wrote the chronicle of *Die Brücke* in 1913. Settled in Berlin in 1911 and moved to Frauenkirch near Davos, Switzerland after World War II. Died by his own hand in 1938. One of the outstanding painters of German Expressionism.

*149 *Before the People,* from *Man and Wife* cycle. 1900. Woodcut. 7⅞ x 7⅞". Allen Art Museum, Oberlin College, Oberlin, Ohio. *Ill. p. 82*

KLIMT, GUSTAV (1862-1918)

Austrian painter and muralist. Studied oil and glass painting, mosaics and ceramics at the Kunstgewerbeschule in Vienna. After important mural commissions for the Burgtheater he was in 1897 co-founder of the Vienna Secession and its first president. Collaborated also with the Wiener Werkstätte. Chief exponent of Art Nouveau painting in Vienna, he created the wall decorations for Josef Hoffmann's Palais Stoclet in Brussels. His three huge murals for the auditorium of the University of Vienna caused public and official furor. Klimt resigned from the Secession which he had dominated and formed a new group "Kunstschau" in 1908 in which he showed together with Egon Schiele and Oskar Kokoschka. Internationally famous as portrait and landscape painter at the turn of the century, his influence extended beyond Central Europe.

*150 *Portrait of a Woman.* (1897.) Pastel. 20⅛ x 10⅞". Allen Art Museum, Oberlin College, Oberlin, Ohio

*151 *Salome.* 1909. Oil on canvas. 70⅛ x 18⅛". Galleria Internazionale d'Arte Moderna, Venice. *Ill. p. 77*

152 *1. Kunstausstellung der Vereinigung bildender Künstler Österreichs. 1. Fassung.* 1898. Poster. 25⅝ x 18½" (first state). Österreichisches Museum für Angewandte Kunst, Vienna

KNOX, ARCHIBALD

153 Jewel Box. (c. 1900.) Silver, decorated with mother-of-pearl, turquoise and enamel. Made by Liberty & Co., London. 11¼ x 6 x 3¼". The Museum of Modern Art, New York. Gift of the family of Abby Aldrich Rockefeller

KOEPPING, KARL (1848-1914)

German painter, etcher and designer craftsman. After early chemistry studies enrolled at the Akademie der Bildenden Künste in Munich where he studied painting and etching, he evolved a superb technique in making etchings after old masters. From 1896 one of the editors of *Pan*. He also developed a very delicate style of glass design, transferring the Japanese technique of fusing different color glazes from earthenware to glass.

*154 Group of glasses in the shape of flowers. (1895-96.) Tinted blown glass. c. 12" high. Det Danske Kunstindustrimuseet, Copenhagen. Acquired from the artist. *Ill. p. 120*

LACOMBE, GEORGES (1868-1916)

French painter and sculptor. Pupil at the Académie Julian, member of the *Nabi* group. Participated in all their activities; made marionette heads for theatrical performances; painted, sculpted and made decorative objects; faithfully adhered to *Nabi* dogma not to sell their work.

*155 Headboard of bed *(Le Rêve).* (1892.) Carved wood. 27¼" high x 55" long. Musée National d'Art Moderne, Paris. *Ill. p. 60*

LALIQUE, RENÉ (1860-1945)

French jewelry designer. Studied at the Ecole des Beaux-Arts. By 1885 he had established his own jewelry workshop in Paris. Lalique was the outstanding French Art Nouveau artist working in jewelry, gold and silver. The asymmetrical settings for his jewelry were primarily derived from floral motifs. He also designed glassware and decorative objects. He was represented anonymusly at the Paris World's Fair of 1889 and awarded a prize. He first became known and his work attracted attention, at the *Salon des Champ de Mars* in 1895. He was represented at the opening of S. Bing's shop L'Art Nouveau and he became one of Bing's regular contributors. His work was acclaimed with

enthusiasm at the Paris University Exposition of 1900, and he exhibited at the Turin exhibition in 1902.

*156 Shallow bowl. (1900.) Semi-translucent opal glass decorated with silver mounting depicting the heads of three cocks in low relief; four opals. 9″ diameter. Signed: "Lalique." Österreichisches Museum für Angewandte Kunst, Vienna. Acquired from the artist, 1900. *Ill. p. 101*

157 Hand mirror in silver frame; enameled handle in the shape of a beetle; back, carved glass with wisteria blossom. (1900.) 9″ long. Signed: "Lalique." Museum für Kunsthandwerk, Frankfurt/Main. Acquired at Universal Exposition, Paris, 1900

158 Necklace (choker). (c. 1900.) Twelve rows of opal beads with five rectangular inserts of enameled gold and opals. 13″ long x 2⅜″ wide. Museum für Kunsthandwerk, Frankfurt am Main

159 Necklace (choker. (1900.) Gold, enamel and opaque glass in the shape of flowering bean vine; white velvet ribbon. 3¼″ long x 2⅜″ wide. Museum für Kunsthandwerk, Frankfurt am Main. Acquired at Universal Exposition, Paris, 1900

160 Brooch. (c. 1900.) Carved horn in the shape of a woman's face, with hair and wings of gold and enamel; pearl drop. c. 4″ wide. Musée des Arts Décoratifs, Paris

161 Brooch. (c. 1900.) Flower spray surmounted by bees. Rock crystal and gold. 7½″ wide. Musée des Arts Décoratifs, Paris

162 Brooch. (c. 1900.) Four dragon flies of enameled gold, translucent enamel and diamonds; large opal in center. 2⅜″ wide. Collection Mrs. Alfred H. Barr, Jr., New York

*163 Decorative comb. (c. 1900.) Carved horn in the shape of a branch surmounted by a bird with enameled gold body. 6⅛″ long. Det Danske Kunstindustrimuseet, Copenhagen. Acquired from the artist at Universal Exposition, Paris, 1900. *Ill. p. 102*

LANGFIER (?)

164 *Loie Fuller.* (c. 1900.) Photograph. 6½ x 4¼″. Museum of the City of New York

LARCHE, RAOUL FRANCOIS (1860-1912)

French sculptor. Pupil of Fr. Jouffroy, Falguière and Delaplanche. Active in Paris. Participated in the exhibition of the *Salon* from 1884 on.

165 *Loïe Fuller, the Dancer.* (c. 1900.) Gilded bronze. 13″ high. Signed. The Museum of Modern Art, New York. Gift of Anthony Russo. *Cover.*

LAUGER, MAX (1864-1952)

German architect. Studied and taught at Kunstgewerbeschule, Karlsruhe. Specialized in ceramics. Simplified tradi-

tional Oriental vase forms, heightening their effect by the placing and the color of his plant motifs. 1908 in Munich first comprehensive exhibition in Germany at the Deutsche Werkstätten.

166 Vase. (Before 1903.) Brown glazed pottery, decorated with black and green plants in relief. 8¼″ high. Marked: "MLK." Museum für Kunsthandwerk, Frankfurt am Main

LEBEAU, JORIS JOHANNES CRISTIAAN (Chris) (1878-1946)

Dutch decorative and graphic artist. Besides woodcuts and lithographs, specialized in designs for industrial art, textiles, glassware, posters, etc.

167 Silk scarf. (c. 1904.) Batik design of animals and scrolls; white on rose. 31½ x 29½″. Made by t'Binnenhuis, Amsterdam. Det Danske Kunstindustrimuseet, Copenhagen

LECHTER, MELCHIOR (1865-1936)

German painter and book designer. 1884 studied at the Hochschule für Bildende Kunst in Berlin. 1886 in Bayreuth. 1900 represented at the *Exposition Universelle* in Paris. Influenced in his painting by the Pre-Raphaelites and in his book designs by Morris. Friend of the German poet Stefan George, all of whose books he designed from 1897-1907.

168 Title page for *Der Teppich des Lebens und die Lieder von Traum und Tod mit einem Vorspiel* by Stefan George. 1899. Book size, 15 x 14½″. Klingspor Museum, Offenbach

169 Type specimen sheet. (1896-1900.) Klingspor Museum, Offenbach

LEMMEN, GEORGES (1865-1916)

Belgian painter, graphic-artist and designer. In painting influenced by Seurat. 1889-92 exhibited at *Salon des Indépendents,* Paris. 1893 contributed to *Van Nu en Straks.* 1894-97 associated with van de Velde in Brussels and member of the group *La Libre Esthétique.* 1899 designs for magazine *Die Insel.* Also designed jewelry, metal fittings, bookbindings and tapestries.

*170 Title page for catalogue *Les XX.* 1891. 5¾ x 5⅝″. Bibliothèque Royale de Belgique, Brussels. *Ill. p. 31*

LIVEMONT, PRIVAT (1861-)

Belgian painter and decorative artist. Studied painting in Brussels with A. Bourson and L. H. Hendrick. Active in Scherrebek near Brussels. Made posters and lithographs.

171 Poster. 1897. 42⅛ x 31½″. Stedelijk Museum, Amsterdam

LÖTZ WITWE, JOH.

Glass factory in Klostermühle, Bohemia, following the example of Tiffany.

172 Vase. (c. 1900.) Silver iridescent glass, with onion-shaped

base and green onion leaf decoration. 8½″ high. Landesgewerbemuseum, Stuttgart

173 Vase. (c. 1900.) Dark purple iridescent glass with light blue abstract decoration. 8¼″ high. Österreichisches Museum für Angewandte Kunst, Vienna

*174 Bottle-vase. (c. 1902.) Sculptured shape; gold iridescent glass. 14⅛″ high. Österreichisches Museum für Angewandte Kunst, Vienna. Gift of Max Ritter von Spaun. *Ill. p. 120*

175 Bowl. (1899.) Green iridescent glass with scalloped edge; leaf rosette in center. c. 4½″ high. Österreichisches Museum für Angewandte Kunst, Vienna. Gift of Max Ritter von Spaun

MacDonald, Frances (1874-1921)
made with MacDonald, Margaret (1865-1933)

Scottish decorative designer and metalworker. Younger sister of Margaret Macdonald. Educated at the Glasgow School of Art. Worked both alone and with her sister. Married the architect J. Herbert McNair in 1899 and afterwards collaborated with him in the design of furniture and stained glass. Taught enameling, gold, silver, and metalwork at Glasgow School of Art from 1907.

176 *The Iliad.* 1899. Two plaques, metal repoussé. 20½ x 6½″, each. Collection Thomas Howarth, Toronto. (N.Y.)

Mackintosh, Charles Rennie (1868-1928)

Scottish architect, designer and watercolorist. 1884 apprenticed to the architect John Hutchison and attended, from 1885 evening classes at the Glasgow School of Art. 1889 joined as draftsman the architectural firm of John Honeyman & Keepie of which he became a partner in 1904. Developed an individual style in architecture, interior design and furniture during the nineties and became the leader of the internationally-known group called The Four: Herbert McNair, Margaret and Frances Macdonald, and himself. Together they explored the decorative arts, evolving in the Glasgow style, a very important element of Art Nouveau. His short architectural career included Windy Hill (1899-1901) and Hill House (1902-03) and culminated in the building of the Glasgow School of Art (1897-1909), a number of tearooms for Miss Cranston (1897-1910) and the Scottish Pavilion at the Turin Exhibition 1902. Later he dedicated himself mainly to furniture design and decoration. Gave up architecture and moved to Port Vendres, France, and painted watercolors.

*177 Preliminary design for the mural decoration in the first-floor room of Miss Cranston's Buchanan Street Tea Rooms, Glasgow. 1897. Watercolor on tracing paper. 14 x 29¼″. The University of Glasgow, Department of Fine Arts. *Ill. p. 68-69*

178 New Year's Card. Pencil. 9⅞ x 2″. The Metropolitan Museum of Art, New York. Whittelsey Fund, 1956

179 *Conversazione* program. 1894. Watercolor. 5¼ x 7¾″. Collection Thomas Howarth, Toronto

*180 *The Scottish Musical Review.* 1896. Poster. 7′8″ x 3′2″. The Museum of Modern Art, New York. *Ill. p. 19*

180a Hand lettering from *Beispiele Künstlerischer Schrift* by Rudolf von Larisch. 1902. The Museum of Modern Art, New York

*181 Cabinet. (c. 1903.) Wood, painted white, decorated with carvings and inlayed figures of enamel and leaded glass. 5′ high. The University of Glasgow Art Collections. *Ill. p. 91*

182 Chair. 1900. Wood, carved and painted white; linen upholstery with stenciled decoration. 5′ high. The University of Glasgow Art Collections

183 Fish knife and fork. (c. 1900.) Silver-plated nickel. 9″ long. The Museum of Modern Art, New York. Gift of The University of Glasgow

184 Wall mirror. (c. 1903.) Surface overlayed with leaded stained glass design. 31¼ x 9¾″. The University of Glasgow Art Collections
See also list of architecture photographic enlargements on page 185.

Mackintosh, Margaret Macdonald (1865-1933)

Scottish decorative designer, metalworker and watercolorist. Educated at the Glasgow School of Art. Designed and executed decorative metalwork with her sister Frances. Married C. R. Mackintosh 1900, and afterwards collaborated in all his work and considerably influenced his decoration. Her later work includes gesso panels and stained glass.

185 *Motherhood.* 1902. Painted gesso relief. 42 x 42″. The Glasgow School of Art

186 Menu for Miss Cranston's White Cockade Tea Room at The International Exhibition, Glasgow, 1901. 9⅛ x 12⅜″ (opened). University of Glasgow Art Collections

Mackmurdo, Arthur Heygate (1851-1942)

English architect, graphic artist, craftsman and economist. About 1870 induced by Ruskin to train as architect. In 1882 (or a little earlier), together with Herert Horne, Selwyn Image and Bernard Creswick, founded the Century Guild, a loose cooperative association of artist-craftsmen. The style of the products of the Century Guild formed the esthetic foundation of Voysey's and Mackintosh's art. 1883 produced book *Wren's City Churches* with woodcut title page. From 1884 edited the magazine of the Century Guild *The Hobby Horse* which in its printing style is the forerunner of the Kelmscott and the Doves Press work. Around 1900 gave up architecture and retired to Essex devoting himself to research in economics in which field he published several books.

*187 Title page for *Wren's City Churches* by A. H. Mackmurdo, A.R.I.B.A. 1883. Book size, 12 x 9". Victoria and Albert Museum, London. *Ill. p. 27*

*188 Two-sectioned screen. 1884. Embroidered silk panels with satinwood frame. 47 x 42¾". Made by The Century Guild. William Morris Gallery, Walthamstow. *Ill. p. 88*

*189 *Cromer Bird*. (c. 1884.) Printed cotton. 36 x 32". Made by The Century Guild. William Morris Gallery, Walthamstow. *Ill. p. 89*

MAILLOL, ARISTIDE (1861-1944)

French sculptor. Started out as painter and tapestry designer. 1882-1886 pupil at the Ecole des Beaux Arts in Paris. Strongly influenced by Gauguin and the Pont-Aven group and friend of the *Nabis* group. 1893-95 workshop for tapestries in Banyuls-sur-Mer. From 1898 on devoted himself to sculpture, becoming one of the most important sculptors of the early twentieth century.

*190 *The Washerwomen*. (1893.) Oil on canvas. 25¼ x 31½". Josefowitz Family Collection, Lausanne. *Ill. p. 61*

*191 *Washerwoman*. (1893.) Bronze. 8" high. Collection Mr. and Mrs. John Hay Whitney, New York. *Ill. p. 60*

MAJORELLE, LOUIS (1859-1926)

French furniture designer. After attending the Académie des Beaux-Arts in Paris, he returned to Nancy to take over his father's business, which specialized in making period furniture. His own first designs were in the rococo manner, before he adopted the Art Nouveau style in 1897-98 under the influence of Gallé. Majorelle made use of Gallé's plant shapes but instead of a flat surface treatment of floral elements, his design was more plastic. This is true also of his free handling of iron in the stair rail for the Galerie La Fayette in Paris. The essential characteristic of his work is the dynamic line. His work was represented at S. Bing's Paris shop L'Art Nouveau, which opened in 1895, and the Turin Exposition of 1902. He is considered the leading furniture producer of the Nancy School, but with its decline, he returned to classicism.

192 Table lamp in the shape of a cluster of water lilies. (c. 1902.) Gilded brass base; sculptured glass shades by Daum Frères. 31⅜" high. Made by Majorelle Frères & Cie., Nancy. Collection Theodoros Stamos, New York

MARTIN, CAMILLE (1861-1898)

French painter and decorative artist. Pupil of Devilly and Lechevallier-Chevignard. Active in Nancy.

193 Desk folder. 1893. Leather repoussé design of maple leaves and thistles; inscribed: "Feuilles d'Automne" and "Il reste la melancolie quand le bonheur s'en est allé." 20 x 13". Musée de l'Ecole de Nancy

MINNE, GEORGE (1866-1941)

Belgian sculptor and draftsman. Studied at the academies of Ghent and Brussels. Member of the *Les XX* in Brussels. Close contact with Symbolist poets and friend of Maeterlinck whose work he illustrated. Major sculptural work the Folkwang Museum fountain formerly in Hagen, now in Essen 1898. Returned later to classical style.

*194 *Kneeling Boy at the Fountain*. (1898.) Bronze. 30¾" high. Musée des Beaux-Arts, Ghent, Belgium. *Ill. p. 72*

MODERSOHN-BECKER, PAULA (1876-1907)

German painter. Early studies in Bremen and Berlin, then at the artists's colony of Worpswede near Bremen where she settled and married the painter Otto Modersohn, friend of Rainer Maria Rilke. Four study trips to Paris between 1900 and 1907, including a trip to Brittany; experienced the impact of French painting: Sérusier, Gauguin; discovered Cézanne in 1901. Developed a strong proto-Expressionist style of her own, cut short by her early death.

*195 *Still Life*. (c. 1900.) Oil on cardboard. 14⅞ x 11½". Collection Stephen Radich, New York. *Ill. p. 84*

MOSER, KOLOMAN (1868-1918)

Austrian painter, designer, and graphic artist. Founding member of Vienna Secession, 1897. Began teaching at Wiener Kunstgewerbeschule in 1899 and became an influential force in Austrian applied-art movement, working in illustration, textile design, posters, frescoes, stained glass, bookbinding, glassware and jewelry. In 1903, with Hoffmann and Wärndorfer established the Wiener Werkstätte.

196 14 vignettes for *Ver Sacrum*. (1898-1903.) Ink. Österreichisches Museum für Angewandte Kunst, Vienna

197 7 initials for *Ver Sacrum;* one head in profile. (1898-1903.) Ink. Österreichisches Museum für Angewandte Kunst, Vienna

198 Marbleized end paper. (c. 1900.) 13⅝ x 9¼". Österreichisches Museum für Angewandte Kunst, Vienna

199 *Woman*. (1901.) Embossing, 5⅞ x 5". Österreichisches Museum für Angewandte Kunst, Vienna

200 Hand lettering from *Beispiele Künstlerischer Schrift* by Rudolf von Larisch, 1900. The Museum of Modern Art, New York

201 *Ver Sacrum. V. Jahr. XIII Ausstellung. D. Vereinigung Bildender Künstler Österreichs Secession*. 1901. Poster 37⅜ x 12⅜". Österreichisches Museum für Angewandte Kunst, Vienna

202 *Fabrik von Wiener Moebeln, A. G. Jacob, Josef Kohn* (text in Russian). Poster. 37⅜ x 24¾". Österreichisches Museum für Angewandte Kunst, Vienna

*203 Liqueur glass. (c. 1900.) Clear glass bowl, red stem and base. 6¼″ high. Österreichisches Museum für Angewandte Kunst, Vienna. Gift of R. Steindl. *Ill. p. 120*

204 Textile. 1899. Silk and wool double weave; abstract mushroom pattern. 48 x 48″. Made by Backhausen & Söhne, Vienna. Österreichisches Museum für Angewandte Kunst, Vienna. Gift of R. Steindl

*205 Textile. 1899. Silk and wool double weave; abstract flower pattern. 48½ x 37¾″. Made by Backhausen & Söhne, Vienna. Österreichisches Museum für Angewandte Kunst, Vienna. Gift of the manufacturer. *Ill. p. 117*

206 Textile. (c. 1899.) Silk and wool double weave; leaf and peacock feather pattern. 50 x 48¾″. Made by Backhausen & Söhne, Vienna. Österreichisches Museum für Angewandte Kunst, Vienna. Gift of R. Steindl

MUCHA, ALFONS MARIA (1860-1939)

Czech painter, graphic and decorative artist. Studied in Munich, Vienna and in Paris at the Académie Julian 1890-1894. Became famous through his posters for Sarah Bernhardt (the first in 1894), and for others. Also active as book designer and illustrator. Contributed to *La Plume* among other magazines. Also did wall paintings for the South-Slavic pavilion at the Universal Exposition in Paris, 1900, and later for theaters and public buildings in Berlin and Prague.

207 *XXme Exposition du Salon des Cent.* 1896. Lithograph, 25¼ x 17″. The Museum of Modern Art, New York. Gift of Ludwig Charell

MUNCH, EDVARD (1863-1944)

Norwegian painter and printmaker. Closely related to Art Nouveau, he used the style with great psychological insight and formal power. One of the chief pioneers of the modern print movement. 1881-1884 studied in Oslo. 1889 first exhibition in Oslo. From 1885 extensive travels to Paris, Germany and Italy. Saw work of Toulouse-Lautrec, Gauguin and van Gogh in Paris. Exhibited in S. Bing's L'Art Nouveau in 1896 and also made decorations for the Théatre de l'Oeuvre. First woodcuts in 1896. Shown in Berlin since 1892, his work had the greatest single influence on German Expressionist painting.

*208 *The Cry.* 1893. Oil on cardboard. 33 x 26½″. Nasjonalgalleriet, Oslo. *Ill. p. 80*

209 *Woman.* (1895.) Drypoint and aquatint. 11¾ x 13½″. Private Collection. New York

*210 *Madonna.* (1895.) Color lithograph. 23¾ x 17½″. The Museum of Modern Art, New York. Purchase. *Ill. p. 81*

NERÉE TOT BABBERICH, KAREL DE (1880-1909)

Dutch draftsman. Self-taught, influenced by Toorop, Beardsley and the Japanese, excellent draftsman of nudes.

211 *Two Women.* 1901-1909. Watercolor and ink. 14¼ x 8⅝″. Gemeentemuseum, The Hague

NIEUWENHUIS, TH. (1866-1951)

Dutch graphic artist, designer and ceramist. Pupil of the architect P. J. H. Cuypers, he was active in the Dutch Art Nouveau movement with Lion Cachet and G. W. Dijsselhof. Among the influences on Dutch artists in the 1890s were Japanese art, the English Arts and Crafts Movement and the batik technique from the East Indies. Nieuwenhuis' work reflects these trends in emphasizing the linear with designs of coiled snakes, peacock feathers and other elements taken from nature. He designed pottery for the De Distel earthenware factory which operated in Amsterdam from 1895-1923.

212 Bottle-vase. 1916-17. Glazed pottery with plant and butterfly design in relief on white background. 12¼″ high. Made by De Distel factory, Amsterdam. Gemeentemuseum, The Hague

OBRIST, HERMANN (1863-1927)

Swiss sculptor and designer. First studied geology and chemistry, but after attending the Karlsruhe Kunstgewerbeschule, he devoted himself to applied art, although he worked independently in sculpture for a time in Paris. 1892 with Berta Ruchet founded an embroidery workshop in Florence, which he moved to Munich in 1894. 1897 founding member and regular collaborator in the Munich Vereinigte Werkstätten für Kunst im Handwerk. Represented by embroideries in "Salle Riemerschmid" at Paris Exhibition of 1900. His motifs are derived from nature with stylized but highly inventive shapes. A series of his embroideries was published in *Pan.* 1902, with Wilhelm von Debschitz, founded the Lehr-und Versuchateliers für freie und Angewandte Kunst in Munich.

*213 Wall hanging. *Peitschenhieb (Whiplash).* 1895. Embroidered in gold colored silk on grey wool, 46⅞ x 72¼″. Initialed "HO." (The original title is *Cyclamen.* The name *Whiplash* derives from an article by Fuchs in *Pan,* 1896. Münchner Stadtmuseum. (Exhibited in New York only). *Ill. p. 113*

214 Ornamental plant composition. Pencil, 16⅛ x 10″. Collection Dr. Siegfried Wichmann, Starnberg, Germany

OLBRICH, JOSEPH MARIA (1867-1908)

Austrian architect, draftsman and designer. Studied with Otto Wagner at Vienna Academy. Began career as illus-

trator, contributing to *Ver Sacrum*. With Josef Hoffmann, leader of Vienna Secession which he helped found in 1897. Designed Secession building 1898-99. Summoned by the Grand-Duke of Hesse to the artists' colony at Mathilden-höhe, Darmstadt in 1899 for which he designed almost all the buildings. Designed an entire room for the 1900 Paris Exhibition and was represented in the Turin Exhibition of 1902. Designed the fountain court of the German pavilion at the St. Louis World's Fair of 1904. His death at the age of 41 ended a promising career at a vital point in development.

215 Type specimen sheet. (1896-1900.) Klingspor Museum, Offenbach

216 Sculpture stand. (1900.) Mahogany. 56″ high. Made by Julius Glückert, Darmstadt. Designed for reception room of Darmstadt Artists' colony, Universal Exposition, Paris, 1900. Museum für Kunsthandwerk, Frankfurt/Main

*217 Two-armed Candelabrum. 1901. Pewter, with abstract incised decoration. 14⅛″ high. On bottom: Artist's mark and manufacturer's identification "Edelzinn E. Hueck. 1819." The Museum of Modern Art, New York. Philip Johnson Fund. *Ill. p. 118*

ORLEY

218 Textile. (1902.) Woven silk; abstract swirl pattern. 49 x 36½″. Made by Backhausen & Söhne. Österreichisches Museum für Angewandte Kunst, Vienna. Gift of the manufacturer

PANKOK, BERNHARD (1872-1943)

German designer and graphic artist. Active in Munich 1892-1902. Contributed to *Jugend*. His style transposed organic forms to furniture and ornaments. Rooms he designed were shown at the VII International Art Exhibition at the Glaspalast in Munich. A founder of the Münchner Vereinigte Werstätte für Kunst in Handwerk. 1899 furnished a room at the Munich Secession exhibition. Designed and decorated the catalogue for the German section of the Paris Universal Exposition of 1900, for which he also furnished a room. After 1902 active in Stuttgart. 1904 represented at St. Louis World's Fair with a music room. 1913-37 Director of the Staatliche Kunstgewerbeschule in Stuttgart.

*219 Armchair. 1899. Carved mahogany with tapestry seat, woven at Webschule, Skaerbaek, Denmark. 29¾″ high. Landesgewerbemuseum, Stuttgart. *Ill. p. 112*

220 End papers for *Weltausstellung in Paris 1900. Amtlicher Katalog der Ausstellung des Deutschen Reichs*. Book size, 9½ x 7½″. Klingspor Museum, Offenbach

PAUL, BRUNO (1874-)

German printmaker and decorative artist. 1886-94 studied at the Kunstgewerbeschule in Dresden and, from 1894 on, at the Academy in Munich. Contributed to *Jugend*. 1897 co-founder of the Vereinigte Werkstätten für Kunst in Handwerk. 1907 head of the Unterrichtsanstalt of the Kunstgewerbemuseum in Berlin, and 1924-32 director of the Vereinigte Staatsschule für freie und angewandte Kunst in Berlin. Lives in Berlin.

221 Cover for *Jugend*, Vol. 1, No. 35, August 1896. Book size 11¾ x 9⅛″. New York Public Library

PICASSO, PABLO (1881-)

Spanish painter, lives in France. Early studies in Barcelona; first visit to France in 1900. Traveled back and forth between Barcelona and Paris up to 1904 when he settled in Paris. Early work strongly related to the "Modernismo" in Barcelona and the Symbolist and Art Nouveau style in Paris.

*222 *The End of the Road*. (c. 1898.) Watercolor. 17¾ x 11½″. Mr. and Mrs. Justin K. Thannhauser Collection, lent through Thannhauser Foundation. *Ill. p. 65*

*223 *Courtesan with Jeweled Collar*. (1901.) Oil on canvas. 25¾ x 21½″. Los Angeles County Museum of Art. Mr. and Mrs. George Gard de Sylva Collection. *Ill. p. 65*

PRENDERGAST, MAURICE (1859-1924)

American painter. 1884-89 studied at the Académie Julian in Paris, together with his brother Charles. Both settled in Winchester, Mass., in 1889, to practice wood carving and gilding. Maurice returning to Europe in 1897, was strongly influenced by Cézanne and Seurat and, on frequent trips to Italy, by Italian masters, particularly Carpaccio, and the decorative arts of Italy. 1905 first New York exhibition. 1913 exhibited in the Armory Show from which time his reputation began to grow.

224 *The Red Cape*. (c. 1900.) Monotype. 14¾ x 10″. Collection Mr. and Mrs. Harold Uris, New York

PROUVÉ, EMILE VICTOR (1858- ?)

French sculptor, medalist, graphic and decorative artist. Pupil and later close friend and collaborator of Gallé. At the age of nineteen decorated a Gallé vase with inscription from de Musset. Asked in 1889 by Gallé to design inlay work for a table with quotations from Tacitus.

225 Ring. 1910. Gold with baroque pearl, small diamonds and emeralds. Signed and dated. Musée de l'Ecole de Nancy

226 Triangular box. (c. 1900.) Leather repoussé design of leaves; butterfly in colored enamel inlaid in leather. c. 10½ x 12″. Signed. Musée de l'Ecole de Nancy

RANSON, PAUL (1864-1909)

French painter and decorative artist. Enrolled as a student at the Académie Julian in 1880. 1889 co-founder of the *Nabi* group. 1892 worked together with Bonnard, Vuillard and Sérusier on the decorations for the Théatre d'Art. Contributed to the *Revue Blanche;* designed tapestries. Close friend of Georges Lacombe. Académie Ranson founded by his wife in 1908 with the help of the *Nabis* who all taught there in the following years (Bonnard, Denis, Maillol, Sérusier, Vallotton, etc.).

*227 *Women Combing Their Hair.* 1892. Distemper. 63 x 51⅛″. Collection Mme Sylvie Mora-Lacombe, Paris. *Ill. p. 58*

228 *Girl Sewing (La Mansarde).* 1893. Distemper on canvas. 21¼ x 17½″. Collection Mr. and Mrs. Samuel Josefowitz, New York

229 *Tiger in the Jungle.* 1893. Color lithograph, 14⅜ x 11″. Peter Deitsch Gallery, New York

230 Cover for *L'Exposition de 1900 et l'Impressionisme* by André Mellerio. (published 1900). 8 x 5½″. Collection John Rewald, New York

REDON, ODILON (1840-1916)

French painter and graphic artist. 1862-69 studied art in Bordeaux and in Paris at the Ecole des Beaux Arts. Friendship with Rodolphe Bresdin whom he later acknowledged as his teacher; met Corot, Delacroix and Fromentin. 1871-1878 painted in the forest of Fontainebleau and in Brittainy. 1879 published his first volume of lithographs *Dans le Rêve.* 1886 participated in the *Salon des XX,* Brussels. 1888 friendship with Mallarmé, interested in the Belgian and French Symbolist movement. 1890 lithographs for Baudelaire's *Les Fleurs du Mal.* 1891 *L'Oeuvre lithographique d'Odilon Redon* published in Brussels by Jules Destrées. 1904 retrospective exhibition of Redon's work at the Salon d'Automne. The visionary "dream world" of Odilon Redon and its symbolist and anti-realistic implications were of prime importance in the formation of Art Nouveau, although Redon himself in his highly personal and intimate style stayed aloof from the movement proper.

231 *Le Buddha.* (1895.) Lithograph. 12⅜ x 9¾″. The Museum of Modern Art, New York. Gift of Mrs. John D. Rockefeller, Jr.

*232 *La Mort: Mon ironie dépasse toutes les autres!* (after 1905.) Oil on canvas. 21½ x 18½″. Collection Mrs. Bertram D. Smith, New York. *Ill. p. 46*

RICKETTS, CHARLES (1866-1931)

English painter, sculptor, printmaker and decorative artist. Born in Geneva, he grew up in France. 1889-97 editor of the magazine *The Dial,* together with his pupil and friend Charles Shannon, with whom he also illustrated several books with woodcuts in the early nineties, among them Oscar Wilde's *A House of Pomegranates* (1891) and *Daphnis and Chloe* (1893). 1896 founded the *Vale Press,* illustrating most of its publications in the following years. In his graphic work he was close to William Morris and the Pre-Raphaelites. As a painter he was a follower of Delacroix, as a sculptor of Rodin. He also made jewelry and small bronzes and was one of the reformers of English stage and costume design. 1922 member of the Royal Academy.

233 Ricketts, Charles and Shannon: *Hero and Leander* by Christopher Marlowe 1894. Book size, 8 x 5½″. Collection Mr. and Mrs. Leonard Baskin, Northampton, Massachusetts

234 Binding for *Sphinx* by Oscar Wilde. 1894. Book size, 8¾ x 7″. Morgan Library, New York

RIEMERSCHMID, RICHARD (1868-1957)

German architect and designer. Studied painting at Munich Academy. 1897 founding member of the Munich Vereinigte Werkstätten für Kunst in Handwerk, with Pankok, Obrist and Bruno Paul, and collaborated with these artists in designing the *Salle Riemerschmid* at the Paris Exposition of 1900. 1901 interior design for the Munich Schauspielhaus. Designs for furniture and silver flatware are typical of his distinctively simple and functional style. 1902-05 taught at the Nuremberg Art School. 1912-24 Director of the School of Applied Arts in Munich. 1926 Director of the Cologne Werkschule.

235 Hand lettering from *Beispiele Künstlerischer Schrift* by Rudolf von Larisch. 1902. The Museum of Modern Art, New York

*236 Side Chair. 1899. Oak, with brown leather upholstery. 30¾″ high. Designed for Riemerschmid's music room, Dresden Exhibition of Decorative Arts, 1899. The Museum of Modern Art, New York. Gift of Liberty & Co., Ltd., London. *Ill. p. 114*

*237 Table flatware. (1900.) Silver (oyster fork, dessert spoon, dessert fork, dessert knife, cheese knife). Landesgewerbemuseum, Stuttgart. *Ill. p. 115*

ROCHE, PIERRE (1855-1922)

French sculptor, medallist and ceramist. Pupil of Roll, Dalou and Rodin. Participated in the *Salon des Artistes Français;* received a silver medal at the Exposition Universelle in 1900.

*238 *Loie Fuller.* (c. 1900.) Bronze. 21⅝″ high. Musée des Arts Décoratifs, Paris. *Ill. p. 64*

RODIN, AUGUSTE (1840-1917)

French sculptor. 1855-64 studied at the Ecole d'Art Décoratif. 1864-71 active in the porcelain manufactory of

Sèvres. 1871-77 in Belgium; friendship with Meunier. 1875 trips to Florence and Rome and 1877 through France for the study of cathedrals. Moved to Bellevue near Sèvres in 1890. Settled in Meudon in 1894. Initiator of the revival of modern sculpture. His sculpture related more closely to Impressionism and Symbolism than to Art Nouveau, nevertheless exerted an important influence on the New Style.

*239 *The Sirens.* (1889.) Bronze. 17″ high. Cleveland Museum of Art. *Ill. p. 72*

ROLAND HOLST, RICHARD NICHOLAÜS (1868-1938)

Dutch painter, graphic artist and essayist. Studied at the Academy of Fine Arts in Amsterdam. Influenced by van Gogh, the Pre-Raphaelites and Beardsley, he developed a predominantly decorative style in his graphic art. Contributed woodcuts to *Van Nu en Straks* in 1893. After 1894 fell under the influence of Charles Ricketts and Charles Shannon's illustrations. From 1896 on turned more and more to nature and became the propagandist of the Socialist movement.

240 Title page for van Gogh exhibition catalogue, Amsterdam, 1892. Lithograph, 6¼ x 7⅛″. Book size, 7 x 8¼″. Museum Boymans-van Beuningen, Rotterdam. *Ill. p. 32*

ROSSETTI, DANTE GABRIEL (1828-1882)

English painter and poet. 1846-48 studied in the Royal Academy schools where he took instruction from Ford Madox Brown and, later, shared a studio with Holman Hunt. Rossetti and Hunt, together with John Everett Millais, formed a secret association which developed into the Pre-Raphaelite Brotherhood of artists combining poetic and religious fervor with truthfulness to reality in their paintings. Rossetti was instrumental in re-awakening interest in William Blake and was a close friend of John Ruskin. He became the outstanding painter of this group which was to influence profoundly the younger generation, among them Edward Burne-Jones, and through him, the formation of Art Nouveau.

*241 Binding for *Atalanta in Calydon.* 1865. Book size, 8⅞ x 6¾″. New York Public Library, Berg Collection. *Ill. p. 26*

ROZENBURG, HAAGSCHE PLATEELBAKKERY, The Hague
Porcelain and earthenware factory, founded 1883.

*242 Bottle-vase with four handles. (c. 1900.) Glazed semi-porcelain, decorated with birds and flowers on white background. 15¾″ high. Landesgewerbemuseum, Stuttgart

243 Bottle-vase with two handles. (c. 1900.) Glazed semi-porcelain, decorated with green and yellow flower design on white background. 15⅜″ high. Österreichisches Museum für Angewandte Kunst, Vienna. *Ill. p. 108*

This type of Rozenburg porcelain was primarily designed by J. Juriaen Kok and decorated by J. Schelling and R. Sterken.

RYSSELBERGHE, THEO VAN (1862-1926)

Belgian painter and graphic artist. Studied at the academies of Ghent and Brussels. Member of *Les XX.* From 1898 on spent much time in Paris. Introduced Neo-impressionism into Belgium, but was also closely related to the Belgian Art Nouveau.

244 *Lady before a Mirror.* (1900.) Wood engraving. 15¾ x 6¾″. Collection Mr. and Mrs. Hugo Perls, New York

SCHARVOGEL, JULIUS JOHANN (1854-1938)

German ceramist. Operated a prosperous workshop in Munich. First experiments in underglaze painting. Strongly influenced by Far Eastern ceramics.

245 Vase. (c. 1900.) Earthenware, glazed and incised, with four wing-like projections. Plant ornament under brown and black glaze. 6⅛″ high. Det Dansk Kunstindustrimuseet, Copenhagen

SCHMITHALS, HANS (1878-)

German architect, painter and decorative artist. 1902 joined the Obrist-Debschitz school in Munich, first as a student and then as teacher. Trips to Paris in 1909 and 1911. Designed interior decorations. Lives near Munich.

246 *The Glacier.* (1903-04.) Oil on paper. 45¼ x 29½″. The Museum of Modern Art, New York. Purchase

SCHNECKENDORF, JOSEF EMIL (1865-)

Sculptor and designer-craftsman. Born in Romania. Studied at Munich Academy. After 1898 devoted himself to the manufacture of fine glassware. 1907 became director of the glassworks in Darmstadt founded by the Grand Duke of Hesse.

247 Vase. (c. 1908.) Iridescent gold glass, with bluish spatter design, 12⅝″ high. Made by the Grossherzoglich Hessische Edelglasmanufaktur, Darmstadt. Österreichisches Museum für Angewandte Kunst, Vienna

SCHNELLENBÜHEL, GERTRAUD VON (1878-)

German painter and designer. First studied painting in Munich. Turned to applied art in 1902 and attended classes in metalware at the Debschitz school. 1911 joined the workshop of the silversmith Adalbert Kinzinger. Represented at the Deutsche Werkbund exhibition in Cologne in 1914.

*248 Candelabrum for 24 candles. (After 1911.) Silver-plated brass. c. 19″ high. Münchner Stadtmuseum. (Exhibited in New York only). *Ill. p. 119*

SÉGUIN, ARMAND (1869-1904)

French painter and printmaker. Friend and pupil of Gau-

guin, belonged to the Pont-Aven group. 1895 exhibition of his work at the Barc de Boutteville in Paris for which Gauguin wrote an introduction.

*249 *The Pleasures of Life.* (1890-91.) Oil on canvas. 4 panels, each 60 x 22½". Private collection, New York. *Ill. p. 59*

249a *Farm in Brittany.* 1894. Etching and aquatint. 9 x 9¹⁄₁₆". The Museum of Modern Art, New York

SÉRUSIER, PAUL (1863-1927)

French painter. After early philosophy studies joined the Académie Julian in 1886. Met Bernard and Gauguin in Pont-Aven in 1888. Co-founder of the *Nabi* group and its most outspoken theoretitian. Wrote *A.B.C. de la Peinture.* Between 1895 and 1907 frequent trips to Italy and Germany. Strongly influenced by the ecclesiastical art school of Kloster Beuren. 1903 settled in Brittany where he retired in 1914, after teaching at the Académie Ranson.

250 *Le Bois Sacré.* (c. 1895.) Oil on canvas. 36¼ x 28¼". Collection Mlle H. Boutaric, Paris

SLOAN, JOHN (1871-1951)

American painter, illustrator and printmaker. 1891 attended night drawing class at the Spring Garden Institute in Philadelphia and in 1892 entered the Pennsylvania Academy of Fine Arts where he worked under Thomas P. Anschutz, (a pupil of Thomas Eakins). Worked for twelve years on newspapers as illustrator for the *Philadelphia Inquirer* and the *Philadelphia Press.* Under the brilliant guidance of Robert Henri, who had spent several years in Paris, Sloan became familiar with the contemporary art of Europe. In his early posters and prints he was strongly influenced by Walter Crane, William Morris and Japanese art. From 1900 on he exhibited paintings regularly in the major American annual art exhibitions. 1902 he started on a series of etched illustrations and drawings for a de luxe edition of the novels of Paul de Kock. In 1904 he moved to New York and, although his chief source of income was illustrating for magazines such as *Collier's* and *The Century,* he dedicated himself more and more to painting and etching. In 1908 he formed the group known as *The Eight,* whose members—Sloan, Glackens, Luks, Shinn, Lawson, Henri, Davies and Prendergast—were pioneers in the movement for freedom in art. He was prominent in organizing the Society of Independent Artists in 1917 and was its president in 1918. From 1916-24 he taught at the Art Students' League in New York and became its president in 1931.

251 *The Echo.* 1895. Poster. 18¾ x 8". The Museum of Modern Art, New York

STAMP, PERCY

*252 Hatpin. (1908.) Silver. Made by Charles Horner, Ltd., Halifax, England. The Museum of Modern Art, New York. Gift of Helen Franc, in memory of Greta Daniel. *Ill. p. 103*

STEICHEN, EDWARD (1879-)

American photographer, born Luxembourg. First exhibited photographs at Philadelphia Photographic Salon, 1899. First one-man show of paintings and photographs at the Maison des Artistes, Paris. 1905 collaborated with Alfred Stieglitz in establishing the Gallery of Photo-Secession, later called "291," which showed works of Rodin, Matisse, Brancusi, Cézanne, John Marin and Gordon Craig. During World War I commanded Photograph Division, Air Service, U.S. Army, A.E.F. 1923-38 chief photographer for Condé Nast publications. One-man retrospective exhibition at Baltimore Museum of Art, 1938. 1941 commissioned to do photo-murals for new Radio City Center Theater. 1941 commissioned as Lieutenant Commander, U.S.N.R., organized and directed Naval aviation photographic unit; attained rank of Captain. 1947 to the present, Director of Department of Department of Photography at Museum of Modern Art. Organized *Family of Man* exhibition which opened in 1955 at Museum of Modern Art. Lives in Ridgefield, Connecticut.

253 *Figure with Iris.* (1902.) Photograph. Original pigment print, 8 x 3¼". The Museum of Modern Art, New York. Gift of the photographer.

254 *Rodin—Le Penseur.* Photograph. 11 x 14". Copy of photogravure in *Camera Work,* No. 11, July, 1905. Original print (1902), 16¼ x 20⅜", owned by Mr. and Mrs. Hans Hammarskiold, Stockhold, Sweden

STEINLEN, THÉOPHILE ALEXANDRE (1859-1923)

Swiss-French designer and graphic artist. Studied art in Lausanne, then active as textile designer in Mulhause (Alsace). 1882 moved to Paris, where he became an illustrator, with biting social criticism, for many magazines and newspapers (partly under the pseudonyme Petit Pierre and Jean Caillou). 1901 naturalized French citizen.

255 *Winter.* (c. 1896.) Color lithograph. 19¼ x 23¼". The Museum of Modern Art, New York. Ludwig Charell Bequest

THORN PRIKKER, JOHAN (1868-1932)

Dutch painter and decorative artist. Studied at the academy of The Hague. Influenced by Maurice Denis and Gauguin. Impressed by meeting Paul Verlaine in 1892, he turned to Symbolism. Exhibited with *Les XX* in 1893 and contributed ornamental designs to *Van Nu en Straks.* Friendship with

Verhaeren and van de Velde through whose influence he applied himself to industrial art. From 1904 on in Germany: taught in Krefeld, from 1910 at the Folkwangschule in Hagen and Essen and later in Munich, Düsseldorf and Cologne. Influential in the development of frescoes, mosaics and stained glass windows for Catholic churches.

*256 *The Bride.* (1892-93.) Oil on canvas. 57½ x 34¾". Rijksmuseum Kröller-Müller, Otterlo. *Ill. p. 74*

TIFFANY, LOUIS COMFORT (1848-1933)

American glass designer and jeweler. Born in New York, the son of Charles Tiffany, goldsmith and jeweler. Instead of joining the family business decided to become a painter. 1866 apprenticed to George Innes. Studied in Paris and active in painting, up to 1878, specializing in genre scenes and landscapes. Turned to decorative arts. First experimented with glass and learned chemistry, working in the Heidt glass works in Brooklyn. First ornamental windows of opalescent glass in 1876 and by 1880 he had applied for the patents on the metallic iridescent glass for which he became noted. 1879 formation of Louis C. Tiffany Company, Associated Artists, which decorated interiors for many private homes and public buildings, including the White House in Washington, D. C. in 1882-83. Tiffany Glass Co. was incorporated in 1885, specializing in stained glass windows and related interiors. 1893 Tiffany designed and built a chapel for the World Columbian Exposition in Chicago, later installed in the Cathedral of St. John the Divine in New York. In this, his first architectural work, the influence of Richardson, Sullivan and the Romanesque are evident. However, Tiffany's ornamentation incorporating Art Nouveau motifs in glass and mosaics had developed into an original and wholly contemporary style. Because of the superb quality of his glass he received commissions to execute a series of windows designed by French artists, including Bonnard, Vuillard and Toulouse-Lautrec which were shown in the Salon of 1895 in Paris. With the building of a new glass factory in 1892 Tiffany concentrated on blown glass vases and bowls. Each piece produced was personally approved by him before it was sold. He gave the trade-mark "Favrile," meaning handmade to this glass which was distinctive for its shapes and its iridescent, brilliant or deeply toned colors. The influence of Near and Far Eastern art was also apparent. S. Bing in Paris had exclusive European distribution rights to Tiffany glass but it was soon widely imitated in Europe, notably by Bohemian glassmakers. One of his "lily-cluster" lamps won a grand prize at the Turin Exposition in 1902. After his father's death that same year, Tiffany concentrated on designing jewelry and building his own residence, Laurel-

ton Hall in Oyster Bay, Long Island. Tiffany Studios and Tiffany & Company continued to produce and sell objects in various media, including glass, pottery, enamels, metalware, as well as memorial windows. In 1911 he designed a mosaic glass curtain for the National Theatre in Mexico City. The Louis Comfort Tiffany Foundation at Laurelton Hall was established in 1918, providing fellowships for young artists to live and work on the estate. In 1932 the Tiffany Studios went bankrupt. Tiffany died in 1933. The collection of Laurelton Hall were sold at auction in 1946.

257 Vase. (c. 1900.) Flower form. Favrile glass, iridescent gold. 16⅛" high. Made by Tiffany Studios, New York. Signed and marked. The Museum of Modern Art, New York. Phyllis B. Lambert Fund

258 Vase. (c. 1900.) Favrile glass, opaque with abstract raised decoration. 10½" high. Made by Tiffany Studios, New York. Signed and marked. The Museum of Modern Art, New York. Phyllis B. Lambert Fund

*259 Vase. (c. 1900.) Glass flower in a metal stand. Favrile glass, translucent white and green; silver-plated bronze. 15⅞" high. Made by Tiffany Studios, New York. Marked and stamped. The Museum of Modern Art, New York. Phyllis B. Lambert Fund. *Ill. p. 106, left*

*260 Vase. (c. 1900.) Favrile glass with irregular textured surface. 4⅝" high. Made by Tiffany Studios, New York. Signed and marked. The Museum of Modern Art, New York. Edgar Kaufmann, Jr. Fund. *Ill. p. 106, center*

261 Vase. (c. 1900.) Favrile glass, calla lily decoration encased in clear glass. 16⅜" high. Made by Tiffany Studios, New York. The Museum of Modern Art, New York. Gift of Joseph H. Heil

262 Candlestick. (c. 1900.) Bronze, lined with opaque green glass. 6" high. Made by Tiffany Studios, New York. Marked. The Museum of Modern Art, New York. Phyllis B. Lambert Fund

263 Candlestick. (c. 1900.) Bronze. Tripod base with root motif: Favrile glass jewel decoration. 12¼" high. Made by Tiffany Studios, New York. Marked Tiff. Studios. The Museum of Modern Art, New York. Gift of Joseph H. Heil

264 Hand mirror with peacock motif. (c. 1900.) Silver, enamel, sapphires. 10¼" long. The Museum of Modern Art, New York

*265 Table lamp. 1892-93. Base and shade forming wisteria vine. Bronze and Favrile glass. 27" high; shade 18" diameter. Lillian Nassau, New York. *Ill. p. 107*

266 Leaded picture window depicting wisteria vine on trellis against blue and purple sky from William Skinner House, 36 East 39 Street, New York. (c. 1905.) 73 x 67". Collection R. Stewart Kilborne, New York

TOOROP, JAN (1858-1928)

Dutch painter and graphic artist. Born in Java. Studied in Amsterdam and Brussels where he joined the group *Les XX* in 1887. Influenced by Ensor and Redon, he associated in 1890 with the Dutch literary group of the "Tachtigers," with Maeterlinck and Verhaeren, and for some time with the Rosicrucian movement and turned to Symbolism, restricting his artistic production mainly to drawings. 1905 converted to Catholicsm.

*267 *The Three Brides.* (1893.) Drawing. 37⅝ x 38½". Rijksmuseum Kröller-Müller, Otterlo. *Ill. p. 75*

*268 *Delftsche Slaolie.* (1895.) Poster. 36¼ x 24⅜". Stedelijk Museum, Amsterdam. *Ill. p. 18*

269 Binding for *Babel* by L. Couperus. (1901.) Stedelijk Museum, Amsterdam. Book size, 8¾ x 6¾".

270 Binding for *Psyche* by L. Couperus. (1898.) Stedelijk Museum, Amsterdam. Book size, 8½ x 6¼".

TOULOUSE-LAUTREC, HENRI DE (1864-1901)

French painter and printmaker. 1878 accident which crippled him for life. 1881 settled in Paris. Studied at the studios of Bonnat and Cormon. Formed the "Ecole du Petit Boulevard" together with Anquetin, Bernard and van Gogh. 1891 first posters, 1892 first color lithographs. 1893 contributed to the *Revue Blanche;* visited van de Velde in Brussels in 1894. 1895 trips to London where he met Wilde and Beardsley. One of the most important figures in the development of French Art Nouveau.

*271 *At the Nouveau Cirque: The Dancer and the Five Stiff Shirts.* (1891.) Oil on paper on canvas, 45¾ x 33½". Philadelphia Museum of Art. *Exhibited in New York only. Ill. p. 63*

*272 *Loie Fuller.* 1893. Color lithograph, 14⅜ x 10½". The Ludwig and Erik Charell Collection. *Ill. p. 64*

273 *Loie Fuller.* 1893. Color lithograph, 14 x 9⅛". The Ludwig and Erik Charell Collection

274 *Jane Avril.* 1895. Lithograph, 10½ x 8⅜". The Museum of Modern Art, New York. Purchase

*275 Jane Avril, 1899. Lithograph 22 x 14". The Museum of Modern Art, New York. Gift of Abby Aldrich Rockefeller. *Ill. p. 37*

VALLOTTON, FÉLIX (1865-1935)

Swiss-French painter and graphic artist. 1882 settled in Paris. Studied at the Académie Julian. Contact with the *Nabi* group. 1890 first woodcuts. Contributed to the *Revue Blanche.* 1908 taught at the Académie Ranson. Trips to Russia, Italy and Germany.

*276 *The Waltz.* (1893.) Oil on canvas. 24 x 19¾". Private collection, Paris. *Ill. p. 63*

277 *The Flute.* (1896.) Plate II from the series *Six Instruments de Musique.* Woodcut. 8¾ x 7". The Museum of Modern Art, New York. Gift of Victor S. Riesenfeld

VELDE, HENRY VAN DE (1863-1957)

Belgian painter, architect and designer. Studied painting in Antwerp and in Paris with Carolus-Duran. In contact with impressionist painters and the symbolists Mallarmé, Verlaine, Debussy. 1885 returned to Belgium, and by 1889 active with the group *Les XX* in Brussels; under the influence of van Rysselberghe turned to neo-impressionism; Through Willy Finch came to know the English Arts and Crafts, and Morris movements. After a period of indecision, followed by a nervous breakdown, he gave up painting and turned to the decorative arts. 1893 showed embroidery *Angels' Guard* at the *Les XX* exhibition; illustrations for *Van Nu en Straks;* first furniture designs. 1894 gave lecture *Déblaiement d'Art* at *Les XX* which was published as a brochure. Van de Velde, as a theoretitian, writer and lecturer, became the most articulate advocate of the new ornamental style and an ardent partisan for applied art. His abstract design was distinctive for its tense energy. In his interiors and furniture he emphasized functional unity. 1895 built and furnished his own house at Uccle, near Brussels, which served as a model to demonstrate his theories of design. Visit by J. Meier-Graefe and S. Bing brought van de Velde to the attention of world outside of Belgium; in 1896 he was asked by Bing to create four rooms for his new Paris shop, *L'Art Nouveau,* that met with a mixed reception in France. These, with an additional room were sent to the Applied Art Exhibition in Dresden in 1897, leading to many commissions in Germany. 1898 took charge of graphic design and advertising for Tropon works, Mulheim; contributed to *Pan.* 1899 commissioned by Meier-Graefe to design interior for new Paris showroom *La Maison Moderne.* 1900 commissioned by Karl Ernst Osthaus to design the interior of the Folkwang Museum at Hagen, completed in 1902. 1901 publication of *Die Renaissance in Modernen Kunstgewerbe.* Invited to Weimar School of Applied Art, introducing his own methods of art instruction. 1907 took part in the founding of the Deutsche Werkbund. 1914 built theater for the Deutsche Werkbund exhibition in Cologne. With outbreak of World War I, as a Belgian dismissed from all positions. His post in Weimar was taken over by Walter Gropius and the school reorganized at the Bauhaus. 1917 allowed to leave Germany and settled in Switzerland where he came in contact with Romain Rolland and E. L. Kirchner. 1921 moved to Holland on invitation of the art collector Kröller-Müller to design the Kröller-Müller Museum in Otterlo, which opened officially in 1938. 1926-35 head of the Institut Supérieur

des Arts Décoratifs, Brussels and Professor of Architecture at University of Ghent from 1926-1936. 1938 collaborated on the Belgian pavilion for New York World's Fair. 1947 settled in Oberägeri, Switzerland.

278 Abstract composition. 1890. Pastel. 18⅝ x 20″. Rijksmuseum Kröller-Müller, Otterlo

*279 *Angels' Guard.* 1893. Wall hanging; wool and silk embroidered appliqué. 55 x 91¾″. Kunstgewerbemuseum, Zurich. *Ill. p. 94*

280 Illustration from *Van Nu en Straks.* 1893. Book size 11½ x 19⅝″. Bibliothéque Royale de Belgique, Brussels

281 Illustration from *Van Nu en Straks.* 1893. Book size, 11½ x 19⅝″. Butler Library, Columbia University, New York.

*282 *Tropon, l'Aliment le Plus Concentré* (Tropon, the Most Concentrated Nourishment). 1899. Offset facsimile of original lithograph, 31⅝ x 21⅜″. The Museum of Modern Art, New York. Gift of Tropon-Werke. *Ill. p. 23*

283 Title page for *Dominical* by Max Elskamp. 1892. Book size, 8⅞ x 5½″. Bibliothèque Royale de Belgique, Brussels

284 Binding for *Ecce Homo* by Friedrich Nietzsche. 1908. Book size, 9⅞ x 7¾″. Klingspor Museum, Offenbach

285 Title page for *Ecce Homo* by Friedrich Nietzsche. 1908. Book size, 9⅞ x 7¾″. The Museum of Modern Art, N.Y.

*286 Side Chair from the artist's house in Uccle. 1895. Paduk with rush seat, 37″ high. The Museum of Modern Art, New York. Purchased from van de Velde estate. *Ill. p. 94*

287 Armchair. (c. 1899.) Polished paduk. 34¼″ high. Woven upholstery, decorated with abstract batik pattern (executed by Thorn Prikker, Amsterdam). Chair designed by van de Velde and executed in his workshops in Ixelles. Nordenfjeldsk Kunstindustrimuseum, Trondheim

*288 Candelabrum for 6 candles. (c. 1902.) Silver-plated bronze. 21¾″ high. Nordenfjeldske Kunstindustrimuseum, Trondheim. *Ill. p. 96*

289 Inkstand. 1898. Polished brass, 8¼″ long. Acquired from *La Maison Moderne* at the Universal Exposition, Paris, 1900. Nordenfjeldske Kunstindustrimuseum, Trondheim

*290 Table flatware. 1902-03. Silver (dinner knife and fork, soup spoon, serving spoon, carving fork, grapefruit spoon). Signed. Made by Theodor Müller, Weimar. Karl-Ernst-Osthaus-Museum, Hagen. *Ill. p. 115*

291 Belt buckle. 1898-1900. Silver, with plant ornament in relief; moonstones and rose diamonds. c. 1⅝″ x 2¾″. Executed in the artist's workshops in Ixelles. Nordenfjeldsk Kunstindustrimuseum, Trondheim

292 Coffee service. (c. 1903.) (Demi-tasse pot, sugar bowl, cups and saucer, plate). White porcelain, grey and grey-blue decoration. Made by Royal Meissen Porcelain Works. Collection Stephen L. Bruce, New York

293 Woven silk fabric; black abstract scrolls on purple background. (c. 1900.) 23¼ x 26″. Det Danske Kunstindustrimuseet, Copenhagen

294 Woven silk fabric; abstract rose design on rose background. 27⅛ x 21¾″. Det Danske Kunstindustrimuseet, Copenhagen. Both fabrics were part of a series called "Künstlerseide," commissioned from artists by the manufacturer Deuss & Oetker, Krefeld

MAISON VEVER

French jewelry manufacturers. Next in importance to Renè Lalique in producing Art Nouveau jewelry. Firm begun by Ernest Vever who withdrew in 1880. It was carried on by Paul Vever (1851-1915), and Henri Vever (1854-1942).

295 Decorative comb. (1900.) Carved horn, decorated with mistletoe in enameled gold and pearls. 6¾″. Musée des Arts Décoratifs, Paris

VILLON, JACQUES (Gaston Duchamp) (1875-)

French painter and printmaker. Oldest brother of Duchamp-Villon and Marcel Duchamp. After early law studies, joined the Atelier Cormon in 1895. At this time mainly occupied as illustrator, cartoonist and lithographer; close to Toulouse-Lautrec. In 1911 turned to Cubism. Lives in Puteaux near Paris.

296 *The Game of Solitaire.* 1903. Color aquatint and etching. 13⅝ x 17⅝″. The Museum of Modern Art, New York. Mrs. John D. Rockefeller, Jr. Fund

297 *Le Grillon: American Bar.* 1899. Poster. 51 x 37″. The Museum of Modern Art New York. Purchase

VOYSEY, CHARLES FRANCIS ANNESLEY (1857-1941)

English architect and designer. Pupil of J. P. Seddon, strongly influenced by Mackmurdo. Specialized in building small country houses which were partly based on the tradition of the English house, and in designing furniture, tapestries, wallpapers and useful objects. His style is characterized by its clean line and graceful simplicity. One of the leading English designers contemporary with Art Nouveau.

*298 Textile. (1897.) Silk and wool double cloth; bird and leaf pattern in green and white. 55 x 49″. Made by Alexander Morton & Co., Carlisle, England. Victoria and Albert Museum, London. *Ill. p. 89*

VUILLARD, EDOUARD (1868-1940)

French painter. 1886 began art studies at the Ecole des Beaux Arts in Paris; changed to the Académie Julian where he met as fellow students the painters with whom he joined in the *Nabi* group in 1889. 1890 shared a studio with Bonnard, Denis and Lugné-Pöe. 1893 together with Roussel, Bonnard and Ranson worked on the scenery of Ibsen's *Rosmersholm* at the Théatre de l'Oeuvre. 1894 decorations for the house of the Natanson brothers. 1896

exhibited with Lautrec and Bonnard with *La Libre Esthétique* in Brussels. 1908 teacher at the Académie Ranson. Developed an intimate style in his paintings and also produced several series of decorative panels for private houses and theaters. 1938 elected to the Institute.

299 *The Dressmakers.* (1891.) Oil on canvas. 19 x 21⅝″. Collection Mrs. Charles Vidor, Beverly Hills

WALLANDER, ALF

Worked for Rörstrand, porcelain factory in Stockholm around 1890.

300 Vase. (c. 1900.) Porcelain, glazed, representing a starfish in relief, partly submerged in the sea. c. 8⅞″ high. Made by Rörstrand, Stockholm. Österreichisches Museum für Angewandte Kunst, Vienna

WEISS, EMIL RUDOLF (1875-　　)

German painter, graphic artist, designer. Studied in Karlsruhe, Stuttgart and Paris. Husband of sculptor Renée Sintenis. Contributed to *Pan*. After 1897 active in all forms of book design (for publishers Eugen Diederichs, die Insel and S. Fischer). 1907-33 taught applied art in Berlin.

301 End papers for *Gugeline* by E. R. Weiss. 1899. Book size 8 x 5¾″. Klingspor Museum, Offenbach

302 Binding for *Die Fischer und andere Gedichte* by A. W. Heymel. 1899. Collection Gerd Rosen, Berlin

WILKE, RUDOLF (1873-1909)

German caricaturist. Born in Braunschweig, he studied in Munich and, 1894-95, at the Académie Julian in Paris. Active in Munich where he contributed continuously to *Jugend* after its inception in 1896, and to *Simplicissimus*. Outstanding caricaturist of the period.

*303 "Ueberbrettl." Drawing for *Simplicissimus*. 1903. Ink, tempera and watercolor. 18½ x 11½″. Staatliche Graphische Sammlung, Munich. *Ill. p. 82*

WOLFERS, PHILIPPE (1858-1929)

Foremost Belgian goldsmith and jeweler, whose family firm had been prominent for two generations. Philippe Wolfers studied under Isidore de Rudder and first worked in the neo-rococo style, but by 1895 had turned completely to Art Nouveau floral and insect motifs. He introduced the use of ivory from the Belgian Congo in creating brooches, combs and decorative objects of extreme refinement. By 1900 his style had become more symmetrical and abstract. He was represented at the Turin Exposition of 1902.

304 *Medusa.* 1898. Pendant on gold chain. Carved ivory, enameled gold and opal. c. 4″ high. Signed P.W. Ex Unique. Collection L. Wittamer-de Camps, Brussels. *Ill. p. 100*

*304a Inkstand. 1895-1900. Gilded bronze. 4¼ x 18⅛″. Collection L. Wittamer-de Camps, Brussels. *Ill. p. 93*

ARCHITECTURE

Photographic Enlargements

VICTOR HORTA

Tassel House, 6 rue Paul-Émile Janson, Brussels; stair hall; 1892-93. *Ill. p. 129*

Van Eetvelde House, 4, avenue Palmerston, Brussels; stair hall; 1895. *Ill. p. 132*

Grand Bazar, Anspach, Brussels, 1895. *Ill. p. 126*

Maison du Peuple, place van de Velde, Brussels; auditorium and façade; 1897-99. *Ill. p. 131*

A l'Innovation, rue Neuve, Brussels, 1901. *Ill. p. 127*

HECTOR GUIMARD

Métropolitain Station, Place de l'Etoile, Paris, 1900 (demolished). *Ill. p. 136*

Métropolitain Station, entrance gate (c. 1900). The Museum of Modern Art. *Ill. p. 135*

Humbert de Romans Building, rue St. Didier, Paris, 1902; auditorium (demolished). *Ill. p. 134*

AUGUST ENDELL

Atelier Elvira, Munich; façade and stair hall; 1897-98 (destroyed). *Ill. pp. 138, 139*

JOSEF HOFFMANN

Palais Stoclet, Brussels; exterior and interior; 1905-11. *Ill. pp. 142, 143*

CHARLES RENNIE MACKINTOSH

School of Art, Glasgow; façade and library; 1897-99. *Ill. p. 145*

ANTONI GAUDÍ

Casa Milá, Barcelona; façade, balcony detail, plaster ceiling decoration; 1905-07. *Ill. pp. 124, 125*

ALFRED MESSEL

Wertheim Store, Leipzigerstrasse, Berlin; 1896. *Ill. p. 128*

C.R.-F.M. JOURDAIN

Samaritaine Store, rue de la Monnaie, Paris; 1905. *Ill. p. 127*

INDEX

by Ilse Falk

Page numbers in italics denote illustrations

Abstract, Abstraction, 10, 70, 93, 95, 98, 102, 114, 137
Académie Julian, 54
Aesthetes, Aesthetic Movement, 8, 16, 65, 66, 75
Africa (African), 13, 102, 106
America (American), see United States
Amsterdam, 106
Anquetin, Louis, 49, 62
Anti-historicism, 11
Antwerp, 66, 68, 70, 125
Architectural Record, 102
L'Art Nouveau Bing, see Bing
L'Art Nouveau Gallery, see Bing
The Art Workers' Guild, 7
Arts and Crafts movement, 7, 8, 12, 29, 81, 91, 114, 140, 141
Arts and Crafts Exhibition Society, 7, 10, 24, 81
Ashbee, Charles Robert, 7, 90, 91, 163; ¡Bowl, *90*
Atelier Elvira, see Endell
Auriol, Georges, 39, *40;* type face, *41*
Austria (Austrian), 9, 10, 75, 91, 117-121, 123, 124, 135, 137, 140-141; see also Vienna
Avril, Jane, *37, 65*

Bakst, Leon, 66, 85
Balat, Alphonse, 125
"Bandwurmstil," 10, 123
Barbey d'Aurevilly, Jules, *Les Diaboliques, 20*
Barcelona, 62, 125
Barlach, Ernst, 83, 163; *Cleopatra, 82,* 83
Baron van Eetvelde house, see Horta
Baroque revival, 12
Batik, 13, 74, 109
Baudelaire, Charles, 10, 29
Bauhaus, 7, 116
Bazel, Karel Petrus Cornelis de, 163
Beardsley, Aubrey Vincent, 7, 8, 9, 11, 12, 14, 16, 19, 22, 24, 31, 38, 39, 42, 66, 72, 77, 163; *Ave Atque Vale, 18,* J'ai baisé ta bouche . . ., *67; Morte d'Arthur, 21, 22, 31, 66; Salome, 7, 21, 67; The Yellow Book,* 8, 66
Beerbohm, Max, 38, 66
Behmer, Marcus, 164
Behrens, Peter, 7, 16, 19, 38, 42, 45, 81, 83, 110, 116, 123, 124, 135, 144, 164; *Der Bunte Vogel, 36;* Dining room, *116; Feste des Lebens . . ., 18;* Kiss, *frontispiece, 10,* 83; Mathildenhöhe, *44,* 116
Belgian Socialist Party, Headquarters, see Horta, Maison du Peuple
"Belgische," "Belgische Stil," 10, 123
Belgium (Belgian), 10, 11, 12, 19, 31, 49, 68, 70, 77, 92-97, 121, 123, 125, 130, 135, 140
Benin bronzes, 14
Benois, Alexandre, 85
Berlage, H. P., 123
Berlin, 79, 83, 116, 121, 140
Bernard, Emile, 16, 49, 51-52, 62, 164; *Bathers, 52, 53; Bretonnerie, 51, 52*
Bierbaum, O. J., *Der Bunte Vogel, 36, 38*
Bindesbøll, Thorvald, 165
Binet, René, 144; Printemps Store, 125, *126, 144*
Bing, S., 11, 12, 14, 55, 81, 97, 101, 103, 105, 109; L'Art Nouveau, 55, 81, 97; L'Art Nouveau Bing, International Exhibition Paris 1900, 11, 103, 105; Exhibition Munch 1896, 11, 81; Maison de L'Art Nouveau, 11, 97, 101, 105, 109, 135
Bing, S., shop L'Art Nouveau, 22 Rue de Province, Paris, see Bing, Maison de L'Art Nouveau
Blake, William, 13, 26, 28, 72; *Little Tom the Sailor, 27; Songs of Innocence, 13, 15*
Bloemenwerf, see van der Velde
Boccioni, Umberto, 165
Bonnard, Pierre, 11, 16, 36, 38, 39, 54, 55-58, 105, 165; *France Champagne, 34, 36, 38, 58; Le Peignoir, 55; Revue Blanche, 37, 38, 58; Screen, 56-57*
Bonnier, Louis, 97
Bonvallet, 165
Book of Kells, *13*
Bosselt, Rudolf, 165
Boston, 106
Botticelli, Sandro, 29
Bouguereau, William, 54
Bradley, William H., 11, 38, 39, 66, 165; Whiting's Ledger Papers, *40*
Brittany, 49, 52, 62
Brouwer, William Coenraad, 166
Brussels, 7, 11, 31, 45, 47, 49, 66, 72, 125, 130, 135, 140, 141; Academy, 125; see also *La Libre Esthétique* and *Les XX*
Buchanan Street Tearooms, see Mackintosh
Buddhism, 9
Buffalo, 125
Buntes Theater, Berlin, see Endell
Burne-Jones, Edward, 65, 66, 77, 166; *Kelmscott Chaucer, 66; The Pelican,* 67
Burns, Robert, *Natura Naturans,* 31
Byzantine mosaics, 77, 79

Cachet, C. A. Lion, 166
Campanini, Alfredo, 135
Carolus-Duran, 68
Carrière, Eugène, 11, 166
Carson Pirie Scott Building, Chicago, see Sullivan
Casagemas, Carlos, 65
Casa Milá, see Gaudí
Casas, Ramón, 62
Castel Béranger, see Guimard
Catalan, 123
Catholicism, 9, 74
Celtic art, 12, *13,* 24, 38, 66
Centennial Exhibition, 1876, see Philadelphia
Centralschrift, see Schoppe
Century Guild of Arts and Crafts, 7, 26, 28, 29, 38, 90, 125
Cézanne, Paul, 49, 54
Chaplet, Ernest, 51
Charpentier, Alexandre, 101, 166; Re-

volving Music Stand, 99
Chéret, Jules, 7, 33, 36, 58, 166; *Folies-Bergère, 34; Yvette Guilbert, 35*
Chicago, 66, 124, 125
Chinese glass, 97
Church of Sagrada Familia, see Gaudí
Cincinnati, 106
Cissarz, J. V., 166
Civilité, 20, 40
Classical motifs, 38
Cloisonisme, 49
Cobden-Sanderson, T. J., 167; binding for *Aeropagitica, 21*
Colenbrander, Theodorus A. Chr., 109, 167; *Plate, 108*
Collage, 77
Colonna, Eugène, 11, 101, 167
Congo, 109, 125
Corinth, Lovis, 167
Cormon, Fernand, 62
Councillor Coulon, 60
Counter-Art Nouveau, 70, 150 n. 18
Crane, Walter, 7, 10, 33, 45
Cranston, Miss, Tearooms, 68, *68-69,* 141
"Curtain-wall," 130
Curvilinear Gothic, 13

Dalpayrat, Adrien-Pierre, 167
Darmstadt, 91, 116, 124, 137; Artists' colony, 91; Mathildenhöhe, 91, 116
D'Aronco, Raymondo, 135
Daum Frères, 98, 167
Day, Lewis, 7
Debschitz, Wilhelm von, 114, 167; Inkstand, *114*
Debucourt, P. L., 12
Debussy, Claude, 7, 49
Decadence, Decadents, 8, 20, 33, 66
Degas, Edgar, 14
Decorative Arts Exhibition, 1897, 1899, Dresden, see Dresden
Decorative Arts Exposition, 1902, Turin, see Turin
Dekorative Kunst, 13-14, 90, 95
Demachy, Robert, 168
Denis, Maurice, 11, 16, 29-31, 33, 36, 45, 54-55, 58, 168; *April, 54; Sagesse, 30*
Des Esseintes, see Huysmans, *A Rebours*
Deutsche Kunst und Dekoration, 7
The Dial, 26, 27, 29
Donaldson, George, 91, 151 n. 1

Dresden, 11, 14, 87, 110; International Exhibition, 1897, 11, 109, 110, 111; German Art Exhibition, 1899, 87, 111, 115
Duchamp, Marcel, 74
Dujardin, Edouard, 49
Dumont, Henri, 36, 38, 168; *Tous les soirs . . ., 35*
Durand-Ruel Gallery, 75
Dutch, see Holland

Eckmann, Otto, 14, 16, 40-42, 81, 110-111, 135, 168; *Five Swans, 110;* Type faces, *43;* Title page for *Die Woche, 42*
"Ecole du Petit Boulevard," 62
Egyptian revival, 12
Eighteenth century, 101, 103, 123, 140; furniture, 98; illustrations, 66
Elskamp, Max, 32; *Dominical, 31*
Elvira Atelier, see Endell
Empire, 12
Endell, August, 10, 81, 83, 85, 110, 111, 114, 137-140, 169; Armchair, *112;* Atelier Elvira, 10, 16, 83, 111, 114, 137, *138-139,* 140; Buntes Theater, *140;* Decorative metal mounting, *113*
England (English), 9, 10, 29, 36, 65-68, 72, 81, 88-91, 93, 97, 105, 109, 114, 117, 123, 124, 125, 141
Ensor, James, 7, 47, 77, 169
Ernst Ludwig, Grand Duke of Hesse, 91, 116
Evenepoel, Henri, J. E., 169
Exhibitions, see under cities, e.g. Dresden
Exposition Universelle Paris, see Paris
Exotic art, 13, 62
Expressionism and Expressionists, 14, 83

Fauves, 14
Far Eastern, 109; see also Oriental
Feure, Georges de, 11, 101
Fin de siècle, 8, 66, 70, 101, 123
Finch, Alfred William, 95
"Flächenkunst," 140, 141
Flamboyant Gothic, 13
Flemish, see Belgium
Florence, 114
Florentine Mannerists, 52
Folkwang Museum, see Hagen
Forma, 65

"The Four," 66, 68
Fraktur, see Type faces
France (French), 9, 10, 12, 29, 31, 39, 40, 49-65, 66, 70, 79, 97-103, 105, 121, 123, 130, 135 ,137, 140, 147
Freud, Sigmund, 141
Fuller, Loie, 16, 62, *64;* Serpentine dance, 16, 62

Gaillard, Eugène, 11, 101, 169
Gaillard, Lucien, 169
Gallé, Emile, 9, 11, 12, 14, 97-98, 102, 105, 106, 169; Screen, *98;* Shell-shaped crystal bowl, 97
Gaudí, Antonio y Cornet, 62, 123, 125, 130; Church of the Sagrada Familia, 62; Casa Milá, 123, *124, 125,* 130
Gauguin, Paul, 7, 9, 14, 29, 31, 49-54, 58, 60, 62, 79, 95, 170; *Leda, 50; Manoa Tupapau, 51; Still Life with Three Puppies, 48, 49, 52;* Vase, *50; Vision after the Sermon, 49; Yellow Christ,* 51; Gauguin or School of Pont Aven, *Decorative Landscape, 50,* 51
Geneva, 75
Germany (German, Germanic), 10, 11, 40, 42, 70, 74, 81-85, 87, 91, 97, 109-116, 117, 123, 135-140, 141; Art Exhibition Dresden, 1899, see Dresden; *Centralschrift,* see Type faces; prints: *Christ as the Man of Sorrow with Four Angels, 22;* Reichsbahn, lettering, 114; woodcuts, 29
"Gesamtkunstwerk," 8
Gide, André, 55
Gilchrist, Herbert H., 28, 148 n. 31
Glasgow, 12, 66, 68, 91, 111, 141; Buchanan Street Tearooms, 12, 68, *68-69*
Glasgow group, 91, 111, 116; "The Glasgow School," 11; see also "The Four" and Mackintosh
Glasgow School of Art, see Mackintosh
Gogh, Theo van, 79
Gogh, Vincent van, 11, 14, 33, 49, 62, 68, 70, 79
Goldwater, Robert, 36
Goncourt, Edmond de, 10, 97
Gothic, 12, 13, 90, 91, 144, 146; Gothic architecture, 13, see also St. Severin, Paris; Gothic Revival, 12, 13

187

Grand Bazar Anspach, see Horta
Grand Duke of Hesse, see Ernst Ludwig
Grand Duke of Saxe-Weimar, 116
Grasset, Eugène, 7, 10, 11, 14, 16, 36, 38-40, 101, 150 n. 34, 170; *Histoire des Quatre Fils Aymon, 39,* 40; Poster for Exposition *Salon des Cent,* 10, *39;* Typefaces, *41*
Greek art, 29, 87; vase painting, 66
Gropius, Walter, 116, 144
Gros Waucquez Building, Brussels, see Horta
Gruebe workshop, Boston, 106
Guaranty Building, Buffalo, see Sullivan
Guilbert, Yvette, *35,* 36, 38
The Guild and School of Handicraft, London, 7, 90
Guimard, Hector, 8, 10, 16, 102-104, 130, 135, 140, 144, 147, 170; Apartment house, rue Fontaine, 130; Castel Béranger, 13, 135, 140; Desk, *104;* Desk chair, 103; Humbert de Romans Building, 16, 130, *134,* 135, 144; Métro, 10, 102, 130, *135, 136,* 137, 144, 147; Side table, *104*
Gulbransson, Olaf, 83
Gutton, André, Grand Bazar (Magasins Réunis), 135

Habich, Ludwig, 171
Haeckel, Ernst, *Kunstformen der Natur,* 14, 16, *17*
Hagen, 70, 75; Folkwang Museum (now Karl-Ernst Osthaus Museum), 70, 151 n. 22; Hohenhof, 75
The Hague, 106, 109
Hallet House, Brussels, see Horta
Hamburg, 11, 116
Hamlin, A. D. F., 11
Hankar, Paul, 12
Harper's Magazine, 38
Hauptmann, Gerhart, 55
Heidt Glass factories, Brooklyn, 105
Heine, Thomas Theodor, 83, 171
Henry, Charles, 10, 29, 70, 148 n. 15
High Victorian, 87; see also Victorian
Historicism, 11, 12, 81
The Hobby Horse, 8, 13, *26,* 28, 29, 40
Hodler, Ferdinand, 9, 68, 75, 171; *The Night,* 75; *The Chosen One,* 75, *76,* 151 n. 22

Hoffmann, Josef, 11, 16, 75, 79, 117, 121, 137, 140-141, 144, 171; Brooch, *121;* Convalescent Home, Purkersdorf, 141; Palais Stoclet, 17, 79, 141, *142, 143,* 144, 147; Project for an entrance, *137;* Wiener Werkstätte, 140-141
Hohenhof, Hagen, see van de Velde
Holland (Dutch), 9, 10, 13, 19, 45, 66, 68, 72, 106-109, 123
Horta, Victor, 8, 12, 13, 16, 45, 49, 66, 93, 95, 102, 110, 125-133, 135, 140, 141, 144, 147, 172; Buildings: Baron van Eetvelde house, 16, 130, *132,* 144; Grand Bazar Anspach, 125, *126;* Gros Waucquez Building, 130, *133;* Hallet house, 130; Hôtel Solvay, 13, *43,* 93, *145;* A l'Innovation, 125, *127,* 130, 144, 147; Maison du Peuple, *44,* 45, 125, 130, *131,* 141, 144, 147; his own house, 130, *133;* Tassel house, 10, 12, 49, 93, 125, *129,* 130; Objects: Electric light fixture, *92,* 93; Inkstand, *93*
Hôtel Solvay, Brussels, see Horta
Hough, Graham, 30
House of a Connoisseur, see Mackintosh
Humbert de Romans Building, see Guimard
Husser house, Chicago, see Wright
Huysmans, J. K. (Joris-Karl), 9, 10, 19, 20, 24, 33, 40, 65; *A Rebours,* 20

Ibels, Henri-Gabriel, 11, 54
Ibsen, Henrik, 12, 55
Iconography, 16
Image, Selwyn, *The Hobby Horse, 26*
Impressionism and Impressionists, 14, 29, 31, 47, 49, 70, 73, 101
Indépendants, see Société des Artistes Indépendants, Paris
India, 109
Inness, George, 105
A l'Innovation, Brussels, see Horta
International Art Exhibition, 1897, Dresden, see Dresden
International Art Exhibition, 1897, Munich, see Munich
International Exhibition of 1900, Paris, see Paris
International Exhibition of Decorative Arts, Turin, 1902, see Turin
International Style, 141

Irish, 24
Italy (Italian), 11, 123, 135

Japanese art, 11, 14, 24, 28, 29, 42, 54, 55, 58, 62, 66, 97, 101, 105; glass, 97; "Grass writing," *41;* Scroll, *41;* Utamaro, *15,* 24; woodcuts, 14, *15,* 24, 28, 42, 58
Jarry, Alfred, *Ubu Roi, 55*
Java, 13, 72, 109
Jenson, Nicolas, 25
Jourdain, Franz, Samaritaine Store, 125, *127,* 135, 144
Joventut, 62
Jugend, 10, 11, 40, 62, 83
Jugendstil, 10, 47, 81, 83, 85, 116, 123, 135, 140

Kandinsky, Wassily, 16, 65, 85, 172; *The Mirror,* 85
Kelmscott Chaucer, 66
Kelmscott Press, 7, 25, 66
Khnopff, Fernand, 11, 12, 31, 40, 47, 77; Cover for *Les XX, 31*
Kinderen, Antoon Johannes der, 172
King, Jessie Marion (Mrs. E. A. Taylor), 173
Kirchner, Ernst Ludwig, 83, 173; *Before the People, 82,* 83
Klimt, Gustav, 9, 11, 16, 66, 75-79, 141, 173; Frieze for Palais Stoclet, 78, 79, 141, *143; Salome,* 77; University of Vienna, 77
Klinger, Max, Beethoven Monument, 77
Klingspor, Karl, 42
Koepping, Karl, 121, 173; Decorative flower glass, *120*
Koch, Alexander, 7
Koch, Robert, 36
Kok, J. Juriaen, 109; Bottle-vase, *108,* 109
Krefeld, 116
Kunstformen der Natur, see Haeckel

Lacombe, Georges, 60, 173; *The Dream, 60*
La Farge, John, 105
Lalique, René, 11, 101-102, 173; Decorative comb, *102;* Shallow bowl, *101*
Larche, Raoul François, 174
Larisch, Rudolf von, 19, *20*
Läuger, Max, 174

Lautréamont, Isidore Ducasse, le Comte de, 47
Lavirotte, Jules Aimé, 135
Lebeau, Joris Johannes Christiaan (Chris), 174
Lechter, Melchior, 174
Lemmen, Georges, 31, 32, 95, 174; Advertisement for Bing's L'Art Nouveau, *105;* Cover for *Les XX,* 31
Le Pouldu, 51, 58
Le Pouldu, Inn, 58
Leczinski, Stanislas, 97
Liberty (Style), see "Stile Liberty"
Liberty, Arthur L., 14
Liberty's, London, 11
La Libre Esthétique, 7, 11, 49, 95
Liège, 93
"Ligne belge," 123
Lipps, Theodor, 83
Livemont, Privat, 174
Lötz, Witwe glass factory (Klostermühle, Bohemia), 121; Bottle-vase, *120*
London, 7, 11, 65, 72, 90, 95, 97; Victoria and Albert Museum, 91, 97
Loos, Adolf, 117, 123, 137, 141, 147
Lugné-Poë, 55

Macdonald, Frances, 16, 66, 73, 92, 175; *A Pond,* 18
Macdonald sisters, 12, 16, 19, 66, 92
Mackintosh, Charles Rennie, 11, 12, 16, 19, 22, 42, 45, 66, 68, 73, 77, 91-92, 116, 141, 175; Buchanan Street Tearooms murals, design for, *68-69, 68;* Cabinet, *91;* Glasgow School of Art, 141, *145;* House of a Connoisseur, 17; Reform movement, 68; *Scottish Musical Review, 19;* Willow Tea Room, 16
Mackintosh, Margaret Macdonald, 12, 16, 19, 66, 141, 175
Mackmurdo, Arthur Heygate, 7, 8, 12, 13, 26, 28, 29, 31, 33, 45, 90, 93, 124, 175; *Cromer Bird, 89; The Hobby Horse,* 8, 13, 26, 28, 29; Monogram, *28;* Two-sectional screen, *88, 90; Wren's City Churches,* 13, 27, 45, 90, 93
MacNair, Herbert, 66, 92
Madsen, Stephan Tschudi, 125
Maeterlinck, Maurice, 10, 55, 72
Maillol, Aristide, 7, 54, 58, 60, 176;

Washerwoman (bronze), *60; The Washerwomen* (painting), 60, *61; Women Playing Guitars,* 60, *61*
Maison d l'Art Nouveau, see Bing
Maison du Peuple, Brussels, see Horta
Majolika haus, see Otto Wagner
Majorelle, Auguste, 12, 176
Majorelle, Louis, 98; Bannister, *99*
Makart, Hans, 77
Mallarmé, Stéphane, 9, 10, 47, 49, 65
Malory, Thomas, *Morte d' Arthur,* 66
Manet, Edouard, 14
Manoeline Stile, 147
Martin, Camille, 176
Mathildenhöhe, see Darmstadt
Matisse, Henri, 52
Maus, Octave, 11, 47
"The mauve decade," 101
Meier-Graefe, Julius, 83, 97
Meisenthal glass factories, 97
Messel, Alfred, Wertheim Store, Berlin, 125, *128*
Metropolitan Underground Stations, Paris, 10, 102, 130, *135, 136,* 137, 144, 147; see also Guimard
Middle Ages, 7, 12, 24, 49, 60, 73, 88
Minne, Georges, 70, 72, 176; *Fountain with Kneeling Boys,* 70, *72*
Moderne Architektur, see Otto Wagner
"Modernismo," 11, 123
"Modern Movement," 16, 140
"Modern Style," 10, 123, 135
Modersohn-Becker, Paula, 83, 176; *Still Life,* 83, *84*
Monet, Claude, 14
Moréas, Jean, *Symbolist Manifesto,* 9
Moreau, Gustave, 29
Morris, William, 7, 8, 10, 12, 24-25, 26, 28, 29, 30, 33, 38, 39, 40, 45, 66, 70, 88, 90, 91, 95, 109, 125; Golden Type, *25; The History of Godefry of Boloyne, 25;* Kelmscott Press, 7, 25, 66
Moser, Koloman, 19, *20,* 117, 121, 137, 176; Liqueur glass, *120,* 121; Woven silk and wool fabric, *117*
Mucha, Alfons Maria, 177
Munch, Edvard, 9, 11, 16, 75, 79-81, 177; *The Cry,* 79, *80;* Exhibition Berlin, 1892, 79; Exhibition Paris, 1896, 11, 81; *Frieze of Life,* 79; *Madonna,* 79, *81*
Munich, 10, 11, 62, 77, 83, 85, 87, 110,

114, 115, 116, 137; Glaspalast, 114; International Art Exhibition, 1897, 114; University, 83
Munich School, 135
Münter, Gabriele, 85
Muthesius, Hermann, 90, 91

Nabis, 9, 29, 36, 54, 55, 58, 60, 62, 75, 81, 97
Nancy, 12, 97, 98; Place Stanislas, 12
Nancy School, 12
Nature and Art Nouveau, 14-16
Near East, 13, 105
Neo-Baroque, 137
Neo-Gothic, 105
Neo-Impressionism, 10, 31, 47, 70
Neo-Renaissance, 105
Neo-Rococo, 98, 105, 137
Nerée tot Babberich, Karel de, 177
Netherlands, see Holland
Newbery, Jessie, 68
New York, 11, 135
Nietzsche, Friedrich, 62
Nieuwenhuis, Th., 177
Nonell, Isidor, 65
Non-Objectivism, 33, 70, 85
Norway (Norwegian), 9, 125

Obrist, Hermann, 14, 81, 83, 110, 114, 135, 140, 177; *Design for a Monument,* 83, *84; The Whiplash* (also called *Cyclamen*), 83, *113,* 114
Offenbach-am-Main, 42
Olbrich, Joseph Maria, 11, 75, 116, 117, 124, 135, 137, 177; Candlestick, *118*
Oriental Art, 11, *15,* 28, 31, 38, 40, *41,* 106, 109; see also Chinese glass and Japanese art
Orthodox Baptistry, Ravenna, see Ravenna
Oslo, 79
Osthaus, Karl Ernst, 70, 75; see also Hagen, Folkwang Museum

Palais Stoclet, Brussels, see Hoffmann; see also Klimt
"Paling Stijl," 11, 123
Pan, 40, 83
Palmer, Samuel, 148 n. 31
Pankok, Bernard, 45, 81, 110, 111, 135, 178; Armchair, 111, *112;* Border illustration, *44;* Smoking room, *111*

189

Paul, Bruno, 83, 110, 111, 178
Parallelism, 75, see also Hodler
Paris, 10, 11, 14, 31, 38, 39, 47, 49, 62, 65, 66, 68, 72, 75, 79, 81, 83, 91, 97, 101, 102, 103, 105, 109, 111, 135, 137; International Exhibitions, 1855, 65; 1889, 60, 101; 1900, 11, 75, 91, 103, 105, 109, 111, 115, 116; Métro Stations, 10, 102, 130, 135, 136, 137, 144, 147; Salon du Champ de Mars, 1895, 101; St. Séverin, 14
Pèl y Ploma, 62
Perret, Auguste, 123, 135, 151 n. 8
Philadelphia, Centennial Exhibition, 1876, 105
Picasso, Pablo, 16, 62, 65, 178; Blue Period, 65; Courtesan with Jeweled Collar, 65; End of the Road, 65
The Picture of Dorian Gray, see Wilde
Pissarro, Camille, 7
Place Stanislas, see Nancy
La Plume, 10, 39; Exhibition of Grasset posters, 39
Plumet, Charles, 101
Poe, Edgar Allan, 72
Pointillism, 70
Pont-Aven, 9, 49, 51, 83
Portugal, 147
Postal Savings Bank, Vienna, see Otto Wagner
Poster movement, 10; Posters, 33-38
Pre-Columbian art, 60
Prendergast, Maurice, 178
Pre-Raphaelites, 16, 26, 65, 66, 72, 75, 90, 92
Primitive art, 60
Proto-Art Nouveau, 26, 125, 149 n. 9
Prouvé, Victor, 178
Pugin, August W. N., 12
Purkersdorf Convalescent Home, see Hoffmann
Puvis de Chavannes, Pierre, 7, 54

Quatre Gats, 62

Ranson, Paul, 11, 54, 55, 58, 60, 179; Women Combing Their Hair, 58
Ravenna, Orthodox Baptistry, 79
Redon, Odilon, 7, 9, 47, 54, 179; "La Mort: Mon ironie dépasse . . .," 46
Reform movement, 68, 114
Renaissance, 88

Renoir, Auguste, 7, 14
La Revue Blanche, 38, 58, 81
Revue illustrée, 39, 40
Revue Wagnérienne, 49, 148 n. 5
Ricketts, Charles, 29, 39, 179; The Dial, 26, 29; In the Key of Blue, 21
Riemerschmid, Richard, 81, 87, 110, 111, 114, 115, 135, 179; Music room, 86, 111; Side chair, 114, 115; Table flatware, 115
Rimbaud, Arthur, 47, 55
Robinson, Charles, binding for Make Believe, 21
Roche, Pierre, 62, 179; Loie Fuller, 62, 64
Rochefoucauld, Count de la, 75
Rococo, 12, 97, 123, 140, 147
Rodin, Auguste, 11, 70, 83, 179; Kiss, 83; The Sirens, 70, 72
Roland Holst, Richard Nicholaüs, 33, 180; Cover for van Gogh catalogue, 32
Roller, Alfred, 117
Roman letter, see Type faces
Romanesque, 90
Romantic, 47
Römische Antiqua, see Type faces
Rookwood Workshop, Cincinnati, 106
Rosicrucians, 9, 75
Rossetti, Dante Gabriel, 7, 26, 65, 148 n. 31, 180; Atalanta in Calydon, 26
Roussel, Ker-Xavier, 11, 54
Rozenburg, The Hague, 108, 109
Rudhard'sche Schriftgiesserei, Offenbach-am-Main, 42
Ruskin, John, 7, 12, 26, 33, 88, 90, 95
Russia, 83, 85
Rysselberghe, Theo van, 47, 180

Sagesse, see Verlaine
Saint-Aubin, Gabriel de, 12
St. Petersburg, 66
St. Severin, Paris, window, 14
Saintenoy, Paul, Old England Store, Brussels, 125, 126
Salome, 7, 66, 77
Salon des Cent, 10, 39
Salon de la Rose-Croix, 75
Salon du Champ de Mars, 1895, see Paris
Sankt Leopold, Hietzing, see Otto Wagner
Sàr Peladan, 75
Savoy, 66

Scala, Arthur von, 117
Scharvogel, Johann Julius, 180
Scherrebek, North Germany, 110
Schmalenbach, Fritz, 140, 141, 149 n. 4
Schmithals, Hans, 180
Schneckendorf, Josef Emil, 180
Schnellenbühel, Gertraud von, 117, 180; Candelabrum, 119
"Schnörkelstil," 10, 123
Schoellkopf, Xavier, 135
Schoppe, Centralschrift, 40, 42; see also Type faces
Schuffenecker, Emile, 49
Schwabe, Carlos, 66, 151 n. 20
Scott, Baillie, 91
Scotland (Scots), 11, 66, 91-92, 141
Secession Vienna, 10, 11, 45, 75, 77, 116, 117, 137
"Secessionsstil," 10, 47, 123, 135, 140
Second Empire, 102
Séguin, Armand, 54, 58, 79, 180; The Pleasures of Life, 58, 59
Selmersheim, Tony, 101
Serpentine curve, 22, 42; dance, see Loie Fuller; form, 111; line, 24
Serrurier-Bovy Gústave, 7, 93, 95; Dining room buffet, 93
Sérusier, Paul, 11, 52, 54, 55, 181
Seurat, Georges, 10, 29, 31, 33, 47, 79; The Bathers, 47; Le Chahut, 47; Le Cirque, 47, 48; La Parade, 47; A Sunday Afternoon on the Island of La Grande Jatte, 47
Shelling, J., 109; Bottle-vase, 108
Signac, Paul, 7, 10, 31
Simplicissimus, 83
Sloan, John, 181
Societé des Artistes Indépendants, Paris, 47
Solvay house, see Horta
Sommaruga, Guiseppe, 135
Somov, Constantine, 85
Songs of Innocence, see Blake
Spain, 11, 123
Stadtbahn stations, Vienna, see Otto Wagner
Stamp, Percy, hatpin, 103
Steichen, Edward, 181
Steinlen, Théophile, 65, 181
"Stile floreale," 11, 47, 123, 135
"Stile inglese," 123
"Stile Liberty," 11, 123

Strawberry Hill, 12
Strindberg, August, 55, 81
Stuck, Franz von, 77
The Studio, 73
"Studio-Stil," 10
"Style de bouche de Métro," 10
"Le Style des Vingt," 11
"Style Guimard," 10
"Style nouille," 10, 123
Sullivan, Louis H., 11, 105, 123, 124, 125, 181; Carson Pirie Scott & Co., *122,* 125; Guaranty Building, 125
Sumner, Heywood, 125
Surrealism and Surrealists, 114, 141
Swinburne, Algernon Charles, 148 n. 31
Switzerland (Swiss), 9, 70, 75, 114
Symbolism and Symbolists, 9-10, 19, 20, 29, 33, 39, 47, 49, 54, 55, 62, 65, 66, 68, 70, 72, 73, 74, 75, 77, 83, 95, 101, 103; Symbolist Manifesto, 9; see also *La Plume*
Symonds, Arthur, 66
Synesthesia, 8
Synthetism, 49

Tassel house, see Horta
Tatlin, Vladimir E., 83
Tearooms, see (Miss) Cranston; see also Glasgow
Terrasse, Claude, 55
Theater, 12, 55
Théâtre de L'Oeuvre, 55
Theosophists, 9
Thorn Prikker, 16, 72, 73-74, 181; *The Bride,* 73, 74
Tiffany, Louis Comfort, 11, 14, 55, 102, 105-106, 121, 124, 182; Group of vases, *106;* Tablelamp, *107;* Tiffany & Company, 105
Tolstoy, Leo, 7, 8
Toorop, Jan, 7, 9, 12, 16, 19, 47, 66, 72-73, 74, 77, 79, 151 n. 20, 183; *Delftsche Slaolie, 18;* Three Brides, 72, *73,* 79
Toulouse-Lautrec, Henri, 7, 8, 11, 14, 16, 36-38, 49, 55, 62, 65, 66, 79, 105, 183; *Jane Avril, 37,* 65; *Loie Fuller, 62, 64; Yvette Guilbert, 35; At the Nouveau Cirque: The Dancer and the Five Stiff Shirts; 62, 63*
Tropon poster, see van de Velde
Turin, 17; International Exhibition, *1902,* 17, 111

Type faces, 24-25, 38-45; *Auriol, 41; Ebony,* 42, *43;* Eckmann, 42, *43;* German *Centralschrift,* 40, 42; *Fraktur,* 40; *French Antique,* 42, *43;* Grasset, 41; Morris, Golden Type, *25;* Old Style, 39; Roman letter, 25, 33, 40, 42; *Römische Antiqua,* 40; Schoppe, *42; Uncial,* 42; see also von Larisch

Ubu Roi, see Jarry
Uccle, 8, 95
United States 11, 25, 36, 38, 87, 91, 102, 105-106, 117, 123, 124, 135
Universal Exposition, Paris, 1900, see Paris
University of Vienna, see Klimt
Utamaro, 24; *Snow, Moon, Flowers, Compared to Woman, 15*

Vallin, Eugène, 12
Vallotton, Félix, 7, 11, 54, 62, 66, 79, 85, 183; *Waltz,* 62, *63*
van de Velde, Henry, 7, 8, 10, 11, 12, 13, 16, 19, 24, 31-33, 38, 42, 45, 47, 68-70, 72, 73, 74, 75, 95-97, 98, 102, 109, 110, 111, 114, 115, 116, 117, 125, 135, 140, 147, 183; *Abstract Composition,* 70, *71, 73; Angels' Guard, 75, 94, 95;* Belt buckle, *103;* Bloemenwerf, 95, 97; Candelabrum, *96, 97; Déblaiement d'art, 32;* Design for pendant, *45;* Desk, *94,* 95; Dresden exhibition, 109, 110, 111; Dress design, 8, *9; Dominical, 31, 32;* Hohenhof, *75;* Lounge, *109,* 110; Side chair, *94,* 116; Table flatware, *115; Tropon* poster, 19, *23,* 24, 33; *Van Nu en Straks,* designs for, *32, 33,* 45, 70
Van Eetvelde house, see Horta
Van Nu en Straks, 32, 33, 45, 70, 74
"Veldesche," 10
Ver Sacrum, 75, 117, 137
Verhaeren, Emile, 72
Verkade, Jan, 9, 55
Verlaine, Paul, 9, 10, 30, 65; *Sagesse, 30*
Vever, Maison Vever, 184
Victoria and Albert Museum, see London
Victorian culture, 66; Victorian drawing room, *86*
Vienna (Viennese), 10, 11, 66, 75, 116, 117, 137, 140, 144; Akademie, 137; Austrian Museum for Art and Indus-

try, 117; Secession, see Secession Vienna; University, 77; see also Austria
Villon, Jacques, 184
Les Vingt, see Les XX
Les XX (vingt), 31, 47, 49, 72, 74, 95; International Exhibition, 31; Khnopff (cover), *31;* Lemmen (cover), *31*
Viollet-Le-Duc, Eugène-Emmanuel, 12, 125, 130
Voysey, Charles F. Annesley, 90, 91, 123, 184; Woven silk and wool fabric, *89*
Vuillard, Edouard, 11, 16, 54, 55, 105, 184

Wagner, Otto, 11, 117, 137, 140, 141, 144; Majolika haus, 137, 140, 141; *Moderne Architektur* (1895), 117; Karlsplatz Stadtbahn, 137, *137;* Postal Savings Bank, 137, 144, *146;* Sankt Leopold, 137
Wagner, Richard, 8, 62
Walker, Emery, 25
Walpole, Sir Horace, Strawberry Hill, 12
Webb, Philip, 141
Weimar School for the Applied Arts, 116
Weiss, Emil Rudolf, 185
Whiplash curve, 22; line, 19, 79; ornament, 12; see also Obrist
Whistler, James MacNeill, 14, 28, 29, 66; Butterfly mark, *28;* Peacock Room, 14; *La Princesse du Pays de la Porcelaine,* 14
Wiener Werkstätte, see Hoffmann
Wilde, Oscar, 7, 8, 19, 20, 24, 55, 66; *Picture of Dorian Gray,* 20; *Salome,* 7, 66
Wilke, Rudolf, 83, 185; *Ueberbrettl, 82*
Willow Tea Room, see Mackintosh
Die Woche, 42, *42*
Wolfers, Philipe, 185; *Medusa, 100*
World's Fair Paris 1855, 1889, 1900, see Paris
Worpswede, 83
Wright, Frank Lloyd, 45, 123, 124; Husser house, Chicago, 124
Wren's City Churches, see Mackmurdo

"Yachting Style," 10, 97
The Yellow Book, see Beardsley

Zola, Emile, 47, 66; *Le Rêve,* 150 n. 20

PHOTOGRAPH CREDITS

A.C.L., Paris, pp. 44 top right, 50 bottom; Archives Photographiques, Paris, p. 55; Art Institute of Chicago, pp. 21 bottom row, 22 left, 40, 51; George Barrows, New York, pp. 19, 103, 106, 107, 120, 121, 135; Walter Binder, Zurich, p. 94 top left; James Blair, Chicago, p. 122 top; Photo B.N., p. 34 left; Photo Bober, p. 14; Brenwasser, New York, p. 59; Brown Brothers, New York, p. 86 right; Photo Cauvin, Paris, p. 53; Cleveland Museum of Art, pp. 34 right, 72 bottom; Dienst voor Schöne Kunsten der Gemeente, The Hague, p. 108 right; Edizioni Artistiche Fiorentini, Venice, p. 77; Fachklasse für Fotografie Gewerbeschule, Zurich, p. 96; D. Galland, Brussels, p. 145 bottom; Gemeente Musea van Amsterdam, p. 18 right; Len Gittleman, Chicago, p. 122 bottom; Franz Gröl, Hagen, p. 76; Ernst Hahn, Zurich, p. 133 bottom; Friedrich Hewicker, Kaltenkirchen/Holstein, p. 82 top; Klingspor Museum, Offenbach, pp. 21 top left, 21 top center, 22 right, 42 bottom, 43 top left, 43 bottom left; Kunstgewerbemuseum, Zurich, pp. 9, 15 right, 27 right, 64, 68, 69, 84, 91, 94 top right, 97, 99 right, 103 top, 104 top, 119; Landesgewerbeamt, Baden-Württemberg, pp. 112 left, 115 top left, 117; Louis Laniepge, Paris, p. 60 bottom; Los Angeles County Museum, p. 65 top; D. S. Lyon, Walthamstow, England, p. 67 left; Foto Marburg, pp. 126, 132; Foto Mas, Barcelona, p. 124; Paul Mayen, New York, pp. 43 bottom left, 133 left, 133 right; Metropolitan Museum of Art, New York, pp. 15, 35 left top, 50; Foto Studio Minders, Genk, pp. 78, 143 top, 143 bottom; Photo Monsieur Delhaye, p. 93 top; Morain Photographe, Brussels, p. 100; Galerie Mouradian, Paris, p. 63 left; Musée des Beaux Arts, Ghent, p. 72; Museum of Decorative Art, Copenhagen, pp. 61 top, 99 left, 102, 110; Museum für Kunst und Gewerbe, Hamburg, p. 118; Museum für Kunsthandwerk, Frankfurt am Main, pp. 21 top right, 114 bottom; Nationalmuseum, Stockholm, p. 50 left; The New York Public Library, pp. 25 right, 26 all, 27 left, 30; Österreichisches Museum für Angewandte Kunst, Vienna, pp. 94 top right, 101, 108 left, 120 left, 120 right; Pierre d'Otreppe, Brussels, p. 92; Philadelphia Museum of Art, p. 63; Princehorn, Oberlin, p. 82 bottom; Princeton University Library, p. 67 right; Percy Rainford, New York, pp. 56, 57; Rijksmuseum Kröller-Müller, Otterlo, pp. 39 top, 54, 71, 73, 74; Walter Rosenblum, New York, p. 61 bottom; David Royter, New York, p. 104 bottom; John D. Schiff, New York, pp. 18 bottom right, 60 top; Stätliche Graphische Sammlung, Munich, p. 82 left; Dr. Franz Stödtner, Düsseldorf, pp. 126, 127, 128, 129, 131 top, 136 bottom, 138, 139, 140, 142, 146; Adolph Studly, New York, pp. 23, 37 right, 39 bottom; Soichi Sunami, New York, frontispiece, pp. 15 right, 35 left, 37 left, 48 right, 64 left, 81, 84 left; O. Vaering, Oslo, p. 80; Victoria and Albert Museum, London, pp. 13, 89 left, 89 right, 90, 98; Photo Viollet, Paris, p. 136 top; William and Morris Gallery, Walthamstow, England, p. 88.